# British Women and Cultural Practices of Empire, 1770–1940

Edited by Rosie Dias and Kate Smith

BLOOMSBURY VISUAL ARTS

NEW YORK • LONDON • OXFORD • NEW DELHI • SYDNEY

BLOOMSBURY VISUAL ARTS
Bloomsbury Publishing Inc
1385 Broadway, New York, NY 10018, USA
50 Bedford Square, London, WC1B 3DP, UK

BLOOMSBURY, BLOOMSBURY VISUAL ARTS and the Diana logo
are trademarks of Bloomsbury Publishing Plc

First published in the United States of America 2019

Cover design: Irene Martinez Costa
Cover image: Julia Margaret Cameron, *Marianne North in Mrs Cameron's
House in Ceylon*, 1877, albumen print. Private Collection

A catalog record for this book is available from the Library of Congress.

ISBN: HB: 978-1-5013-3215-9
ePDF: 978-1-5013-3216-6
eBook: 978-1-5013-3217-3

Series: Material Culture of Art and Design

Typeset by Deanta Global Publishing Services, Chennai, India
Printed and bound in the United States of America

To find out more about our authors and books visit www.bloomsbury.com
and sign up for our newsletters.

Material Culture of Art and Design

*Series Editor:* Michael E. Yonan

**Titles in the Series**

# British Women and Cultural Practices of Empire, 1770–1940

# Contents

# List of Illustrations

## Colour Plates

1   Martha Berkeley, Australia, 1813–99, *Mount Lofty from the Terrace, Adelaide*, c. 1840, Adelaide. Watercolour on paper, 34.5 × 45.0 cm. South Australian Government Grant 1935. Art Gallery of South Australia, Adelaide.

2   Martha Berkeley, Australia, 1813–99, *Government Hut, Adelaide*, c. 1839, Adelaide. Watercolour on paper. 29.0 × 34.0 cm. South Australian Government Grant 1935. Art Gallery of South Australia, Adelaide.

3   Martha Berkeley, Australia, 1813–99. *The First Dinner Given to the Aborigines 1838*, 1838, Adelaide. Watercolour on paper, 37.5 × 49.5 cm. Gift of J. P. Tonkin 1922. Art Gallery of South Australia, Adelaide

4   Theresa Walker, *Kertamaroo, A Native of South Australia* [&] *Mocatta, Commonly Known as Pretty Mary, a Native of South Australia*, c. 1840, two wax medallions in velvet-covered mount. State Library of New South Wales.

5   Front cover, lacquered board with mother-of-pearl inlay, *Album of Miss Eliza Younghusband, South Australia*, 1856–65. National Library of Australia.

6   'Bouquet of flowers', c. 1860, gouache, *Album of Miss Eliza Younghusband, South Australia*, 1856–65. National Library of Australia.

7   'Lake scene on a gum leaf', c. 1860, oil on gum leaf, *Album of Miss Eliza Younghusband, South Australia*, 1856–65. National Library of Australia.

8   William Wyatt, 'Cooroboree at Wallaroo Bay, South Australia', 1860, watercolour, *Album of Miss Eliza Younghusband, South Australia*, 1856–65. National Library of Australia.

9   Hand-coloured lantern slide showing the interior of the saloon of the Brasseys' yacht *Sunbeam*, c. 1878. Bexhill Museum, Bexhill-on-Sea, East Sussex.

# List of Figures

# List of Contributors

David Arnold is emeritus professor of history at the University of Warwick. He has written widely on science, technology and medicine in modern India. His publications include *Colonizing the Body: State Medicine and Epidemic Disease in Nineteenth-Century India* (University of California Press, 1993), *The Problem of Nature: Environment, Culture and European Expansion* (Blackwell, 1996), *Everyday Technology: Machines and the Making of India's Modernity* (University of Chicago Press, 2013) and *Toxic Histories: Poison and Pollution in Modern India* (Cambridge University Press, 2016).

Viccy Coltman is professor of eighteenth-century history of art at the University of Edinburgh, where she specializes in visual and material culture in Britain and its colonial territories. She has written two books, *Fabricating the Antique: Neoclassicism in Britain, 1760–1800* (University of Chicago Press, 2006) and *Classical Sculpture and the Culture of Collecting in Britain Since 1760* (Oxford University Press, 2009), edited one volume of essays and co-edited another. She is currently completing a cultural history of Scotland from 1745 to 1832.

Rosie Dias is associate professor in the history of art at the University of Warwick. She specializes in eighteenth- and nineteenth-century British art, as well as in the art of colonial India. Her book, *Exhibiting Englishness: John Boydell's Shakespeare Gallery and the Promotion of a National Aesthetic*, was published by Yale University Press in 2013, and she has also published essays and articles on art in colonial India and on the relationship between British and Venetian art.

Molly Duggins is lecturer in the Department of Art History and Theory at the National Art School, Sydney. Her recent publications include 'Pacific Ocean Flowers: Colonial Seaweed Albums' in *The Sea in Nineteenth-Century Anglophone Literary Culture* (Routledge, 2016); '"The World's Fernery": New Zealand and Nineteenth-Century Fern Fever' in *New Zealand's Empire* (Manchester University Press, 2015) and '"Which Mimic Art Hath Made": Crafting Nature in the Victorian Book and Album' in *Of Green Leaf, Bird, and Flower: Artists' Books and the Natural World* (Yale University Press, 2014). She is currently co-editing

a volume on art, science and the commodification of the ocean world in the long nineteenth century.

Ellen Filor received her PhD in 2014 from University College London. Since graduating, she has held a Fulbright at the University of Michigan and postdoctoral fellowships at University College London and the University of Edinburgh.

Caroline Jordan is research associate in the humanities and social sciences at La Trobe University, Melbourne, where she was previously lecturer in art history. Her research interests include Australian art (colonial to modern), Australian women artists and the history of art galleries and museums. She is the author of *Picturesque Pursuits: Colonial Women Artists and the Amateur Tradition* (Melbourne University Press, 2005) and is currently investigating the Carnegie Corporation of New York and its influence on the Australian and New Zealand art worlds from the 1930s.

Sarah Longair is senior lecturer in the history of Empire at the University of Lincoln and previously worked at the British Museum for eleven years. Her research examines British colonial history in East Africa and the Indian Ocean world through material and visual culture. Her first monograph, *Cracks in the Dome: Fractured Histories of Empire in the Zanzibar Museum* (Ashgate, 2015), examined the history of the museum and colonial culture in Zanzibar.

Amy Miller is completing her doctorate at University College London on the emergence of the globetrotter in the nineteenth century with specific focus on India, China and Japan. Formerly curator of decorative arts and material culture at the Royal Museums Greenwich, her monograph *The Globetrotter: Cosmopolitan travel, connecting cultures and conjuring the 'authentic' East in the age of Globalisation, 1870–1920* will be published with the British Library.

Kate Smith is senior lecturer in eighteenth-century history at the University of Birmingham. She uses cultural and material approaches to interrogate historical processes as they occurred in Britain during the long eighteenth century and has become increasingly interested in imperial and global histories. Kate published her first monograph titled *Material Goods, Moving Hands: Perceiving Production in England, 1700–1830* with Manchester University Press in 2014 and in 2015 published a co-edited volume (with Margot Finn) titled *New Paths to Public Histories: Collaborative Strategies for Uncovering Britain's Colonial Past* with Palgrave Macmillan.

Rosie Spooner is lecturer in design history and theory at the Glasgow School of Art, and lecturer in information studies at the University of Glasgow. Her research concerns the visual and material culture of empire, focusing especially on themes of identity and representation in nineteenth- and twentieth-century Scotland and Canada. Her work has been published in academic journals (*Journal of Curatorial Studies, International Journal on the Inclusive Magazine, Burlington Magazine*), critical arts publications (*C Magazine, Kapsula*) and exhibition catalogues (*Every.Now.Then*, Art Gallery of Ontario).

# Acknowledgements

*British Women and Cultural Practices of Empire, 1770–1940* arises from a conference, 'Visualizing and Materializing Colonial Spaces: Female Responses to Empire', which took place at the University of Warwick in January 2014. We would like to thank the Paul Mellon Centre for Studies in British Art, the Royal Historical Society and the University of Warwick's Humanities Research Centre for their generous funding of the conference, which brought together a group of interdisciplinary scholars to examine the ways in which women produced colonial spaces through visual and material means from the eighteenth to the twentieth century. Since then, those involved in the discussions arising from the conference have worked to hone their ideas for this volume – we are grateful to all our contributors for the intellectual rigour and hard work that they have brought to the project.

At Bloomsbury, we were fortunate to receive the encouragement and support of Margaret Michniewicz, who, along with Katherine De Chant and Erin Duffy, has worked with exemplary professionalism and patience to bring the volume to fruition. We are grateful also for the insights of our series editor, Michael Yonan, and of the manuscript's reviewers. Despite the many people who we are indebted to, responsibility for any errors remains our own.

Rosie Dias
Kate Smith

# List of Abbreviations

| | |
|---|---|
| BL | British Library |
| CMAA | Cambridge Museum of Archaeology and Anthropology |
| NLS | National Library of Scotland |
| NMS | National Museum of Scotland |
| NT | National Trust |
| RA | Royal Archive |
| RCSL | Royal Commonwealth Society Library |
| RHL | Rhodes House Library |
| TNA | The National Archives |
| ZNA | Zanzibar National Archive |

# Introduction

Rosie Dias and Kate Smith

You probably conceive, that, in this gay and enervating climate, industry is the last idea that would suggest itself to the mind of a fine lady: but you are mistaken; for the ladies at Calcutta are very fond of working upon muslin, of knotting, netting and all the little methods of whiling away the time, without hanging weights on the attention.[1]

I am building a room in the garden and a *laboratory* for all sorts of odd rocks and works and shall endeavour to fancy myself in England. I mean to learn Persian in the Moorish language. I must do something to make me understand and be understood. Besides I hope that, as I must do *something*, I shall grow *prosperous* and hold forth in all the eloquence of the East and in that style I may pour forth my soul at your feet when I return. I cannot help already thinking what I shall do when *I go back again.*[2]

Writing home from India at the end of the eighteenth century, Sophia Goldborne and Henrietta Clive testify to the importance of women's work while living in the colony. As a means of 'whiling away the time', of remembering home, of understanding the East, and of communicating – the feminine endeavours that Goldborne and Clive describe above served to negotiate the spatial, topographical, social and linguistic distances between home and colony. As Henrietta Clive's letter suggests, the activities she intends to pursue will enable her both to locate familiarity in an exotic landscape and to return home exoticized – conceptual journeys which can be undertaken only through her own processes of colonial knowledge, ordering and embodiment. The chapters that make up *British Women and Cultural Practices of Empire, 1770–1940* seek to uncover how the material, textual and visual practices enacted by British women like Clive and Goldborne shaped the construction of empire.

Clive and Goldborne shared similar journeys, both travelling to India with male relatives who were in the service of the East India Company (EIC). As

the wife of the governor of Madras, Clive found herself in the unique position of being able to travel – along with her two daughters – extensively through her husband's administrative territories, undertaking a seven-month tour of South India that covered over 1,000 miles, while Edward Clive himself remained tied up in Madras on business. En route she collected plants, seeds, animals, shells and rocks; she visited zenanas, temples and sites of colonial conflict; and she met native princes, often accepting gifts from them. Her experiences and observations were recorded in letters, while the objects she acquired were sent back to Madras (and some of them eventually to Britain) where they were incorporated into domestic spaces and garden projects. Sophia Goldborne, meanwhile, travelled with her father – a captain in the EIC – to Calcutta where she threw herself into the fashionable European social life for which the city had, by the 1780s, become conspicuous. Female occupation for Goldborne was a welcome means of occupying empty time in an inhospitable climate, while not exerting too many demands on one's concentration or understanding.

The ultimately differing attitudes to female colonial work in these two letters might be accounted for by the fact that Goldborne was a fictional character – one invested with a modicum of satire by the author of the 1789 novel *Hartly House, Calcutta*, Phebe Gibbes. More suggestive, perhaps, than the work that Goldborne describes, is that undertaken by Gibbes herself, who never actually travelled to India. *Hartly House, Calcutta* is, in itself, an intriguing example of how a female novelist might materialize and conceptualize empire from the distance of the metropole. With her son based in Calcutta, Gibbes seems to have woven the fabric of her novel from rich threads of textual and visual sources – her son's letters, contemporary publications on India and – most likely – recently published topographical prints of Calcutta by Thomas and William Daniell.[3] In constructing her fictional narrative, Gibbes accumulated materials that encompassed family correspondence, scholarly texts, newspaper reports and visual culture, investing and embellishing them with her own sentimental responses and fictional imaginings in ways that brought together her various positions as mother, novelist and citizen of empire. Despite her physical distance from India, Gibbes, like Henrietta Clive, negotiated objects accrued through colonial encounter in ways that were inflected by her own gendered and social position – and in doing so created social and cultural meanings that were simultaneously personal and contributory to wider conceptualizations of empire.

In their constructions of objects, spaces, collections and selves, Gibbes and Clive anticipate the wide range of cultural practices that the women examined

in this volume engaged across Britain's colonial territories – processes through which they experienced and shaped imperial projects, and comprehended and reconstructed their own dislocated identities. *British Women and Cultural Practices of Empire* largely focuses on the long nineteenth century, examining how the objects – texts, sketches, albums and collections – that women created in and about empire produced personal, social and imperial meanings. The essays in this volume actively attend to and explore the expressions and silences within these productions. Rather than making claims to being comprehensive, the volume seeks to begin the work of exploring practices at the disposal of women through which they expressed their responses to imperial sites in India, the Caribbean, America, Canada, Australia and Zanzibar.

## British women and empire

Histories of imperialism have increasingly come to deconstruct the cultural practices and productions that supported and maintained systems of colonialism in the modern period.[4] Edward Said's intervention, which revealed the latent processes at work within literary texts, remains seminal.[5] Subsequently, material and visual 'turns' have encouraged scholars to place other cultural productions under greater scrutiny. Examining practices such as collecting and productions such as published writing has taken imperial scholars outside of the colonial archives and has allowed them to begin to recognize the different means through which contemporaries constructed difference and embedded the asymmetrical power relations that lay at the heart of colonizing processes. Nevertheless, these studies have tended to focus on the cultural productions created by men, with much less attention given to those of women.[6] In contrast, the present volume engages with a broad range of cultural practices and productions enacted by British women from published writings to albums and from collections housed in rural settings to objects acquired through international travel. Using a self-consciously gendered lens is crucial to this approach.[7] Privileging objects and writings created by women allows this volume to examine practices and productions previously unrecognized as significant within imperial projects.

Sites of female colonial work were often distinct from the employments and spaces experienced by male relatives and counterparts. Differentiating these colonial spaces and productions is critical to understanding not only the lived experiences of those in empire, but also the broader social, cultural

and political meanings which constituted empire. The last thirty years have witnessed a shift in the scholarly attention given to the roles played by British women in different imperial spaces and the lives they lived there. Important early work by scholars such as Claudia Knapman, Helen Callaway and Mary Ann Lind focused on white European women in empire, distinctly disrupting understandings of imperial projects as largely masculine in tone, purpose and personnel.[8] These works responded to developments in women's history, which urged scholars to seek out female voices as they appeared in the historical record and reveal their roles in processes of historical change. In working to understand the roles white women played in empire, these scholars focused on power and exploitation to question whether women were complicit in, or resistant to, an imperial project that had previously been characterized as exclusively masculine. Through this focus European women often came to be understood as adhering to one end of a binary split that categorized them as either victim or aggressor, while simultaneously obscuring the colonial setting in which they acted.[9] Focusing on white women meant that indigenous people and culture only appeared in the guise they assumed 'through European eyes'.[10] The importance of gender was underlined for white men and women, but native populations were rarely gendered, largely excluding colonized women 'from the concept of woman'.[11] Changing understandings of gender, which began to examine gendered identities as relational constructs, challenged work that approached women and feminine identities in isolation.[12] In response, scholars sought to resituate European women's experiences and identities as existing at the intersections between gender, race, nation and class.[13] In response, for example, Billie Melman's important work looked to the importance of class and gender to consider whether English women developed 'a separate feminine experience' and a particularly female mode of looking, which constructed and shaped imperial sites.[14]

More recent research has continued to examine the complex, interdependent and changing nature of gendered identities in imperial spaces by exploring the experiences of colonized women and examining European women's roles within networks such as missionary projects, imperial office and kinship groups.[15] Taking this approach has enabled historians to recognize the complex set of relationships that governed the lives and identities of men and women and have underlined experiences of gender as highly differentiated rather than universal.[16] The family has emerged as a significant unit of analysis for imperial historians.[17] Sexuality and sexual practices have also increasingly been

examined to shed light on the intimate dynamics of imperial power.[18] Focusing on the family and sexuality has brought to light the important and complex roles that native women played in imperial life as concubines, mothers and nurses.[19] Such important interventions underline the need to reject modes of analysis that simply separate out the experiences of white women and instead to simultaneously reveal and examine the often intertwined experiences of colonized men and women.[20] Doing so has further highlighted the importance of race to experiences of colonized and colonial women in imperial sites. At the same time, it has revealed the blurry nature of lines of demarcation that supposedly existed between these two groups. Such work has underlined the complexity of women's lives in empire and our inability to remove them from the webs of relationships and spaces in which they operated, webs that were often simultaneously proximate and maintained across vast distances through material practices of letter writing and gift giving.[21]

New imperial history has given importance to interconnection, permeability, mobility and hybridity when understanding individuals, groups and spaces. In response, *British Women and Cultural Practices of Empire* seeks to focus on British women as the principal node within interconnected assemblages of people to deconstruct the range of voices through which colonial systems were produced, maintained and understood. As with earlier work, however, such an approach is problematic and contains limitations. By featuring British women, it at times obscures the lives of colonized men and women and only interrogates their lives as they were constructed through European eyes. However, by examining the nature and modes of such constructions through material, visual and literary sources, it seeks to make a significant contribution to the work of broadening the imperial archive. Our approach recognizes that uncovering the lives of colonized and colonializing women in empire has long been frustrated by the structures and limitations of institutional archives. The work of Betty Joseph, Durba Ghosh, Antoinette Burton and Ann Laura Stoler has shown the necessity of reading into and against archives to reveal the roles that both native women and European women played in empire.[22] Other historians have looked to alternative sources: as Mary A. Procida has argued, recovering 'the lived experiences of women in the empire ... necessitates the investigation of alternative sources'.[23] This volume seeks to do just this by looking to the cultural work such women created. Rather than responding exclusively to histories of gender then, this volume simultaneously responds to and expands upon the visual and material turns within imperial history. As such, it hopes to open

avenues for future analysis of comparisons with, and responses to, the material, visual and literary work of colonized men and women.

## Practices and productions

Material culture studies highlight how meaning, knowledge and power are and were made manifest in material forms such as teacups, axes, gardens and bridges. Originating within the disciplines of archaeology and anthropology, the methodologies and concerns of material culture studies have significantly impacted upon historical and art historical scholarship.[24] In recent years, imperial history has begun to take the material turn, giving increased recognition to objects and foodstuffs and the ways in which people related to and expressed meaning through them.[25] Studies of imperial material culture have often focused on global trade and consumption, tracking a single commodity, such as sugar, across time and space.[26] Other studies have focused on flows of imperial objects as they travelled between individuals and families as forms of gift exchange.[27] Alternatively, some studies have focused upon objects made prominent by particular political, social or cultural events, such as the so-called 'nabob' controversy.[28] In addition, the rendering of object meanings through literature or museum displays has also received examination.[29] Within these narratives, goods and gifts are primarily understood in terms of what they signified to those who consumed them, and as part of a system of economic exchange and acquisition that was simultaneously productive and reflective of fashion, taste and social distinction.[30] An inevitable consequence of such understandings has been that women are figured as eager consumers, and rarely as producers, of global objects. More generally, those 'things' produced by British people while away in empire or in response to forms of empire they encountered in the metropole have received less attention. Collections, domestic interiors, foodstuffs, sketches, albums, writings and photographs produced by colonizers did not tend to reach the marketplace (although, as David Arnold and Viccy Coltman's chapters show, this was not always the case). Rather they were consumed by smaller groups of individuals and were exchanged through gifting practices. Often such 'things' are missing from historical analysis due to being dismissed as amateur productions of little significance, not quite aligning with the sphere of culture on the one hand, or commodity exchange on the other.

In asserting the importance of critically engaging with these seemingly peripheral cultural productions, Caroline Jordan has forcefully argued that the category of 'the amateur' needs to be reconceived as historically and culturally contingent.[31] It is no longer enough to resist amateur status by celebrating historic occurrences of women's work; rather scholars need to critically engage with what the term 'amateur' meant within specific historical periods and cultures. In the nineteenth century, amateur status did not mean that a person or their work was deemed to be inferior to that of a professional.[32] Often amateurs were highly skilled after training either inside or outside the academy. The ability to retain amateur status was frequently regarded as a sign of power and prestige, while turning professional often had negative consequences. Moreover, as Kyriaki Hadjiafxendi and Patricia Zakreski have observed, the categories and practices of amateur and professional were far from oppositional ones, operating rather within 'overlapping yet dialectical relationships'.[33] Within the colonies, where there was often a dearth of professionals, amateur cultures tended to be particularly well developed; indeed, in colonial spaces, the divide between professionals and amateurs was often unclear and the status granted to both or either was constantly negotiated.[34]

Whether carried out as an amateur or professional practice, the act of making and creating was important. As Maureen Daly Goggin and Beth Fowkes Tobin have highlighted, 'women engaged in meaning making, identity formation, and commemoration through their production and manipulation of material artifacts'.[35] In imperial contexts, the acts of meaning-making captured by material artefacts offer important insights into different women's conceptions of empire and their roles in producing it. Highlighting making practices also underscores the various types of labour and work that contributed to the formation of imperial sites. Tim Barringer has argued that the Victorians were deeply engaged in gendering and moralizing labour both at home and abroad.[36] Representations of men at work in imperial contexts were significant and, in collecting material artefacts and through engagement with imperial sites, British women produced further representations of both male and female labour for consumption in the metropole.[37] Such productions facilitated a dialogue between the craft practices and material work enacted by colonized and colonizing men and women.

Material practices could come in a range of forms. For example, Dianne Lawrence's recent work on colonialist homes in West Africa, Australia, New Zealand and India demonstrates the ways in which British women used the creation of domestic interiors as an important means of constructing female

gentility and a sense of self (themes explored further in Rosie Spooner's chapter in this volume).[38] The competences enacted might include bringing objects from home, but also acquiring goods on the second-hand market and then appropriating them (and often their provenances) into the construction of their own narratives.[39] Conversely, as Anna K. C. Petersen has shown in relation to late-nineteenth-century New Zealand, female colonialists were occasionally attracted to the possibilities of a life freed from material encumbrances and domestic cares, and chose to actively invoke the example of indigenous female cultures and their perceived proximity to nature.[40] Within this plethora of domestic and material possibilities, it is clear that in negotiating these new spaces, their associated labours and their often-random array (and, occasionally, absence) of objects, women could, and did, construct a sense of self, alongside particular gendered, racial and social identities. At the same time, such projects also enabled British women to obscure and silence the identities and experiences of others.

In elite homes, however, women were often constrained as to the extent of changes they could perform. Women living in official residences such as Government House in Calcutta were particularly liable to experiencing restrictions on their freedom.[41] In the later eighteenth century, EIC elites strove to legitimize their governance roles by recasting themselves as newly appointed Indian nobles, determined to rediscover India's ancient laws.[42] They appropriated a range of Indian practices to achieve this particular form of legitimacy, such as magnificent ceremonies and large retinues of servants. Unlike British country houses, however, the spaces of Government House in Calcutta failed to distinguish between household members and their servants, meaning that relationships between servant and master required constant negotiation.[43] In the later period, writers such as Flora Annie Steel advised women (particularly those lower down the social scale) to hone their language skills and proactively manage their servants. Through appropriating the idioms of colonial bureaucracy, women in the later nineteenth century learned the value of 'inspection parades' and routines as means of controlling the fractured and often transient nature of the colonial home.[44] Controlling and curating domestic spaces and the assemblages of objects, plants and animals they contained, alongside managing the servants and the relationships with them, existed as cultural work, which created meaning, order and difference central to imperial projects.

Some British women focused on more self-conscious practices of curating in their professional roles within museums (as Sarah Longair's chapter

explores) while others engaged in such practices through their own collecting. Scholarship by art and cultural historians has highlighted the importance of collecting practices to imperial projects undertaken by different European powers in the subcontinent.[45] Collecting – making judgements on objects, displaying and discussing them – allowed imperial men to reinvent themselves and fashion their identities anew. At the same time, by exchanging parts of their collections with other EIC officials or with Indian princes, EIC men were able to consolidate relationships and contacts that were beneficial to their careers.[46] Collections also aided the consolidation of prestige, status and standing. The objects looted in large quantities by British forces following the Siege of Seringapatam in 1799 were largely understood as trophies which, although used in gifting practices that could often have emotional resonances, were chiefly important for the prestige they gave and narratives of victory they produced. How then did women respond to the potential for collecting in the subcontinent? Were female practices of collecting distinct from those that men enacted? Were collections put to different purposes? The practices adopted by itinerant traveller Fanny Parkes demonstrate some of the ways in which women could also be understood to assume and utilize collecting practices.[47] During her Indian travels, Parkes began collecting an assortment of objects, beginning with the acquisition around 1830 of a lathi, a heavy weapon that had been confiscated from a man after he used it to commit two murders.[48] While her collecting can be understood as curiosity, on her return to Britain and the death of her husband, Parkes used such objects to claim status and notoriety within Britain (themes further explored by Amy Miller in her chapter on Lady Brassey, Annie Russell Cotes and Nora Beatrice Gardner). Moreover, as Ellen Filor's and Rosie Dias's chapters in this volume demonstrate, women were also able to amass collections of imperial objects while never entering imperial spaces. Collecting, in different ways and for different ends, allowed women to construct alternative narratives of empire, and themselves, that nevertheless contributed to the ideological basis of imperial projects.

Female collecting was often understood as occupying a specific position within a gendered division of acquisition and reception, a conceptual separation, which – in colonial contexts – was not entirely unfounded, given the distinctive practices of looting, and gifting that took place in such arenas. But this division had traditionally persisted in other areas of female cultural work also; in relation to botanizing, the *Edinburgh Review* demarcated zones of activity in which the white male botanist, after a day's exertion in the field,

would return with his trophy, at which point 'the female pencil is called forth to copy the new or the rare plant'.[49] This was not necessarily to denigrate the role played by white women in the production and dissemination of natural history knowledge; indeed, as Ann Bermingham has argued, flower painting (a category into which botanical painting was subsumed) 'legitimated women's artistic endeavours, and so gave women a kind of cultural agency and, finally, authority'.[50] White women's contributions to botanical painting were long-established and highly valued across Europe by the beginning of the nineteenth century, necessitated and spurred by vast, ongoing colonial projects which brought to the metropole field drawings and specimens for female artists to work up.[51] In Britain, more direct female engagements with natural history were legitimated within royal, aristocratic and bluestocking networks over the course of the eighteenth century, establishing 'polite' parameters within which elite white women could participate.

Nonetheless, as scholars such as Anne B. Shtier and Sam George have shown, botany held problematic associations for women, particularly in the aftermath of Linnaeus's emphasis on the sexuality of plants, with the result that, by the early nineteenth century, clear boundaries had been established between 'polite' female botany and a professional sphere of 'botanical science' that was reserved for white men.[52] Rather less attention has been paid, however, to women who undertook botanical and other natural history activities in colonial spaces where the parameters of 'polite' feminine botanical activity seem to have notably expanded (as Molly Duggins's chapter shows, feminine botanical activities could take many forms). In India, women such as Lady Anne Monson and Lady Henrietta Clive undertook self-directed tours and expeditions independently of their otherwise-occupied husbands; their activities were complemented by those of naturalists such as Lady Mary Impey, who built up and recorded a substantial collection of zoological and ornithological specimens, some of them new to the European scientific community.[53] Such pursuits undertaken by women of EIC families mirrored, and even contributed to, some of the official activities of the company, which set up botanical gardens in India and included naturalists in its vast survey projects, seeing such acquisitions and orderings of knowledge as an essential basis for the successful government of nature in its expanding territories and thus part of the wider project of imperial domination. Taking account of such female activity within imperial contexts not only allows for a more nuanced understanding of how colonial knowledge was acquired and shaped, but also exposes the permeability of gendered parameters for botanical

work once such activity was relocated to the colony. Albeit with asymmetrical claims to power, white men *and* women were actively involved in forms and practices of knowledge production fundamentally important to the ideological grounding of imperial projects.

## The pictorial arts and the female colonial gaze

Until the mid-nineteenth century, sketching proved indispensable to the colonial project, acting as a means of recording, ordering and transmitting imperial knowledge and forwarding the imperial project. While British institutions such as the Admiralty and the EIC occasionally engaged professional artists, great reliance was placed upon the skills of amateur practitioners, as well as of those whose draughtsmanship (and, subsequently, photographic skills) had been honed through a broader military training. In recent years, art historians have paid increasing attention to the broad spectrum of colonial art that encompasses the careers and practices of such individuals as Johann Zoffany and William Hodges – at the highest rank of the eighteenth-century British art establishment – as well as military officers and anonymous native artists drafted in to work on extensive imperial surveys.[54] Yet sketching also took on less obviously instrumental roles, and was practised particularly assiduously by elite colonial women. In eighteenth- and nineteenth-century Britain, genteel and elite women pursued drawing as a polite leisure activity, focusing their attentions mainly – though by no means exclusively – on the depiction of landscape.[55] Those who travelled out to the colonies in this period continued to deploy their pencils, often working with greater intensity and with access to a wider range of subject matter than they had at home. Sketching represented both an appropriately genteel activity and a medium through which women could engage with and record their environment, contributing to the broader imperial project of possession and domination and acquiring power and distinction for themselves.[56] Women's sketches had a variety of afterlives, sometimes bound into albums, often sent with a letter to a friend or relative back in Britain, and occasionally passed onto publishers in Britain and the colonies for reproduction and wider dissemination.

Recent scholarship has begun to illuminate and unpick the varied contributions of female artists in representing colonial spaces and encounters, as well as the distinctive challenges and shifts in practice that such relocations engendered (and such shifts are further explored in Caroline Jordan's chapter).[57]

Genteel women learned not only to draw but also to produce drawing materials such as charcoals, quills and watercolours, skills which would have been useful once resident in new colonial spaces such as Australia.[58] Their skills were thus adaptable, but there were, nonetheless, many ways in which practices were both enhanced and limited by the geographical and cultural contexts of specific colonial locations, as well as by factors such as economic means and class identity. In addition, women's artistic practices would have been shaped significantly by the materiality and limitations of their chosen medium. While watercolour, for example, was a fluid and portable medium that could be readily engaged for the purposes of a swift sketch when travelling, other pictorial technologies such as oil paint and photography presented specific challenges, and thus structured women's colonial encounters accordingly. Working outdoors using oil paints, for example, meant that Marianne North's encounters with native peoples and landscapes were necessarily prolonged, defined through the technical difficulties, including drying time, inherent with the medium. This goes some way towards accounting for the numerous physical discomforts and cultural clashes – including the natives' awareness of her sustained and scrutinizing gaze – that are described in her autobiography.[59] In an intriguing photograph by Julia Margaret Cameron taken on the veranda of Cameron's home in Sri Lanka, North is captured in the process of painting a dhoti-clad boy, posed with a pot on his shoulder (Figure 0.1). The pictorial space (and implied civilizational distance) between him and the figure of North, attired in heavy Victorian dress, establishes her authority on every level over her sitter, who is to be captured in paint (and through the lens) like so many ethnographic subjects before and after him. However, we must be alert here to the performative nature of this work, with North posing for another female artist, and siting her work within the comfortable space of the colonial home. In practice, such exercising of cultural and colonial control was less easily achieved for women who sought to represent colonial subjects and spaces. Difficulties often arose from the native subject's concern at being observed and delineated not only by a foreigner, but by a woman; the Anglo-Indian artist, Sophia Belnos, for example, when preparing her 1851 publication, *The Sundhya, or the Daily Prayers of the Brahmins*, encountered considerable reluctance from her subjects when she asked them to adopt and hold the poses associated with their rituals so that she could sketch them. She found that 'few Brahmans [*sic*] would condescend to enlighten a European female on such grave topics; nor could they comprehend why I should feel any

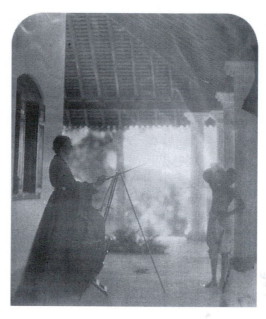

**Figure 0.1** Julia Margaret Cameron, *Marianne North in Mrs Cameron's House in Ceylon, 1877*, albumen print. Private Collection.

interest in the subject, or take any pains for a purpose (which they considered) so incompatible with my sex and *caste*'. [60]

The arrival of photography onto the artistic scene in the mid-nineteenth century posed further challenges and opportunities for female practitioners. As Jennifer Tucker notes, prior to the widespread use of the gelatin dry plate in the 1870s and 1880s, engagement with the wet plate collodion process was a 'messy process unfitting of a middle-class woman'.[61] Consequently, it is not surprising to find that, although white female photographers existed in the colonies, their activities – and opportunities to represent particular subjects – were rather more limited than those of white women who worked with a pencil or brush.[62] Historians of photography have noted that women in Europe and America became increasingly involved in photographic practice, criticism and societies from the 1850s onwards, encouraged by the increasing refinement of its technical processes, as well as the possibilities of situating its practice within domestic spaces.[63] However, there is a conspicuous lack of scholarship examining practices and approaches of women photographers in colonial locations, with the exception of some suggestive work on the late career of Julia Margaret Cameron in Ceylon, which proposes a gendered identification on the

part of Cameron with her native female subjects that is at odds with established Western aesthetic, voyeuristic and ethnographic modes and authority. [64] The few known examples of female photographers in the colonies – and particularly in the subcontinent – build a complex picture of feminine photographic production, the propriety of which was, to a significant degree, denoted by the specific context and genre of photography being undertaken. In professional studios in India, for example, the presence of a female photographer, for much of the second half of the nineteenth century, ensured the studio's ability to attract native women and families to sit for their portraits. Little is known about these female photographers beyond their names, but it is clear that, in cities such as Calcutta, Bombay and Hyderabad, they played a significant role in large photography establishments, such as that of Lala Deen Dayal, and sometimes even opened their own zenana studios with entrances and facilities suitable for women in purdah. In these spaces, the female photographer's gaze was conspicuously differentiated from that of her male counterpart; it was recognized and marketed for the sexual innocence of its vision. Moreover, female photographers were also disseminators of photographic techniques, offering lessons to Indian women in the studio or private homes, with at least one advertisement for such tuition reassuring Bengali readers that the queen's daughter, Beatrice, was an enthusiastic amateur photographer.[65] Thus, despite photography's many problematic aspects for female practitioners, the studio was a space into which women photographers were actively invited and could enjoy a professional identity, autonomy and self-sufficiency that was difficult to achieve in other fields of visual practice. Moreover, these examples underline how attention to the material and social contexts in which cultural productions were created reveals the fine-grained politics and meaning at work within empire.

## Producing empire

The photographic studio relied upon specific gendered and colonial relationships in order to function; in turn, it produced visual objects which themselves implicated spaces (the album, domestic rooms, the photographic print itself) that engendered additional kinds of relationships and encounters. Rather than understand space as a static dimension, Doreen Massey has insisted that it be understood as inherently dynamic. For Massey the spatial is 'constituted out of

social relations', it is 'social relations "stretched out"'.[66] In historical terms then, space needs to be understood as a dynamic phenomenon, which was continually constructed, performed and negotiated between historical actors. Massey's reading of the spatial is important in understanding how space is considered in this volume. Here the spaces that made up empire are understood as constituted through experiencing particular social relationships, which were construed and given meaning through different representations, objects and collections. The chapters included here seek to uncover how female material, visual and textual practices contributed to the construction of imperial spaces, giving them meaning and shape. As such it asks, what does empire look like when examined through the cultural practices of women?

The piecemeal construction and geographical scope of the British empire from the early seventeenth century into the twentieth, means that it is important to recognize from the outset that the women discussed in this volume had experiences of colonial spaces and peoples that were often sharply differentiated rather than broadly consistent. The emergence of British women in particular colonial locales – and, indeed, their absence from others – operated in highly specific ways, which were inflected and mediated to a large extent through the challenges presented by factors such as the terrain, climate and state of development of the colony in question, as well as the kinds of economic, trading or territorial concerns that shaped the colony. Such factors determined how and where women travelled within colonial space, the kinds of encounters that they had with landscapes and peoples, and the length of time that they would spend away from Britain. On an individual level, factors such as marital or familial status, education, economic means and age shaped colonial experiences, as did the traveller's awareness of their own situation within the imperial context (the experiences and practices of the short-term traveller, for example, differing from that of the settler). Some of the women examined in this volume did not travel to colonial territories at all; rather they remained at home and negotiated empire's shape and meanings from its centre.

Part One (Travelling) of this volume explores how experiences of travel and colonial encounter structured, informed and, sometimes, frustrated feminine constructions of empire. Looking at travel in both its physical and virtual manifestations, this section illuminates how spatial experiences and productions enabled women to construct and exploit colonial knowledge. The essays in this section engage with different kinds of colonial travellers and settlers, demonstrating the ways in which concepts and spaces such as

the picturesque and the frontier could be shaped or engaged anew by British women, often in ways that differed fundamentally from the practices of male imperial agents. In his chapter, David Arnold focuses on British women travellers and their writing in early-nineteenth-century India to examine the varied attitudes women developed to the social and physical conditions of the landscapes they encountered. British women travelled both through and with landscape (as it appeared in their imaginings), often summoning up 'the picturesque' as a means of describing and knowing the spaces they encountered. This female version of the 'picturesque' contrasted with the aesthetics and morality of Indian homes and domestic spaces as a means of voicing implied or explicit critiques about the poverty and degradation women travellers identified with India. Arnold's chapter begins a discussion that runs throughout the volume and questions whether women travelled through and constructed the subcontinent in different ways to men. Similarly, Viccy Coltman's chapter highlights how Janet Schaw's letters, written during sixteen months of travel, provide an uncommon example of a Scottish woman visiting first-hand distant parts of the British empire in the mid-1770s and constructing that experience in epistolary form. It considers how Schaw used the space of the letter as a means to loyally conform to or wilfully subvert the social practices of Britain's expansive imperial regime that was territorially on the point of contraction with the loss of the American colonies. Likewise, Caroline Jordan's chapter argues for the need to recognize the distinct presence of women in the frontier landscapes of Australia. Jordan takes up a contemporary reimagining of the frontier as multiple, urban, intimate and occurring over a protracted time frame to re-examine the productions of Australian colonial women artists. She asks, what if the well-educated, literate women who practised sketching, painting and modelling in the colonies were neither ideologically nor physically separated from the frontier but lived on it, knew about frontier violence and perpetrated it in various ways? Jordan uses depictions of Aborigines by women artists living, variously, on the emptied-out post-frontier of urban Tasmania of the 1840s and 1850s, the urbanizing frontier of Adelaide, South Australia, in the late 1830s and amid the open guerrilla warfare of the North Queensland frontier of the late 1860s and early 1870s as a conduit to connect white women and their cultural productions to the colonial land grab and its destructive consequences for the indigenous inhabitants. Collectively, these chapters generate suggestive issues of home

and colony, travel and space, cultural encounter, pedagogy and social class that pivot around the practices and identities of the female traveller.

While the chapters in Part One focus on expansive spaces of empire that women travelled through and with, Part Two (Collecting) turns to dwell on more localized spaces of display, such as the album, museum or domestic collection. The three chapters in Part Two examine how women collected, curated and displayed collections acquired in or from empire. Ellen Filor's chapter demonstrates the importance of collecting practices for women who remained in the metropole. Wilhelmina Malcolm constructed a museum at Langholm in Dumfriesshire, displaying a series of objects sent by her brothers and male friends away on imperial careers. Through this project, Filor argues, Malcolm involved herself in a form of imperial exploitation that was at once fundamentally different from but also complementary to the colonialism enacted by her brothers and nephews abroad. The processes of translation undertaken by Wilhelmina Malcolm can also be seen in the curatorial practices enacted by Miss Eliza Younghusband, whose albums circulated through informal networks to transmit cultural and aesthetic values throughout the British empire. Molly Duggins's chapter focuses on the album Younghusband produced in the years leading up to her marriage, demonstrating the role that the language of flowers played in the social lives of young women settlers. Simultaneously nostalgic for the European landscape and steeped in the emergence of a local aesthetic, such media forms, Duggins argues, allowed women to navigate the often precarious borderlands that they occupied at particular points within their lifecycles. In contrast, the final chapter in this section explores acquisition and collecting at distance and the use of objects in facilitating representations of 'authenticity' of experience. Amy Miller's chapter focuses on the later nineteenth century and demonstrates how travellers continued to use print, visual and material culture to traverse changing imperial distances. Lady Anne Brassey's 1878 account of her circumnavigation of the globe upon her luxury yacht *Sunbeam* allowed potential travellers a means of imagining new travel experiences. At the same time, travellers such as Brassey and Annie Russell Cotes worked hard to claim their journeys as 'authentic' adventures into the unknown. Curating exhibitions of objects brought back from travel offered one means of claiming authenticity. Collectively, these essays demonstrate the various ways in which women adapted, expanded upon, and sometimes sidestepped, persuasive masculine approaches to imperial knowledge and service by acquiring,

curating and displaying collections that consolidated and rendered their own understandings of, and aspirations for, the colonial project.

After the localized and mobile spaces of the album and the collection, Part Three (Administering) moves on to explore the construction of domestic and professional spaces within different parts of the colonial world. The three chapters in Part Three focus on Britain, India, Upper Canada and Zanzibar, respectively, exploring the disjunctions that often existed between British (metropolitan) space and that of the colony or protectorate, illuminating the ways in which women sought to address (or repress) agency, belonging, borders and encounters. First, Rosie Dias's chapter explores the ways in which Queen Victoria engaged with her Indian empire through objects gifted to her by native rulers. Such objects – displayed in the royal households, put to use in portraiture, and circulated so that they could be viewed by the British public – played an important role in Victoria's conceptualization of empire and of her own political role in relation to her Indian subjects. Dias argues that, while never visiting India, Victoria nonetheless shaped a material empire at home through political, private and gendered practices that were sharply differentiated from the masculine politics of the Raj, but which nonetheless served to sustain and cement its imperial project. Complementing these insights, Rosie Spooner's chapter on Anne Langton explores how imperial spaces were selectively appropriated and excluded in constructions of metropolitan identity and questions the role that gender played in such selections. On finding herself in colonial Upper Canada, Langton found that her gendered identity, particularly her ideas of feminine gentility was challenged by the physical effort that her new pioneer-like life required. An analysis of her diaries shows that by immersing herself in decorating and arranging the family's new home according to dominant notions of civility and comfort, Anne hoped to resolve her conflicted sense of self. Sarah Longair's chapter on professional women in colonial Zanzibar in the 1930s further extends the examination of conflict and contestation that is central to Part Three. In her chapter, Longair explores how two women – Helen Haylett (née Wilson), office assistant to the Zanzibar Secretariat, and curator of the Zanzibar Museum Ailsa Nicol Smith – forged professional and social paths in the colonial world. This chapter focuses upon the diversity of female responses to colonial service. The experiences of these two women complicate generalizations about 'colonial women' by focusing on the 1930s, a period during which various factors simultaneously enabled and inhibited women's participation in colonial government.

Overall, the volume highlights the differentiated, complex positions which British women occupied in relation to the colonial project by interrogating their materialized conceptions of empire. Some of the women examined experienced the empire from the metropole, acquiring its objects and organizing and engaging them from a distance within the spaces and routines of everyday life. Others were the wives, daughters and sisters of imperial agents who travelled to the far-flung reaches of the empire to provide familial support and moral credibility for their menfolk. Others travelled under their own steam as emigrants, explorers, missionaries or tourists, exposed to varying degrees to the often harsh realities of life in the colonies. What was common to many of these women was the need to record, comprehend and give material form to their experiences in myriad, often complex, ways – by writing, sketching, photographing, collecting and installing empire, by preserving (and obscuring) its sights, peoples, objects and meanings within conceptual and physical spaces constructed both in Britain and far beyond. Their experiences may not have been consistent – these women, after all, engaged with empire in ways that reflected a broad range of social positions, economic means, ages and personal and professional interests, while the geographical and political spaces of the British empire were similarly heterogeneous. But common to their various practices was a desire to articulate their colonial knowledge, experiences and identities. Often the forms that these materializations of empire took were deeply inflected by their creators' feminine identities, which both allowed and denied them access to specific spaces and practices in ways that differed sharply from those experienced by white men. In many instances, it is clear that while men concerned themselves with the administrative and military business of empire, their wives, sisters and daughters embarked upon practices of viewing and materializing that could only be achieved through prolonged periods of leisure; yet, the extent to which these male and female spheres of colonial and material practice both diverged and intersected is crucial to understanding the complex conceptions of empire that emerged from the eighteenth to twentieth centuries and the power these conceptions held. It is the experiences, practices and work of these imperial women – their materializations and visualizations of empire and its spaces, peoples and processes – that this book sets out to explore. In doing so, it will shed light not only on the women themselves, but also on the ways in which the British colonies were articulated, conceptualized, disseminated and domesticated, and how, in the process, its ideologies were produced, upheld and subverted by these women of empire.

# Notes

1 Phebe Gibbes, *Hartly House, Calcutta*, edited and with an introduction by Michael J. Franklin [1789] (Oxford: Oxford University Press, 2007), 21.

2 Henrietta Clive to Lady Douglas, 24 August 1798, in Nancy K. Shields, *Birds of Passage: Henrietta Clive in South India, 1798–1801* (London: Eland Publishing, 2007), 59.

3 On *Hartly House, Calcutta*, see Michael J. Franklin's introduction to the 2007 edition (*op.cit.*); Isobel Grundy, "'The Barbarous Character We Give Them': White Women Travellers Report on Other Races', *Studies in Eighteenth-Century Culture* 22 (1993): 73–86; Felicity Nussbaum, *Torrid Zones: Maternity, Sexuality and Empire in Eighteenth-Century Narratives* (Baltimore, MD and London: John Hopkins University Press, 1995).

4 For summary of this shift see Catherine Hall (ed.), *Cultures of Empire: A Reader: Colonizers in Britain and the Empire in the Nineteenth and Twentieth Centuries* (Manchester: Manchester University Press, 2000), 1–36.

5 Edward Said, *Orientalism* (London: Routledge and Kegan Paul, 1978); Edward Said, *Culture and Imperialism* (London: Vintage Books, 1994).

6 For example, while Maya Jasanoff's brilliant *Edge of Empire* features the collecting strategies enacted by women such as Henrietta Clive, its main focus is male collectors such as Claude Martin, Antoine Polier and Tipu Sultan. Maya Jasanoff, *Edge of Empire: Conquest and Collecting in the East 1750–1850* (London: Fourth Estate, 2005).

7 For a useful overview of the importance of interrogating the relationship between gender and empire, see Philippa Levine (ed.), *Gender and Empire* (Oxford: Oxford University Press, 2007), 1–13; Clare Midgley, 'Introduction: Gender and Imperialism: Mapping Connections', in *Gender and Imperialism*, ed. Clare Midgley (Manchester: Manchester University Press, 1998), 1–18.

8 Claudia Knapman, *White Women in Fiji, 1835–1930: The Ruin of Empire?* (Sydney: Allen and Unwin, 1986); Helen Callaway, *Gender, Culture and Empire: European Women in Colonial Nigeria* (Basingstoke: Macmillan; Urbana: University of Illinois Press, 1987); Mary Ann Lind, *The Compassionate Memsahibs: Welfare Activities of British Women in India, 1900–1947* (New York: Greenwood Press, 1988). Also see various popular histories of women's experiences in India that were also published in the late 1980s: Pat Barr, *The Dust in the Balance: British Women in India, 1905–1945* (London: Hamish Hamilton, 1989); Margaret MacMillan, *Women of the Raj* (London: Thames and Hudson, 1988); Marian Fowler, *Below the Peacock Fan: First Ladies of the Raj* (Harmondsworth: Viking, 1987).

9 Jane Haggis, 'Gendering Colonialism or Colonising Gender? Recent Women's Studies Approaches to White Women and the History of British Colonialism', *Women's Studies International Forum* 13, no. 1/2 (1990): 110 and 112.

10 Haggis, 'Gendering Colonialism or Colonising Gender', 111.

11 Ibid., 114.

12 Joan Wallach Scott, 'Gender: A Useful Category of Historical Analysis', *American Historical Review* 91, no. 5 (1986): 1053–75.

13 See Nupur Chaudhuri and Margaret Strobel, 'Introduction', in *Western Women and Imperialism: Complicity and Resistance,* eds Nupur Chaudhuri and Margaret Strobel (Bloomington and Indianapolis: Indiana University Press, 1992), 5; Margaret Strobel, *European Women and the Second British Empire* (Bloomington and Indianapolis: Indiana University Press, 1991); Susan Thorne, *Congregational Missions and the Making of an Imperial Culture in Nineteenth-Century England* (Stanford, CA: Stanford University Press, 1999); Catherine Hall, *Civilising Subjects: Metropole and Colony in the English Imagination, 1830–1867* (Cambridge: Polity, 2002).

14 Billie Melman, *Women's Orients: English Women and the Middle East, 1718–1918* [1992] (Basingstoke: Macmillan, 1992; Ann Arbor: University of Michigan Press, 1998), 2.

15 For more on the role of women in missionary life, see Fiona Bowie, Deborah Kirkwood and Shirley Ardener (eds), *Women and Missions: Past and Present: Anthropological and Historical Perspectives* (Providence and Oxford: Berg, 1993); Mary Taylor Huber and Nany C. Lutkehaus (eds), *Gendered Missions: Women and Men in Missionary Discourse and Practice* (Ann Arbor: University of Michigan Press, 1999); Dana L. Robert (ed.), *Gospel Bearers, Gender Barriers: Missionary Women in the Twentieth Century* (New York: Orbis, 2002); Hall, *Civilising Subjects*; Rhonda A. Semple, *Missionary Women: Gender, Professionalism and the late Victorian Idea of Christian Mission* (Woodbridge: Boydell, 2003); Clare Midgley, 'Can Women be Missionaries? Envisioning Female Agency in the Early Nineteenth-Century British Empire', *Journal of British Studies* 45 (2006): 335–58; Clare Midgley, *Feminism and Empire: Women Activists in Imperial Britain, 1790–1865* (London: Routledge, 2007); Alison Twells, *The Civilising Mission and the English Middle Classes, 1792–1850: The 'Heathen' at Home and Overseas* (Basingstoke: Palgrave Macmillan, 2009); Emily J. Manktelow, 'The Rise and Demise of Missionary Wives', *Journal of Women's History* 26, no. 1 (2014): 135–59.

16 Philippa Levine, 'Introduction', in Levine, *Gender and Empire*, 2.

17 Emma Rothschild, *The Inner Life of Empires: An Eighteenth-Century History* (Princeton and Oxford: Princeton University Press, 2011); Esme Cleall, Laura Ishiguro and Emily J. Mantelow, 'Imperial Relations: Histories of Family in the British Empire', *Journal of Colonialism and Colonial History* 14, no. 1 (2013): n.p.; Margot Finn, 'Anglo-Indian Lives in the Later Eighteenth and Early Nineteenth Centuries', *Journal for Eighteenth-Century Studies* 31, no. 1 (2010): 49–65; Margot Finn, 'Slaves Out of Context: Domestic Slavery and the Anglo-Indian Family,

c. 1780–1820', *Transactions of the Royal Historical Society* 19 (2009): 181–203; Margot Finn, 'Family Formations: Anglo-India and the Familial Proto-State', in *Structures and Transformations in Modern British History: Essays for Gareth Stedman Jones,* eds David Feldman and Jon Lawrence (Cambridge: Cambridge University Press, 2011), 100–17.

18  See, for example, Anne McClintock, *Imperial Leather: Race, Gender and Sexuality in the Colonial Context* (London: Routledge, 1995); Ann Laura Stoler, *Race and the Education of Desire: Foucault's 'History of Sexuality' and the Colonial Order of Things* (Durham, NC: Duke University Press, 1995); Ann Laura Stoler, *Carnal Knowledge and Imperial Power: Race and the Intimate Colonial Rule* (Berkeley, CA and London: University of California Press, 2002); Philippa Levine, 'Naked Truths: Bodies, Knowledge, and the Erotics of Colonial Power', *Journal of British Studies* 52, no. 1 (2013): 5–25.

19  Durba Ghosh, *Sex and the Family in Colonial India: The Making of Empire* (Cambridge: Cambridge University Press, 2006); Christopher J. Hawes, *Poor Relations: The Making of a Eurasian Community in British India, 1773–1833* (London: Routledge, 1996).

20  Jane Haggis, 'White Women and Colonialism: Towards a Non-Recuperative History', in *Gender and Imperialism*, ed. Claire Midgley (Manchester: Manchester University Press, 1998), 45–75.

21  For more on the importance of imperial letter writing, see Sarah M.S. Pearsall, *Atlantic Families: Lives and Letters in the Later Eighteenth Century* (Oxford: Oxford University Press, 2008); Kate Teltscher, 'The Sentimental Ambassador: The Letters of George Bogel from Bengal, Bhutan and Tibet, 1770–1781', in *Epistolary Selves: Letters and Letter-Writers, 1600–1945,* ed. Rebecca Earle (Aldershot, Brookfield, Singapore and Sydney: Ashgate, 1999), 79–94; Elizabeth Vibert, 'Writing "Home": Sibling Intimacy and Mobility in a Scottish Colonial Memoir', in *Moving Subjects: Gender, Mobility and Intimacy in an Age of Global Empire,* eds Tony Ballantyne and Antoinette Burton (Urbana and Chicago: University of Illinois Press, 2009), 67–88; Kate Smith, 'Imperial Families: Women Writing Home in Georgian Britain', *Women's History Review* 24, no. 6 (2015): 843–60.

22  Betty Joseph, *Reading the East India Company 1720–1840: Colonial Currencies of Gender* (Chicago: University of Chicago Press, 2003); Ghosh, *Sex and the Family in Colonial India*; Ann Laura Stoler, *Along the Archival Grain: Epistemic Anxieties and Colonial Common Sense* (Princeton: Princeton University Press, 2009); Antoinette Burton, *Burdens of History: British Feminists, Indian Women and Imperial Culture, 1865–1915* (Chapel Hill: University of North Carolina, 1994).

23  Mary Procida, *Married to the Empire: Gender, Politics and Imperialism in India, 1883–1947* (Manchester: Manchester University Press, 2002), 4.

24  See, for example, Dan Hicks and Mary C. Beaudry (eds), *The Oxford Handbook of Material Culture Studies* (Oxford: Oxford University Press, 2010); Ian Woodward, *Understanding Material Culture* (London: Sage, 2007); John Potvin and Alla Myzelev (eds), *Material Cultures, 1740-1920* (Farnham and Burlington, VT: Ashgate, 2009); Anne Gerritsen and Giorgio Riello (eds), *Writing Material Culture History* (London and New York: Bloomsbury, 2015).

25  For more on the importance of foodstuffs, see James Walvin, *Fruits of Empire: Exotic Produce and British Taste, 1660-1800* (Basingstoke, Macmillan, 1997); Troy Bickham, 'Eating the Empire: Intersections of Food, Cookery and Imperialism in Eighteenth-Century Britain', *Past and Present* 198 (2008): 71–109; Elizabeth Collingham, *Curry: A Tale of Cooks and Conquerors* (New York: Oxford University Press, 2006); Paul Young, '"The Cooking Animal," Economic Man at the Great Exhibition', *Victorian Literature and Culture* 36, no. 2 (2008): 569–89; Susan Zlotnick, 'Domesticating Imperialism: Curry and Cookbooks in Victorian England', *Journal of Women Studies* 16 (1996): 51–68.

26  For examples of single-commodity histories situated in the imperial context, see Sidney Mintz, *Sweetness and Power: The Place of Sugar in Modern History* (New York and London: Sifton, 1985); William Gervase Clarence-Smith, *Cocoa and Chocolate, 1765-1914* (London: Routledge, 2000); David Hancock, *Oceans of Wine: Madeira and the Emergence of American Trade and Taste* (New Haven and London: Yale University Press, 2009); Kris E. Lane, *Color of Paradise: The Emerald in the Age of Gunpowder Empires* (New Haven and London: Yale University Press, 2010); Giorgio Riello, *Cotton: The Fabric that Made the Modern World* (Cambridge and New York: Cambridge University Press, 2013).

27  For more on gift giving and the flows of imperial objects managed through the personal means of families and individuals, see John Plotz, *Portable Property: Victorian Culture on the Move* (Princeton, NJ: Princeton University Press, 2008); John Plotz, 'The First Strawberries in India: Cultural Portability in Victorian Greater Britain', *Victorian Studies: An Interdisciplinary Journal of Social, Political and Cultural Studies* 49, no. 4 (2007): 659–84; Margot C. Finn, 'Colonial Gifts: Family Politics and the Exchange of Goods in British India, c.1780–1820', *Modern Asian Studies* 40, no. 1 (2006): 203–31.

28  For examples of research focusing on objects made prominent by specific events or episodes, see Lara Kriegel, *Grand Designs: Labor, Empire and the Museum in Victorian Culture* (Durham, NC and London: Duke University Press, 2007); Danielle Kinsey, 'Koh-i-Noor: Empire, Diamonds and the Performance of British Material Culture', *Journal of British Studies* 48, no. 2 (2009): 391–419; Tillman Nechtman, *Nabobs: Empire and Identity in Eighteenth-Century Britain* (Cambridge: Cambridge University Press, 2010); Tillman W. Nechtman, 'Nabobinas: Luxury,

Gender, and the Sexual Politics of British Imperialism in India in the Late Eighteenth Century', *Journal of Women's History* 18, no. 4 (2006): 8–30.

29 For more on imperial objects in literature, see Suzanne Daly, *The Empire Inside: Indian Commodities in Victorian Domestic Novels* (Ann Arbor: The University of Michigan Press, 2011); Elaine Freedgood, *The Idea in Things: Fugitive Meaning in the Victorian Novel* (Chicago: The University of Chicago Press, 2006). For work on display of colonial objects in museums, see Elizabeth Edwards, Chris Gosden and Ruth B. Phillips (eds), *Sensible Objects: Colonialism, Museums and Material Culture* (Oxford: Berg, 2006); Sarah Longair and John McAleer (eds), *Curating Empire: Museums and the British Imperial Experience* (Manchester: Manchester University Press, 2016).

30 See, for example, Amanda Vickery and John Styles (eds), *Gender, Taste and Material Culture in Britain and North America, 1700–1830* (New Haven and London: Yale University Press, 2006); Jennie Batchelor and Cora Kaplan, *Women and Material Culture, 1660–1830* (Basingstoke: Palgrave Macmillan, 2007).

31 Caroline Jordan, *Picturesque Pursuits: Colonial Women Artists and the Amateur Tradition* (Carlton: Melbourne University Press, 2005), 180.

32 Jordan, *Picturesque Pursuits,* 182.

33 Kyriaki Hadjiafxendi and Patricia Zakreski (eds), *Crafting the Woman Professional in the Long Nineteenth Century: Artistry and Industry in Britain* (Farnham and Burlington, VT: Ashgate Publishing), 2.

34 Jordan, *Picturesque Pursuits,* 183.

35 Beth Fowkes Tobin and Maureen Daly Goggin, 'Introduction: Materializing Women', in *Women and Things, 1750–1950: Gendered Material Strategies,* eds Beth Fowkes Tobin and Maureen Daly Goggin (Farnham and Burlington, VT: Ashgate, 2009), 1.

36 Tim Barringer, *Men at Work: Art and Labour in Victorian Britain* (New Haven and London: Yale University Press, 2005), 2.

37 For importance of representations of colonized men at work, see Barringer, *Men at Work,* 243–311.

38 Dianne Lawrence, *Genteel Women: Empire and Domestic Material Culture, 1840–1910* (Manchester: Manchester University Press, 2012), 223.

39 Lawrence, *Genteel Women,* 106–9. For more on the material construction of domestic life, see Swati Chattopadhyay, '"Goods, Chattels and Sundry Items": Constructing Nineteenth-Century Anglo-Indian Domestic Life', *Journal of Material Culture* 7, no. 243 (2002): 243–71; William J. Glover, '"A Feeling of Absence from Old England": The Colonial Bungalow', *Home Cultures* 1, no. 1 (2004): 61–82; Robin D. Jones, '"Furnished in English Style": Anglicization of Local Elite Domestic Interiors in Ceylon (Sri Lanka) c. 1850 to 1910', *South Asian Studies*, 20 (2003): 45–56; Sara Mills, 'Colonial Domestic Space', *Renaissance and Modern Studies* 39, no. 1 (1996): 46–60.

40  Anna K. C. Petersen, 'The European Use of Maori Art in New Zealand Homes, c.1890–1914', in *At Home in New Zealand: History, Houses, People,* ed. Barbara Brookes (Wellington: Bridget Williams Books, 2000), 58–9.

41  Swati Chattopadhyay, 'Blurring Boundaries: The Limits of "White Town" in Colonial Calcutta', *Journal of the Society of Architectural Historians* 59, no. 2 (2000): 154–79.

42  E. M. Collingham, *Imperial Bodies: The Physical Experience of the Raj, c.1800–1947* (Oxford: Oxford University Press; Malden, MA and Cambridge: Polity, 2001), 15.

43  Kate Smith, 'Empire and the Country House in Early Nineteenth-Century Britain: The Amhersts of Montreal Park, Kent', *Journal of Colonialism and Colonial History* 16, no. 3 (2015): n.p.

44  Chattopadhyay, '"Goods, Chattels and Sundry Items"', 261–63.

45  See Maya Jasanoff, 'Collectors of Empire: Objects, Conquests and Imperial Self-Fashioning', *Past & Present,* 184 (2004): 109–36; Jasanoff, *Edge of Empire*; Tim Barringer and Tom Flynn (eds), *Colonialism and the Object: Empire, Material Culture and the Museum* (Abingdon: Routledge, 1998); Longair and McAleer (eds), *Curating Empire.*

46  Jasanoff, 'Collectors of Empire': 118–19. Gifting more generally was also important in consolidating alliances and networks. See Finn, 'Colonial Gifts': 203–32.

47  Joanna Goldsworthy, 'Fanny Parkes (1794–1875): Her "Grand Moving Diorama of Hindostan", Her Museum and Her Cabinet of Curiosities', *East India Company at Home*, 2. http://blogs.ucl.ac.uk/eicah/files/2014/06/Fanny-Parks-PDF-Final-19.08.14.pdf (accessed June 2014).

48  Goldsworthy, 'Fanny Parkes (1794–1875)', 12.

49  James Edward Smith, 'Memoirs and Correspondence of the Late Sir James Edward Smith', *The Edinburgh Review* 57, no. 155 (1833): 40. As quoted in Jim Endersby, *Imperial Nature Hooker and the Practices of Victorian Science* (Chicago: University of Chicago Press, 2008), 38.

50  Ann Bermingham, *Learning to Draw: Studies in the Cultural History of a Polite and Useful Art* (New Haven and London: Yale University Press, 2000), 202.

51  See Daniela Bleichmar, *Visible Empire: Botanical Expeditions and Visual Culture in the Hispanic Enlightenment* (Chicago and London: Chicago University Press, 2012).

52  Ann B. Shteir, *Cultivating Women, Cultivating Science: Flora's Daughters and Botany in England, 1760 to 1860* (Baltimore and London: The John Hopkins University Press, 1996); Samantha George, *Botany, Sexuality and Women's Writing 1660–1830: From Modest Shoot to Forward Plant* (Manchester: Manchester University Press, 2007).

53  See Mildred Archer, 'British Patrons of Indian Artists', *Country Life*, 118 (1955): 340–41; Stuart Carey Welch, *India: Art and Culture, 1300–1900* (New York: Metropolitan Museum of Art, 1985), 422–5.

54  See, for example, John E. Crowley, *Imperial Landscapes: Britain's Global Visual Culture* (New Haven and London: Yale University Press, 2011); Geoff Quilley

and John Bonehill (eds), *William Hodges, 1744–1797: The Art of Exploration* (New Haven and London: Yale University Press, 2004); Tim Barringer, Geoff Quilley and Douglas Fordham (eds), *Art and the British Empire* (Manchester: Manchester University Press, 2009); Beth Fowkes Tobin, *Picturing Imperial Power: Colonial Subjects in Eighteenth-Century British Painting* (Durham, NC: Duke University Press, 1999); Geoff Quilley and Kay Dian Kriz, *An Economy of Colour: Visual Culture and the North Atlantic World, 1660–1830* (Manchester: Manchester University Press, 2003); Romita Ray, *Under the Banyan Tree: Relocating the Picturesque in British India* (New Haven and London: Yale University Press, 2013); Kay Dian Kriz, *Slavery, Sugar and the Culture of Refinement* (New Haven and London: Yale University Press, 2008); Jennifer Howes, *Illustrating India: The Early Colonial Investigations of Colin Mackenzie* (New Delhi: Oxford University Press, 2010); Mildred Archer, *Company Paintings: Indian Paintings of the British Period* (London: Grantha, 1992). On colonial photography, see Christopher Pinney, *Camera Indica: The Social Life of Indian Photographs* (London: Reaktion, 1997); Zahid R. Chaudhary, *Afterimage of Empire: Photography in Nineteenth-Century Empire* (Minneapolis: University of Minnesota Press, 2012); James Ryan, *Picturing Empire: Photography and the Visualisation of the British Empire* (Chicago: University of Chicago Press, 1998); Vidhya Dehejia, *India Through the Lens: Photography, 1840–1911* (Washington DC: Smithsonian Institute, 2006); Eleanor M. Hight and Gary D. Sampson (eds), Colonialist Photography: Imag(in)ing Place and Race (London: Routledge, 2002); Anne Maxwell, *Colonial Photography and Exhibitions: Representations of the Native and the Making of European Identities* (London and New York: Leicester University Press, 1999).

55   See Ann Bermingham, 'An Exquisite Practice: The Institution of Drawing as a Polite Art in Britain', in *Towards a Modern Art World,* ed. Brian Allen (New Haven and London: Yale University Press, 1995); Bermingham, *Learning to Draw*; Francesca Irwin, 'Amusement or Instruction: Watercolour Manuals and the Woman Amateur', in *Women in the Victorian Art World,* ed. Clarissa Campbell Orr (Manchester and New York: Manchester University Press, 1995), 149–66; Kim Sloan, '*A Noble Art*': Amateur Artists and Drawing Masters, c.1600–1800 (London: British Museum Press, 2000).

56   Caroline Jordan, 'Emma Macpherson in the "blacks' camp" and Other Australian Interludes: A Scottish Lady Artist's Tour in New South Wales in 1856–57', in *Intrepid Women: Victorian Artists Travel,* ed. Jordana Pomeroy (Aldershot: Ashgate, 2005), 90.

57   See, most notably, Pomeroy, *Intrepid Women*; Jordan, *Picturesque Pursuits*; Romita Ray, 'The Memsahib's Brush: Anglo-Indian Women and the Art of the Picturesque', in *Orientalism Transposed: The Impact of the Colonies on British Culture,* eds Julie Codell and Dianne S. Macleod (Aldershot: Ashgate, 1998), 89–111.

58  Jordan, *Picturesque Pursuits*, 21.

59  Marianne North, *Recollections of a Happy Life, being the Autobiography of Marianne North, edited by her sister Mrs John Addington Symonds* (London: Macmillan and Co., 1892). See, for example, the episodes recounted in I, 339, 342–3 and 350, and II, 3.

60  S. C. Belnos, *The Sundhya, or the Daily Prayers of the Brahmins Illustrated in a Series of Original Drawings from Nature* (London: Day & Son, 1851), n.p.

61  Jennifer Tucker, 'Gender and Genre in Victorian Scientific Photography', in *Figuring It Out: Gender, Science and Visual Culture*, eds Anne B. Shtier and Bernard V. Lightman (Lebanon, NH: University Press of New England, 2006), 149.

62  One early exception, Harriet Tytler, who photographed Mutiny sites in India using the calotype process, worked in partnership with her husband, Captain Robert Tytler, whose military role gave him access to equipment and logistical resources that would have eluded a female photographer working independently. Little is known about the Tytlers' photographic methods, and their work typically features as a footnote to Mutiny memorial photography by more fully analysed professional photographers such as Felice Beato.

63  See Val Williams, *The Other Observers: Women Photographers in Britain, 1990 to the Present* (London: Virago Press, 1986); Liz Heron and Val Williams (eds), *Illuminations: Women Writing on Photography from the 1850s to the Present* (London and New York: I.B. Tauris, 1996).

64  On Cameron, see Joanne Lukisch, '"Simply Pictures of Peasants": Artistry, Authorship and Ideology in Julia Margaret Cameron's Photography in Sri Lanka, 1875–1879', *The Yale Journal of Criticism* 9, no. 2 (1996): 283–308; Kanchanakesi Channa Warnapala, 'Dismantling the Gaze: Julia Margaret Cameron's Sri Lankan Photographs', *Postcolonial Text* 4, no. 1 (2008): 1–20; Jeff Rosen, 'Cameron's Colonized Eden: Picturesque Politics at the Edge of the Empire', in Pomeroy, *Intrepid Women*, 109–128.

65  See 'Zenana Studio: Early Women Photographers of Bengal', from *Taking Pictures: The Practice of Photography by Bengalis* by Siddhartha Ghosh', trans. Debjani Sengupta, in *In Translation* 4, no. 2 (2014): n.p., online journal *Trans Asia Photography Review*, doi: http://hdl.handle.net/2027/spo.7977573.0004.202; Vidya Dehejia, 'Fixing a Shadow', in *India Through the Lens: Photography, 1840–1911*, ed. Vidya Dehejia (Washington DC: Smithsonian Institution, 2000), 11–33.

66  Doreen Massey, *Space, Place and Gender* (Oxford: Polity Press, 1994), 2.

# Part One

# Travel

# The Travelling Eye: British Women in Early Nineteenth-Century India

David Arnold

The relationship between British women travellers in India in the first half of the nineteenth century and the material and cultural world they inhabited is reflected in the letters they wrote and in their published correspondence. Although the subject of women travellers, in British India and under empire more generally, has been extensively discussed, the nature and significance of the 'female gaze' still calls for re-examination – not least in the light of what men observed and wrote.[1] This can best be done not only by examining the letters that women produced and, in many cases, published, but also by regarding women as having, through their journeying and their representational techniques, a distinctive role in the visualizing of India. The letters written by observant and literary-minded women, the wider circulation of that correspondence in print, and the sketching and drawing that accompanied letter writing or to which extensive reference was made in letters constitute a creative nexus that both complemented and contrasted with the work of men. Letters, travelogues and sketches further underscore the importance of mobility – the movement of people as well as objects – to the creative impulse and to our understanding of the material environment and cultural milieu of white women travellers.

## Writing home

While the British women who travelled in nineteenth-century India and wrote about their experiences once found little place in the male-oriented historiography of empire, it is now clear that there were a substantial number of educated white women who wrote, often influentially, about their travels, and

imperial history writing has itself grown more sensitive to their observations and reminiscences. Some women's correspondence remained unpublished until recently (the letters of Henrietta Clive and Honoria Lawrence, for example); but many other women published works that either had their origin in letters or partially retained the epistolary form when they appeared in print. It is a mark of their contemporary standing that many of these volumes were issued by leading publishing houses in London or Edinburgh. Some soon lapsed into obscurity, but others were widely read and reviewed at the time. A few (Maria Graham's *Journal*, Mrs Mackenzie's *Life*) were republished within a year or two of their first appearance. Emily Eden's collection of letters *Up the Country* has even been hailed as 'one of the great classics of British imperial literature'.[2] Table 1.1 lists the authors discussed in this chapter, though their works formed only a small part of the voluminous writing about India produced by British women between the late eighteenth and mid-nineteenth centuries.[3]

These women were not in India as independent travellers but because they were married to (or were the daughters, sisters or sisters-in-law of) men employed in India as military or naval officers of the Crown or servants of the English East India Company (EIC). Maria Graham's husband was a captain in the Royal Navy, whose subsequent travels took her to Brazil and Chile.[4] Others were the wives of civilians: Ann Deane's husband was a district collector in Bihar; Fanny Parkes was married to a civil servant in Allahabad. Of the aristocratic authors, Emily Eden was in India because her unmarried brother George, Lord Auckland, was governor-general of India. Lady Clive's husband was governor of Madras, Lady Falkland's that of Bombay. While some writers, such as the irrepressible Parkes, exuded almost unbounded enthusiasm for India, others, like Emily Eden and her sister Fanny, regarded India as 'this horrid country' and felt they had been 'transported' there involuntarily, like convicts condemned to live in unsought exile.[5] One of the most widely quoted passages in Emma Roberts's *Scenes and Characteristics* related her discomfort at finding herself a single woman in India, an inconvenient accessory and financial burden to her sister and brother-in-law.[6]

The concentration of these texts between the 1820s and mid-1850s is itself significant. By 1820, EIC rule had been established over a large swathe of the subcontinent and, with the defeat or subordination of most of the 'country' powers, especially the Marathas in 1817, it became safer for women as well as men to travel 'up country' into the interior of India. Travel for Europeans was made easier by road-building projects, jungle clearance, more reliable transport

**Table 1.1** British women travellers and their works, c. 1800–56[7]

| Author | Period | Published work |
| --- | --- | --- |
| Henrietta Clive | 1798–1801 | *Birds of Passage* (2009) |
| Maria Graham | 1809–11 | *Journal of a Residence in India* (1812) |
| Ann Deane | 1804–14 | *A Tour through the Upper Provinces of Hindostan* (1823) |
| Anne Elwood | 1826–8 | *Narrative of a Journey Overland from England* (1830) |
| Fanny Parkes | 1827–38 | *Wanderings of a Pilgrim in Search of the Picturesque* (1850) |
| Emma Roberts | 1830s | *Scenes and Characteristics of Hindostan* (1835) |
| Marianne Postans | 1830s | *Cutch: Or, Random Sketches* (1839) |
| Julia Maitland | 1836–9 | *Letters from Madras* (1846) |
| Emily Eden | 1836–42 | *Up the Country* (1867) |
| Honoria Lawrence | 1837–54 | *The Journals of Honoria Lawrence* (1980) |
| Mrs Colin Mackenzie | 1846–52 | *Life in the Mission, the Camp, and the Zenana* (1854) |
| Lady Falkland | 1848–53 | *Chow-Chow* (1857) |

systems and bungalow accommodation. Conversely, by the 1850s, India had become far more familiar to British readers and, until the crisis of the Mutiny and Rebellion in 1857 (which generated a very different kind of reportage), there was little left to say that was particularly original or beguiling. The role of white women in India had become more physically restricted and socially circumscribed by the 1850s, leaving them less freedom to travel and to develop their creativity. The coming of the railway and the ossifying routine life of the civil lines, cantonments and hill stations rendered India a less appealing subject.[8] Although the epistolary genre persisted into the late nineteenth century – a notable example being Lady Dufferin's letters to her mother published in 1889 – it, too, became less common after mid-century.[9]

Women's travel writing was structured by the routes they followed and the literary form in which they wrote. Most nineteenth-century travel accounts began with the ports – Bombay, Calcutta, Madras – where women first disembarked; few travelled overland, except (like Elwood) in their passage through Egypt from the Mediterranean to the Red Sea. Travellers then followed well-established routes into the interior, especially from Calcutta, the capital of British India, through Benares and Allahabad to Agra, Delhi, and on to Punjab and the Himalayas. These were also routes that male travellers took, and so there would have been considerable duplication *if* men and women had written about the same things and in an almost identical manner.

Some travel narratives ignored or passed quickly over the coastal cities and took up-country locations as their main point of departure: Lady Falkland visited Poona and the Western Ghats from Bombay; Marianne Postans journeyed from Bombay to Kutch, where her husband was Resident (political agent) to the princely states of western Gujarat; Lady Clive ventured inland from Madras to Bangalore and Mysore before returning to the Coromandel Coast; Julia Maitland moved with her civil service husband from Madras to Rajahmundry and so, rather unusually, visited the northern districts of the Madras Presidency. Some published works, including those of Parkes and Roberts, did not follow a single narrative sequence but were constructed around a series of topics or forays. Many employed the idea of 'scenes' or 'sketches' (terms that carried both written and visual connotations) as a series of social and topographical vignettes. This was what Falkland called her 'chow-chow', meaning the odds and ends found in a Bohra peddler's basket in Bombay, and offered to the public in the hope that 'something, however trifling, may be found in it, suited to the taste of everyone'.[10] This seemingly self-deprecating way of characterizing their writing – as fragmentary, episodic and, possibly, trivial – was a limitation women appeared to place upon themselves and yet it can also be understood as a strategy designed to differentiate their work from that of men.

Furthermore, being dictated by the routes women followed (largely dictated by their husband's postings or tour of duty), the particular form of their creative endeavour also structured these travelogues. Their published work consisted primarily of letters, of journal entries that doubled as letters, or narratives extracted from original correspondence. Letters were social as well as material objects, whose circulation and survival has proved as important to historians as to contemporary readers.[11] The letter form was, of course, very extensively used in eighteenth- and early nineteenth-century writing – for novels, social commentaries, political tracts and commercial treatises, as well as travel accounts. Decades after their first publication in 1774, Lord Chesterfield's letters to his son remained a model for similar guides to European conduct in India.[12] But the letter form was significant for more than literary convention alone. Almost all the women authors cited here whose work was published in their own lifetimes stated that they did not originally intend to write a book; they wrote for the amusement and edification of their family and friends or in response to requests from home that they write about their Indian experiences.[13] The letters, once circulated, evoked sufficient interest for the writer to feel that her observations were worth making public. The transition from handwritten

letter to printed text was supposedly done without substantial changes to the original text, apart from what Maitland referred to as 'the necessary omission of family details'.[14] The identity of the addressee was sometimes removed, the names of Europeans (but seldom Indians) were disguised, and many (but not all) personal details omitted. For many women, writing letters, and the reception they received, gave them the confidence to feel that their work was worth publishing as a kind of complementary art, deserving to be set alongside the work of men.

Male travellers also wrote and published letters, but it was a literary genre more common among women, or more commonly retained by them in print, in part because it served their collective desire to employ a different way (to echo Manu Goswami) of 'producing India' from men.[15] Letters and their by-products helped create an epistolary empire, in which the more intimate observational and experiential aspects of life in India could be foregrounded. Men 'made' India through their discussion of history, politics, military matters, trade and economics; increasingly women wrote about religion, customs and ethnography. Although it would be rash to generalize too widely, these were not matters that women expressed much interest in or about which they felt they had much of their own to contribute. Despite being the sister of the governor-general, Emily Eden hardly wrote about the tumultuous events of Lord Auckland's administration, including the disastrous Afghan war. One might even conclude that she made a point of *not* writing about such contentious matters in order to present her brother, the ordeal of India, and the sacrifices required for its governance, in a more engaging light. Mackenzie wrote more directly about political and military affairs since her husband commanded one of the Sikh regiments enlisted to fight in the last Anglo-Sikh war; but her account was heavily criticized in India precisely because it ventured too far into a man's world of which, it was assumed, she could have only second-hand, inexact knowledge. In the preface to the second edition of her work, she was notably more defensive.[16]

Other women seemed to entertain more modest ambitions from the onset. In 1812, Graham introduced her *Journal* by observing that although India was much visited there were as yet few accounts of the scenery and monuments of the country or the manners and habits of 'natives and resident colonists'. The white men who went to India as administrators, soldiers and traders had no time for what was 'merely curious or interesting to a contemplative spectator'. She sought instead to record 'what strikes the eye and the mind of an observant stranger'.[17]

In what Maitland called its 'genuine unsophisticated state', the letter leant itself to informality and immediacy, to observation more than abstraction.[18] Letters preserved the idioms and intimacies of a long-distance conversation. Maitland was clearly responding to specific questions from her correspondents in Britain: What is the scenery like in Madras? How do you manage your servants? Who are the Thugs?[19] Interrupting the flow of her narrative, Mackenzie adds conversationally, 'I forgot to tell you of two of the things we saw at Lahore ...'[20]

Letters did not require a complex narrative structure or a plethora of statistics relating to health, trade and revenue; tables, charts and maps were as rare in women's works as pictorial imagery was common. While not wanting to lose sight of the horror and the fascination of India, women emphasized the reliability of their observations. Even when describing the seemingly far-fetched and fabulous, Elwood assured readers that she was 'not favouring you with any of Baron Munchausen's flights of fancy'.[21] The genre allowed women to capture their first impressions (which, in time, were bound to fade), to represent their evolving understanding of the country and to present scenes of Indian life that addressed both emotions and the cultured intellect. Letters sustained a sense of belonging to family, friends and places far removed from India. By writing in this fashion, and retaining the letter form in print, women made the issues of empire – or, more exactly, since empire was rarely explicit in these narratives, of living and travelling away from home – more immediate and accessible to their readers.

That sense of intimacy and emotional engagement extended, as a kind of surrogate self, to white society at large. One reviewer of Robert's *Scenes and Characteristics* praised her 'acute mind' and 'the great spirit and accuracy' of her 'sketches', but also commended her originality in illuminating the lives of Europeans: 'While many able and industrious men have devoted labour to elucidate the native institutions, habits, and customs of India, no one has taken much trouble to make us acquainted with the condition of European society in that country.' These were 'matters into which few have thought of enquiring'.[22]

## The female gaze

Women did not, in general, set out to write about public affairs or to fashion a grand narrative of empire.[23] One of the criticisms made of Emma Roberts was that her work was of a 'light and desultory nature, such as one might expect to find in the familiar correspondence of a clever and accomplished women'. She

might write with perception and wit about shops and shopping, marriage or cooking, but, as one reviewer put it, 'From graver topics she has abstained.'[24] Nor, even in praise, could commentators forget that she was a woman. A review in the *Athenaeum* commended 'this agreeable work', but then added, 'Miss Roberts seems to have examined society in Hindostan as carefully as others do the texture of a Cashmere shawl.'[25]

In fact, women did not altogether eschew such grand themes as empire, religion, race and civilization. One has only to read Honoria Lawrence's letters of 1841–2 to realize the extent of her awareness of the calamitous nature of the Afghan war and its anguished human consequences, but this was in correspondence not published in her own lifetime.[26] Women also wrote, however impressionistically, about race.[27] Religion was a common preoccupation, perhaps, in part, because men in EIC service were constrained by their official position from speaking out themselves and committed to a policy of religious toleration. Maitland made clear her hostility to 'heathen' Hinduism and her disgust at the support given to 'idolatry' by the EIC.[28] Mackenzie, earnest evangelical as well as loyal army wife, devoted a large part of her narrative to scenes and encounters that illuminated the progress of Christianity in India.[29] Indeed, her zealotry tended to obstruct her more spontaneous appreciation of India. 'We saw a pretty sight the other evening,' she wrote from Simla in 1849, 'the town being illuminated on account of a Hindu festival, and the shops hung with garlands of flowers. If it had not been in honour of an idolatrous, and therefore God-dishonouring[,] festival, it would have been a pleasure to see it.'[30] Others, like Graham and Falkland, were less prone to missionary rhetoric and presented themselves as more impartial, even appreciative, observers. Graham wrote enthusiastically about her visit to the Hindu temple on Elephanta Island, though Elwood was still more fulsome in her praise for its 'magnificent grandeur'.[31] Falkland declared herself 'never tired of observing the curious customs of the people. Every day there was something new to excite one's curiosity.'[32]

In discussing travel writing, Mary Morris has observed that women 'move through the world differently than men. The constraints and perils, the perceptions and complex emotions women journey with are different from those of men.'[33] I have often wondered about the veracity of that statement, especially whether women chose to travel and to write differently from men, or whether, in effect, they had such differences imposed upon them.[34] There might be several ways of responding to Morris's insight. It could argued at the outset that the experiences and writing of women travellers cannot be isolated (as is so often the case) from the world of men and from the writings of men by means of which women so often

referenced their own observation. Some women clearly modelled their work on men's writing, especially Bishop Heber and his *Narrative of a Journey through the Upper Provinces of India*, seeking only to add what was of interest from a female perspective.[35] But others, Roberts and Parkes among them, were prepared to take issue with Heber, suggesting that, for all his romantic sensibilities, he often got things wrong, or failed to understand 'the native character'.[36]

It is also possible to compare male and female writers making similar journeys and visiting many of the same sites. One could take Fanny Parkes's *Wanderings*, published in 1850, and compare her text with the *Tours in Upper India* published by her father, Major E. C. Archer, seventeen years earlier. Archer's narrative is the more obviously earnest, literary and didactic. He is less appreciative of Indian customs than Parkes, more prejudicial in his racial remarks; he appears more detached from the Indians he encounters and the cultural world they inhabit. Archer is more sober and censorious than Parkes about the current state of India, more disposed to speculate on broader issues like the prospects for European colonization, and he displays little of the engaging playfulness and exuberance of his daughter. He has, of course, no access to the zenana, scenes of which enliven Parkes's narrative; he is, conversely, more drawn to the scenery of the Himalayan foothills and the 'remembrances' of home that a temperate landscape and vegetation inspire. And yet, father and daughter visit many of the same places and their descriptions, as of the Taj at Agra, are not so very dissimilar, with a taste for the romantic and picturesque, if more muted in Archer, common to them both.[37]

Most of the women discussed in this essay felt some constraint on their freedom to travel, and so to observe, sketch and record their impressions as freely as they wished. Certainly, women complained about the restrictions imposed on their movement by the climate, by poor roads, dense jungles and the enclosed palanquins in which they travel, but so did men. But the sense of constriction women feel goes beyond this. Parkes complained that in India it was not possible to roam as freely as a woman might in England.[38] Falkland complained that sightseeing in India was 'very fatiguing'. She found the early sun 'very overpowering'; it was 'impossible to go out in the middle of the day' unless 'protected in a carriage, or in a palanquin'; and the afternoons were so hot and short that it required 'some resolution, and a good deal of health and strength to overcome all these drawbacks'.[39] She did, however, venture out, often in a *tonjon* (an open sedan chair carried by Indian bearers) to observe and to sketch, but she frequently found herself interrupted by Indians curious as to

what she was doing or forced to abandon her work by animals, children and the dust of the street.[40] Mackenzie, by contrast, appeared far less constrained and seemed to move freely around the countryside as well as the cities – walking, riding, travelling by buggy or being transported in a palanquin or *tonjon*.[41] In general, women writers expressed little sense of personal danger and physical vulnerability; as Mackenzie wrote, 'With good servants, one travels in great comfort in India.'[42] Violence, where noticed at all, was transposed onto Indian subjects, notably the Thugs. Only with the Mutiny and Rebellion of 1857–8 did white women, catastrophically, find themselves the victims of violence.[43]

Aside from the constraints on their physical mobility, women travellers wrote (probably more than men) about interior spaces, the inner landscape, as it were, of white and 'native' society. One of the advantages women writers claimed over their male counterparts was access to the zenana, the female quarters of middle- and high-status Indian homes, spaces from which men were strictly excluded.[44] Since so much of early nineteenth-century colonialism in the subcontinent was concerned with making India visible to Western eyes, this offered women a distinct advantage. They could write first-hand about the women of the zenana, record conversations with them, describe their appearance, costumes and (seemingly idle) pastimes.[45] This style of transcultural female engagement, with its overtones of both the erotic and the exotic, had been pioneered by Lady Mary Wortley Montagu in her letters from Constantinople in 1763, though none of the authors discussed here actually referred to her.[46]

'Life in the zenana' proved a recurring theme. Parkes devoted several chapters to it, and Mackenzie, who as an evangelical saw a promising site for missionary endeavour, identified the zenana even in the title of her book. In her chapter on 'The Harem', Postans described meeting the wives of the Rao of Kutch and the prince's mother, 'a very lovely woman' who held her hand and showed great curiosity about the clothes her Western visitor wore.[47] This privileged access to the zenana also served as a vehicle for moral condemnation and an opportunity for women to identify, through their own observations, with the colonial project of 'improvement'.[48] To Western eyes, these female-only spaces signal ignorance, superstition and an oppressive denial of liberty: the itinerant, observant European woman contrasts with her Indian counterpart, almost immobile, fixed, as if for eternity, within the near sightless confines of the zenana. Graham regarded the zenana women she met in Bombay as being 'totally void of cultivation'.[49] Postans, appalled by the Kutch ranis' 'degraded, useless, and demoralizing condition',

looked forward to the 'emancipation of Eastern women from their present mental and personal imprisonment', though she doubted whether such a task of reformation was 'consistent with the objects of British power in India'.[50]

The zenana provided an obvious site of female observation, for women as both the seeing and the seen; but it was not the only kind of interior landscape privileged in women's writings. A striking number of women travellers also visited orphanages and schools for mixed-race as well as Indian children in Calcutta, Bombay and Madras. The reasons for this are not hard to discern. These were physically and culturally accessible spaces (in a way that Hindu temples might not be), and visiting such educational and charitable institutions in India might be regarded as an extension of precisely the kind of philanthropic visiting middle-class and aristocratic women might have engaged in in Britain.[51] Other enclosed or, in various senses, interior spaces also lent themselves to visiting by women, often escorted by male guides and companions. Among these were botanic gardens (given many women's personal interest in botany),[52] cemeteries (which carried mournful associations with European sacrifice and loss)[53] and prisons (as exemplary sites of order and reformation).[54] To a greater degree than men, women took on a mission to reflect on institutions and the inner life of empire they revealed.

As noted earlier, published letters generally omitted what Graham called 'such private details and trifling anecdotes of individuals as could not with propriety be obtruded on the world'.[55] But what was erased, or what remained unpublished in the author's own lifetime, often spoke powerfully to the writer's inner sentiments and innermost anxieties. In their private correspondence, women were often able to engage with another kind of colonial space, one that was, if surely not absent, then at least less evidently expressed among men. They represented grief, absence, and loss, often projecting onto the landscape they observed around them their fears for themselves, their husbands and, above all, their children. India's landscapes thus became burdened with loss or memorialized through the anticipation of loss. In her letters, Maitland began by describing her bright, healthy baby Henrietta, born soon after she and her husband had arrived in Madras; but after a few years, she and 'Etta' have to return to England without him. 'That', she observed, 'is the grand Indian sorrow – the necessity of parting with one's children.'[56]

In an article published by Honoria Lawrence in 1845, she described how 'European life in India sadly lacks the evening and morning tints': civilians and soldiers retired before they became too old and infirm, and 'the climate debars us from watching the growth of our children, whom we are compelled to send away from us, just at the age when intimate sympathy and confidences would be

a priceless blessing to parent and child'.[57] One has to read these public reflections alongside Lawrence's letters (not published at the time) with their frequent reference to her repeated illnesses, the death of her children and the anticipation of her own death (she died in 1854). Here the fleeting pleasures of the picturesque seem to war with mourning and melancholy. India, for her, rapidly becomes 'this very land of death'.[58] Her personal bleakness seems transposed onto the landscape itself, as when travelling in Bundelkhand in 1838 at a time of dearth: 'The country is the most miserable I ever saw ... the blackened fields looked the very image of famine'.[59] Seven years later, now in Kathmandu, she remarks: 'How I love the sound of running water. Sir Thomas Munro [a celebrated governor of Madras] says it is the only sound that is the same at home and abroad.' But then she reflects that it was not the only such sound, for there was also the cry of an infant 'beginning to articulate'.[60] The rapid shift between home (in Britain) and here (in India) then leads her from the pleasant sound of running water to the cries of a pitiful infant – of whom she had lost more than one to India's 'climate'. Landscape and loss converge to exist in painful unison. Just as women gaze, as men literally cannot, into the interior space of the zenana, so do they see, or express, more clearly than men the personal cost empire entails.

## India envisioned

Women wrote, too, about external scenes, about landscapes and the colourful tableau of 'native' life.[61] Women (no less than men) project on to what they outwardly see what they inwardly recollect. There are many devices by which Indian scenes are given meaning through association. One of the commonest was to invoke the *Arabian Nights* (for many Britons the most familiar site of the orientalist exotic). Thus Graham, encountering a brightly lit evening bazaar, was instantly put in mind of the 'Arabian Nights entertainments'.[62] The monuments and ruins of Delhi and Agra reminded women of the prints of Thomas and William Daniell, one of the ways in which 'the Orient' has already been made visually familiar to them and laden with scenic expectations.[63] Others turned to the Old Testament to capture scenes that appeared both eastern and anachronistic: Falkland's letters are littered with biblical allusions.[64] Common, too, are references to poets – Milton, Shakespeare, Byron, Wordsworth and Shelley – and to novels – the *Mysteries of Udolpho* to evoke a Gothic India, Walter Scott for an imagined likeness to Highland glens and tribal gatherings.

Women, more than men in this period, commonly included in their work visual depictions of Indian scenes that further announced them as active observers and recorders. These sometimes took the form of reproductions of their own sketches (as in Parkes) or as scenic vignettes and frontispieces that had been worked up by others as lithographs specifically for publication (as with Roberts). Postans's *Cutch* contains a number of colour plates, which must have been costly – made from her own sketches, these mainly depicted styles of dress and 'native types', such as grasscutters and soldiers. The 'random sketches' of her title were therefore both pictorial depictions and written impressions.[65] In their written text, women, like men, relied heavily on the conventions of the picturesque. But for India the picturesque bore a dual significance. It signified a landscape or vista so pleasing to the eye that it looked like a picture or deserved to be represented as one – a grove of trees, a riverbank, a hilltop fort or ruined temple. But the picturesque also encapsulated scenes of human activity, men and women in exotic costumes, soldiers in gay uniforms, men and women washing clothes, drawing water, praying, bathing. When Parkes set out 'in search of the picturesque', she mainly sought scenes that were 'picturesque, animated, and full of novelty'.[66] The pleasures of landscape played a more subdued part in her narrative until (like her father) she arrived in the Himalayan foothills. By day, and not infrequently by night, by full moon and or the light of fires, lamps and torches, the picturesque captured the essence of India's 'enchantment'.[67]

Graham described a scene near Madras in which decaying temples, noble trees and shimmering water combined to great visual effect. 'These objects,' she noted, 'highlighted by the setting sun, with groups of natives bathing, and cattle grazing on the edge of the tank as we went by, made an enchanting picture.'[68] In similar vein, Falkland wrote of 'stately temples, picturesque buildings, mingled with graceful palms, bamboos with their feathering foliage, and groves of fine mangoes, making a very pleasant picture.'[69] Postans began her letters by describing the 'picturesque effects' of Bombay harbour, 'a scene teeming with interest and animation'.[70] Having arrived in Kutch, she noted the 'highly picturesque' dress worn by Kutchi women and the 'grace and beauty of their persons'.[71] Thereafter in her narrative hilltop forts appeared as among the 'most picturesque features' of Indian scenery – until she returned to Kutch, to its ruler in his 'strikingly picturesque' dress alongside his 'singularly picturesque' horsemen.[72] The picturesque was still in vogue when Mackenzie, entering the age of photography, was writing in the early 1850s.

Used so routinely, the picturesque became barely an aesthetic at all, but a rather indiscriminate way of trying to inject animation into a somewhat lifeless or repetitive narrative. And yet, if we treat the picturesque only as a hackneyed ideal we risk ignoring its value, not least in reminding us of the centrality of visual impressions and visual modes of expression to women travellers. The picturesque operated as a recognized technique by which the writer could engage her readers' attention, encouraging them (thousands of miles away) to create their own mind-pictures of exotic scenes they have no means of viewing for themselves or to reprise textual sources and visual impressions writer and reader might have in common.

Consideration of the picturesque draws us further into the culture of contemporary letters, for it underscores the way in which women, sketching and painting as well as penning letters, themselves recognized a close interconnection between writing and picturing. Using words to communicate essentially, visual experience is a common device, but, in writing home and in seeking authority for their written text, it assumed an extra significance. Thus Graham wrote at the start of her *Journal*: 'I mean to paint from the life and to adhere to the sober colouring of nature.' On arriving in Bombay she observed, 'A painter might have studied all the varieties of attitude and motion in the picturesque figures of the *koolies* [coolies, labourers] employed in washing at their appropriate *tanks* and wells.'[73] In so much of this literature, the idea of what constitutes 'scenes' and 'sketches' constantly moves between what is written and what is (or could be) drawn, between what is faithfully replicated from life and what is summoned up from the imagination.

Landscapes 'travel' in at least two senses. There are the landscapes that travellers actually move through, that are displayed before them to be observed, experienced and remarked upon; and there are those imagined landscapes that move in the traveller's mind, that are recalled from an earlier stage of life, are inscribed in the traveller's culture, or represent a preconceived notion (culled from books, pictures and travellers' tales) of what the visited landscape should be like but so often is not. In practice, landscapes are commonly a combination of these two, as the real and present landscape is measured alongside the imagined or remembered one. It is common for women, as well as men, to be looking at some novel Indian scene while seeing in their mind's eye a corresponding building, landscape or assemblage of people in Britain or continental Europe. Street scenes, colourful costumes and the celebration of Holi remind Elwood of the Venetian carnival.[74] Travelling through the barren landscape of Kutch, she remarks, 'The scenery of these ghauts [hillsides] reminded us strongly of the Apennines in the neighbourhood of Pietra Mala, between Bologna and

Florence, both wearing an equally barren and desolate appearance.'[75] Sometimes the analogy appears faintly ridiculous. Elwood comments in passing through a remote Bhil village: 'The prettiest I ever saw in India, situated among banyan trees, and so wild and picturesque, that I could have fancied myself in Wales.'[76]

But the picturesque was seldom all it superficially seemed and might even highlight the inadequacy of pictorial representation, especially when it encompassed India's more gruesome sights. The pleasing innocence of the picturesque was constantly contaminated and subverted by what was squalid, oppressive or horrific. The landscape so pleasantly or wistfully that travelled in the mind of the traveller was often jarringly at odds with the landscape actually seen. Thus, Graham wrote of the River Hooghly at Barrackpore: 'There is something in the scenery of this place that reminds me of the beauty of the banks of the Thames; the same verdure, the same rich foliage, the same majestic body of water; here are even villas too along the banks.' But there the nostalgic association abruptly ended, as she grew aware of the misery of the people in the scene before her: 'I feel degraded when seeing them half-clothed, half-fed, covered with loathsome disease.'[77] A few weeks later, she further recorded her 'disgust and horror' at seeing dead bodies floating down the river she so recently likened to the Thames. And yet, she concluded sadly, 'such are the daily sights.'[78]

It is not only imagery and the imagination that travel. Journeying also gives rise to its own expressions of material culture. Women write more extensively than men about the physical objects that they see or acquire – textiles, items of dress, wooden boxes, ivory ornaments, jewellery – as well as the plants, animals and insects, the strange or precious-looking stones, that arouse their curiosity or which they offer up to science. On her South Indian tour, Lady Clive was an assiduous collector of objects.[79] In Kutch, Postans appears almost obsessed by the cloth and clothing of Gujarat. Uniforms and costumes feature conspicuously in her drawings; textiles intrude into her written depictions of Indian life and 'native' crafts. She even interrupts her account of a sati to explain that the deceased husband was 'wrapped in a rich kinkaub' (*kincob*, gold brocade).[80] But then she was writing at a time when many of her readers in Britain hardly knew of India except through its calicos and chintzes, so descriptions of cloth provide them with an important means of visual recognition. Further, the remark quoted earlier about Roberts observing society in India 'as others do the texture of a Cashmere shawl' reflects the association of women with textiles and dress, an association that was common not only in men's eyes. These itinerant observations of objects provide us in turn with a discursive guide to the material objects with which European women surrounded themselves in India or send home.

There has been broad recognition among scholars that the science of seeing and the art of visual representation were essential to the Victorian imagination and the imperial endeavour.[81] But it has not been sufficiently recognized that white women travellers were visual specialists whose activities and techniques did not necessarily map directly onto men's lives and works. Following Foucault, it has been all too easy, especially in the imperial context, to assume that ocularity automatically conferred authority, that seeing was in itself an articulation of knowledge and an exercise in superior power. What the activities and writings of women travellers suggest is that, beyond the apparent blandness of the picturesque, the use of visual technique – in seeing, writing, depicting – was an ongoing process of exploration and acquisition, a medium of commodification, memorialization and exchange.

Mackenzie's narrative of her six years in India offers one of the fullest accounts of the range of women's visual techniques and productions. Apart from writing freely about the scenes she observes through the prism of the picturesque or through visual associations with places she has previously visited in Britain and Germany, she devotes a great deal of time and effort to making sketches of people and scenes, sometimes with the assistance of a portable camera obscura. Her drawings provide her with a means of studying and memorializing what she sees: in the Himalayas she reports making a sketch 'more as a memorandum than as a representation of it'.[82] As with many women travellers, drawing is also a way of engaging with her human subjects, with close attention given to their facial expression and 'countenance'. For example, as she sketches Indian Christian converts she learns about how they came to their faith and what it has meant for them. To her mind, drawing enables her to read their character, believing that Indians are more open and more easily 'read' than Europeans who keep their emotions and inner feelings closely concealed.[83] In Delhi, having wandered uninvited into the royal palace in the Red Fort, Mackenzie moves from sketching buildings to drawing the king of Delhi's principal wife, Zinat Mahal, and his son Mirza Jewan Bakht, her camera obscura is almost as much the object of their attention as the sketches themselves.[84] She thus not only gains physical access to the zenana but also is able to gain what she sees as an insight into the character of the Mughal royal family. Throughout her travels, sketching provides her with a medium of interaction and exchange. In Bombay, Mackenzie shares her work with Lady Falkland, whom she sees as a superior artist, and they compare the places they have seen and drawn.[85] In north India, while sketching the architecture of Agra and Fatehpur Sikri, she encounters Mr Middleton from the government college who is taking daguerreotype images of the buildings, and she receives a lesson in calotype technique from Dr John Murray, one of the

pioneers of Indian photography.[86] Mackenzie's letters and journal testify to these encounters but also underscore the visual nature of her engagement with India. Seeing, as much as writing, becomes her means of 'producing' India – her way of educating herself and her readers. Sketching, writing and taking photographs could thereby serve, for Mackenzie as for other women of the period, as a means to 'educate the eye' and 'cultivate the senses': they were not the passive or peripheral activities they have often been taken to be.[87]

## Conclusion

In so much of the writing of early nineteenth-century British women in India, the travelling 'I' is also the observant 'eye'. Roberts, for instance, repeatedly plays on the trope of visuality, delighting in the 'coup d'oeil', taking the part of the 'musing spectator', seeking to replicate in words the 'enchantment produced upon the eye', dwelling on what 'disgusts' or is 'pleasing to the eye'.[88] Women were by no means the only visual specialists in European India, but their activities significantly complemented and supplement what male travellers were doing. Like letter writing, painting and drawing were part of an educated woman's accomplishments in Britain at the time and, unlike music or needlework, transferred readily to India. The paucity of professional European artists in the country meant that their pictorial skills were even more to be valued, less as works of polished artistry than as a means of engaging and memorializing India. Letters and sketches, the written and the visual, worked together to as a kind of superior education of the eye. Landscapes and portraits were a means to try to understand, and not merely judge, India, and to bring to the experience of India a sense of immediacy and depth of emotion not always so evident in the works of men.

## Notes

1  In addition to works cited below, see Linda Colley, *The Ordeal of Elizabeth Marsh: A Woman in World History* (London: HarperCollins, 2007); Barbara Korte, *English Travel Writing: From Pilgrimages to Postcolonial Explorations* (Basingstoke: Palgrave, 2000), ch. 6; Melman, *Women's Orients*.

2  William Dalrymple, 'Introduction', *Begums, Thugs and White Mughals: The Journals of Fanny Parkes* (London: Sickle Moon Books, 2002), v.

3  For a fuller listing, see Rosemary Raza, *In Their Own Words: British Women Writers and India, 1740-1857* (New Delhi: Oxford University Press, 2006), 232–40. Some of

these 'literary ladies' (to quote Mrs Elwood) also wrote novels, short stories, histories, and, in Roberts's case, a cookery book, which to varying degrees reflected their Indian experiences: see E. R. [Emma Roberts], *A New System of Domestic Cookery, by a Lady* (London: John Murray, 1842), esp. 'Preface' and ch. 15, 'Oriental Cookery'.

4  Maria Dundas Graham, *Journal of a Voyage to Brazil, and Residence There during Part of the Years 1821, 1822, 1823* (1824; repr., New York: Frederick A. Praeger, 1969). On her South American travels, see Mary Louise Pratt, *Imperial Eyes: Travel Writing and Transculturation* (London: Routledge, 1992), 155–71.

5  Emily Eden, *Letters from India*, 2 vols (London: Richard Bentley, 1872), 1: 132, 181.

6  Emma Roberts, *Scenes and Characteristics of Hindostan, with Sketches of Anglo-Indian Society*, 3 vols (London: William H. Allen, 1835), 1: 33–4; cf. [Anon.], 'Scenes and Characteristics of Hindostan by Miss Emma Roberts', *Quarterly Review* 55, no. 109 (1835): 180.

7  Nancy K. Shields (ed.), *Birds of Passage: Henrietta Clive's Travels in South India, 1798-1801* (London: Eland, 2009); Maria Graham, *Journal of a Residence in India* (Edinburgh: Archibald Constable, 1812); A. D. [Ann Deane], *A Tour through the Upper Provinces of Hindostan* (London: C. & J. Rivington, 1823); Mrs Elwood, *Narrative of a Journey Overland from England* (2 vols, London: Henry Coulburn and Richard Bentley, 1830); Fanny Parkes, *Wanderings of a Pilgrim in Search of the Picturesque*, 2 vols (London: Pelham Richardson, 1850); Roberts, *Scenes*; Mrs Postans, *Cutch: Or, Random Sketches, Taken during a Residence in One of the Northern Provinces of Western India* (London: Smith, Elder, 1839); [Julia Maitland], *Letters from Madras, during the Years 1836-39, by a Lady* (London: John Murray, 1846); Emily Eden, *'Up the Country': Letters Written to Her Sister from the Upper Provinces of India* (London: R. Bentley, 1867), supplemented after her death in 1869 by Eleanor Eden (ed.), Eden, *Letters*; John Lawrence and Audrey Woodiwiss, *The Journals of Honoria Lawrence: India Observed, 1837-1854* (London: Hodder & Stoughton, 1980); Mrs Colin Mackenzie, *Life in the Mission, the Camp, and the Zenana; Or, Six Years in India*, 2nd edn, 2 vols (London: Richard Bentley, 1854); Lady Falkland, *Chow-Chow: Being Selections from a Journal Kept in India, Egypt, and Syria*, 2nd edn, 2 vols (London: Hurst & Blackett, 1857).

8  Mackenzie remarked that railways were 'admirable for convenience-sake, but marching is the way to enjoy travelling through a beautiful country': Mackenzie, *Life*, 2: 386.

9  Daniel Sanjiv Roberts, '"Merely Birds of Passage": Lady Hariot Dufferin's Travel Writings and Medical Work in India, 1884-1888', *Women's History Review* 15, no. 3 (2006): 443–57.

10  Falkland, *Chow-Chow*, 1: 'Preface'.

11  For the constraints on publishing other people's letters, even after their death, see Roberts' 'Memoir' of Letitia Elizabeth Landon in [Emma Roberts, ed.], *The Zenana and Minor Poems of L. E. L.* (London: Fisher & Son, 1839), 25.

12  John Briggs, *Letters Addressed to a Young Person in India* (London: John Murray, 1828), 177.

13  On culture and class in letter writing, see Clare Brandt's 'Introduction' to Mary Wortley Montagu, *Letters* (London: Everyman's Library, 1992), x–xiii.

14  Maitland, *Letters*, iii. For the relationship between Maria Graham's letters and printed text, see Regina Akel, *Maria Graham: A Literary Biography* (Amherst, NY: Cambria Press, 2009), 41–66.

15  Manu Goswami, *Producing India: From Colonial Economy to National Space* (Chicago: University of Chicago Press, 2004).

16  Mackenzie, *Life*, 1: vi.

17  Graham, *Journal*, v–vi.

18  Maitland, *Letters*, iii.

19  Ibid., 30, 45, 51.

20  Mackenzie, *Life*, 2: 175.

21  Elwood, *Narrative*, 2: 282.

22  [Anon.], '*Scenes and Characteristics*', 175–6.

23  Maitland, *Letters*, iii. But some women did: see Harriet Martineau, *Suggestions towards the Future Government of India*, 2nd edn (London: Smith, Elder, 1858).

24  *Eclectic Review*, no. 14, November 1835, 415, 431.

25  *Athenaeum*, no. 407, 15 August 1835, 616.

26  H. B. Edwardes and Herman Merivale, *Life of Sir Henry Lawrence*, 2nd edn, 2 vols (London: Smith, Elder, 1872), 1: 226–421.

27  For instance, Deane, *Tour*, 12–15.

28  Maitland, *Letters*, 90, 121–2.

29  As in Mackenzie, *Life*, 2: 235, 246–47, 280–87.

30  Ibid., 2: 145.

31  Graham, *Journal*, 54; Elwood, *Narrative*, 2: 302–5.

32  Falkland, *Chow-Chow*, 1: 161.

33  Mary Morris, 'Introduction', in Mary Morris (ed.), *The Virago Book of Women Travellers* (London: Virago, 1996), xvii. A similar question is posed by Indira Ghose who asks, 'Did [European] women travellers perceive India differently from men'? And, was there a distinctively 'female gaze'? See Indira Ghose, *Women Travellers in Colonial India: The Power of the Female Gaze* (New Delhi: Oxford University Press, 1995), 1. Her conclusion is that there was no 'specifically female gaze', only 'a wide spectrum of gazes': ibid., 158.

34  A presumption of difference is again central to Sara Mills, *Discourses of Difference: An Analysis of Women's Travel Writing and Colonialism* (London: Routledge, 1991).

35  Elwood, *Narrative*, 1: iv, 407; 2: 85, 97, 272. On Heber, see David Arnold, *The Tropics and the Traveling Gaze: India, Landscape and Science, 1800-1856* (Seattle: Washington University Press, 2006), 93–8.

36  Roberts, *Scenes*, 2: 93, 290; 3: 69, 255; Parkes, *Wanderings*, 1: 141.

37  E. C. Archer, *Tours in Upper India and in Parts of the Himalaya Mountains*, 2 vols (London: Richard Bentley, 1833); Parks, *Wanderings*.

38  Parkes, *Wanderings*, 1: 115.

39  Falkland, *Chow-Chow*, 1: 193.

40  Ibid., 283.

41  Mackenzie, *Life*, 2: 101–33.

42  Ibid., 2: 151.

43  Ghose, *Women Travellers*, ch. 5; Alison Blunt, 'Embodying War: British Women and Domestic Defilement in the Indian "Mutiny", 1857-8', *Journal of Historical Geography* 26 (2000): 403–28.

44  Janaki Nair, 'Uncovering the Zenana: Visions of Indian Womanhood in Englishwomen's Writings, 1813-1940', *Journal of Women's History* 2 (1990): 8–34.

45  On the zenana, see Ghose, *Women Travellers*, ch. 3.

46  On Montagu and her letters, see Grundy, '"The Barbarous Character We Give Them"', 73–86.

47  Postans, *Cutch*, 52.

48  On women's commitment to 'improvement', see Maitland, *Letters*, iv; Roberts, *Scenes*, 3: 246.

49  Graham, *Journal*, 18.

50  Postans, *Cutch*, 55-7.

51  For examples, see Eden, *Letters*, 1: 113, 2: 226; Edwardes and Merivale, *Life*,1: 145–7; Falkland, *Chow-Chow*, 16–17; Roberts, *Scenes*, 1: 42–3. This is not to say that male travellers never visited or described these institutions, but such visits were more common to women and given greater prominence in their writing.

52  For instance, Graham, *Journal*, 144–6; Eden, *Letters*, 2: 52. Graham, whose brother was professor of botany at Edinburgh University, had an interest both in plants and their pictorial representation: Betty Hagglund, 'The Botanical Writings of Maria Graham', *Journal of Literature and Science* 4, no. 1 (2011): 44–58.

53  Elwood, *Narrative*, 2: 177; Graham, *Journal*, 141; Roberts, *Scenes*, 2, ch. 2.

54  Eden, *Letters*, 1: 211–12; Mackenzie, *Life*, 2: 199–200; Roberts, *Scenes*, 3: 62–4.

55  Graham, *Journal*, vi.

56  Maitland, *Letters*, 137.

57  [Honoria Lawrence], 'English Women in Hindustan', *Calcutta Review* 4, no. 7 (1845): 106.

58  Lawrence and Woodiwiss, *Journals*, 109.

59  Ibid., 85.

60  Ibid., 175.

61  India's vivid and varied colours are a recurring trope in this writing: see, for example, Falkland, *Chow-Chow*, 1: 11. Since photography was unable to represent colour directly, painting retained an expressive advantage.

62  Graham, *Journal*, 33.

63   Roberts, *Scenes*, 3: 197, 246, 266.

64   Falkland, *Chow-Chow*, 1: 88, 132.

65   Postans, *Cutch*, for example, plate 'Arab Soldiers', following 130.

66   Parkes, *Wanderings*, 1: 178.

67   Julian C. T. Baker, 'Darkness, Travel and Landscape: India by Fire- and Starlight, c. 1820-c. 1860', *Environment and Planning D* 33 (2015): 749–65.

68   Graham, *Journal*, 160–1.

69   Falkland, *Chow-Chow*, 1: 187–8.

70   Postans, *Cutch*, 1.

71   Ibid., 16.

72   Ibid., 29, 34, 45.

73   Graham, *Journal*, 1.

74   Elwood, *Narrative*, 1: 374; 2: 230.

75   Ibid., 2: 189.

76   Ibid., 2: 300.

77   Graham, *Journal*, 144.

78   Ibid., 148. The sight of naked and dead bodies, so rarely seen in Britain, was one of the aspects of India women travellers found most disturbing.

79   Shields, *Birds of Passage*, 144–51.

80   Postans, *Cutch,* 68.

81   In addition to Pratt's *Imperial Eyes*, see Lata Mani, *Contentious Traditions: The Debate on Sati in Colonial India* (Berkeley: University of California Press, 1998), ch. 5 'The Female Subject, the Colonial Gaze: Eyewitness Accounts of *Sati*'; Timothy Mitchell, *Colonizing Egypt* (Cambridge: Cambridge University Press, 1988). On visuality, see Kate Flint, *The Victorians and the Visual Imagination* (Cambridge: Cambridge University Press, 2000).

82   Mackenzie, *Life*, 2: 148.

83   Ibid., 1: 206; 2: 142, 164–71, 177. This close attention to Indians' expression and demeanour is also evident from other women artists of the period, especially Emily Eden, *Water Colour Sketches on the Princes and People of India* (Calcutta: Victoria Memorial, 1972).

84   Mackenzie, *Life*, 2: 182–4, 194.

85   Ibid., 2: 327.

86   Ibid., 2: 202, 204.

87   I take the expressions 'the education of the eye' and the 'cultivation of the sense' from a rather different and later context because they seem directly pertinent to women travellers in India a few decades earlier. See 'Middlesex Hospital: Introductory Address by Mr. Hensman', *Lancet*, 6 October 1877, 490, further quoted by the Governor of Bombay, Sir Richard Temple, at Grant Medical College in Bombay in March 1880: *Times of India* (Bombay), 10 March 1880, 3.

88   Roberts, *Scenes*, 1: 2–3, 178; 2: 37.

# Paper Trails of Imperial Trav(a)ils: Janet Schaw's *Journal of a Journey from Scotland to the West Indies, North Carolina and Portugal, 1774–1776*[1]

Viccy Coltman

Like the medicinal chicken broth made by her brother's Indian servant to settle the passengers' seasick stomachs on board the *Jamaica Packet*, Janet Schaw's *Journal* has gone 'thro' many Editions' (25).[2] The manuscript formerly in the British Museum known as Egerton 2423 was first published in 1921 in a volume with copious notes and fourteen appendices edited by Evangelina Walker Andrews in collaboration with her husband, Charles McLean Andrews, professor of American history at Yale.[3] The manuscript which they 'stumbled upon accidentally' (1) in 1904 as they recount in the introduction was mislabelled in the British Museum catalogue as a 'Journal by a Lady, of a Voyage from Scotland to the West Indies and South Carolina, with an account of personal experiences during the War of Independence, and a visit to Lisbon on her return, 25 October 1774–December 1775'. The cataloguer meant North, not South Carolina; on the precipice of the American War, rather than during it and with an end date of February 1776. The Andrews's edition, published under the title *The Journal of a Lady of Quality*, first appeared in 1921, with three further reprints in the decade (1922, 1923 and 1927), and two subsequent editions in the 1930s (1934 and 1939). Janet Schaw's authorship of the anonymous journal in the British Museum was confirmed by her editors based on a dedicatory inscription to her younger brother Alexander (Figure 2.1) dated 10 March 1778 in the front of one of the other surviving copies in manuscript then owned by Vere Langford Oliver, a historian of Antigua (2–3); it was later acquired by Everett D. Graff and donated by him to the Manuscripts and Archives department at Yale.

Little is known about Schaw and her social credentials beyond the leaves of her retrospectively-published journal. When she undertook her travels in October 1774, she was probably in her mid-thirties to forty years old, an educated, unmarried woman from Lauriston on the fringes of Edinburgh. Imperial historians have long recognized the wide range of ways in which family and empire are entangled and Schaw's imperial trav(a)ils conform to the prevailing view of the later eighteenth-century empire as a family affair and most notably in the context of Scotland, of family as an imperial affair.[4] On the outward voyage to the West Indies, she was joined by Alexander, who was en route to St Kitts where he had been appointed to a position in the customs office. She also accompanied her relations, the three Rutherfurd children, Frances 'Fanny' (eighteen years old) and her two brothers 'the young rogues' (214) John (who was twelve) and William 'Billie' (ten years old). Having been sent back to Scotland after their mother died in 1768, they were being reunited with their father, John Rutherfurd, a loyalist planter who lived near Wilmington in North Carolina.[5] Schaw's elder brother Robert had emigrated to America 'while he was a boy and was many years in trade before he turned planter' (160). Indentured to a Scottish-American merchant in Wilmington and later owner of a plantation Schawfield, on the northwestern branch of the Cape Fear River, he married Rutherfurd's

**Figure 2.1**  Henry Raeburn, *Portrait of Alexander Schaw*, c. 1810–15. Oil on canvas. 76.2 × 63.8 cm. Philadelphia Museum of Art: The John Howard McFadden Collection, 1928 (M1928-1-27).

sister Anne and, after her death, an American woman. At its commencement, Schaw represents her voyage to the New World as a gesture of sibling affection both ongoing and renewed, where 'my going will chear the Travils of the best of Brothers [Alexander], and once more give me the other [Robert], lost from childhood' (21). The microhistories of these two brothers, Robert and Alexander Schaw, are implicated into wider British imperial histories of Scottish emigration and colonial service: in Schaw's summary phrases 'seeking precarious bitter bread in a foreign land' (34), or mending and making their fortunes (55) in the vicissitudes of empire.

For her editors Andrews and Andrews, the merit of Schaw's journal as a literary work and a 'human document … places its author among the littérateurs of her country and century' (9). In almost a century since they first published the journal, she has yet to take her place in the male-dominated pantheon of eighteenth-century so-called 'Scottish Enlightenment' authors that the Andrews would appear to be indicating. Since Schaw did not write for publication, technically she was not an author like her better-known male counterparts. In the 1920s and 1930s, when three editions of the journal were published, a number of reviewers identified the historical significance of the Andrews's chapter III for the study of imperial politics – citing the nine months Schaw spent in North Carolina from mid-March 1775 as being of particular value to students of the incipient American Revolution.[6] Since then, with the shifting priorities of the Academy and the explosion in colonial and postcolonial studies, Schaw's journal is primarily discussed with reference to the preceding chapter II when she was based in Antigua and St Kitts in terms of its representation of race, especially for her aporetic sentiments regarding the institution of slavery in the colonial plantation culture of the West Indies.[7]

This chapter revisits aspects of these existing accounts in an attempt to highlight the historical significance of Schaw's letters, as the products and productions of an epistolary empire in which their author is a woman traveller. The essay is framed by a series of rhetorical binary oppositions of the sort favoured by colonial regimes, focusing on the corpora of identity that result from expanding geographical horizons and that demarcate – predictably – gender (men/women) alongside species (human/animal), place (home/not home) and race (white/black, colonizer/colonized, dressed/naked).[8] By examining the extent to which Schaw conforms to or subverts these binaries, this chapter seeks to position her as a traveller and journalist engaged in the cultural construction of empire. Significantly it reveals the fluid nature of her conformity as she travelled across

space and time. The chapter looks at the content of the letters that constitute Schaw's journal *in* their own terms and *on* their own terms, as a case study rather than a comparative or collective one, eschewing references to texts by contemporary men and women travellers. It does this in part because Schaw had previously been discussed alongside published authors including Edward Long, John Singleton and her Scottish countrywoman Maria Riddell in essays by Coleman and Andrews, in whose accounts the West Indian chapter of her travels is privileged.[9] If Schaw's account of race and slavery in this British colony has eclipsed that of imperial politics in another (America), then her epistolary femininity and feminine epistolarity (in Gilroy and Verhoeven's phrase) were given additional impetus in the 1980s, when scholars started to reflect on the letter as a cultural institution with multiple histories.[10] Letters are 'ideal places for exploring, constructing, and expressing women's subjectivity', writes a historian of the genre, with Schaw's *Journal* being described as 'one woman imperialist's complex response to the colonial project'.[11]

This account seeks to probe the complexity of Schaw's response to the colonial project in terms of the wider aims of *British Women and Cultural Practices of Empire, 1770–1940*. That is, how she negotiated people, places and objects in ways that were heavily inflected by her gender, her national identity and her social position. Her sixteen-month travels provide an uncommon example of a Scottish woman visiting first-hand distant parts of the British empire in the mid-1770s and constructing that experience in epistolary form – in a series of letters that were subsequently copied at least in quadruplicate, of which one version was first published as a journal 150 years later. Like David Arnold's essay elsewhere in this volume, this chapter considers how Schaw's letters were structured by the geographical route she followed and the literary form in which she wrote, with her letters functioning as social as well as material objects. It also goes beyond Arnold's discussion of British women in early nineteenth-century India, to consider how Schaw uses the space of the letter as a means of articulating how she loyally conforms to or wilfully subverts the social practices of Britain's expansive imperial regime that was territorially on the point of contraction with the loss of the American colonies. Unusually given the privileged emphasis on Andrews and Andrews's chapter II, it gives equal precedence to three of their four chapters – looking at vignettes from the voyage to Antigua which lasted from 26 October to mid-December 1774, the sojourn in the West Indies over Christmas and during the nine months Schaw spent in North Carolina. The Lisbon leg of the return journey will be referenced in terms of its recurrent

themes, the most striking of which has not been recognized by the many scholars discussing her sojourn in the West Indies – how Schaw's first-hand experience of slavery and its 'inhuman' (108) weapons like the whip become potent metaphors in her succeeding accounts of colonial America and Catholic Portugal. 'This land of nominal freedom and real slavery' (212) is how Schaw, the staunch loyalist, characterizes the American colonies as she makes her swift exit. 'You know I am no bigoted Presbyterian' (93), she writes, but in Schaw's account of 'such a farce' (227) as the tyranny (as she perceived it) of Roman Catholicism in Portugal, she deduced that 'religion is held as a whip over slaves, and every individual has a court of Inquisition within his own breast' (229). Since Portugal is the culmination of her account of her trav(a)ils, it is necessary to rewind to their outset in the autumn of 1774, during the seven-week maritime crossing to Antigua.

## Species

In an often-cited passage, early on in the voyage, Schaw recounts ascending the cabin stair to discover that her small party were no longer the only passengers on board the *Jamaica Packet*:

> Judge of all my surprize, I saw the deck covered with people of all ages, from three weeks old to three score, men, women, children and suckling infants. For some time I was unable to credit my senses, it appeared a scene raised by the power of Magic to bring such a crowd together in the middle of the Sea, when I believed there was not a soul aboard but the ship's crew and our own family. Never did my eyes behold so wretched, so disgusting a sight. They looked like a Cargo of Dean Swift's Yahoos newly caught. (28)

The inimical comparison of the mixed company of emigrants smuggled on board ship with 'Swift's Yahoos' makes reference to the fourth voyage of *Gulliver's Travels*. In so doing, Schaw situates her own account of her voyage within the popular contemporaneous genre of travel writing. This is one of a choice library of intertextual references that Schaw invokes throughout her letters. Another characterful comparison is to Don Quixote's Maritornes (222), who is mentioned in conjunction with the household of a Senora Maria, with whom Schaw and company dined in St Tubes, 'with her jacket and rouff-eye; have not seen such an animal [writes Schaw]. She would measure half as much again

round, as from head to foot, Her bushy black hair was frizled up, which with her little winking eyes and cock-nose made a most complete appearance' (222–3). Schaw creates an evocative epistolary portrait of the rotund, diminutive body and distinctive facial features of the maid of their Spanish hostess, which echoes that of Cervantes's Asturian wench. In the course of her journal, she quotes Milton (191), evokes Shakespeare's Falstaff (143), paraphrases Voltaire (223) and finds Ossian unjustly criticized for calling the sea blue and the stars green (74). More than one commentator cites Schaw's familiarity with the volumes of Scottish Enlightenment authors, like Lord Kames's *Elements of Criticism*.[12] A more careful reading of the initial reference to Kames confirms that this was the first book her travelling companion Fanny Rutherfurd grabbed during the tumultuous experience of a ten-day storm at sea and read aloud to Schaw, who describes listening 'with much seeming attention, tho' neither she nor I knew a word it contained' (44).

In contrast with her lack of familiarity with Kames, Schaw confidently asserts having read 'all the descriptions that have been published of America, yet meet every moment with something I never read or heard of' (151). A traveller herself, Schaw makes specific reference to recently published volumes in the male-dominated genre in which she is reading and writing, including Patrick Brydone's *A Tour through Sicily and Malta* (London, 1773; 183) and Richard Twiss's *Travels through Portugal and Spain in 1772 and 1773* (London, 1775; 250). Of Twiss she writes, 'His travels seem only a journal of his own bad humours, prejudices and mistakes' (250), a guide she seems keen to fashion her own letters in contradistinction to, admitting 'I am at a loss to think where he found the dirty scenes he describes. I have been at no pains to avoid them, yet have met with no such thing.' The recipient of her letters is instructed to refer to reference volumes they had in common, including Thomas Salmon's *A New Geographical and Historical Grammar* (60–1) and to Philip Miller's *The Gardener's Dictionary* for accounts ranging from the Azores islands (168), to the cultivation of rice in North Carolina (194), to a description of the magnolia (203) there. This same recipient was presumably familiar with Jonathan Swift's *Gulliver's Travels*, which first published nearly fifty years earlier in 1726.

According to Nash in his study *Wild Enlightenment* 'no wild man has left a more lasting literary impression' than Swift's Yahoos.[13] In spite of this legacy, Nash comments that from Swift's day to the present, virtually no attention is paid to Gulliver's initial description of the Yahoos. It is precisely this description,

which emphasizes their animality, rather than presumes their humanity, that Schaw references. In his account of his fourth voyage, Gulliver describes the Yahoos as 'animals' which he encountered in a field and sitting in trees; their shape was 'very singular, and deformed'.[14] Observing them from behind a thicket, he writes that their heads and breasts were covered with a thick hair, frizzled or lank, with beards like goats and hair on the backs and foreparts of their legs and feet; the rest of their bodies were naked, with skin of a brown buff colour. Noting their sharped pointed claws 'before and behind', which enabled them to climb trees as nimbly as squirrels, he offers the following summary: 'Upon the whole, I never beheld in all my Travels so disagreeable an Animal, or one against which I naturally conceived so strong an Antipathy.'

Like Gulliver, Schaw's first impression of the emigrants smuggled on board the *Jamaica Packet* was one of visceral hostility – of wild animals undomesticated ('newly caught') and even denied of their animate status by being classed as merchandise ('cargo').[15] Gulliver's succeeding account of the 'filthy Yahoos', with their brown hairy skins, their nakedness, their 'strange disposition to nastiness and dirt', and their 'very rank' smell 'somewhat between a *Weasel* and a *Fox*, but much more disagreeable', all belong to eighteenth-century classifications of racial difference focusing on the figure of the negro.[16] The rhetorical binaries human/animal and naked/clothed will be revisited in Schaw's journal in due course. For now, in an equivalent sensorium of disgust, Schaw mentions the smell coming from the 'hole' where the emigrants were confined and voices her fear of unwanted infestation from their body lice – 'For I make no doubt they have bought thousands alongst with them. Faugh! let me not think of it' (30).

Yet six pages later in the printed edition, Schaw poses a rhetorical question:

> Where are now the Cargo of Yahoos? they are transformed into a Company of the most respectable of sufferers, whom it is both my duty and inclination to comfort, and do all in my power to alleviate their misfortunes, which have not sprung from their guilt or folly, but from the guilt and folly of others. (36)

Schaw's Yahoos have metamorphosed from her first impression of an undifferentiated 'cargo' into a 'Company of the most respectable sufferers'. Well might the reader ask, what has happened to shift Schaw's response from one of unconcealed disgust into sentimental sympathy? How, to quote Wyrick, have the emigrants 'moved from being figures in someone else's text [Swift's] to being figures in her own'.[17] The transformation comes about as the *Jamaica Packet* sails past the Shetland and Orkney Islands and the emigrants take a last view of their

former home with Schaw recognizing the differing emotional registers between 'them and me':

> What chilled my blood and disgusted my eye, filled their bosom and warmed their hearts with the fondest, the most tender sensations, while sweet remembrance rushed on their minds and melted the roughest into tears of tenderness. The rude scene before us, with its wild rocks and snow cover'd mountains, was dear to them, far more dear than the most fertile plains will ever appear. It was their native land, and how much is contained within that short Sentence, none but those who have parted with their own can be judge of. (33–4)

In this emotive epiphany, Schaw 'cranks the steerage passengers into the category of the human' and starts to differentiate between the group of emigrants; her gaze focusing in particular on one weeping woman breastfeeding her baby.[18] For Wyrick, this 'domestic pietà' as she dubs it is 'a commonplace trope of sentimental art'. [19] A pietà is a dead adult Christ in the arms of his mother, and a more thorough reading of this passage in Schaw's journal shows the group is not a straightforward mother and child configuration – a Virgin lactans – as at the mother's knee is a two-year-old and standing nearby also weeping is a daughter of about eight. Nevertheless, we are still in the domain of sentimental artistry with this affective, even lachrymose, descriptive tableau of a mother and her three children. Schaw actually writes of 'wish[ing] for Miss Forbes, with her pencil of Sensibility, to have done justice to this group of heart-affecting figures' (35).[20] Despite the vastly different socioeconomic circumstances between Schaw and her party and those she subsequently identifies using the possessive as 'my Emigrants' (54), what unites them across the class divide as an affective community is their sentimental attachment to Scotland, 'their native land' as they sailed past its furthest borders.

## Place

'Their native land, and how much is contained within that short Sentence' muses Schaw from the deck of the *Jamaica Packet* (34). From the pages of her *Journal*, it would seem as if there were as many, if not more, Scots in or en route to the British colonies in the mid-1770s as there were the varieties of thirty-two fruits served for dessert at John Halliday's dining table on the island of Antigua (97). Halliday was one such Scot employed as a colonial servant as collector at

St John's, and Schaw expends some five pages discussing the culinary delights of Antigua following the gastronomic excesses at Halliday's plantation. 'We had a family dinner [she writes], which in England might figure away in a newspaper, had it been given by a Lord Mayor, or the first Duke in the kingdom' (95). It would be easy to labour Schaw's profound Scottishness, as the author herself does. Scotland is 'my dear Native land' (22), 'the finest Country in the World' (24), 'thou dear, loved native land. In vain I am told of finer Climates, or of richer soils, none will ever equal Scotland in my estimation' (42). Starting with Schaw's extended 'family' on board ship (28) to 'my Emigrants' (54) as she came to identify them, Schaw encountered Scots dispersed throughout the empire as she traversed it, with a particular concentration in the West Indies, where large numbers of plantations were owned by Scots (100). 'Man is certainly by nature a kindly Social animal. The law of affection was planted in his breast for the best of purposes' (46), she proclaims, and Schaw's sojourn on Antigua and St Kitts was to demonstrate the efficacy of such a Scottish Enlightenment tenet – with acquaintances and friendships renewed, forged or – if the recipients were not present – regretted, as was the case with the absent Sir Ralph Payn, the Governor of the Leeward islands and his wife (89). While lodging with a Mrs Dunbar on Antigua who had been married to a Scotsman (79), Schaw identified another Mrs Dunbar (no relation to the first) as the wife of her old friend Dr Dunbar 'with whom I had been well acquainted in Scotland, and who had resided many months at my father's house' (80). 'Here was a whole company of Scotch people [writes Schaw, referring to herself, her brother, Alexander, Dr Dunbar, John Halliday, Charles Baird and Martin, a young man] our language, our manners, our circle of friends and connections, all the same. … We were intimates in a moment' (81–2).

In addition to common linguistic idioms, etiquettes and sociabilities, Scots shared a distinctive diet of foodstuffs. On board the *Rebecca* in the mid-Atlantic bound for Cape Fear, Schaw and her extended family enjoyed 'a Scotch dinner. … We eat haggis, sheep-head, barley-broth and blood puddings' (139) with a captain and a mate who were both Scottish. As in Antigua, the products of the tablescape became the foci for national and social identities, only with less fussy and more substantial dishes than were consumed in the Caribbean.[21] These expatriate Scotsmen who Schaw encountered worked across the professional careers that empire afforded, in the medical (Dunbar) and civil spheres (Halliday and Baird), naval, military (83) and ecclesiastical (129). While most were making a living from the exigencies of empire, others had expired in

its service. Schaw recorded the names of deceased Scots preserved in a burial ground on Antigua, including 'poor Jock Trumble of Curry, who died here while with his regiment' (83) and mourned the loss of Eleanora, 'the Lady I had known in Scotland' (91) who had been killed in a recent hurricane. Of the living expatriate female population, who were far fewer in number than their male superiors, Schaw was reunited with her friend, Lady Belle Hamilton, mistress of the Olovaze plantation on the island of St Kitts; Fanny Rutherfurd met many of her boarding school acquaintances (92), and both women attended a ball at the house of Dr Muir, whose daughters were also boarding school acquaintances of Fanny's (109). Where the Scots Schaw encountered were personally unknown to her and her travelling family, there was often an interlocutor, like the shopkeeper at St John's, a Mrs Tudhope, whose brother-in-law was a Mr Ross, a writer at Edinburgh (115), or the aide-de-camp of the governor of Lisbon, Major Scott from Midlothian, Scott of Mollinie's eldest son and Major Lindsay, brother to Lindsay of Wormiston in Fife (238).

If the West Indies was saturated with Scots, then Schaw's sentimental attachment to her 'native land' (34) was manifest in other ways in her epistolary account of her travels. Scotland as 'home' provided a series of reference points for the traveller on unfamiliar territory as a world of 'known limits' and a space of 'absolute familiarity' to Schaw and the still unidentified recipient of her letters.[22] So she writes of her first view of Antigua from the deck of the *Jamaica Packet*: 'Its principal beauty to me is the resemblance it has to Scotland, yes, to Scotland, and not only to Scotland in general, but to the Highlands in particular' (74). A mountain steam in the West Indies 'resembles one of our highland burns' (126); their transport from Antigua to St Kitts' was 'no larger than a Kinghorn boat' (117); the gaping jaws of a fifteen foot alligator she witnessed being bludgeoned in the Cape Fear river 'might have admitted if not a Highland cow, at least a Lowland calf' (150); while the Duke of Alvara's palace had a balcony longer than that of the Abbey at Holyrood house (230). At Brunswick, she sees items of Scottish manufacture exported to the colonies – a Carron stove and Scotch coals (144–5). Though she had 'often been told that Lisbon resembled Edinburgh' (242), after a 'round of the town' Schaw admitted that she did not like it as well as her home town (250). At Belleim, the winter palace of the king of Portugal, she could not name all the Indian fowl she saw 'but they are well represented on the Indian papers we get at home'. (247) 'The comfort of a world of known limits [writes Guha] derives precisely from the known measure of things', the comfort of home as opposed to the discomfort that was the immeasurability of

empire.[23] In Schaw's case, these measures were both metaphorical and literal. Having fled from North Carolina and en route to Portugal, she 'long[ed] for a drink of Scotch two penny, and will salute the first pint-stoop I meet and kiss the first Scotch earth I touch' (218).

# Race

In her discussion of how the aesthetics of colonialism blurs the violently disharmonious elements of colonial society, Bohls writes, 'Colonial discourse is peculiarly *at home* [my emphasis] in the register of the visible, predisposed to paint pictures with words, since colonial rule is based on that most visible and seemingly natural of signs, the color of skin.'[24] Bohls draws on another of the many different resonances of what being at home in empire might mean.[25] Though highly visible and seemingly natural, the colour of skin is 'an unstable boundary marker', a surface layer of corporeality in which the real is characterized by its visual obliqueness, rather than its transparency.[26] Here is Schaw describing the colonial women in the West Indies:

> They want only colour to be termed beautiful, but the sun who bestows such rich taints on every other flower, gives none to his lovely daughters; the tincture of whose skin is as pure as the lily, and as pale. Yet this I am convinced is owing to the way in which they live, entirely excluded from proper air and exercise. From childhood they never suffer to have the sun to peep at them, and to prevent him are covered with masks and bonnets that make them look as if they were stewed. Fanny, who just now is blooming as a new rose, was prevailed upon to wear a mask, while we were on our Tour, which in a week changed her colour, and if she had persevered I am sure a few months would have made her as pale as any of them. As to your humble servant, I have always set my face to the weather; wherever I have been. I hope you have no quarrel at brown beauty. (114–15)

The content and context of this passage confirms the extent to which whiteness as a visually racial category emerged as an explicit value in the eighteenth century.[27] The complexions of these colonial women form part of the profusion of the flora and fauna of the islands they inhabit that Schaw's letters describe at length and in detail. Their masks and bonnets, in which they are 'stewed' extend the cultivated culinary delights beyond the groaning colonial dining room table. While her companion, the as yet unmarried Fanny Rutherfurd, 'was prevailed

upon' to adopt their longstanding practice – of protecting her face by wearing a mask to artificially produce whiteness – the more mature Schaw allows the sun to penetrate her skin and to produce a suntanned complexion that she describes as 'brown beauty'.[28] The phrase is an oxymoronic one – a suntanned complexion was 'outside the pale, so to speak, of ladylike beauty in late eighteenth-century Britain'.[29] Schaw had previously described Fanny as being 'in great beauty, she has improved amazingly with her Sea-Voyage' (69), though Fanny's bloom was to be curtailed in the West Indies in favour of a contrived ghostly pallor. Even earlier during the transatlantic crossing from Scotland, Schaw had noted that Fanny, who was seasick, 'sits like a statue of monumental alabaster, so white, so cold, so patient' (30). However fleeting or commonplace, these gendered references to the lily and to alabaster refute DiPiero's claim that no European observer in the eighteenth century lists varieties or shades of whiteness.[30]

For Bohls, Schaw's brown beauty situates her between monochrome races (black/white) and between genders, not pale and protected like the women she encountered, but robustly tinged.[31] Additionally, Schaw's brown complexion aligns her with two distinct colonial groups as regards their gender and race: emigrant men and those of mixed-race parentage. Schaw encounters both simultaneously on a visit to the Olovaze plantation on St Kitts, where she was reunited with her friend, Lady Isabella Hamilton. Like Fanny Rutherfurd, Isabella Hamilton's complexion was whitened by its premeditated lack of exposure to the sun ('the lily has far got the better of the rose' writes Schaw (122)), while her husband's was 'dark brown-nut' (123). When Schaw first sees her friend in the plantation's great hall, she recounts, 'She had standing by her a little Mulatto girl not above five years old, whom she retains as a pet. This brown beauty was dressed out like an infant Sultana, and is a fine contrast to the delicate complexion of her Lady' (123–4). In this chiaroscuro tableau, the binaries between a monochrome palette of black and white and the social fissure between mistress and servant are melded by complexion and costume. Castle's description of how the masquerade metamorphosis 'insinuated a new global fluidity' breaching ideological divisions between various binaries, including light and dark races, rank and class, master (or rather mistress) and servant is pertinent for our understanding of the dress of Hamilton's mulatto 'pet' and her brown skin – a product of her mixed-race parentage.[32]

Schaw's designation of the girl as a pet is also pertinent to our analysis. According to Tague's recent study, the two defining characteristics of a pet are that it lives in the domestic space and that its primary purpose for humans is one

of entertainment and companionship.³³ For Tague, pets in eighteenth-century Britain blurred the boundary between human and animal – a boundary that was equally permeable in Schaw's epistolary empire, where she recounts witnessing first-hand slaves being shackled (22–3) and whipped (127), and wild animals being domesticated for human possession. The 'many pets' Schaw acquired in North Carolina, included a dog (176), a fawn (176) and a bear (217). 'We were afraid he [the bear] would join his brethren of the congress, and as he has more apparent sagacity, than any of them, he would be no small addition to their councils', writes Schaw, unambiguously casting the rebellious male population as stupid beasts.

Lady Hamilton's mulatto pet was one of the new (notably animate) objects that Schaw encountered in the spaces and places of the empire as she traversed it by sea and land. In the first week of December 1774, as the *Jamaica Packet* approached the Tropic of Cancer, Schaw wrote of the tropical birds they had seen, explaining 'as we are now approaching a new World, we have also reason to look for new objects' (66). Once back in the old world, she writes of her attachment to a Scottish countryman at Lisbon, a Major Lindsay, who is the brother of Lindsay of Wormiston in Fife (238). Schaw explains, 'He has such an accurate manner of explaining the present objects and describing the absent, that I am at a loss to discover with which of the two I am most pleased.' Schaw's own travels were furnished with specific objects which made their way into her journal – making the absent object palpably present for her reader. Schaw's letters were themselves material objects, intended to be read, passed around and reread. She had anticipated a wider audience for at least one of her letters devoted to the gastronomic feast at Halliday's, whose contents 'will amuse some of our eating friends' (97). Later, during the thirty-two day voyage to Portugal, Schaw expresses doubt that it 'will furnish anything new' (217) and even if it should, she is unable to write 'as my brother begged my stock of writing materials, there being none to be had for love or money'. The material culture of letter writing was itself part of a transatlantic and global economy – a trade in what have been identified as 'unglamorous utilitarian commodities' including oak galls from Syria, gum Arabic from the Sudan and alum and copperas from Britain, which were combined to make ink.³⁴

Even more than the overseer's long and short whips (127), or the mask Fanny wore to ensure her ghostly white complexion (114–15), the social inequities of the West Indian plantocracy in which Schaw is complicit are powerfully represented by the design and deployment of a drinking vessel. Describing the marble

reservoirs which kept water cool and fresh, Schaw explains, 'It is presented to you in a Cocoa nut shell ornamented with Silver, at the end of a hickory handle. This is lest the breath of the Servant who presents it should contaminate its purity' (111). This vessel is a powerful metonym for the slave economy in which it was deployed – a natural object filigreed with luxury workmanship and owned by those whose fears of pollution and impurity were projected onto those who facilitated its use.

The object of material culture that best encapsulates the nine months that Schaw subsequently spent in North Carolina is the tar pot. A form of corporeal punishment, an encounter with the tar pot and its sticky contents was followed by a shower of feathers being despatched over the victim, who could be stripped naked or clothed then whipped at the gallows. B. H. Irvin has exhaustively documented the importation to the New World and the transformation of this form of popular punishment that dates at least as far back as the medieval period.[35] From the maritime traditions of the transatlantic rim, it was taken up by Whig enforcers after the Townshend Act of 1767 to resist unjust taxation and to enforce the Articles of Association. As the 1770s progressed, it was reclaimed by the people as 'a trademark of the American cause', as a means of distinguishing rebel friend from loyalist enemy and to assert patriotic allegiance to liberty. Irvin explains how pine tar was a familiar commodity in British North America, where it was used to waterproof ships, sails and rigging. It was obtained by roasting mature pine trees over an open pit fire and distilling the bituminous substance that boiled out. Its partner in crime, feathers, were also a familiar commodity, domestic, rather than maritime, as they were used to stuff beds, pillows and cushions.

Although Irvin quotes Schaw on the recruiting practices of the North Carolina militia, which she observed first-hand, her *Journal* has deeper tar and feathering resonance.[36] In the first instance, because her initial view of America from the deck of the *Rebecca* as her party sailed into Brunswick is populated by the trees from which the tar was obtained – 'A dreary Waste of white barren sand, and melancholy nodding pines…. All seems dreary, savage and desert' (141). Months later on board the *George* in the bay of St Tubes and under what she dubs 'an Italian sky', she remembers the North Carolina vista where 'an eye that had been … confined to a dead level or nodding black pines equally disagreeable' (219). How different is this account from her first glimpse of Antigua, where, as we have seen, its principal beauty to Schaw is in its resemblance to the Scottish Highlands. In collusion with the aesthetics of colonialism already referred to, the beauty of

the West Indies only increases as she visits the Eleanora plantations on St Kitts, with Schaw exclaiming over its 'delightful Vision, a fairy Scene or a peep into Elysium' (91). The 'dazzling lustre' (91) of the visual prospects afforded by one British colony, the West Indies, offered a dramatic chiaroscuro to the darkness of another. Travelling to Schawfield, her brother's plantations, at night, Schaw's vision was obscured; in her own words she was 'lost in the most impenetrable darkness, from which we could neither see sky, nor distinguish a single object' (147). While Coleman has established the extent to which whiteness in the West Indies differed from whiteness in the rebellious American colonies, it is useful to see this in broader terms as part of an imperial palette, that ranged from white to black, including light and darkness, and that offered alternative aesthetics of colonialism suited to the different British colonies.[37]

That Schaw was familiar with tar and feathering prior to her arrival in the insurgent American colonies is witnessed during the aftermath of a storm across the Atlantic where she recounts many items below deck having being spilled and upset, including 'a barrel of molasses [which] pitched directly on me, as did also a box of small candles, so I appeared as if tarred and feathered' (52). Schaw would later observe first-hand and 'with much attention' (125) the working plantations in the saccharocratic culture of the West Indian islands that refined sugar into molasses. Once in North Carolina, however, being tarred and feathered took on a very different complexion. Schaw wrote that she could not look at the men 'who are natives of the country … without connecting the idea of tar and feather' (154). On a repeat visit to Wilmington, she fears the felonious nature of her letter's loyalist contents – 'I risk tar and feather was it to be seen' (181). Coleman notes how the act of tar and feathering in the American colonies, in which the victim went from white to black via the tar and to white again via the feathers, resulted in rendering the British loyalist as racially indeterminate (182). This indeterminacy, we might add, extended to their species, with the target transformed into a bird/human, covered with layers of feathered tar.

## Dress

According to a contemporary eighteenth-century chain of being, nakedness was associated with barbarism, while its corporeal antithesis, dress, with refinement – an outer layer of clothes serving to separate the civilized man from the lack of apparel sported by the primitive beast like Swift's Yahoos. The importunate

figure of the naked or half-naked negro was placed on this scale in its proximity to man or ape.[38] As she embarks at the town of St John's on Antigua on 12 December, Schaw describes mistaking a group of negro children for 'a parcel of monkeys … naked as they were born' (78). On this occasion, Schaw invokes with remarkable economy the human/animal and naked/dressed binaries.[39] On another, she deliberately plays on the latter in an account of a visit to a ball in Wilmington, in which she objectifies herself under a spotlight carried by a half-naked black woman. Full of self-deprecating humour, she writes of herself as a parody of fashionable dress as opposed to a paragon of genteel refinement: 'There was no object on which my own ridicule fixed equal to myself and the figure I made, dressed out in all my British airs with a high head and hoop and trudging thro' the unpaved streets in embroidered shoes by the light of a lanthorn carried by a black wench half-naked. No chair, no carriage – good leather shoes need none. The ridicule was the silk shoes in such a place' (154). Lawrence has established the importance of dress to the gendered imperial project in a later historical period, from 1840–1910, where 'because of its intimate relation to core subjectivity, [it] is very sensitive to the reflexive element of identity.'[40] On this occasion, the satire of Schaw's sartorial Britishness is displayed in the incongruity of her hooped skirts and her embroidered silk shoes in the unpaved and unlit streets of Wilmington. Where she is inappropriately overdressed, her female light bearer is only half dressed, in another chiaroscuro tableau taking place at night with choreographed lighting.

This account in which Schaw describes herself walking at night echoes in reverse her earlier narrative of gender and mobility in the West Indies. Here, where the physical passage of the creoles (to adopt Schaw's terminology) was circumscribed, not only do 'no Ladies ever walk' (78), but they never travel by carriage without a gentleman to accompany them (87). On the island of St Kitts, Schaw undertakes an uphill walk of 2 miles, writing to her 'dearest of friends' (93), 'This was truly a British frolick, and what no creole would ever dream of' (125). Like her tinged complexion or 'brown beauty', Schaw's unfettered mobility in the West Indies is a sign of her emancipation from the immobile imperial strictures imposed on white émigré British women in colonial society.

Later, in a letter written from the rebellious colony of North Carolina, Schaw invokes her original reader explicitly and emphatically where she describes a 'midnight march' – joining a patrol to cross from one side of Wilmington to another: 'For God's sake! draw a picture of your friend in this situation and see if 'tis possible to know me. Oh! I shall make a glorious knapsack-bearer. You have

formed a very wrong idea of my delicacy; I find I can put it on and off like any piece of dress' (201). If dress is the most intimate expression of self, as historians of empire and gender like Lawrence have claimed, it may not necessarily be a reflection of an authentic self, as dress forms an exterior carapace of identity that can be assumed, contrived and manipulated.[41] On this occasion, Schaw uses dress as a simile to describe the cultivation of her delicacy in relation to that of her sartorial fashioning. By the time she visits Lisbon, her travelling clothes are no longer a sign of her refinement, but the opposite – her barbarism. She writes of being 'perfect Goths in the article of dress, so much has fashion altered since we left Britain' (239).

The rhetorical binaries dressed/naked and civilization/barbarism form part of the classificatory sinews of colonial regimes and by which they produce and reproduce the tenets of imperial power. For our purposes and in drawing a conclusion, how Schaw conforms to or subverts these and other binaries enables us to position her as a traveller/journalist in the mid-1770s. In the insurgent British colony of North Carolina, Schaw displays no sympathy for the colonists – her politics are intransigently black and white in terms of the rebels and the loyalists. If we use dress as a figure of speech, as Schaw herself does, while her gendered body was fashionably overdressed in the seditious streets of Wilmington, her face was naked or unmasked in the West Indies. In this other British colony, Schaw's social practices were more elastic in the way she cultivates a suntanned face and enjoys a degree of unfettered mobility. These relative freedoms position her in opposition to the colonial female population and align her more closely with members of the male community which was seemingly swarming with her countrymen. Schaw's gender as a female traveller in the British Atlantic empire and as the author of a series of letters about those travels was always imbricated with other corpora of her identity, her species, place and race. These became especially pronounced in imperial landscapes and seascapes with their expanded geographical horizons and their extended repertoire of social interactions.

# Notes

1   My thanks to Adam Budd and Freya Gowrley for their comments on an earlier draft and to Katrina O'Loughlin who very kindly allowed me to read her chapter on Schaw when it was at the proof stage. I am indebted to the Board of Directors of the

North Caroliniana Society for the award of two Archie K. Davis Fellowships which enabled me to visit the Wilson Library, UNC Chapel Hill and the Sterling Memorial Library at Yale.

2   I am using the 1923 reprint; page numbers will be given in parentheses: *Journal of a Lady of Quality: Being the Narrative of a Journey from Scotland to the West Indies, North Carolina and Portugal in the Years 1774 to 1776*, ed. Evangeline Walker Andrews in collaboration with Charles McLean Andrews (New Haven and London: Yale University Press, 1923).

3   Since 1963, the improperly labelled manuscript in a quarto volume in the British Museum that the Andrews published has been missing. For details of 1921 edition, see *Journal of a Lady of Quality: Being the Narrative of a Journey from Scotland to the West Indies, North Carolina and Portugal in the Years 1774 to 1776*, ed. Evangeline Walker Andrews in collaboration with Charles McLean Andrews (New Haven and London: Yale University Press, 1921).

4   Cleall, Ishiguro and Manktelow, 'Imperial Relations', n.p.

5   John Rutherfurd's wife Frances was the widow of the Scottish-born Governor of North Carolina, Gabriel Johnston, when she married Rutherfurd in 1754.

6   For instance, reviewers noted that 'it is … her impressions of North Carolina which make the book most valuable', *American Historical Review* 27, no. 4 (1922): 802; 'This part of her Journal is of great historical importance', *The Geographical Journal* 95, no. 6 (1940): 471.

7   All the key texts are listed below. Given the emphasis on the West Indian sojourn in the secondary literature, Katrina O'Loughlin's recent chapter is especially welcome in its focus on the signifying role of landscape and weather as part of Schaw's emotional response to the developing civil conflict in the colony. See Katrina O'Loughlin, '"In Brazen Bonds": The Warring Landscapes of North Carolina, 1775', in *Emotions and War: Medieval to Romantic Literature*, eds Stephanie Downes, Andrew Lynch and Katrina O'Loughlin (Basingstoke: Palgrave Macmillan, 2015), 218–34.

8   Tim Fulford and Peter J. Kitson (eds), *Romanticism and Colonialism: Writing and Empire, 1780-1830* (Cambridge: Cambridge University Press, 1998), 11. It is worth noting that three of my categories – gender, race and species – echo those of Dror Wahrman in his influential *The Making of the Modern Self: Identity and culture in Eighteenth-Century England* (New Haven and London, 2004). Wahrman includes class as a fourth category of what he designates personal identity. The addition of 'place' is indebted to Ian Baucom, *Out of Place: Englishness, Empire and the Locations of Identity* (Princeton: Princeton University Press, 1999), esp. 19, where he describes the locations of identity as follows: 'They are places where an identity-preserving, identity-enhancing, and identity-transforming aura lingers, or is made to appear.'

9  For racialization of skin colour in Schaw, Long and Singleton, see Deirdre
Coleman, 'Janet Schaw and the Complexions of Empire', *Eighteenth-Century
Studies* 36, no. 2 (2003): 169–93. For Schaw and Riddell, see Corey E. Andrews,
'Scarred, Suffering Bodies: Eighteenth-Century Scottish Women Travellers on
Slavery, Sentiment and Sensibility', in *Women in Eighteenth-Century Scotland:
Intimate, Intellectual and Public Lives*, eds. Katie Barclay and Deborah Simonton
(Farnham: Ashgate, 2013), 171–89.

10  Amanda Gilroy and Wil M. Verhoeven (eds), *Epistolary Histories: Letters, Fiction,
Culture* (Charlottesville and London: University Press of Virginia, 2000), 1, 4.

11  Temma Berg, *The Lives and Letters of an Eighteenth-Century Circle of
Acquaintance* (Aldershot: Ashgate, 2006), 6, 15; E. S. Kim, 'Complicating
"Complicity/Resistance" in Janet Schaw's *Journal of a Lady of Quality*', *Auto/
Biography Studies* 12, no. 2 (1997): 184. In their 1999 publication, David Barton
and Nigel Hall claimed there had been little study of letters as a genre, in contrast
with poetry or novels. This is emphatically no longer the case and the texts I have
found most useful are cited throughout the footnotes. See David Barton and
Nigel Hall (eds), *Letter Writing as Social Practice* (Amsterdam: John Benjamins
Publishing, 1999), 2.

12  Warren Montag, 'The Universalisation of Whiteness: Racism and Enlightenment',
in *Whiteness: A Critical Reader,* ed. Mike Hill (New York and London: New York
University Press, 1997), 282; Dorothy McMillan, 'Some Early Travellers', in *A
History of Scottish Women's Writing*, eds Douglas Gifford and Dorothy McMillan
(Edinburgh: Edinburgh University Press, 1997), 121, refers to Schaw's 'knowledge
of Swift and Lord Kames'.

13  Richard Nash, *Wild Enlightenment: The Borders of Human Identity in the Eighteenth
Century* (Charlottesville: University Press of Virginia, 2003), 103.

14  Jonathan Swift, *Gulliver's Travels* (1726; repr., Oxford: Basil Blackwell, 1941), 207.

15  Lynn Festa, *Sentimental Figures of Empire in Eighteenth-Century Britain and France*
(Baltimore: John Hopkins University Press, 2006), 172.

16  Laura Brown, 'Reading Race and Gender: Jonathan Swift', *Eighteenth-Century
Studies* 23, no. 4 (1990): 439. Brown points out that the Yahoos do not stand for
African blacks in any straightforward allegorical fashion, 440. As Brown expands in
her *Homeless Dogs & Melancholy Apes: Humans and Other Animals in the Modern
Literary Imagination* (Ithaca: Cornell University Press, 2010), 48. Swift presents a
double genealogy of the Yahoo, who is a composite of Hottentot and hominoid ape,
both of which are themselves collated beings.

17  D. B. Wyrick, '"My Emigrants" and "Mere Brutes": The Rhetoric of Colonialism in
Janet Schaw's *Journal of a Lady of Quality*', *Michigan Feminist Studies* 9 (1994–5): 87.
Inexplicably, Wyrick describes Schaw's passage to the West Indies as 'an otherwise

uneventful trip over a blank ocean', apparently overlooking the two prolonged storms, during one of which a woman miscarried.

18 Festa, *Sentimental Figures of Empire*, 173.

19 Wyrick, "'My Emigrants" and "Mere Brutes"', 85.

20 A Scottish woman portrait painter, Anne Forbes was an exact contemporary of Schaw.

21 Mimi Sheller, *Consuming the Caribbean: From Arawaks to Zombies* (New York: Routledge, 2003), esp. 71–104.

22 Ranajit Guha, 'Not at Home in Empire', *Critical Inquiry* 23, no. 3 (1997): 484.

23 Guha, 'Not at Home in Empire', 484.

24 Elizabeth A. Bohls, 'The Aesthetics of Colonialism: Janet Schaw in the West Indies, 1774-1775', *Eighteenth-Century Studies* 27, no. 3 (1994): 372.

25 For a metropolitan perspective on home, see Catherine Hall and Sonya O. Rose (eds), *At Home with the Empire: Metropolitan Culture and the Imperial World* (Cambridge: Cambridge University Press, 2006), esp. 1–31.

26 Coleman, 'Janet Schaw and the Complexions of Empire', 172. See also Thomas DiPiero, 'Missing Links: Whiteness and the Color of Reason in the Eighteenth Century', *The Eighteenth Century* 40, no. 2 (1999): 155–74; Montag, 'The Universalisation of Whiteness', 281–93.

27 Angela Rosenthal, 'Visceral Culture: Blushing and the Legibility of Whiteness in Eighteenth-Century British Portraiture', *Art History* 27, no. 4 (2004): 567.

28 Coleman, 'Janet Schaw and the Complexions of Empire', 178. Schaw also drinks madeira (81) on one occasion, rather than the lime juice and water favoured by the young women (80). The women are said to drink nothing stronger than sherbet (113).

29 Bohls, 'The Aesthetics of Colonialism', 388.

30 DiPiero, 'Missing Links', 166.

31 Bohls, 'The Aesthetics of Colonialism', 389.

32 Terry Castle, *Masquerade and Civilization: The Carnivalesque in Eighteenth-Century English Culture and Fiction* (Stanford: Stanford University Press, 1986), 77.

33 Ingrid Tague, *Animal Companions: Pets and Social Change in Eighteenth-Century Britain* (Pennsylvania: Penn State University Press, 2015), 3.

34 Konstantin Dierks, *In My Power: Letter Writing and Communications in Early America* (Philadelphia: University of Pennsylvania Press, 2009), 4.

35 Benjamin H. Irvin, 'Tar, Feathers and the Enemies of American Liberties, 1768-1776', *The New England Quarterly* 76, no. 2 (2003): 197–238. In an appendix (230-8), Irvin lists all the known incidents of tar and feathering in British North America from 1766–84.

36 Irvin, 'Tar, Feathers and the Enemies of American Liberties', 222.

37  Coleman, 'Janet Schaw and the Complexions of Empire', 170.

38  Brown, 'Reading Race and Gender', 436.

39  The phrase 'remarkable economy' is Montag's, see Montag 'The Universalisation of Whiteness', 282.

40  Lawrence, *Genteel Women*, 19.

41  Ibid., 12–72.

# Sketches from the Gendered Frontier: Colonial Women's Images of Encounters with Aboriginal People in Australia, 1830s–1860s

Caroline Jordan

The frontier is the subject of a burgeoning literature in Australia, fuelled by a highly politicized debate from the early 2000s about the extent and causes of the violence between settlers and Aborigines.[1] Yet colonial women have traditionally featured very little, if at all, in histories of frontier conflict. In historical and popular conception, the frontier was a shifting, masculine, lawless zone located out on the pastoral boundary line. The zone occupied by colonial women was outside this, in the home, and their 'mission' domestication, civilization and urbanization. Segregated from the frontier, women created the conditions for a peaceable post-frontier phase where it was possible to imagine that Aborigines had never occupied the land at all. Yet, as Patrick Wolfe points out, 'Invasion is a structure not an event'.[2] Wolfe argues that the 'elimination of the native' in the pursuit of territory is the organizing principle of settler-colonial society rather than a one-off occurrence. If settler women were not the direct perpetrators of frontier homicide, then they were still caught up in what Wolfe calls the logic of elimination and its strategies of ongoing assimilation, including the collapse of native title into freehold, officially encouraged miscegenation, native citizenship, child abduction, religious conversion and more.

Definitions of the frontier have also expanded in recent scholarship, in ways that allow it to be populated by settler women. Penny Edmonds recasts early settler-colonial towns and cities as urbanizing frontiers which were 'charged and often violent contact zones of racialized spatial contestations … mosaic-like, mercurial, transcultural and, importantly, intimate and gendered'.[3] Similarly, Australia's most prolific historian of the frontier, Henry Reynolds, characterizes the frontier as a messy mosaic rather than as an inexorably advancing line,

and as a persistent feature of Australian life for 140 years. 'The country was settled district by district,' observes Reynolds, and no template existed for how events might unfold. Conflict might begin as soon as settlers arrived, or follow 'periods of uneasy accommodation' and could last anywhere from a few months to many years.[4]

This chapter takes this contemporary reimagining of the frontier as multiple, urban, intimate and occurring over a protracted time frame to re-examine the productions of Australian colonial women artists. It asks, what if the well-educated, literate women that practised sketching, painting and modelling in the colonies were neither ideologically nor physically separated from the frontier but lived on it, knew about frontier violence and perpetrated it in various ways? And how is that knowledge and experience embedded in their cultural productions?

Admittedly, at first glance frontier violence seems not remotely connected to the polite, mainly amateur oeuvre of colonial women artists. In my 2005 book, I discuss the conventions of private amateur artistic training that led women to favour certain 'gendered genres'.[5] Flower painting was practised by most women at all levels of skill, from the student-copyist up to the professional natural history artist, with the more ambitious progressing to original paintings of native insects, butterflies and fauna. Other common genres among women were portraits (usually in miniature) and landscape showing familiarity with picturesque conventions (usually restricted to drawings in a sketchbook). Women produced documentary sketches of towns, landscapes and houses often to send to their families as evidence of the standard of their colonial habitation. And that is about it. With the reattribution of the Sydney sketchbooks from the 1810s by Sophia Campbell to her soldier-artist nephew, Edward Close,[6] an exceptional body of documentation of business, public and military life that includes the description of soldiers, Aborigines and convicts, disappeared at a stroke from the feminine oeuvre. There remain only two known panoramas painted by Australian women artists and not a single image of a convict. Nor is there any reliable attribution to a woman of an image of frontier warfare. Aborigines, however, are commonly mentioned in women's published and unpublished writings and women produced images that feature Aborigines, although the latter are not numerous.[7]

In this chapter, I use these depictions of Aborigines as an entry point to connect women artists and their cultural productions to moments on the frontier that highlight its diversity and geographic and temporal range: there is the bishop's wife, Anna Maria Nixon, living in the emptied-out post-frontier of

urban Tasmania of the 1840s and 1850s; the professional artist-sisters Martha Berkeley and Theresa Walker who camped on the urbanizing frontier of Adelaide, South Australia, in the late 1830s with their neighbours, the Aborigines; and the squatter's wife, Lucy Gray, who struggled to create a narrative of her life on a remote cattle station in North Queensland in the late 1860s and early 1870s, amid bloody racial violence and social disintegration.

Cross-referencing the women's images and writings with those by men helps to settle questions about women's awareness of frontier violence, and raises other questions about who was authorized to speak about or depict it. Women's experience, and women's accounting of that experience, was quite distinct from men's, even from that of their own husbands. Women were expected to write publicly from the modest point of view of 'a lady', or more typically confine themselves to private diaries, memoirs and sketchbooks. When it comes to narrating the frontier and its secrets, however, privacy becomes an advantage. The personal, localized evidence in journals and sketchbooks can be an important source of information about frontier conflict, which for obvious reasons was often repressed in official and published accounts. Further, when authored by women, such evidence can complicate our understanding of the frontier by illuminating its gendered dimensions.

## Absence in Tasmania

In 1844, Anna Maria Nixon sent her father in England some lithographic views by John Skinner Prout, a visiting English artist much admired in Hobart in the colony of Van Diemen's Land (Tasmania). She explained the inferior quality of the prints with an amusing story:

> The reason of the impressions being so faint is ludicrous enough; they were taken off upon a [lithographic] stone upon which the figure of a native had been drawn, and though apparently well cleaned off before Mr. Prout's drawing had been made, it came out again in full force in the process of making an impression of his views, so that in order to avoid the blacks they were obliged to make his views very – I was going to say 'fair', but I will leave this pun to Papa, and he may call it his own.[8]

The irrepressible figure of the native that refuses to be erased and returns as a ghostly presence to haunt the colonial landscape is a metaphor for Mrs Nixon's

experience of the Aborigines. By the mid-1840s, disease and war had effectively eliminated Tasmanian Aborigines as a presence in settler daily life, if not in the settler imagination. Her husband, the Anglican bishop of Tasmania, was an exception to this rule because he ministered to both the convict and Aboriginal communities.

Mrs Nixon was well acquainted with this ministry through her work as his secretary, which entailed many hours spent copying his private letters and sketches as well as official church correspondence. In 1843, she sent her father a copy of part of the bishop's journal 'relative to Flinders Island' to pass on to the wife of the archbishop of Canterbury. 'Some day I hope to get you an opossum rug', she added, referring to a traditional item of Aboriginal clothing.[9] The extract concerned a recent visit the bishop had made to Flinders Island, off the main island of Tasmania, where the surviving Aborigines had been sent to live in exile. Mrs Nixon did not accompany him on such a dangerous journey. Her letters are preoccupied with her five young children, the furnishing of the house, the spiritual, educational and artistic development of the colony, visitors, her secretarial work and her husband's sermons. When her father questioned her about the 'natives at Flinders' she regretted that she would have to refer them to the late superintendent there.[10] Mrs Nixon's confined ambit in the town no more allowed her to comment from her own observation on Aborigines than it did on local wildlife, which was already, by 1845, disappearing from the vicinity:

> To really give you a full account of the natural history and productions of V.D.L. is quite beyond me. I have never seen a kangaroo near, but once in an enclosure. They are becoming very rare, and so are the opossums. The woods near here are painfully silent, with the exception of the parrot.[11]

The Nixons exemplify typical gendered differences of access to and knowledge about Aborigines and the frontier. The bishop had the freedom granted by his gender and profession to move back and forth between the spaces of white settlement and the outlying spaces of Aboriginal occupation. By her own admission, Mrs Nixon knew next to nothing about Aborigines, while the bishop became an authority who disseminated his knowledge in a self-illustrated volume, *The Cruise of the Beacon: A Narrative of a Visit to the Islands in Bass's Strait* (Figure 3.1).[12] The book was written after the bishop's second and final journey by government schooner to Flinders and other outlying islands in 1854. Significant changes had occurred since the bishop's last visit in 1843. Then, 'the beach was covered with the Aborigines … capering and gesticulating with

**Figure 3.1** Frances Russell Nixon, *The Cruise of the Beacon: A Narrative of a Visit to the Islands in Bass's Strait* (London, 1857), frontispiece. British Library, London.

movements more indicative of exuberant wild joy than of elegance or propriety'.[13] Now all was still. The bishop climbed up the dunes to find abandoned buildings and desolation 'wherever the eye was turned'.[14] In 1843, there were fifty-four Aborigines on Flinders Island, living in government huts under the eye of the superintendent. They had been gradually transported there following the Black Wars, waged on and off since the foundation of the penal colony in 1803 and culminating over 1829–31. Nixon refers to acts of brutality, murder and revenge on both sides until the last free individual was captured or capitulated in December 1842. In exile, according to Nixon, 'They gradually sank into listless apathy'.[15] In 1847, this diminished group (according to the bishop, only sixteen remained by 1854) was moved back to Tasmania to live out their days at a former penal station in Oyster Cove, where the bishop, a pioneer photographer, recorded them in 1858.

While deploring the vicious violence inflicted on Aboriginal Tasmanians, which he conveniently ascribed to the 'coarse brutality of a miserable portion of the European population', the bishop nonetheless had a low view of the Aboriginal character: They were 'poor ignorant savages', 'indolent and unenterprising' with 'no trace … or any religious usage or sentiment'. Subscribing to the common view, Nixon believed that this inferiority sealed their fate: they were 'fast disappearing from the face of the earth; and in all probability the lapse of a few years will find the race extinct, and no trace left to tell of those who once were lords of these fair possessions'.[16]

Nixon was completely blind to all evidence to the contrary. On nearby Guncarriage Island, a sealing colony with a thriving, Christian, Aboriginal population, he baptized six 'half-caste' children, the offspring of white sealers and Aboriginal women, and formalized the de facto relationship of one old couple.[17] Descendants of outlying groups such as these constitute the lineage of the robust Aboriginal population of Tasmania today. In the nineteenth century, however, only 'full bloods', in the terminology of the time, were considered to be real Aborigines and their passing was therefore thought to herald the 'last of the Tasmanians'.[18]

Mrs Nixon's isolation from the Tasmanian Aborigines contrasts with her husband's first-hand exposure to them. The bishop was part of a motley cohort of 'male travellers, colonial officials, missionaries, settlers and amateur ethnologists' who 'claimed privileged knowledge of Aboriginal customs and practices and authored texts for British public and fellow colonists alike'.[19] The gendered knowledge gap was particularly exaggerated in Tasmania where the early banishment of Aborigines meant that only professional men like the bishop with a reason to travel to their places of exile might see them. As Aborigines around Australia were pushed off their country to live on missions in the later nineteenth century, Mrs Nixon's impoverished, second-hand experience of Aborigines, filtered through the accounts of male 'experts', including her husband, would eventually become the norm for generations of settlers, especially those living in urban areas.

## Accommodation in South Australia

This was not necessarily the case for women living on rural and urbanizing frontiers. The Chauncey sisters, Martha Berkeley and Theresa Walker, had a close

engagement with Aborigines on the early, urbanizing frontier of Adelaide, South Australia. The sisters were both skilled miniature portraitists who successfully monetized their work in the colonies. Martha worked in oils and watercolour and Theresa in wax, which she modelled to make profile portraits in low relief, like a cameo. Accompanied by Martha's husband Captain Berkeley, the sisters arrived in February 1837, at the height of the dry, baking South Australian summer, six weeks after the colony was proclaimed in December 1836.[20] Unable to take up their town allotments until the town had finished being surveyed, the sisters were obliged to camp for eight months alongside 200 other settler families in the Adelaide Parklands on the banks of the River Torrens in somewhat uneasy daily proximity with the traditional owners, the Kaurna people.[21]

Berkeley's two watercolour views of the camp, approximately dated c. 1839–40, show the visibility and mobility of the Kaurna on the Parklands. In the spacious, semi-cleared landscape of *Mount Lofty from the Terrace* (Plate 1), a settler leads his bullock dray on the right while a man raises his spear at an unseen target on the left. Some way behind him, a child trails two women holding digging sticks. This and its companion sketch *The Government Hut* (Plate 2) are awkward in their handling of perspective and the relative scale of the figures. In *Mount Lofty*, the hunter is placed so far to the left that he looks as if he is about to walk out of the picture frame, throwing out the compositional balance. In *The Government Hut*, Berkeley creates more stability by means of a clearly delineated foreground, middle ground and background. In the foreground, a settler sits on the bare earth to cook in an iron pot over an open fire. In the middle distance, a horse-drawn water cart follows a well-worn muddy track down the riverbank. Towards the right, heading into a grove of eucalypts are two small huts, three canvas tents and a knot of Aboriginal men, women and children. The focal point of the picture, in the third level of distance, is the government hut flying the British flag.

Berkeley and Walker left no surviving written records, but other settlers testify to the descriptive accuracy of these scenes. In May 1838, James Hawker trekked into town on foot from the beach at Glenelg, a present-day suburb about 7 miles from Adelaide. Hawker was 'staggered' to discover the 'metropolis' no more than a muddy tent city:

> Instead of the stone or brick buildings we expected to see, were wooden ones, interspersed with tents. ... We were thoroughly astonished at the architectural appearance of [Government House]. It was a hut, with slabs of wood for the sides. ... We determined to look for the River Torrens ... and we came to a

watercourse in which was a miserable dribbling current with an occasional waterhole ... 'That the Torrens!' was the general exclamation.[22]

Camping on this barely urbanized frontier may have contributed to personal tensions between the sisters. As their brother Philip delicately phrased it, 'There was an incompatibility of temper and disposition between [them] that rendered their further residence together undesirable.'[23] Sometime in 1837, Theresa left for Tasmania, where she acquired a husband, before returning to Adelaide in May 1838 to take up a town allotment and build a house.

The presence of the Kaurna on the Parklands may have been a further source of tension, as settlers battled to get them to accept European-defined rules of coexistence. In April 1837, an official 'Native Location' on the Parklands was established and a school for Aboriginal children in December 1840.[24] The memoirs of Mary Thomas, wife of the newspaper proprietor, however, show a less regulated interchange than these attempts at spatial confinement and re-education might suggest. Thomas was greeted by several Aboriginal people who came around her tent at Glenelg, begging or asking to work for clothes and food. In 1840, she walked into Adelaide, passing a native camp comprising about 100 men, women and children and their many 'ill-looking curs'. She reported, 'Most of the women were seated round the fires outside the wurlies [bark shelters] and, as I could plainly observe, made their remarks on me as I passed, though I did not understand a word they said.'[25] Many settlers found the Kaurna and their dogs too conspicuous for their liking. Hawker records that 'for some time a source of great annoyance' for settlers 'was caused by the mostly nude natives basking in the sun under the windows and close to the entrance' of the unfenced Government House.[26]

Berkeley's camp pictures suggest a more harmonious coexistence between Kaurna and settler on the Parklands than these written accounts. Unusually, they present white labour and signs of settlement with that of Aboriginal hunter-gatherers within the same image. Colonial artists frequently depict Aborigines in more conventionally romantic ways: as noble savages in a pre-lapsarian Eden, inhabiting a parallel universe where invasion never happened; as gesticulating marionettes lending animation to the wild landscape; as spatially segregated figures patrolling the margins of white settlement, where their presence invites the viewer to marvel at the triumph of European progress over the land; or, as in Tasmania, loaded up with melancholy as the living relics of a dying race. Berkeley has not evidently placed Aboriginal people within her landscapes to illustrate any of these self-serving settler fantasies about

the Aborigine's nature and destiny. Rather, she depicts them in family groups going about their daily business on land visibly degraded through the impact of settler occupation.

Historians of the South Australian frontier, Foster, Hosking and Nettlebeck, confirm Berkeley's intimation of the apparently peaceable coexistence of settlers and Aborigines in the Parklands in the first eighteen months of settlement.[27] The South Australians liked to attribute this to enlightened attitudes that made them different to other colonists. When Mary Thomas received criticism from 'neighbouring colonies' of the rough living arrangements in Adelaide, she commented tartly that they had nothing to brag about, in a pointed reference to the 'convict stain' that blighted New South Wales, Tasmania and latterly Western Australia.[28] Thomas's superiority stemmed from the fact that Adelaide was founded as an English utopia for a better class of educated, skilled and voluntary emigrants who had the means to purchase their land in advance through a private company. Supported by anti-slavery campaigners in the Colonial Office in London, they intended to run the colony on enlightened principles, including religious freedom and the humane treatment of Aborigines, who would be recognized as British subjects under the law. Foster et al. conclude, however, that 'it was neither government policy nor the "good character" of the settlers that accounted for South Australia's relatively peaceful years; the Kaurna of the Adelaide Plains were simply overwhelmed by the sheer weight and concentration of European settlement'.[29]

The pictorial legacy of Berkeley and Walker suggests that they, like Thomas, took pride in the utopian ideals of the colony's founders. Those concerning the treatment of Aborigines were communicated in a public ceremony which Berkeley attended and worked up into a large, finished watercolour (Plate 3). Women artists rarely depicted public events such as meetings, and it says much about the peculiar make-up of South Australia that there was not one but two women artists present who depicted the first 'dinner' for Aborigines held in Adelaide in October 1838.[30] This was an important diplomatic occasion, designed to formally introduce the Kaurna, Njarrandjeri and other local tribes and their 'chiefs' to Governor Gawler, who had arrived in the colony earlier in the month. The aim was to demonstrate the good intentions of the settlers towards the Aborigines, and at the same time elicit a matching contract of good behaviour from them, which might eliminate such embarrassments as encountering their semi-naked persons in public places. The meeting was held outside in the river plains behind Government House, underneath a giant

eucalypt. The 'dinner' consisted of 'Barrels of biscuits – boiled joints of beef and mutton – tea in buckets – drunk out of tin quarts. Also, according to an 1847 inscription on the back of the drawing, a distribution of new blankets'.[31] Two blue-coated functionaries pour out a biscuit barrel onto the dirt while others distribute items to naked Aboriginal children.

A feature of Berkeley's picture is her observation of the distinctions of costume between men, women and children, settler and Aborigine, governor and 'native chief', master and servant, that such an important public gathering could be expected to elicit. Colonists in their finery stand two to three persons deep in the large outer circle. The men sport long or cropped jackets, shiny toppers and the women, bonnets, shawls, parasols and even an ermine stole. Costume historian Marion Fletcher affirms the historical accuracy of the English-style dress of labouring men in the picture.[32] Of interest is whether Berkeley paid equally careful attention to the costuming of the Aborigines (Figure 3.2). The masses seated in the inner ring wear opossum cloaks while the three chiefs standing holding spears on the right sport assorted hats and coats belted like dressing gowns over bare legs. This was a common adaptation among Aborigines who adopted settler clothes. They wore shirt and jacket but appeared to dislike trousers intensely, perhaps because they did not conform to any article of traditional attire.[33]

Written accounts suggest this was not so much a meeting of equals between Aborigines and settlers, as a theatrical tableau scripted by settlers and peopled

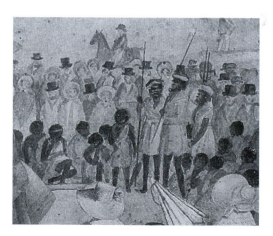

**Figure 3.2** Martha Berkeley, Australia, 1813–99. *The First Dinner Given to the Aborigines 1838* (Detail), 1838, Adelaide. Watercolour on paper, 37.5 × 49.5 cm. Gift of J. P. Tonkin 1922. Art Gallery of South Australia, Adelaide.

with Aboriginal actors costumed for the occasion. Eyewitnesses agree that settlers supplied the chiefs' costumes, although they vary considerably on the details. The drawing's inscription notes they were given blue shirts, 'Their opossum rugs being dropped for the day', yet Hawker reports they were 'presented with red woollen sailor's shirts, and in order that they should be decently clad before females, moleskin trousers'.[34] The most detailed and probably most reliable description comes from the diary of Clamor Schurmann, one of a pair of German Lutheran missionaries who had arrived on the same ship as Governor Gawler, with the intention of living among those whom they hoped to convert:

> On the first of November was a festival for the natives such as they have never had before in their entire history. ... For such a festivity, suitable finery was required, which was supplied to most adults. Many of the women received a woollen blanket, and of the men, 15 to 20 were strikingly dressed. As a head covering, all wore a blue soldier cap with white edging. Instead of jackets, half of them wore red, the other half blue, sailor shirts. The latter had a yellow apron strip of calico around their body and a violet-coloured sash around the shoulder, while the red-shirted ones had violet aprons and a yellow sash. ... King John and Captain Jack['s] very colourful red shoulders were further decorated with a bunch of variously coloured ribbons, and likewise the right sides of their chests. On the right arm, each had three strokes like a caricatured sergeant. The outfits gave them the appearance of warriors, and each carried his *winda* (spear), his *waddi* (club), and his *wommera* in his hands.[35]

The military details of the dress, 'Like a caricatured sergeant', which lent the chiefs the 'appearance of warriors' (rather than the actual warriors they were suggested by their traditional weapons) suggests the parodic status of the 'native chief' within settler society. This is further acknowledged in the nicknames and mock titles assigned to them: 'King John', 'Captain Jack' and 'Rodney', names that mark them as part-elected go-between, part-court jester in white eyes. These appointments were probably made regardless of the actual leadership hierarchies within local Aboriginal tribal groupings. Evidence of chieftainship, of a clear chain of command among the occupied peoples, was a perplexing question, like most things to do with the Aborigines whose culture, language and spiritual systems were so fundamentally foreign to settlers. Schurmann believed 'there were no chiefs among the natives' but then changed his mind. The chief, he explained, was called *Burka* and had the hereditary honour of directing the *Unyawaieti* ceremony or Corroborree. The present *Burka* of the Adelaide tribe

*Kua Kartameru* or 'King John' had four wives, more than any other man of his tribe. Schurmann referred to Captain Jack and King John as 'two outstanding, clever personalities' and it was this, no doubt, that guaranteed their elevation as 'chiefs' in the eyes of settlers.[36]

What the chiefs thought of the ceremony can only be read through settler accounts. Eyewitnesses agree the Aborigines failed to understand (or chose to ignore) the message contained in the governor's speech, which was conveyed to them with the help of an interpreter and the Protector of Aborigines. As loosely reported by Hawker, 'They were [told] to become good British subjects – give up eating each other – dress in proper clothing (for they generally went about stark naked), and love all white people &c. &c.'[37] One of their leaders, King John, made a pointed rejection of this message in the final act of the day's performance. Given the emphasis in the proceedings on Aborigines adopting European dress, his defiance was particularly directed at the borrowed clothing. He, Captain Jack and several other men were to demonstrate their prowess at spear-throwing. Targets were set up but the men became agitated because they believed they had been placed too far away. According to Hawker, King John then

> suddenly stripped off his red woollen shirt and moleskin pants, appeared in full Adamite costume, and before anyone could interfere ... gave a tremendous yell and dashed two of his spears right through the centre of the target. Then turning quickly around to the spectators, many of whom were making a rapid departure ... he pointed to the target and shouted, 'Varey goodey', and then, shaking his fist at his clothes on the ground, 'no goodey'.[38]

King John makes a reappearance in a pictorial postscript to Berkeley's recording of the historic meeting with the native chiefs by her sister. Theresa Walker made a modest income by making profile miniature portraits carved from wax. These were mainly of important male public figures such as Bishop Nixon and the doomed explorers Burke and Wills, and were produced in multiples. Around 1840, Walker made portraits of Kertamaroo or King John and one of his wives, Mocatta, otherwise known as 'Pretty Mary' (Plate 4).[39] Berkeley's images of Aboriginal subjects are more typical of others made by women artists in that they are observed from a distance and presented anonymously and interchangeably. Walker's images are rare and possibly unique as intimate miniature portraits of Aboriginal subjects by a woman artist. Walker is careful to record their Aboriginal as well as parodic or common names, a

sign of respect and possibly of personal acquaintance. Moreover, Walker, the professional miniaturist, has the skills to do her subjects justice. The profiled faces of Kertamaroo and Mocatta are intelligent, serious and refined, their clothing elegant and dignified: he wears a flowing cravat and she a traditional opossum cloak. With the darkness of their skin reversed in the medium of the white wax, they are not immediately distinguishable when grouped together with their white cohort. This remarkable Aboriginal pair was exhibited at the Royal Academy in 1841.

Unlike Mrs Nixon in Hobart, Berkeley and Walker were not physically separated from the frontier but lived on it for a period of eight months in 1837. The Parklands, occupied simultaneously by settlers and Kaurna, was an important contact zone in which the two groups were able to observe each other at first-hand in daily life, conducted by necessity largely outdoors, and in a public ceremony, one of many held on the Parklands. The free colony of Adelaide was founded by humanitarians, and it is possible to venture civility towards Aborigines as a unifying theme of Berkeley's images of settlers and Aborigines peacefully cohabiting on the Parklands, of settlers making a great effort at a public meeting to welcome and induct Aborigines into an understanding of the new roles expected of them, and of Walker's sympathetic portraits of an Aboriginal leader and his wife, presented in context as equal to the leaders of settler society. Yet contemporary accounts suggest a more uneasy accommodation between the Kaurna, swamped by waves of settlers moving onto the Parklands and subject to their attempts at confinement and re-education, and settlers discomfited by the Kaurna's dogs, lack of clothing and general air of being at home. Nor did humanitarian beliefs fundamentally alter the logic of elimination. The settlers of Adelaide, like settlers everywhere, had come with the intention of dispossessing the indigenous people of their land. The sisters had no reason to question this logic. They had bought their land back in England. Camping on the Parklands in proximity to Aborigines was only ever a temporary arrangement for them as they awaited their slice of the carving-up of Aboriginal country into freehold.

## War in far North Queensland

Lucy Gray lived on a later frontier where the 'elimination of the native' was excessively violently enforced. The daughter of a Tasmanian minister, Gray

moved with her new husband Charles to live on a station on the pastoral frontier in tropical far North Queensland. To commemorate this momentous change, Gray kept a diary and journal between September 1868 and November 1872. The journal is illustrated with rapid pen and ink sketches and describes Gray's steamer voyage from Sydney up to Townsville (recently founded in 1864), her journey on horseback to Hughenden station and her life there. There are signs that Gray wrote the journal with some form of publication in mind; it is a mishmash of drafts, written up in sections or chapters, which address an unspecified reader, some passages are worked up into picturesque description and she uses literary conventions such as C- for Charles.[40] Further, she censored what went into the journal in comparison with her prosaic diary notes, notably relating to her husband's punitive raids against Aborigines.

Gray portrays herself as unconventional and perhaps not like other women. Warned in Townsville by a lady who had lived 'up country' that she would find life without 'servants, shops and society' very rough, she comments, 'Which I was quite prepared to do'.[41] Her journal contains none of the usual self-deprecating statements that she is offering readers 'only' a woman's point of view or experience. Instead she makes a point of stating her independence and singularity:

> These letters are to be chiefly about what I did, and what I saw, what I thought, etc. Queensland exclusively from my point of view; consequently things that are in the foreground in my pictures are in the middle distance, or on the far horizon, of other peoples.[42]

She reinforces her individualism when she talks about how her aesthetic of the Australian landscape differs from that of most people:

> I have often found the generality of people don't know what is pretty, unless they are told. Australians, especially, don't seem to care for any place that is quite wild & uncultivated, they prefer trim, well-kept gardens, & open country without many hills, or trees.[43]

Gray elides her 'letters' with 'pictures' of the landscape in which she, as an artist trained in the principles of picturesque rearrangement, will consciously select which elements to emphasize. Aborigines exist as an important element of the Queensland scenery that she brings into the foreground of her 'pictures'. Just as she professes to appreciate 'wild and uncultivated' landscapes that others

despise, so too she feels able to look beyond the conventional negative view of Aborigines to see the joy in their 'free open air life':

> The blacks seem miserable enough to people who cannot imagine happiness without comfort, but really in their free open air life, they are far happier than the poor in crowded alleys and close rooms of large towns.[44]

Holed up in Townsville over three days as Charles readied for their journey to the station, Gray concluded that the real threat to Aborigines was the corrupting contact with settlers. Gray observed that the Aborigines lived segregated and under curfew in a camp separated from the town by a body of water, which they crossed daily to work for scraps in the settler economy:

> There are numbers of them in this town in the daytime, but they are all obliged to decamp at sundown. There was a large camp … across the mouth of [the] creek, opposite the town. In the evening and morning we used to watch them from the hotel, trooping across: old & young even the gins with their picaninnies. White people would not venture to bathe there. The blacks did not seem afraid – though they had to swim (unless it was low water) carrying their clothes on their heads. … People employed them cutting wood, drawing water, etc., & gave them old clothes, food, tobacco (which they like best) or money. It would be much better for them if they were not allowed into the town, they only learn what is bad, & after all, get a miserable living compared to what they do in their wild life.[45]

Gray watched this fascinating migration twice a day from her hotel. One afternoon, her eye was arrested by an apparition 'in a flowing white dress sailing along the wet sands':

> I watched, curious to see who it could be out at that time of the day without an umbrella. As she came nearer I saw that it was a gin arrayed in thin white muslin marching along with a queenly air, her head thrown back, a long yam stick in her hand, her dress flowing out in a long train, her slender black figure showing through.[46]

Gray jotted down a sketch to remember her (Figure 3.3). This image of a proud, confident and striking Aboriginal woman who momentarily passes for white marked a crossroads for Gray. When she traded the watery landscape of Townsville for the oppressive heat, humidity and dust of the cattle station, she would forge closer and far more complex relationships with Aborigines and discover that Aboriginal freedom, even in their 'wild life', was not something settlers were prepared to tolerate.

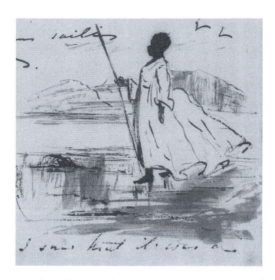

**Figure 3.3** Lucy Gray, [an Aboriginal woman crossing creek in Townsville], 1868, ink and wash on paper. Illustration from Gray's unpublished journal. John Oxley Library, Brisbane, Queensland.

Gray's brother-in-law, Robert, owned the neighbouring cattle run and mentions her in his published memoirs. Robert estimated that within a radius of 100 miles, there were probably less than 200 white men and 6 white women.[47] Robert wrote that Gray

> was a great rider, and although a risky thing to do with blacks about, she used to sometimes to ride down to us, doing the thirty miles in four hours, unattended, and armed with a revolver which I am afraid would not have been much use to her if the blacks intended mischief. The manner in which she used to remain at the Homestead, sometimes for ten days at a time, whilst my brother and his party were out mustering, was very plucky; it was a lonely spot, no travelers pass that way, and her only companion was frequently a black gin, when old Nairn, the carpenter, was away at his work.[48]

Robert and Charles were not only out mustering. Robert bluntly states that successful white occupation of the country depended on a sustained campaign of murderous assault:

> It was essential that the blacks should be prevented from destroying life and property if white people were to be allowed to occupy the country, and this could not be done without a certain amount of bloodshed.[49]

Did Gray understand this? Yes. Her diary makes explicit mention of her husband's role in reprisals, usually in response to incidents of cattle spearing, in several entries over 1869–70: November 1869, 'Charlie out all day looking for niggers, very dull long day'; April 1870, 'Came upon two more blacks on the river, C went off on in pursuit.'[50] One of these incidents allows for comparison between Charles's account, Gray's diary and her journal. The diary entry reads as follows:

> Thursday 28 July All came in after tea, cattle speared on Prairie Creek.
> Charlie decided on giving the blacks a lesson.
> Friday Mac starts to Reedy Springs to get a trooper to track the blacks.
> Sunday Charlie at home all day. Very hot.
> Wednesday Charlie, Mowbray, Mr Smith and the black boys started out after the blacks. Rode up on the Downs to sketch with Jeanie and saw blacks fires.
> Sat … Mr Smith came in the evening bringing letters from Charlie[51]

In one of these letters delivered by Smith, dated August 1870, Charles asks Gray to send him his toothbrush and stock whip, and writes about how he gave 'the blacks a lesson' with other settlers and 'Jingo', a deserter from the Native Police:

> Mr Smith and Mac are going out mustering – he got two niggers near Betts range we [ought?] to have got more. … They have been having a rare cororoboree at the back of Mt Agnes – a few days ago they also speared a Kanaka at Betts. Jingo is a first rate hand after the blacks he appeared almost drunk with excitement afterwards. … It will be necessary to keep a careful eye upon these niggers in future they ought to have been seen to when I first saw their smoke.[52]

Gray's corresponding account in her journal shifts the locus of violence from humans to animals – and sanitizes the racist language. Charles's customary use of the word 'nigger' never appears there:

> The blacks have commenced their depredations among the cattle again. C-found the remains of a beast yesterday … & in other places cattle wounded, & one with a spear sticking in its side. He was obliged to go after them himself as the Police are away.[53]

Although Gray was at a distance from these murderous raids, the atmosphere took its toll and she became depressed and lonely. Her diary records that in early 1870 she often experienced 'low esprit': 2 March 1870, 'Kept to my bed, obedient to my spouse all day. Very low esprit'; 27 March 1870, 'Very dull, low esprit'; 20 April 1870, 'Am very lonely.'[54] On 27 April, she 'went down to the river in the aft

& read sitting on the bank, which was very sweet. Made up my mind to read a great deal more than I have done. Likewise to sketch.' Riding, reading, drafting her journal and sketching were Gray's consolations and distractions for living in a war zone.[55]

Gray's journal shows her efforts to shape her frontier experience into 'pictures'. The frontier that she chooses to dwell on is the one she knows best, the intimate one of the extended household of the station, which includes Aboriginal servants. These, her daily companions, are vividly depicted in character sketches as baffling, frustrating, amusing, wilful individuals. At first, Gray has a young South Sea Islander man, Nungita, assigned to her to do the cooking and the laundry. The 'Kanakas' formed a large part of the workforce on the Gray station, where they were paid wages on a three-year term of contract.[56] Gray sketched him sitting tending his outdoor cooking fire under a bough shelter.[57] She felt his scheduled departure in 1869 as an enormous loss.[58]

After Nungita, replacements had to be found, and the solution was Aboriginal children, abducted by Charles and Robert. These victims of frontier violence came to live with Gray, and she became their jailer, slave-mistress and teacher as well as the only biographer of their otherwise unrecorded lives. Gray describes how Charles first brought back a 'little black boy' from a station 50 miles away which he had allegedly bought from an 'old gin for a couple of handkerchiefs, at least he asked her to give him the boy, which she did willingly, and he gave her his handkerchiefs as a present, with which she was delighted'.[59] Who knows what an old woman alone was doing in charge of the boy 'Walladur' or the reality behind this preposterous 'Jack and the beanstalk' exchange. Walladur followed Charles around silently, 'like a little dog' wrote Gray. At night 'I thought it looked like making a slave of him, when C put handcuffs on his little slender black legs' to prevent him running away.[60] In 1870, Robert returned from Townsville with a twelve-year-old girl and a boy that were renamed Moggie and Billy. 'Mournful looking creatures they were, when first they came.'[61] These children had been stolen by six squatters on a raid of a camp of Wulguru people. The children repeatedly tried to escape but were hunted down by mounted men before being brought to the Grays after a punishing twelve-day ride. Moggie was for Gray to train up as her maid.[62] In her diary, she wrote, '"Moggie" is a little wretch, can not say what she may turn out.'[63] In the journal, she concedes that Moggie eventually becomes 'very useful', but complains that she is 'very stupid compared with Walladur and Billy, they learn just as quickly as clever white children'.[64]

Gray did not draw the stolen children, but she did sketch another Aboriginal woman, which makes a depressed bracket to the image of the woman in the white dress she glimpsed across the water in Townsville. Riding out with a friend and Moggy 'as groom' Gray became intrigued by an Aboriginal 'shepherdess' 'dressed in a short cotton shirt' and carrying her baby in a bark sling (Figure 3.4).[65] While the women were looking at the baby the woman's husband, 'a very evil looking blackfellow', approached. Gray then made a cruel remark that exposes how frontier violence had the potential to corrupt every encounter between Aborigine and settler. She said, 'In fun, "for how much you sell me piccaninny". He pretended not to hear, but presently took his revolver out of his belt, & laid it on the ground beside the baby, as much to say that is how I value it.'[66] Following this rebuke, Gray reports that the man not only murdered his wife and child shortly after, but also 'feigned the greatest grief' to obtain a rifle with which he became a 'ringleader among the cattle spearers'.[67] This was a familiar settler refrain: Aborigines were treacherous and murderous, even towards their own people.

In far North Queensland, Lucy Gray's notes and sketches of Aboriginal men, women and children demonstrate a hardening of attitudes as she went deeper into the heart of darkness of a viciously violent frontier no less frightening for being intimate and domestic. Possessed, by her own account, of an independent mind

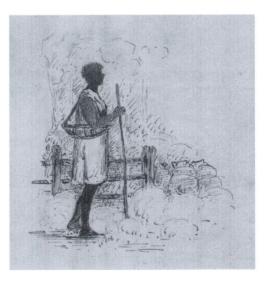

**Figure 3.4** Lucy Gray, [an Aboriginal shepherdess], c. 1870, 1868, ink and wash on paper. Illustration from Gray's unpublished journal. John Oxley Library, Brisbane, Queensland.

and adventurous spirit, Gray set out on her journey prepared to take up positions in opposition to the mainstream. She made an acute assessment of Aboriginal oppression in the settler-colonial economy in Townsville and ventured notions of Aboriginal freedom and nobility in their 'wild life'. Romantic ideas like these were soon trampled into the dust of the pastoral frontier, where her husband and other settlers brutally and daily demonstrated that the lives of cattle were more valuable than indigenous human lives. Gray accepted their justifications for homicide and child abduction, even as living with the consequences of this violence drained her body of health and her soul of compassion. In 1875, the Grays left Queensland and Lucy died of tuberculosis in 1878, some eight years after the capture of Moggie and Billy. She was thirty-eight.[68]

## Conclusion

If the 'elimination of the native' in the pursuit of territory was the organizing principle of settler-colonial society, then lines of connection should be able to be drawn between settler women, their cultural productions and the violence of the frontier perpetrated by men. Women's images of, and written references to, Aborigines offer a way in to making these connections, especially when considered in relation to those by settler men. If Aborigines and the existence of frontier violence are often embedded in women's cultural productions principally through their absence, then one usually does not have to look far to find them through their husband's. Absence or silence could be due to obfuscation, repression and shame surrounding violence, or to gendered restrictions on travel and entry to professions that prevented some women from encountering and documenting Aborigines first-hand, or – even when they did have access – to gendered prohibitions on women taking up a public speaking position as authorities on Aborigines, a space thoroughly occupied by men.

Yet absence did not necessarily mean ignorance, nor was it a defining condition of women's experience and representation of the frontier. It depended on when and where they lived. All frontiers were not alike; they were fluid, ephemeral and shaped by distinctive local factors. Anna Maria Nixon was distanced from a frontier in its late stages that she knew of only second-hand, Martha Berkeley and Theresa Walker recorded an urbanizing frontier in a very early, relatively peaceful phase of uneasy accommodation, while Lucy Gray was plunged into a bloody guerrilla war. A comparison between her strictly private diary and her

more elaborate journal written for an imagined audience shows her grappling with how to represent frontier violence. Gray waters down accounts of murder, replaces the most extreme racist language (reserved for daily use) and focuses on the personalities and adventures in her domestic life. Yet her journal shows how the 'logic of elimination' seeped into every aspect of this too, from the pistol she carried while out riding to the abducted Aboriginal children she trained as her servants. Gray could find no respite from the violence of the frontier, try as she might to calm her nerves by sketching by the river.

Another way of looking at the relationship of these women to the violence of the frontier is from the perspective of the land, the root cause of the violence. All were conscious of living on what had been in recent memory Aboriginal land. Gray confronted and condoned frontier homicide in wresting land away from Aborigines, because her husband played a keen part in it. Minus the bloodshed, Berkeley and Walker observed the daily infringements made on Aboriginal tenure on the Parklands by the influx of settlers. Land sharing with Aborigines was not part of the utopian promise of their settlement, but a temporary inconvenience while their pre-purchased land was surveyed and subdivided. For Mrs Nixon, it was different. Around Hobart, there were no Aborigines to remind her of prior ownership, but the bush felt painfully silent.

# Notes

1  See Robert Manne (ed.), *Whitewash: On Keith Windschuttle's Fabrication of Aboriginal History* (Melbourne: Black Inc. Agenda, 2003), 1–13.

2  Patrick Wolfe, 'Settler Colonialism and the Elimination of the Native', *Journal of Genocide Research* 8, no. 4 (2006): 387–409, 388.

3  Penelope Edmonds, 'The Intimate, Urbanising Frontier: Native Camps and Settler Colonialism's Violent Array of Spaces around Early Melbourne', in *Making Settler Colonial Space: Perspectives on Race, Place and Identity*, ed. Tracey Banivanua Mar and Penelope Edmonds (Houndmills, Basingstoke: Palgrave Macmillan, 2010), 129–54, 131.

4  Henry Reynolds, *Forgotten War* (Sydney: University of New South Wales [NSW] Press, 2013), 50.

5  Jordan, *Picturesque Pursuits*.

6  The attribution of Close's *Sketchbook of New South Wales Views, c. 1817* to Sophia Campbell was by family tradition and confirmed by distinguished women's art historian Joan Kerr in J. Kerr and Hugh Falkus, *From Sydney Cove to Duntroon* (Richmond, VIC: Hutchison, 1982), an attribution I followed in *Picturesque*

*Pursuits*. In 2010, a second, earlier sketchbook from an English collection was put up for auction and Sotheby's David Hansen found its dates and images did not tally with Sophia's residency in NSW. See D. Hansen, 'The Lady Vanishes (Or, an Adventure in Conoisseurship)', *Art Monthly Australia* 241 (2011): 46–9. The Close sketchbook has now been fully digitized online by the State Library of New South Wales.

7   I have previously discussed other examples in 'Progress versus the Picturesque: White Women and the Aesthetics of Environmentalism in Colonial Australia 1820–1860', *Art History* 25, no. 3 (2002): 341–57, and 'Emma MacPherson in the "Black's Camp"', 88–107.

8   N. Nixon (comp.), *The Pioneer Bishop in Van Diemen's Land 1843-1863: Letters and Memories of Francis Russell Nixon, D.D. First Bishop of Tasmania* (Hobart: J. Walch & Sons, 1953), 27. (Nixon to father, 5 July 1844).

9   Nixon, *The Pioneer Bishop*, 17. (Nixon to father, 30 December 1843).

10  Ibid., 41. (Nixon to father, 30 December 1844).

11  Ibid., 47. (Nixon to father, 6 April 1845).

12  Francis Russell Nixon, *The Cruise of the Beacon: a Narrative of a Visit to the Islands in Bass's Straits* (London: Bell and Daldy, 1857).

13  Nixon, *Cruise*, 17.

14  Ibid., 18.

15  Ibid., 18–24.

16  Ibid., 18–21.

17  Ibid., 41–2.

18  Richard Broome, *Aboriginal Victorians: A History Since 1800* (Crows Nest, NSW: Allen & Unwin, 2005), 101–2; James Bonwick, *The Last of the Tasmanians* (London: Sampson Low, Son and Marsden, 1870).

19  Patricia Grimshaw and Julie Evans, 'Colonial Women on Intercultural Frontiers: Rosa Campbell Praed, Mary Bundock and Katie Langloh Parker', *Australian Historical Studies* 27, no. 106 (1996): 79–95, 80.

20  The standard work is Jane Hylton, *Colonial Sisters: Martha Berkeley and Theresa Walker* (Adelaide: Art Gallery of South Australia [SA], 1994).

21  Patricia Sumerling, *The Adelaide Parklands: A Social History* (Kent Town, SA: Wakefield Press, 2011), 141–2; Shirley Cameron Wilson and Keith Borrow, *The Bridge Over the Ocean: Thomas Wilson (1787-1863) Art Collector and Mayor of Adelaide* (Adelaide: Wilson & Borrow, 1973), 104.

22  James C. Hawker, *Early Experiences in South Australia*, (1899, 1901), facsimile edn (Adelaide: Libraries Board of SA, 1975), 7.

23  Philip Chauncey, *Memoirs of Mrs Poole and Mrs Chauncey* (Kilmore, VIC: Lowden, 1974), 7.

24  Sumerling, *Adelaide Parklands*, 141.

25   E. K. Thomas (ed.), *The Diaries and Letters of Mary Thomas (1836-1866)*, 2nd edn (Adelaide: W. K. Thomas & Co., 1915), 73.

26   Hawker, *Early Experiences*, 9.

27   Robert Foster, Amanda Nettlebeck and Rick Hosking, *Fatal Collisions: The South Australian Frontier and the Violence of Memory* (Kent Town, SA: Wakefield Press, 2001), 3.

28   Thomas, *Diaries and Letters of Mary Thomas*, 67.

29   Foster, Nettlebeck and Hosking, *Fatal Collisions*, 3.

30   The other female artist was Mary Hindmarsh, daughter of the former Governor, *Feast given to the Natives by Governor Gawler. October 1838. Adelaide S.A.*, State Library of NSW.

31   Hylton, *Colonial Sisters*, 84, 41–3.

32   Marion Fletcher, *Costume in Australia 1788-1901* (Melbourne: Oxford University Press, 1984), 61.

33   Margaret Maynard, *Fashioned from Penury: Dress as Cultural Practice in Colonial Australia* (Melbourne: Cambridge University Press, 1994), 71.

34   Hylton, *Colonial Sisters*, 84; Hawker, *Early Experiences*, 8.

35   Edwin A. Schurmann, *I'd Rather Dig Potatoes: Clamor Schurmann and the Aborigines of South Australia 1838-1853* (Adelaide: Lutheran Publishing House, 1987), 35.

36   Schurmann, *I'd Rather Dig Potatoes*, 35.

37   Hawker, *Early Experiences*, 8; Hylton, *Colonial Sisters*, 41.

38   Hawker, *Early Experiences*, 8–9.

39   Hylton, *Colonial Sisters*, 51–5.

40   Anne Allingham, *Frontierswomen: The Australian Journals of Lucy Gray and Eva Gray, 1868-1892*, unpublished manuscript, c. 1987 in Eva Gray and Lucy Gray Journals Box 11256 O/S (A3), manuscripts collection, State Library of Queensland [SLQ], Introduction, 4. The MS contains annotated transcripts of the primary material interpolated with biographical chapters. The box contains two MS versions. Version 2 is extensively revised after consultation with Joe Reser re Aborigines and addresses frontier violence passed over in version 1. See n. 63, 69. References here are all to MS version 2 and its pencil page numbers.

41   Allingham, *Frontierswomen*, 80.

42   Ibid., 72.

43   Ibid., 77.

44   Ibid., 84.

45   Ibid., 81–2.

46   Ibid., 83–4.

47 Robert Gray, *Reminiscences of India and North Queensland 1857-1912* (London: Constable and Company, 1913), 78–9.

48 Ibid., 149–50.

49 Ibid., 79.

50 Allingham, *Frontierswomen*, 2, 9.

51 Ibid., 14.

52 SLQ, Lucy Gray Papers (contains bound photocopies of originals in SLQ collection, includes letters C. Gray to L. Gray 1868-1870, and Gray's diaries and journal), Box 8949, unpaginated.

53 Allingham, *Frontierswomen*, 214.

54 Ibid., 7–9.

55 Ibid., 9–10.

56 Ibid., 162.

57 Ibid., 129.

58 Ibid., 163.

59 Ibid., 145.

60 Ibid., 146.

61 Ibid., 178.

62 Ibid., 172.

63 Ibid., 248.

64 Ibid., 189.

65 Ibid., 194.

66 Ibid., 183.

67 Ibid., 183–4.

68 Ibid., 68.

# Part Two

# Collecting

# 'Of Manly Enterprise, and Female Taste!': Mina Malcolm's Cottage as Imperial Exhibition, c. 1790s–1970s[1]

Ellen Filor

'Beneath thy roof what splendid proofs are plac'd/Of manly enterprise, and female taste!', William Park (1788–1843) exclaimed in a poem from 1833, 'How many distant lands have lent their aid/To deck thy walls, sweet Cottage of the shade!'[2] The subject of this paean was a cottage in rural Dumfriesshire and a collection contained within that had been built by Mina Malcolm (1765–1832) at the beginning of the nineteenth century. Malcolm's collection was a product of the extensive Georgian Scottish diaspora, containing objects procured by 'manly enterprise' both within and outwith the British Empire, spanning from Brazil and Canada to India and Persia. Building on and expanding recent research on women collectors in the Georgian period, this chapter will explore Mina's cottage, outlining her gendered building, commissioning and curatorial practices. By recreating a now-dispersed Georgian collection and the cottage that contained it, this chapter will place Malcolm's collection again under one roof, displaying the power of the collection in sustaining and encouraging service in the British Empire.

Eighteenth-century collecting by elite women has received much recent attention. Most notably in connection with the Grand Tour, scholars have demonstrated how the collections these women accrued in Europe differed in physical and metaphysical ways from that of their male counterparts.[3] In Beth Fowkes Tobin and Stacey Sloboda's work on the Duchess of Portland (1715–85), the links of such collections to the global has been made more explicit. Portland used her vast wealth and illustrious connections to hunt for shells at Weymouth, buy Chinese porcelain at auction and badger Captain Cook for objects from his voyages.[4] Both Tobin and Sloboda's work underline that certain objects were

acceptable for women to collect: porcelain and natural history, which made up some 90 per cent of the duchess' collection.[5] Much of Malcolm's collection can be fitted within such 'feminine' and 'acceptable' categories.[6] However, still more of the objects that adorned her museum run closer to the 'gentlemanly' collections which Charles Wainwright has examined. Malcolm's collection of weaponry, for example, shares a similarity with her contemporary Walter Scott (1771–1832), who decorated the 'Armoury' in Abbotsford, Selkirkshire, with arms and armour he gathered in Europe and those sent by friends from around the world.[7] Paying close attention to the moments when Malcolm ascribed to or subverted such gendered collecting norms grants an understanding of the opportunities her connections to empire, on occasion, opened up to her.

Therefore, while the global is increasingly a part of these stories of collections made by women, the role of colonialism has been less fully explored. The collection at Burnfoot allows the British Empire and the role of women in sustaining it to be placed front and centre. Through Malcolm, I want to suggest ways that women, especially those that did not travel, need to be integrated into this story and the scope of their collections reexamined. Wilhelmina Malcolm was born in 1765, the third of daughter of George Malcolm (1722–1803), a gentleman farmer in Dumfries. Burnfoot was relatively isolated and rural with the nearest large town being Langholm some 4 miles away. She was one of seventeen siblings and her much indebted father struggled to provide for his progeny. As with many other Scottish families during the period, George Malcolm dealt with his dependant family and indebted farm by sending his sons to empire to make their fortune.[8] Judged in terms of their careers, the Malcolm sons were enormously successful in numerous fields: Sir James Malcolm (1767–1849) was instrumental in founding the Royal Marines, Sir Charles Malcolm (1782–1851) was appointed superintendent of the Bombay Marine, Sir Pulteney Malcolm (1768–1838) guarded Napoleon on St Helena, while Sir John Malcolm's (1769–1833) writings on India were key texts over much of the nineteenth century.[9] The strategy of sending boys to empire was replicated in the second generation as many of their sons and nephews were born in and sent to empire. Many of the second generation of children were sent 'home' to Burnfoot at a young age and the four unmarried sisters who remained in Scotland were integral to raising and teaching them. The brothers careering in the colonies and the sisters raising the next generation of imperial agents at home underlines that empire was a family project,[10] one which was reliant on a gendered division of labour.

Malcolm's collection of objects, arranged at the family farm in Burnfoot, can be considered another facet of this imperial family network. How Malcolm, with little money or property and far removed from the fashionable circles of her contemporary collectors, managed to assemble her collection is at issue. To get at her collecting practices and reassemble the physical extent and space of her museum, in the main, I have used family letters and the objects mentioned within them. Here, the Malcolm of Burnfoot letters held at the National Library of Scotland offer a rich and largely untapped resource. On one level, these letters detail the glittering imperial careers of several of the male Malcolms, adding to an already vibrant picture of Scottish engagement with the British Empire.[11] On another, these letters offer access to a complex web of monetary and emotional exchange to and from empire and the family home in Dumfriesshire. As Emma Rothschild and Sarah Pearsall have suggested for the East and West Indies respectively, female members of a family often acted as a 'hub' by writing letters to the empire from the family home.[12] The Malcolm letters are combined with sources written by those outside the family, such as poems, visitor accounts and museum curators. The perils of recreating a dispersed collection via written sources alone are manifold and, wherever possible, the objects in question have been recovered. Indeed, at least one of the items once contained in Malcolm's cottage has found its way into an archive box at the National Library of Scotland, overlooked by the compiler of the handlist who described its contents as 'miscellaneous papers'.[13] That this carved palmyra leaf is now housed alongside family letters similar to the one it was probably sent with stands as representative of how objects as well as letters bound imperial families together. As Margot Finn has demonstrated, practices of gifting among East India Company men were examples of 'emotional economies', and examining their exchange allows the historian to explore more fully 'the role played by extended kin groups in constructing the British empire'.[14] For the male Malcolms, these 'gifts' sent home to their sister could take on the form of a material exchange: a means for them to repay the labour Malcolm expended bringing up their children. What Malcolm's museum suggests is her ability to collect on a budget was predicated on her exploiting her position in relation to this imperial 'emotional economy'.

To fully understand the uniqueness of Malcolm's collection, it is necessary to consider the coming of the public museum alongside these smaller, semi-public eighteenth-century examples. The British Museum, for example, opened in 1753 and contained objects from all over the globe, many acquired by imperialism.[15] However, historians have tended to see the Great Exhibition in 1851 as a turning

point for the imperial museum. Tony Bennett argues that the Great Exhibition saw the establishment of 'the dominating influence of principles of classification based on nations and supra-national constructs of empires and races'.[16] Following Foucault, he argues that the shift from ragtag exhibitions (such as the fairground or freakshow) to museums over the course of the nineteenth century also marked a shift in the state's power and control of knowledge. As such, this was the period when museums changed 'into major organs of the state dedicated to the instruction and edification of the general public'.[17] A key part of this shift was the precise cataloguing and classification of what were once a group of disparate artefacts. However, as Judith Pascoe has suggested, the dividing line between curiosities and the logic of the museum were nowhere near as clear-cut as Bennett proposes. Instead, Pascoe emphasizes the 'oddly unsystematic ways that seem to uncut the very notion of achieving control through sorting and labelling', leading her to advocate looking at small objects and 'comparatively modest collections'.[18] The small and semi-public nature of Malcolm's collection, therefore, has something to offer even in a period of expansion of national museums. By examining Malcolm's collection over the longue durée from 1800 to the present day, the regimes of collecting in and outwith museums at the British Empire's height as well as subsequent decolonization can be examined. Explicitly, the fluctuating fortunes and power of the British Empire offer a fruitful arena in which to gauge the cogency of Bennett's Foucauldian analysis.

To fully reveal Malcolm's collecting practices, this chapter is divided into four sections that explore different aspects of how her collection was created, viewed and utilized. The first looks to the physical building of the collection, examining how the scope of Malcolm's collection broadened from natural curiosities in the 1800s to ancient antiquities by the 1830s. The second part considers the visitors to the cottage, emphasizing its semi-public nature. The cottage became the space where Malcolm children were educated for empire and where adults visited after retirement from imperial careers, suggesting the continued potency of the museum over a complete lifecycle. In the third section, Malcolm's collecting and commissioning practices are examined. By considering the items she requested from abroad and the objects she received but excluded from the cottage, a thicker conception of the role gender played in her commissioning and curating practices will emerge. The final section focuses on the afterlives of the collection by tracing the objects up to the present day, showing how Malcolm's collection was given away, allowed to decay or sold to national museums. Using the case study of Malcolm's collection over a 200-year period, the shifting

importance of women collectors will emerge, emphasizing how such small-scale and parochial collections contributed to and supported the British Empire.

## Building the cottage

The cottage which housed Malcolm's collection is marked now by little more than a pile of rocks. During its heyday, however, the structure was impressive as one of the three known images of the cottage shows (see Figure 4.1). Malcolm's collection was most likely begun during the 1790s, and letters to Mina suggest that she continued receiving objects for it until her death in 1832. A relative of Malcolm's was still running a 'museum' in Burnfoot in 1900, and in 1950 a number of these objects were auctioned when Burnfoot estate was sold. One of the earliest descriptions of the collection comes from 1804 in a letter Mina wrote to her illegitimate cousin Charles Pasley (1780–1861). She stated that 'I have built a Cottage in the Wood for holding natural curiosities and a beautiful Place it is':

> The Collection consists and is to consist of Stones, Coral, Spar, Pitorfactron [sic] Skins of Animals (have already to [sic] Leapords [sic]) Stuff'd Birds, Sea Weed,

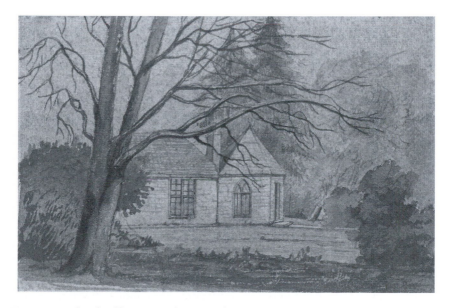

**Figure 4.1** Sketch of 'Aunt Mina's Cottage', c. 1830, NLS, Acc. 11757.

curious Stones & Plants &c. &c. – The four windows are all Shell work in the inside to open latice below, and the Gothic Arch at the top of the Roof is very high the six sides form into a middle about five feet square – It is upon the inside roof that the skins are to be placed.[19]

Malcolm's description and display of 'natural curiosities' fits within conventional historiography on women's collections as primarily focused on botany and natural history.[20] Similarly, the use of natural materials to decorate the cottage bears comparison to other buildings executed by women such as the Parminter cousins at A la Ronde (Exmouth) or Sara Losh's pinecone-inspired architecture at St Mary's Church, Cumbria.[21] Malcolm's early collection, therefore, shared a number of similarities with other notable female collectors.

A few years later Malcolm's conception of the cottage had shifted. She began expanding it, including a room containing books where she could study. Here she placed the many books that her relatives authored, writing to Pasley:

And so my Friend you are going to be an Author And I am trully [sic] glad, as I have not the least doubt but that you will do yourself Credit I shall be Proud to see your Work standing in my Book Press. I have lately purchased a very handsome Book case for standing upon my Cabinet.[22]

The shift from pure natural history to the incorporation of a small library marked a new direction in Malcolm's collection. She encouraged her relatives, including the prolific John Malcolm and Charles Pasley, to send her copies of their books.[23] On one level, this shift can be seen as conditioned by the objects available to her then-renowned male relatives. On another, the combination of natural history and enlightening books shifts the cottage away from the realm of the curiosity cabinet into that of the gentlemanly library.[24]

Malcolm's extension to the cottage did not just contain books but also mementoes from various military campaigns. In 1809, on hearing that Pasley had been injured in the Walcheren Campaign during the Napoleonic Wars and would never again see active service, she wrote to rebuke him: 'I must not enquire if duty call'd you to be present at the Storming of the Fort – where you mention to have gained your wounds If you was prompted by an excess of Manly spirit I shall hope that in future you will not needlessly expose yourself'.[25] It was six months before Pasley was well enough to write a reply, his recovery delayed by his shoulder wound reopening. In this letter, to mollify her, he mentioned he had bought an engraving of the Battle of Maida, copied from Philip James de Loutherberg's oil painting, from Sotheby's to send to her.[26]

Malcolm welcomed this 'most acceptable present' and added that 'the sword you gave me will thus be doubly valuable I hope you will bring it yourself'.[27] In de Loutherberg's composition, the battle has been placed in the background and in the foreground a British surgeon dresses the wound of a French soldier, and a Calabrian Friar gives a dead Frenchman the last rites.[28] As David Solkin has outlined, this type of composition was a common one by the nineteenth century, deployed to balance martial valour with more civilizing virtues.[29] The engraving and sword, thus, can be viewed as a measured memorial to Pasley's military exploits. Malcolm's reading of these martial gifts diverged only marginally from such convention. For Malcolm, influenced by Pasley's near-fatal and recurring wound, the image of Maida was not only a memorial to 'civilized' martial service but also a warning against an 'excess' of 'Manly spirit' that had almost ended the gift-giver's life.

The final shift in Malcolm's collecting of objects came at some stage in the 1810s when she sought out imperial antiquities. Writing to Mary Hutchison (1770–1859) on 3 August 1814, Sara Hutchison (1775–1835) described the contents as 'most valuable and tastefully arranged, from every part of the globe brought by her Brothers & Friends'.[30] Park's poem demonstrates further how Malcolm's museum shifted from containing only 'natural curiosities' to a wider global collection. He describes the outside landscape of Scotland as 'When Nature's varied beauties bloom around, / And thy banks, fair Esk ! Seem fairy ground. / The frowning mountain rising high and hoar'[31] to the interior where Park 'travels' 'From high Imaus, where glacier gleams, / To Andes, gilt by morning beams; / From cliffs of Thule, winter's throne of gloom, / To Lybian wilds, swept by the fell Simoon.'[32] Park was a provincial peasant poet, which meant that he (like Mina Malcolm) had never been abroad. Instead, it was through the objects in the collection that he 'travelled' beyond the 'fairy ground' of the Esk to the Himalayas, Chile, America and Libya. The objects included inscribed bricks from Babylon, Mexican hieroglyphics written on tree bark, and inscriptions on the leaves of a palmyra tree from Burma. Mobile and transient goods are conceived of as not simply objects from a country but objects that can become a country, allowing even those who have not travelled to understand and possess knowledge of these lands. Indeed, similarities can be perceived in the objects at Burnfoot that came to represent the countries of their origin and later the transplanting of entire villages and their 'natives' to the Empire Exhibitions in the second half of the nineteenth century.[33] That Malcolm's collection evolved from 'womanly' natural history to

'gentlemanly' library to imperial exhibition demonstrates how she gradually copied, perfected then subverted conventional gendered collecting practices of the period.

## A semi-public museum

Who visited Malcolm's collection remains a key question. Its remote situation and position within private grounds meant that this was never a space that would reach a mass audience. Often, her sister Stephana Malcolm's (1774–1861) diary would simply record 'We were alone all day'.[34] This provincialism meant that Mina's primary audience for her cottage was the extended Malcolm family. As well as any number of the Malcolm clan, Stephana's diary records the visits of near-relations such as the Ogilvies of Chesters or Mrs Roberts and her family or General and Colonel Elphinstone. These men and women were not only relatives but also intrinsically bound up in empire. Thomas Ogilvie (1751–1831) had been a Madras civil servant in the 1780s; Jean Roberts (1813–72) had lived in Ireland and married a member of the Bombay Marine in India; the Elphinstones were army officers who had fought in multiple imperial wars. This overlap between family and empire connections highlights the dual aspects of the museum: acting as a centre for a sundered family while simultaneously offering a space for imperial display.[35]

Indeed, this dual aspect was inherent in Malcolm's education and childrearing of her brother's sons and daughters sent home while their parents were abroad. She used the cottage to teach her young charges and encouraged them to help extend the cottage. In 1811 she wrote to Pasley: 'In our Play hours we are building a Bee House that will be a very fine Place – from Situation, Construction, & beautiful furnishing. Under the same roof is a seat, divided by a solid partition – in which I hope one day to see you seated – and admiring our Building. George and Elliot are excellent assistants for their years – has each a little Wheelbarrow'.[36] Utilizing her nephews and nieces under her care to help build and extend the cottage was not only cheap labour but also a further way she integrated them into the history of her collection. Indeed, the museum was used to educate and inspire children well into the twentieth century. In July 1909, an article in the *Eskdale and Liddesdale Advertiser* described a children's picnic at Burnfoot that had been an annual event for around fifty years.[37] Nor was the cottage a place only for young children. Writing to her nephew, Mina reported: 'Robert [Pringle] cannot

be here the General & Mrs Dirom set off tomorrow for Liverpool to see him before he sails [for India], I wish he had come here, my Cottage & the ground around are in complete order.'[38] That the cottage was a final stop off for teenaged Robert Pringle (1802–97) before setting sail for a long career in India underlines Malcolm's use of the space to encourage and shape the future imperial careers of the next generation in a manner which she thought acceptable from early childhood through to their late teens.

Even after the children had left Burnfoot, Mina kept them up to date with her extensions and improvements. In 1829 she wrote to her step-niece Charlotte Stewart (1811–68), then in India: 'I have made a fanciful entrance with a wicker gate before you come to the first Hut and a road to the Cottage from Johnny's garden by the back of the Huts. You cannot think what an improvement it is.'[39] On one level this extract underlines the collective building practices and labour (Johnny's garden) that Malcolm utilized to realize her ever expanding cottage. On another, the very banality of her precise depiction of the extensions and additions suggest how the cottage came to be a means of maintaining familial links to the children (of both sexes) she had helped raise after they left for empire. In 1826, on the Persian Gulf, George Alexander Malcolm (1805–26) wrote to Charlotte in Scotland with marked homesickness: 'How beautiful everything must now be looking about the cottage, the primroses & violets in full blow scenting the air with their perfume & the Mavis & Blackbirds making the woods resound with their mellow notes.' The nostalgia of this sylvan vision was rendered all the more poignant by his current situation: 'Here I smell nothing but Pitch & Bilgewater & hear no sound but the clocking of the hens & quacking of the Ducks.'[40] The cottage thus connected and sustained the extended Malcolm family (whether epistolary or physically) to their home of Burnfoot.

If the cottage was at once an infant playroom and classroom, and a sustainer of imperial service while abroad, then the collection also played a significant role in the lives of the returned sojourner. Park's poetry encapsulated this desire of the imperial servant to return to the place of their birth. He wrote of the museum's intended viewers:

> And they, whose names are graved on honour's pale,
> The brothers who have left Esk's fairy dale,
> When from the toils of field and flood remov'd
> To rural ease, and scenes in youth belov'd,
> Oft shall some token, while they ponder here,
> Recall the doings of their past career.[41]

The museum was thus configured as a space of imperial nostalgia, a shrine to and for men, allowing them to 'recall the doings of their past career'. In many ways, this reading threatens to subsume Mina's role in the creation of the collection. While created by 'female taste', this aspect was subordinated to the 'manly enterprise' of those abroad. Yet, as the extracts above from the letter to Charlotte Stewart in India have demonstrated, there was no neat gendered division between men abroad and women at home. In the light of Tony Bennett's work on the educational space of the museum, Malcolm's museum shares some of the civilizing and disciplinary purposes he outlines, especially in reference to the children she educated there. However, Malcolm's role and her collection's potency over the entire lifecycle of an imperial career for both men and women (from their childhood education, to sustenance in empire before the cottage became space of nostalgia in retirement) suggests that the cottage should instead be read as much as for the discouragement as the encouragement it gave to both 'manliness' and 'enterprise' in empire. Such a reading disrupts Bennett's state-centred narrative, instead demonstrating in the Georgian period the didactic nature of collections such as Malcolm's were shaped by the emotional needs of the family, sometimes running counter to the needs of the British Empire.

## Commissioning and collecting

Malcolm's employment of her young charges for labour and her use of natural materials was the main reason she was able to build and maintain her cottage with very little money. To gain exotic objects, she again turned to her family for help. A letter to Pasley in 1804 points to the tactics she deployed to induce friends and family to send her objects:

> This I can with truth say, that I have always thought of you with the affection of a Sister and take the same kind of pleasure in recollecting the scenes of your early days that I do those of my own brothers – ... but I have a claim upon you Charles that I hope you have not forgotten, and that is having been the first who taught you how to write letters. ... Is Malta a Place for picking up Sea Weeds? ... You must know that it is not every one that I could ask this Weed from, for if it is not gathered with taste and preserved with judgement it may turn out good for nothing – a dozen of fine Weeds would be a valuable acquisition to my collection which I hope one day to shew you.[42]

Her 'claim' over Pasley is manifold. For teaching him how to write letters, the reminder of their shared childhood in Langholm, and the assertion of herself as his veritable 'Sister' all act to put pressure on Pasley to send Malcolm exotic seaweed. Coupled with the use of flattery to emphasize that she only trusts those with 'taste' to gather her seaweed, this letter displays the strategic means that Malcolm employed to get exotic goods sent from abroad. The pressure Malcolm exerted in this letter suggests that not all of her collection can be classified as 'gifts' but rather many of the objects were procured through a mix of blackmail and flattery. Even after Malcolm's mischievous coercion, however, Pasley did not neglect the relationship. A year later he wrote that he was sending Malcolm 'two pieces of the Pyramids and a piece of Granite of Cleopatra's Needle, which though ugly in themselves may from their venerable titles obtain a place in your Grotto'.[43] This physical act of touristic vandalism can be perceived as a minor example of Western control over Egypt's Pharaonic past.[44] Alongside this more obvious act of violent imperialism, this gift was a way of solidifying Pasley's insecure familial links to the family and integrating himself more fully into the Malcolms' Scottish home. He stated in the same letter that he had 'always looked forward to Burnfoot as a home'.[45] With this 'ugly' gift, hacked from the Pyramids while on tour as a British soldier, Pasley asserted his imperial power over Egypt while simultaneously maintaining his precarious position within the space of 'home' in Scotland.

In the early years of the cottage, Malcolm was slower to assert ownership over objects her relations sent from abroad than she would be later. In 1806, her brother Pulteney wrote to her that 'Charles tells me Mina that you don't consider the shells as yours'. He continued: 'I do and also every thing else I have sent & shall send to the cottage these late times have given me to [sic] much occupations to have thought of adding to the collection'.[46] A decade later, however, she was more brusque in her rejection of items which did not meet her exacting standards. In 1816 Agnes Malcolm (1763–1836) informed Pulteney, then guarding Napoleon Bonaparte on St Helena, that his gift of 'Bonniparte's [sic] Hair is a great curiosity here'. Mina was less pleased with this object than her sister, Agnes stating: 'Altho Mina will not admit it to the Cottage but it is shewn & the sight is viewed by many – some thing belonging to this once terror of the world'.[47] No written account of Mina's rationale for excluding Napoleon's hair survives. What can be concluded, however, is that even under pressure from her brother Pulteney abroad and her sisters at home, Mina felt powerful enough to exclude artefacts from her cottage.

Because of the lack of a catalogue for the museum, Park's poem, while a problematic source, remains one of the fullest descriptions of the objects sent from abroad, and nine footnotes describe some items in detail. Park's poetry can be perceived as the first (surviving) attempt to catalogue and classify the contents of Malcolm's cottage, underscored by him calling the space a 'museum'. That Park, a ploughman unrelated to the Malcolms, felt he had the authority to catalogue the cottage in this manner, is in part explained by the dedication of the book to 'Sir John Malcolm', rendering the memorialization of Mina's cottage a means of repaying John's patronage.[48] In part, the poem reflects the fact that Mina had died the year before without having produced her own catalogue. These two factors, wanting to please a patron and being free from the purview of the collection's owner, mean that the catalogue cannot be read as merely a neutral description of objects and instead Park's descriptions need to be carefully unpicked. A carved marble stone, for example, two foot in length by 16 inches in breadth, from the staircase in Persepolis, was noted as having been 'procured at no small hazard by the late Lieutenant John Little'.[49] Bought by the National Museum of Scotland in 1950, the relief is of two figures each holding a rod, considered to be officers of the court.[50] The carving sets off an Orientalist reverie from Park:

> These forms which hold the symbols of command,
> Of senseless stone fram'd by the artist's hand,
> From the abyss of distant years recall
> The pageantry of Khosroo's capital ;
> The martial shew, the banquet and the feast,
> And all the pomp of the voluptuous east.
> Birth-place of fancy, and romantic dreams,
> Where Poesy hath found her loftiest themes !
> Land of delights ! of every charm possest,
> Save liberty, to heighten all the rest.[51]

Playing on familiar tropes of the once great but now stagnant East, the object transports Park not only geographically but temporally to Iran's supposed ancient heyday.[52] The line 'all the pomp of the voluptuous east' casts the Orient in conventional terms as ostentatiously luxurious and sensually feminine. But this veneration of Iran, even in its ancient form, remains an uneasy construction. Park attempted to overcome this ambiguity by tempering his praise: it is a country that while 'of every charm possest, / Save liberty, to heighten all the rest'.

Such a lack of 'liberty' therefore maintained Iran as a lower stage in civilization to present day Scotland and asserted Park's authority to write about it.

While Park's description of the 'voluptuous' Persian stone threatens again to privilege the masculine, Malcolm's cottage demands a more complex reading. A more nuanced understanding of Malcolm's commissioning is evident in a correspondence over exotic animal skins that incorporates the aspects of 'manly enterprise' and 'female taste'. A letter from Pulteney Malcolm's wife Clementina (d. 1830) in 1810 informed the sisters at Burnfoot that their brother John sent 'a Tiger skin for your Grotto and as he has not time to write himself, he begs me to tell you he is going to Persia on purpose to hunt Lions that your beautiful Mama may be adorned with their skins!'[53] This extract demonstrates how imperial endeavour was configured as an intensely personal act to 'adorn' John Malcolm's mother rather than for purely national gain. By 1815 Clementina wrote that 'I have got your Tigers (which looks like a Leopards) skin safe.'[54] Even while Mina would go on to receive many more of these skins over her lifetime, she appeared deeply ambivalent about them and worried about risks her relatives would take to get them. In 1829 she wrote to Charlotte Stewart, about to ship to Bombay: 'If you find Duncan in health what a mercy – do convince him what a foolish thing this Tiger Hunting is.'[55] The masculine act of hunting has in the imperial sphere been described by historian Elizabeth Collingham as enabling the colonial agent to 'demonstrate his possession of some of the essential qualities which made Englishmen [sic] racially superior'.[56] However, within the space of Mina's cottage, the tiger (or leopard) skin renders the spoils of hunting a feminine object even as she declared the hunt 'foolish', a peculiar means of asserting her feminine 'superiority' in the imperial context. The cottage, therefore, was a space that encapsulated far more than a binary of power/knowledge can contain. Malcolm's cottage became a means through which collecting rendered empire an emotive and familial space.

## From cottage to museum

With Malcolm's death in 1832, the importance and understanding of the cottage and collection (unsurprisingly) altered. The change was exemplified in objects that were not retained or donated to Malcolm's museum, despite potentially fitting into her remit. In 1835, three years after Mina's death, her brother Pulteney wrote to Dr French at the Fitzwilliam Museum, Cambridge, offering them

a sarcophagus he had dug up at Chania, Crete, while he was thecommander of the Mediterranean Fleet. Now Mina was dead, Pulteney no longer had a brotherly duty to donate his curiosities to her cottage. Instead, he could fulfil another familial demand on him by donating the sarcophagus to the university where 'my brother the Revd Gilbert Malcolm was a fellow'.[57] Mina's nephew George Alexander Malcolm (1810–88) wrote to the British Museum in 1854, asking them to purchase a Persepolis carving, not unlike the one already at Burnfoot. He used the museum at Burnfoot as leverage to raise the price: 'I have not yet heard from my Niece but expect to have a letter soon. I do not think she will part with the things at the nominal prices. … I think she will prefer giving them to her Cousin W[illiam]. Malcolm who has a Museum in Scotland.'[58] George's bargaining worked and the British Museum paid for the relief.

While evident in Mina's lifetime, as the nineteenth century progressed, the reading of the museum as a shrine to imperial service of the male Malcolms, helped by Victorian biographies of John Malcolm, became the dominant one.[59] In 1858, William Elphinstone Malcolm (1817–1907) 'exhibited' at Hawick Archaeological Society 'a lock of Napoleon's hair, and some specimens of his handwriting; and portraits of Sir John and Sir James Malcolm, – the latter by Raeburn'.[60] The objects of interest to William were those linked closely to his own family history, whether his father and mother's time at St Helena or his famous uncles' portraits. When moved from the interior of the museum, these objects were no longer memorials to and encouragement of a global familial project curated under the watchful eye of Mina but rather an almost exclusive focus on the triumphal histories of a few 'great men'. Indeed William moving the cottage's contents to a new space underlined this curatorial shift. William extended Burnfoot House considerably between during the 1840s, and one of his additions was an annexe which doubled as a library and museum. A photograph from around 1900 (see Figure 4.2) shows how these objects were displayed in the annexe by William to emphasize his father's naval history. Carefully labelled and set on tartan material, the display is dominated by Pulteney's medals and swords, watched over by portraits of him in military garb. In 1896, the members of the Dumfriesshire and Galloway Natural History and Antiquarian Society were given a tour of the museum. The record of the meeting stresses the Malcolm brothers as all important, listing the achievements of John, Pulteney and Charles in India. When outlining the career of Pulteney, the article makes particular reference to his guarding of Napoleon on St Helena: 'Among other mementos of the fallen Emperor there are here a lock of his hair, a piece of cloth from his coat,

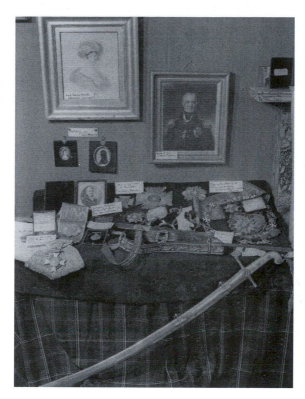

**Figure 4.2** Display of objects at Burnfoot, c. 1900, NLS, Acc. 11757.

and a coloured portrait-sketch.'[61] There is no reference to Mina as the instigator and curator of the collection. Indeed, the only reference to her comes when the party view the family portraits in the main house: 'Agnes and Mina, the latter of whom Colonel [William] Malcolm characterized as the genius of the women of the family'.[62] But this glance at the sisters is swiftly shifted back towards male achievements in empire: 'there is a portrait painting of the Court of Persia, in which Sir John Malcolm is a prominent figure'.[63] This move from curiosities to a celebration of the 'great men' of empire erased Mina's contribution to the museum. Exemplified in the now prominent display of Napoleon's hair that Mina had vehemently denied entry during her lifetime, the shift from cottage to museum in the period of high imperialism saw the memorializing of male endeavour brought to the fore at the expense of Mina's own vital contribution.

By the mid-twentieth century, the museum had again changed, if due more to the influence of time than human action. In 1956, Goddard Wilson visited Burnfoot and found a 'dilapidated library/museum'. The then descendant and

owner John Palmer-Douglas (b. 1929) gifted Wilson a book of John Malcolm's letters from 1808, stating, 'Take it … I'm not interested in that stuff.'[64] In 2015, Catherine Wilson remembered staying at Burnfoot while a university student and recalled 'the few heirlooms in the family dating from Sir Pultney Malcolm's time in St Helena, when he became a friend of the prisoner Napoleon. There was among others, a locket that held some strands of Napoleon's hair.'[65] This slow decay of the building and shedding of objects (even Napoleon's hair reduced from a 'lock' to 'some strands') suggests that with the decolonialistion of the British Empire, the museum's explicit imperial impetus waned.

The final resting place of a section of Mina Malcolm's collection was the National Museum of Scotland. Of the twenty-four objects the museum bought from Palmer-Douglas in 1950, nineteen were from ancient Egypt, two from Mesopotamia, one Persian, one Greek and one American. The only object that did not come from ancient or classical antiquity was an American comb from the nineteenth century.[66] The decision to buy mainly Egyptian antiquities reflects the interests of curator Cyril Aldred (1914–91), with one fellow curator commenting after Aldred's death that the Egyptian collection at the National Museum of Scotland was 'his'.[67] Aldred spent much of the post-war years collecting Egyptian objects from obscure museums throughout Scotland, such as the granite base of a state of Ahmose Pennekheb that was 'languishing' under a table in the Stewartry Museum, Kirkcudbrightshire, in 1948.[68] It is not a stretch to perceive his purchase of Malcolm's Egyptian objects in a similar light. Aldred set up a small exhibition of Egyptian life in 1952, emphasizing the 'cultural rather than funerary arrangements of the Ancient Egyptians'.[69] In 1972, this exhibition was expanded and made permanent (indeed, it still exists) with a series of dioramas intended to 'illustrate some aspects of their daily life'.[70] Aldred's successor wrote of the display: 'Its thematic approach has assisted hundreds of school parties to learn about life and death in ancient Egypt, and given immense pleasure to the general public.'[71] Here, there is a neat circularity that some of the few surviving objects collected by Malcolm continue to educate children, just as she had done in her cottage at Burnfoot. Indeed, such classification and education fits within Tony Bennett's analysis of a national museum as a controlling and disciplinary space. However, in their Aldred-curated afterlives, Malcolm's objects came to represent the ancient and everyday lives of the Egyptians who had made and used them. Thus, the emphasis on classification and categorization within a national museum saw the erasure of Malcolm's role, and thus the role of British imperialism, in generating the collection.

# Conclusion

This reconstruction of a rural and minor museum has demonstrated how Mina utilized the semi-domestic, semi-public space of the cottage to forward the Malcolms' fortunes in empire. Indeed, the museum came to bookend the imperial careers of her relatives. Educated there as children, on their return they could remember a successful career. For Malcolm, the gifts she received from empire were not just about maintaining kinship networks but simultaneously a means of moderating the behaviour of the giver and shaping their future imperial career. While Mina's objects were not fastidiously organized and catalogued, they were used to mould children under her care into imperial agents for, first, the benefit of the Malcolm family and, second, the glory of the British Empire. The overlapping geographies of Malcolm's provincial cottage can be viewed as an imperial appropriation of foreign lands, made possible by the routes that connected Burnfoot to global locations. Indeed, this collecting can be seen as a forerunner to those large-scale imperial exhibitions such as the Great Exhibition that brought the British Empire to a mass audience in the second half of the nineteenth century. Malcolm's own 'empowerment' was based on a subjugation of foreign lands whose imaginative frontiers could be found within the space of the Scottish museum. Thus, the museum stands as a space where Mina Malcolm could enact a form of cultural imperialism at 'home', one that sometimes encouraged and sometimes moderated the physically violent colonialism practised by her male counterparts in empire.

Even so, this contemporary reading of the cottage as 'Mina's' was short-lived. As the nineteenth century progressed, the reading of the museum as a shrine to successful imperial careers became the dominant one. In the process, Malcolm's role as a collector was erased. By the mid-twentieth century, with the decline of the British Empire, this emphasis on imperial celebration also waned. The uneven route of the objects from empire to cottage of curiosities to private museum to national museum disrupts the clear-cut Foucauldian narrative of Bennett. Indeed, transplanted to the National Museum of Scotland, Malcolm's Egyptian curiosities might still help discipline children today but the exhibition does so by eliding any narrative other than that of the everyday lives of the ancient Egyptians. As such, this move from cottage to museum expunged not only Mina but also empire from the history of these objects. By privileging large-scale, national collections, therefore, scholars risk missing something terribly important: the role played by women in developing

these provincial collections and the imperial deeds which procured the objects now displayed in public museums.

# Notes

1   Thanks to John Malcolm for his help in rooting out sources and the editors for their valuable comments.

2   William Park, *The Vale of Esk, and Other Poems* (Edinburgh: William Blackwood, 1833), 23.

3   Lisa L. Moore, 'Queer Gardens: Mary Delany's Flowers and Friendships', *Eighteenth-Century Studies* 39 (2005): 49–70; Pamela Buck, 'Collecting An Empire: The Napoleonic Louvre and the Cabinet of Curiosities in Catherine Wilmot's *An Irish Peer on the Continent*', *Prose Studies* 33, no. 3 (2011): 188–99; Brian Dolan, *Ladies of the Grand Tour* (London: Flamingo, 2002), 196–8.

4   Beth Fowkes Tobin, *The Duchess's Shells: Natural History Collecting in the Age of Cook's Voyages* (Yale University Press: New Haven, 2014), 71–122, 145–80; Stacey Sloboda, 'Material Displays: Porcelain and Natural History in the Duchess of Portland's Museum', *Eighteenth-Century Studies* 43 (2010): 455–72.

5   Sloboda, 'Material Displays', 456.

6   For a discussion of 'acceptable' forms of women's connoisseurship, see Ann Bermingham, 'The Aesthetics of Ignorance: The Accomplished Woman in the Culture of Connoisseurship', *Oxford Art Journal* 16 (1993): 3–20.

7   Charles Wainwright, *The Romantic Interior: The British Collector at Home, 1750–1850* (London: Yale University Press, 1989), 170–5, 201–7.

8   George McGilvary, *East India Patronage and the British State: The Scottish Elite and Politics in the Eighteenth Century* (London: I. B. Tauris, 2008).

9   John Malcolm, *Political History of India* (London: John Murray, 1826); idem., *The Government of India* (London: John Murray, 1833).

10  On empire as a family project, see Finn, 'Family Formations', 100–17; Elizabeth Buettner, *Empire Families: Britons and Late Imperial India* (Oxford: Oxford University Press, 2004).

11  T. M. Devine, *Scotland's Empire, 1600–1815* (London: Penguin, 2003); Michael Fry, *The Scottish Empire* (East Linton: Tuckwell Press, 2001).

12  Pearsall, *Atlantic Families*; Rothschild, *The Inner Life of Empires.*

13  National Library of Scotland (hereafter NLS), Miscellaneous papers, 1701–1845, Acc. 9756/3.

14  Finn, 'Colonial Gifts', 203–1.

15  Inderpal Grewal, *Home and Harem: Nation, Gender, Empire and the Cultures of Travel* (London: Duke University Press, 1996), 85–130.

16  Tony Bennett, *The Birth of the Museum: History, Theory, Politics* (Abingdon: Routledge, 1995), 81.

17  Bennett, *The Birth of the Museum*, 109.

18  Judith Pascoe, *The Hummingbird Cabinet: A Rare and Curious History of Romantic Collectors* (Ithaca: Cornell University Press, 2006), 61.

19  British Library (hereafter BL), Mina Malcolm to Charles Pasley, 1 March 1804, Add. MS 41961/337-38.

20  Andrea Wulf, *The Brother Gardeners: Botany, Empire and the Birth of an Obsession* (London: Heinemann, 2011), 223; Samantha George, *Botany, Sexuality and Women's Writing 1760-1830: From Modest Shoot to Forward Plant* (Manchester: Manchester University Press, 2008).

21  Susan Pearce, 'Material History as Cultural Transition: A La Ronde, Exmouth, Devon, England', *Material Culture Review* 50 (1999): 26–34; Jenny Uglow, *The Pinecone: The Story of Sarah Losh* (Faber: London, 2012).

22  BL, Mina Malcolm to Charles William Pasley, 28 May 1808, Add. MS 41962/63-64.

23  NLS, Mina Malcolm to [Unnamed] Sister, 30 September 1822, Acc. 6684/24.

24  Viccy Coltman, *Fabricating the Antique: Neoclassicism in Britain, 1760-1800* (London: University of Chicago Press, 2006), 17–38.

25  BL, Mina Malcolm to Charles William Pasley, 28 September 1809, Add. MS 41962/169-70.

26  BL, Charles William Pasley to Mina Malcolm, 6 June 1810, Add. MS 41962/205.

27  Ibid.

28  National Trust Collections, 'Antonie Cardon, Battle of Maida the 4th of July 1806', NT 732789.

29  David H. Solkin, *Painting for Money: The Visual Arts and the Public Sphere in Eighteenth-Century England* (New Haven and London: Yale University Press, 1996), 209–13.

30  As cited in Kathleen Cockburn (ed.), *Letters of Sara Hutchinson from 1800-1835* (London: Routledge & Kegan Paul, 1954), 73.

31  Park, *Vale of Esk*, 22.

32  Ibid., 23.

33  On the transplanting of entire villages, see Timothy Mitchell, *Colonizing Egypt* (Cambridge: Cambridge University Press, 1991), 1–33.

34  NLS, Stephana Malcolm's Diary, 9 July 1814, Acc. 6684/41.

35  Rothschild, *Inner Life of Empires*, 192.

36  BL, Mina Malcolm to Charles William Pasley, 23 July 1811, Add. MS 41962/332-33.

37  'Picnic at Burnfoot', *Eskdale and Liddesdale Advertiser*, 29 July 1909.

38  NLS, Mina Malcolm to George Alexander Malcolm, 27 April 1825, Acc. 6684/13.

39  Mina Malcolm to Charlotte Stewart, 1 May 1829, http://www.victorianweb.org/previctorian/letters/malcolm.html (accessed 28 December 2015).

40  NLS, George Alexander Malcolm to Mina Malcolm, 21 May 1826, Acc. 6684/13.

41  Park, *Vale of Esk,* 33.

42  BL, Mina Malcolm to Charles William Pasley, 1 March 1804, Add. MS 41961/337-38.

43  NLS, Charles Pasley to Mina Malcolm, 30 April 1805, Acc. 6684/23.

44  Peter France, *The Rape of Egypt: How the Europeans Stripped Egypt of Its Heritage* (London: Barrie & Jenkins 1991); Donald Malcolm Reid, *Whose Pharaohs?: Archaeology, Museums, and Egyptian National Identity from Napoleon to World War I* (London: University of California Press, 2002).

45  NLS, Charles Pasley to Mina Malcolm, 30 April 1805, Acc. 6684/23.

46  NLS, Pulteney Malcolm to Mina Malcolm, 9 May 1806, Acc. 6684/5.

47  NLS, Agnes Malcolm to Clementina Malcolm, 24 September 1816, Acc. 6684/19.

48  Park, *Vale of Esk*, iii.

49  Ibid., 131. On other such carvings, see Lindsay Allen, "'Come then ye Classic Thieves of Each Degree": The Social Context of the Persepolis Diaspora in the Early Nineteenth Century', *Iran* 51 (2013): 207–34.

50  National Museum Scotland (hereafter NMS), 'Fragment of Relief from Persepolis', Persian, 6th–5th Century BC, A.1950.138.

51  Park, *Vale of Esk*, 25.

52  See, for example, David Blow, 'Persia: Through Writers' Eyes', *Asian Affairs* 39 (2008): 400–12. For the stagnation of the wider East, the key text is Edward Said, *Orientalism* (Harmondsworth: Penguin, 1995).

53  NLS, Clementina Malcolm to Mina Malcolm, 13 July 1810, Acc. 6684/24.

54  Ibid., 1815, Acc. 6684/24.

55  Mina Malcolm to Charlotte Stewart, 1 May 1829, http://www.victorianweb.org/previctorian/letters/malcolm.html (accessed 28 December 2015).

56  Collingham, *Imperial Bodies*, 125.

57  As cited in John Willis Clark, *Endowments of the University of Cambridge* (Cambridge: Cambridge University Press, 1904), 496.

58  British Museum, Middle East Department Archives, Colonel George Alexander Malcolm to Birch, 3 May 1854, Correspondence 1826-1860 vol. 9 MA-MY.

59  John William Kaye, *The Life and Correspondence of Major-General Sir John Malcolm* (London: Smith, Elder & Co., 1856).

60  'Exhibition of Antiquities and Paintings held in the Society's Museum, March, 1866', *Transactions of the Hawick Archaeological Society* (1866), 4.

61  W. Dickie, 'To Burnfoot, in Eskdale', *The Transactions and Journal of Proceedings of the Dumfriesshire and Galloway Natural History and Antiquarian Society* 13 (1898): 144.

62  Dickie, 'To Burnfoot, in Eskdale', 147.

63  Ibid.

64  John Malcolm, *Malcolm – Soldier, Diplomat, Ideologue of British India* (Edinburgh: John Donald, 2014), xvii.

65  Catherine Wilson, 'Burnfoot and the Malcolm Family', http://www.burnfoot.
    net/?p=264 (accessed 29 December 2015).

66  NMS, Palmer-Douglas Objects, A.1950.138-A.1950.160.

67  Bernard V. Bothmer, 'Cyril Aldred', in *Chief of Seers: Egyptian Studies in Memory
    of Cyril Aldred,* eds Elizabeth Goring, Nicholas Reeves and John Ruffle (London:
    Kegan Paul International, 2009), 2.

68  Elizabeth Goring, 'Cyril Aldred: "A Very Cautious Young Man"', in *Chief of Seers*, 5–6.

69  Cyril Aldred, 'A New Diorama in the Egyptian Hall of the Royal Scottish Museum',
    *The Museums Journal* 11 (1949): 232.

70  Cyril Aldred, *Scenes from Ancient Egypt in the Royal Scottish Museum Edinburgh*
    (Edinburgh: The Royal Scottish Museum, 1979), 3.

71  Goring, 'Cyril Aldred', 6.

# A Lily of the Murray: Cultivating the Colonial Landscape through Album Assemblage

Molly Duggins

A drawing from an album compiled in Adelaide between 1856 and 1865 by Eliza Younghusband, daughter of William Younghusband, the chief secretary of South Australia and a pastoralist and shipping merchant who pioneered the navigation of the Murray River, suggests the strong relationship that existed between women's albums and the natural realm in the mid-nineteenth century (Figure 5.1).[1] In it, a young woman is seated by an open window with an album on her lap and a flower resting on the windowsill beside her, bridging the divide between nature and the domesticated interior. Within the value-laden spaces of the British home and garden, significant public sites in feminine social culture both at the imperial centre and in the colonies, the cultivation of nature was encoded with contemporary ideals of femininity and domesticity, revolving around acts of arranging, ordering and harmonizing.

Emerging in the eighteenth century as an aristocratic pastime, English women embraced the aesthetic properties of *naturalia*. Through the collection and display of botanical specimens, women such as Mary Delany (1700–88) – a tastemaker in the court circles of George III and Queen Charlotte who created a hortus siccus of plants out of delicate paper collage – sought to rearrange the natural realm as an exercise in taste and sensibility.[2] By the early nineteenth century, such practices extended to the middle classes and became entangled in feminine domestic ritual. Artistic manuals on domestic decoration, such as Shirley Hibberd's *Rustic Adornments for Homes of Taste* (1856), encouraged the creation of romantic material landscapes that merged art and nature within the domestic interior and exterior, while tastemakers such as John Ruskin ascribed women a moral purity aligned with the natural realm and equated the feminine tending of the garden with that of the state, as epitomized in his published

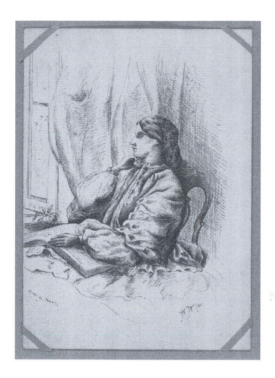

**Figure 5.1** 'Once a Week', 1860, ink drawing, *Album of Miss Eliza Younghusband, South Australia*, 1856–65. National Library of Australia.

lecture, 'Lilies: Of Queens' Gardens' (1864).[3] The emphasis on arrangement underlying such cultural discourse was further shaped by a confluence of scientific and artistic traditions relating to nineteenth-century women's amateur pursuits. Natural history practices, especially botany and the related ornamental art of flower painting, advocated an empirical approach to representing nature through the dissection and reconstruction of plant systems. Similarly, picturesque landscape painting prescribed a cut-and-paste approach to forming a picture of nature out of a select variety of compositional elements to highlight an aesthetic effect.

A combined initiative of collection and display performed by British women of the upper-middle classes, album assemblage provided a versatile vehicle to convey, in particular, the feminine and domestic ideals embodied in the art of arranging nature and culture. Within albums, women created and displayed a variety of visual culture relating to amateur natural history and picturesque pursuits, from botanical illustrations and pressed specimens to prints and

sketches of scenic landscapes, rustic villages and Gothic ruins. In such imagery, the cultivation of nature was associated with the cultivation of taste. Through snipping and cutting, painting and pasting material onto pages, album compilation physically enacted the domestic ritual of arrangement, while the visual narratives invoked through album assemblage offered a malleable medium for women to advertise artistic accomplishments, fashion social identities and forge sentimental ties through the display and exchange of artwork, keepsakes and inscriptions.[4] Portable culture-bearing artefacts that circulated through informal networks, women's albums played a crucial role in transmitting such gender, social and cultural imperatives encoded in the art of arrangement throughout the colonies.[5]

Immigrating to South Australia as a young girl with her family in 1844, Eliza was raised with her sister in a large villa staffed with Chinese domestic labourers in the fashionable district of North Adelaide.[6] She primarily assembled her album in the years leading up to her marriage to Henry Frederick Shipster, son of an English solicitor, in 1864, suggesting its significance as a critical exercise not only in self-promotion but also in fostering relationships for eligible women in colonial society. Indeed, Eliza's album contains images and inscriptions from a variety of contributors, from family members and social acquaintances to male admirers. The inherent tactility of the album experience, which required intimate handling both in terms of its compilation and persual, encouraged a tangible connection with those who contributed material.

Typical of women's albums from the mid-nineteenth century, Eliza's album presents a carefully orchestrated visual topography of taste in its assembled contents of natural history illustrations, pressed natural specimens and flower paintings as well as prints and drawings of European and Australian landscapes, literary genre scenes, embossed sentimental and religious scraps, poetic inscriptions and autographs. Enhanced by its binding, which features a lacquered-board cover with a mother-of-pearl arrangement of flowers and fruit encircled in a wreath and lined with floral endpapers, the album reflects the broad visual culture of decorative *naturalia* that distinguished the Victorian home and garden, from lacquered furniture and patterned wallpapers and textiles to the craftwork and floral arrangements that women installed in the curated spaces of their domestic abodes (Plate 5).

Dedicated to 'Lillie', a pet name for Eliza, from her 'dear Mama', the album is distingushed in particular by a pervasive floral content that reveals the vital

role the language of flowers played in the lives of young colonial women.[7] Fusing elements of botany, poetry, morality, spirituality and nationalism, this Victorian floral vocabulary encoded plants with affective significance, providing a malleable medium for sentimental exchange that was communicated both textually and visually. Within a colonial context, the language of flowers further represented a means through which to transplant cultural traditions and nurture a relationship with the Australian landscape, significant initiatives for pastoralist immigrants such as the Younghusbands. This adaptive trajectory is embodied in the album in the representation of Eliza's floral namesake, the lily. Associated with majesty and purity in the language of flowers, the lily's significance is grafted onto a local species populating the banks of the Murray River, where her father was instrumental in the development of steam navigation in the 1850s.[8] Through such floral personification, Eliza is envisaged within the pages of her album as a 'Lily of the Murray', an acclimatized antipodean maiden whose youth, beauty and naturalness parallel the model development of a blossoming Australia in colonial discourse.

While this encoded floral language provided a vehicle to imbue Australian nature with association through a particularized approach to native flora, the art of arrangement offered a means to cultivate the colonial environment at large through its strategic inscription into the picturesque platform of the album. Interspersed among the flower paintings and floral poetry of Eliza's album are not only scenic views of colonial homesteads and the bush that subscribe to picturesque conventions, but also images of a less hospitable Australian landscape distinguished by frontier conflict with Aborigines, notably a trio of images relating to the ill-fated Victorian Exploring Expedition to the Gulf of Carpentaria led by Robert O'Hara Burke and William John Wills from 1860 to 1861. In addition to women artists who created a native picturesque through the production of drawings and sketches that selectively charted colonial progress, in this chapter I suggest that women such as Eliza who received and displayed such an imagery were also active culturizers of the colonial landscape.[9] Through album assemblage, depictions of the vast and bleak Australian interior and its original inhabitants are subsumed into the album's picturesque terrain, neutralized into a form of decorative drawing-room entertainment, which nevertheless suggests a complicit participation in the imperial drive to subject indigenous nature and culture.

## Transplanting the language of flowers

As an assemblage of artwork, artefacts and text, Eliza's album functioned as an active agent of self-definition and sociality that relied on a visual system of communication embowered in a legacy of floral culture. An integral part of daily life, flowers were considered a commodity and women, who were granted a cultural authority in contemporary literature and media on the arts of arrangement and cultivation within the domestic sphere, were largely responsible for their consumption and display as a demonstration of taste and accomplishment.[10] Consequently, flowers and floral art became crucial vehicles of representation; women reinforced their class pretensions and fashioned social identities by producing, exchanging and displaying bouquets and wreaths, flower painting and fancywork with floral decoration.

Distinguished by a rich cult of symbolism, such floral expression was inspired in part by the visual and literary genre of the language of flowers, in which flora were attributed a coded meaning that could be read through the aid of a dictionary.[11] First popularized in France by Charlotte de Latour's *Le Langage de Fleurs* (1819), the language of flowers was disseminated in Britain through a genre of poetic flower books exemplified in the early works of Louisa Anne Meredith née Twamley, whose *The Romance of Nature, or the Flower Seasons Illustrated* (1836) sought 'to express the beauty, poetry, and Romance of Nature which appear in the forms and characters of flowers'.[12] Meredith's flower books were supplemented by a number of popular floral dictionaries in the mid-Victorian era including Robert Tyas's *Language of Flowers or Floral Emblems of Thoughts, Feelings and Sentiments* (1869) which contained explanations on the symbolism of British and exotic flowers combining poetry, folklore and botanical description with natural theology.

Such publications were often accompanied by hand-coloured or colour-printed plates of floral arrangements, combining the empirical conventions of botanical illustration and the aesthetic prerogatives of flower painting, both of which were significant practices in the ornamental education of middle- and upper-class Victorian women. From a relatively young age, girls were instructed in the arts of observing, collecting, preserving, displaying, illustrating and cultivating various flora. Botany was taught in the drawing room, breakfast room and near the home in private gardens, local natural environs and public botanic gardens. Drawing lessons, which provided a curricula based on the copy method, often utilized flower painting that emphasized the artistic over

the botanical through compositions of floral bouquets distinguished by a variety and harmony of colour and form derived from the *florilegium* tradition.[13] Self-instruction was faciliated through the introduction of commercial art supplies and manuals such as George Brookshaw's *A New Treatise on Flower-Painting, or Every Lady Her Own Drawing Master* (1818), which were available for purchase at specialized emporiums in the early decades of the nineteenth century. By mid-century, the floral decoration of chromolithographic prints and scraps, gift annuals and ladies' magazines provided added inspiration for the amateur artist.

As Caroline Jordan has demonstrated in her examination of the gendered practices of flower and picturesque landscape painting in colonial Australia, such feminine amateur pursuits were critical in forging social networks on a familial, community and imperial level, while fostering bonds of sentiment that played a key role in negotiating distance and navigating a nascent colonial society.[14] Artistic skills were handed down as a form of intergenerational feminine knowledge and honed through the reproduction of botanical prints, genre scenes and landscape that was transferred to and disseminated throughout the colonies in albums, journals and sketchbooks.[15] These networks of feminine amateur art were further facilitated by a burgeoning infrastructure of art education in the 1850s. In Adelaide, for instance, classes for ladies were offered on Tuesday and Friday afternoons at seven shillings per month by the painter and engraver Charles Hill who immigrated to South Australia in 1854 and founded the Adelaide School of Arts in 1855 and the South Australian Society of Arts in 1856.[16]

Despite the circulation of floral imagery in the colonies, as an imported cultural discourse, the language of flowers faced a number of challenges driven by the discrepancy between the colonial natural environment and inherited perceptions of 'nature' from the Old World. Flowers that were firmly entrenched in the cultural ideology of Britain were initially absent from Australia and the new antipodean species often differed greatly from their northern counterparts and presented not only an aesthetic but also a physical obstacle to the British immigrant. The moral undercurrent of the language of flowers was inflected with a sense of imperial and racial supremacy that condemned the perceived greed, corruption, and threatening nature of indigenous plants in contrast to the behavioural and economic qualities of British flora.[17]

For immigrants to Australia, the acclimatization and cultivation of English flowers as well as their representation in albums where they formed virtual surrogate gardens, not only represented a means through which to alleviate

homesickness, but also an accessible method for creating cultural associations with the unfamiliar Australian landscape.[18] Colonial nurseries, horticultural societies and botanic gardens catered to the desire for such cultivated flora. In Adelaide, commerical seedsmen such as E. B. Heyne of Adelaide supplied a range of British florist flowers to private homes and gardens such as irises, lillies, marigolds, pansies, roses, sweet peas and zinnias, while the first two directors of the Adelaide Botanic Gardens, William Francis and Richard Schomburgk, introduced a number of British and exotic species to supplement 'the paucity of [indigenous] flowering plants' and to add to 'the beauty and riches of the colony'.[19]

The implicit connection between such trajectories of floral acclimatization and the deployment of an idealized imperial femininity to culturise the colonial landscape is manifest in Edward Hopley's genre painting, *A Primrose from England* (1855), an image that was disseminated through the Australian colonies in print form.[20] Amid a cross section of colonial society gazing adoringly at a potted primrose plant transported to Melbourne from London, a fair young middle-class immigrant, Madonna-like and bathed in an ethereal glow emanating from the flowers, stands out as an emblem of Englishness whose delicacy is threatened by the rough and tumble colonial environment. Within the painting the pairing of the primrose, associated with youth and hope in the language of flowers, and the female immigrant reflects contemporary views on the nature of acclimatization in the Australian colonies – both for plants and people.[21] It suggests the nostalgia for English nature and the desire to recreate a familiar environment in the distant antipodes, the colonies' potential for development through acclimatization, and the central role that women played in acclimatization as the embodiment of British culture and taste.

The extent to which Eliza Younghusband and her social circle would have been familiar not only with the cult of British floral symbolism and its association with idealized values of femininity and domesticity, but also with its ideological implications in a colonial setting, is demonstrated by the visual and textual programme of her album which favours imported floral imagery and metaphors. A number of flower paintings in the album favour a range of British flowers over Australian natives, although one composition seems to include a grevillea and periwinkle, a naturalized species.[22] This emphasis reflects the preference for non-indigenous over indigenous species in the language of flowers in which the English wildflower was both a symbol of national pride and an emblem for feminine purity while showy exotic blooms were tainted by a vulgarity and immodesty equated with foreign culture.[23]

As suggested by Hopley's *A Primrose from England*, roses were a favourite due to their connection to an idealized vision of British femininity encapsulated in young Queen Victoria's epithet as the 'Rosebud of England' in Meredith's *Flora's Gems or, The Treasures of the Parterre* (1837).[24] Roses not only figure in most of the flower paintings in Eliza's album, but were also a common feature at the Adelaide Botanic Gardens and South Australian horticultural shows. Perpetuating the analogy between flora and contemporary perceptions of femininity, these flowers were valued for their beauty and arrangement as revealed in the reviews of such exhibitions which praised their 'freshness, vigour, perfect outline, and bright coloring'.[25]

The correlation between women and flowers is made explicit in Eliza's album through the prominent representation of the lily, her floral namesake, in two of the flower paintings. One includes a white lily, the quintessential symbol of purity and majesty, as the focal point in a circular posy, while in the other a scarlet lily, accompanied by two unfurled buds, dominates the upper half of the composition (Plate 6).[26] The presence of both fully fledged bloom and nascent bud in the latter painting adds an additional interpretive dimension, suggesting innocence and awakening, which perhaps evoked Eliza's liminal position as a woman coming of age in colonial society. Indeed, flowers, which were initially defined by their sexuality according to the Linnaean system of classification, were active agents in flirtatious play; their allure, fragility and attractiveness, which were aligned with the feminine, positioned them as easily appropriated objects through which to channel desire.[27]

Women were able to draw upon the attraction of flowers as a way of delicately displaying their own sexuality cloaked in a floral mythology associated with innocence, morality and virtue, just as they relied on the painted, pressed and poetic flowers in their albums to advertise taste and skill screened by the industriousness associated with such accomplishments.[28] The expressive potential of flora was not limited to women, however; men participated in reading and writing the language of flowers as a means of polite social discourse, genuine sentiment, and courtship. Their presence is well documented in Eliza's album through several drawings and poems, including contributions from her husband, Henry Frederick Shipster. Representing virtual bouquets, the floral paintings in the album embody flirtateous gestures, heartfelt gifts and palpable material reminders of their givers.[29] A bouquet of flowers was seen, according to Tyas as 'the mark of the politest attention' while showing 'an anxious desire to give gratification'.[30]

Within Eliza's album, poetic floral inscriptions perform a similar function to these painted bouquets, employing the language of flowers to convey an inherited cultural legacy, feminine ideals of accomplishment and encoded messages of affection. Suited to the colonial predicament of separation, the forget-me-not, described by Meredith as 'the sentimental favourite of modern Poetasters', is the subject of a poem composed in Adelaide in 1857 inscribed on a page near the beginning of the album.[31] Describing the transplantation of the flower from heaven to earth, its cultivation through an angel's tears, and its role as an agent of commemoration, the poem is anchored in a set of themes that resonate with the adaptation of the language of flowers in a colonial setting. A painted garland of forget-me-nots wreathes the top of the poem, acting as a form of sentimental enclosure that reinforces the text's memorial theme. Such framing motifs were typical in album arrangements and other forms of nineteenth-century women's amateur art and craftwork, often adding a coded layer of interpretation to the central composition, while contributing to the creation of bounded visual and material landscapes anchored in sentiment and nostalgia.

As with the pictorial contents of Eliza's album, its textual material reveals a thematic emphasis on the lily. An acrostic spelling out 'LILLIE' plays upon the conflation of Eliza with her floral namesake, describing it subject as 'loveliest of the fragrant bower' and brighter than the 'fairest flower', reflecting the vernacular poetic tradition of the language of flowers.[32] More interestingly, however, a poem entitled, 'To a Lily of the Murray', transcends such generic floral verse in its portrayal of a native-born lily growing along the banks of the River Murray, as revealed in its opening stanza:

By Murray's flowing streams,
With gentle breezes nourished
A fair and lovely flow'r grew,
Grew tall and Queen-like flourished.[33]

While this lily is described as 'tall and Queen-like' and as possessing a beauty 'decked with modesty', displaying its familiar attributes, the poem also emphasizes its 'wondrous growth' and its dependency on its 'native soil'. Alluding to Eliza's role as the daughter of one of the pioneers of trade along the Murray River, it suggests an attachment to its South Australian setting that signals a departure from the nostalgic narratives embodied in transplanted floral symbolism. In contrast to Hopley's representation of a delicate English immigrant unsure of her new surroundings and bent over the pallid petals of a primrose plant, a

fragile symbol of Home, the Murray lily in Eliza's album is portrayed as majestic and flourishing, pointing to the development of a native language of flowers that would play a central role in the development of an Australian cultural identity.

Native wildflowers, as one of the most readily available botanical resources, were ultimately embraced by colonial women and adopted into their repertoire of amateur pursuits. Enlisting a specimen aesthetic ranging from the rational to the romantic, they trained a scrutinizing lens on Australian flora to delineate the antipodean landscape. By the 1860s a number of Australian illustrated books that combined botany with flower painting were published, including *Some of My Bush Friends of Tasmania: Native Flowers, Berries, and Insects* (1860) by Louisa Anne Meredith who immigrated to Australia in 1839 where she continued to work as a botanical illustrator and author, *Wild Flowers of South Australia* (1861) by Fanny de Mole, and *Wildflowers around Melbourne* (1867) by Fanny Ann Charsley.[34] Such works integrated Australian flora into a cultural legacy of floral symbolism, relying on inherited aesthetic conventions to depict native flowers and describe them in comparative terms to British species. In doing so, they initiated a cross-cultural botanical discourse that inspired a sentimental embrace of the bush built on the precepts of familiarity and domestication.[35] De Mole's book, for instance, the first published on the flora of South Australia, was geared towards familiarizing a British and immigrant audience with the local flowers, which according to the preface,

> we daily meet in our grounds and neighbourhood and with which we would gladly make our friends in England familiar, showing them that though we miss some of those dear to our childhood, yet the Creator has liberally adorned the land of our adoption with others of equal beauty.[36]

Colonial floral dictionaries were even produced. *The Language of Australian Flowers*, which went through five editions before 1891, offered a sentimental interpretation of flora indigenous to each of the Australian colonies. Attributing a significant role to the language of flowers in nationalist discourse, the preface to the fifth edition proclaims, '... It is confidently believed that the "LANGUAGE OF FLOWERS" will play no mean or unimportant part in promoting the *federation* of the Australian colonies'.[37] In addition to these published floral books and dictionaries, colonial exhibition reports reveal that women frequently submitted arrangements of pressed flowers and painted botanical diagrams of native species.[38] As Martha Sear has demonstrated, such women's work was championed as a form of native industry that aligned 'a vision

of colonial femininity that was 'improving, adaptive and transformative' with colonial progress through cultural and economic production.[39] The impact of these floral books and arrangements are suggested in Eliza's album through the inclusion of a decorative paper cut-out of an open book inscribed, 'Australian Flora – being a complete series of all the flowers and plants known throughout the Australian Province!'[40]

Her album, however, ultimately represents but one platform for this nascent language of native flora. Eliza also played the role of a Murray Lily in the public sphere. In 1853 she was selected to perform the 'christening' of the *Eureka*, the barge that accompanied the *Lady Augusta*, a paddle steamer built by Captain Francis Cadell, her father's business partner, on its maiden voyage along the Murray. As reported in the press, the event was presided over by Governor Henry Young and attended by three hundred people. Of Eliza's performance, the correspondent for the *Register* observed:

> It was a pretty sight to see the graceful little girl, only thirteen years of age, as she stood, crowned with a wreath of native flowers, in that elevated position – proud of her dignified office, but half shrinking from its strange publicity. No more appropriate 'godmother' could have been chosen for that light and elegant vessel than a creature as sylph-like as itself, and as full of promise.[41]

Reminscent of the description of the Murray lily in her album, Eliza's performance in this ceremony as a native daughter bedecked with local flora resembles an early incarnation of the allegorical figure of Miss Australia, which began to appear in colonial visual culture in the illustrated press, in *tableaux vivants*, and fancy dress costumes from the mid-nineteenth century.[42] Signifying the cusp of womanhood and nationhood, the radiant and regal 'Lillie' embodies an idealized feminine personification of a budding Australia.[43] Her performance, echoing the role of her album assemblage, links the launch of the *Eureka* to a visual narrative of colonial progress underwritten through the embellishment of Australia flora and its association with a nascent genre of nationalist imagery.

## Cultivating a native picturesque

As the perceived bearers of an idealized domesticity linked to an imperial drive to civilize, women such as Eliza Younghusband played a significant role in the cultural acclimatization of the colonies. One of the principal channels through

which this acclimatization occurred was through the incorporation of the British cult of floral symbolism into colonial art and design in drawing rooms and gardens, exhibitions and ceremonies, and in the more portable spaces of books and albums. As I have argued, such floral imagery, refracted as it was through a lens of sociocultural tradition, was employed to perform class-bound notions of femininity and to articulate personal, familial and national affiliations, while ultimately providing a medium with which to embrace antipodean nature.

Encouraging an itemized approach to the colonial natural realm, the conventions of flower painting and botanical illustration also provided a stimulus for the appreciation of a native picturesque.[44] While such floral imagery facilitated an intimate and direct engagement with the natural environment, the picturesque genre promoted the creation of an idealized landscape, which represented, as Ian Mclean has argued, a powerful language of British identity that traversed class and geography.[45] Through a visual iconography of assimilation, it offered an established imperial framework anchored in control and containment to conceptualize a sense of 'Home'.

Far from a neutral aesthetic statement, the reconstruction of the English countryside in colonial imagery, through the picturesque process of selection and combination, asserted European dominance over the indigenous environment while masking the trajectories of destruction and dispossession associated with imperial conquest.[46] Women – whose prescribed role in harmonizing the interior and exterior took on added significance outside of the imperial metropole where the creation and preservation of the home and garden replicated the clearing, settling and acclimatizing processes of colonization on a miniature scale – were active participants in this drive to subjugate through the art of arrangement.[47]

A sketch in Eliza's album of her father's station at Crystal Brook north of Adelaide encapsulates this domesticating trajectory of aestheticization: the house is nestled within a picturesque landscape framed by clusters of trees and bordered by a fenced-in ornamental garden with flowering shrubs and plants arranged amid winding pathways.[48] Such private gardens created a performative buffer zone that separated the civilized realm of the colonial homestead from the wild bush. Their symbolic significance, reinforced through social ritual, is suggested by the picturesque design schemes of contemporary public gardens, including the Adelaide Botanic Gardens where the Younghusbands were active patrons in the period when Eliza was compiling her album.[49] A year after the Adelaide Botanic Gardens were established in 1855, Director George William

Francis announced his plan to cultivate the native plants and shrubs of the Australian colonies in an ornamental arrangement of circles, while in 1865 his successor, Schomburgk, implemented a gardenesque style then fashionable in Britain and Europe that emphasized the blending of art with nature.[50] Featuring geometric parterres, meandering walks lined with decorative floral borders, and strategically placed ornamental buildings, bridges, statuary and a fountain, this picturesque style of landscape design is echoed in the pictorial programme of Eliza's album: the flower paintings and floral borders, drawings of church ruins and figure studies from Shakespeare that make up its contents reveal a concerted attempt to create a curated aesthetic terrain, which like private and public colonial gardens, operated on a performative level as a site for the demonstration of transplanted notions of imperial culture.

An oil painting on a gum leaf in Eliza's album of a tranquil lake scene graced with waterfowl and framed by eucalypts evokes the picturesque sensibility curtailed by ornamental contrivance that distinguished these Gardens (Plate 7).[51] Such decorated gum leaves were produced by colonial amateur artists as bush curiosities and were displayed at a number of exhibitions, including the Melbourne intercolonial exhibition of 1867.[52] Mounted on the album page in a taxonomic manner, the use of a leaf support conflates the empirical with the picturesque, embodying how the study of the minutiae of nature triggered the transformation of the colonial environment into a familiar landscape. In using a native leaf as a canvas, the artist has literally inscribed the face of Australian nature with the civilizing strokes of a paintbrush, transforming the role of the leaf support from a specimen into a drawing-room decoration engaged in the process of naturalization.[53] While the domesticating trajectory of the colonial environment is perhaps more visible in the album's depiction of the cultivated landscape of the Younghusband's station at Crystal Brook, the ornamental display of this gum leaf is no less encoded with ideals of arrangement employed to harmonize the colonial interior and exterior.[54]

Within Eliza's album, it is the art of arrangement rather than the production of such domesticated views of colonial nature that plays a more significant role in creating a native picturesque. This becomes apparent in the inclusion of several images related to the Victorian Exploring Expedition that attempted to cross the continent of Australia from Melbourne to the Gulf of Carpentaria between 1860 and 1861 led by Robert O'Hara Burke and William John Wills. Plagued by delays and poor planning, the expedition resulted in a number of fatalities. Nevertheless, it was instrumental in painting a picture of the Australian interior

at a time when colonial interest in inland exploration was strong, and was widely publicized in colonial visual culture.[55]

Sandwiched between a natural history illustration of shells by Eliza's husband, and the drawing of a young woman holding an album and gazing out the window, discussed at the start of this chapter, is a lithograph depicting the heavily burdened expedition wagons, horses and camels slowly advancing through the Victorian countryside.[56] This image, based on a drawing by Ludwig Becker, the artist and naturalist appointed to the expedition, would have been of particular interest to Eliza's family. William Younghusband's associate in the Murray River Steam Navigation Company, Captain Francis Cadell, had offered to transport the expedition supplies from Melbourne to Adelaide by ship and then up the Murray and Darling Rivers, but was refused by Burke in response to Cadell's initial opposition to his appointment as expedition leader. The decision to proceed with supplies overland critically hindered the expedition's progress. Dominated by an ancient crater south of the present town of Heathcote, the vastness of this landscape is effectively conveyed by Becker with the human imprint of the expedition dwarfed by this primordial geological wonder. The image invokes a sublime response to the indomitable forces of a strange and harsh Australian environment.

Distinguished by a similar horizontal sublimity and sense of desolation, a pencil sketch by William Oswald Hodgkinson, a Melbourne journalist who joined the Burke and Wills expedition rear supply party, portrays the meagre camp at Koorliatto, NSW, in April 1861, where Ludwig Becker along with two other expedition members died from malnutrition (Figure 5.2).[57] Framed in a roundel, a dead tree trunk lies at the edge of a waterhole in the foreground, its turpid horizontal ripples echoing the flat scrubland of the landscape beyond with paltry tents and camels visible, while two solitary expedition figures hover near desiccated trees and brush. In the distance a trio of spear-bearing Aborigines witness the scene, referencing the frequent, somewhat strained, contact between the expedition party and the Wangkumara people in the vicinity.[58]

A poem by Hodgkinson, highlighting the threat this treacherous landscape posed to European explorers, accompanies the drawing:

Arid sandhills, crowned with pine, tainted water, mirage fine,
Withered shrubs, and thorny ground, May amid this scene be found.
Why should memory here retrace, Features destitute of grace,
Spots which Nature's angry hand, Clothes with mounds of burning sand?
This the reason briefly told – Foolish mortals prize as gold -
Every memory of the past, With Danger linked or Death o'ercast.

**Figure 5.2** William Oswald Hodgkinson, 'Koorliatto, New South Wales', 1861, pencil drawing, *Album of Miss Eliza Younghusband, South Australia*, 1856–65. National Library of Australia.

The antithesis of the verdant river scene painted on a gum leaf, this image of an outback waterhole formed by hostile Nature, is nevertheless memorialized through such romantic verse and its sentimental inscription in an oval format.

In addition to this drawing, Eliza's album also contains a watercolour by Hodgkinson of a skirmish between members of the expedition party and the Wangkumara at Bulloo in southwest Queensland on 22 April 1861.[59] After a number of exchanges in which the Wangkumara entreated the expedition party to leave the camp, which encroached upon a significant ceremonial site, violence ensued. Hodgkinson depicts the moment when the Wangkumara, wearing body paint and bearing clubs and spears, advance on the expeditioners who fire rifles from an improvized stockade. Such images of frontier conflict outside of the contact zone are rare in the colonial visual archive, and women's albums thus play a critical yet undervalued role in their preservation.[60] Moreover, the integration of Hodgkinson's drawings into the pictorial programme of Eliza's album provides intriguing insight into how such imagery was displayed and domesticated in a drawing-room context.

Hodgkinson presented these images to Eliza for her album along with a lengthy poem of affection on 12 August just days before he left to join the South Australian Burke Relief Expedition on 16 August 1861. Intended as a flirtatious conversation piece that potentially capitalized upon the Younghusbands' connection to the expedition's proposed supply transport system, his contribution satisfied the contemporary appetite for illustrated accounts of exploration and travel that highlighted the adversity of the Australian landscape in the face of colonial progress.[61] Appearing on the verso of his poetic tribute, the drawing of the clash at Bulloo is juxtaposed with a sketch from Shakespeare's *Twelfth Night*. This incongruous arrangement tempers the impact of such first-hand testimony of frontier devastation, which is neutralized through its inscription in the decorative, sentimental and entertaining trajectory of Eliza's album. Relegated to the past through commemorative display in the drawing room, a civilized zone far removed from such conflict, the incorporation of Hodgkinson's imagery in the album reveals the crucial part that album assemblage played in mythicizing the dispossession of Australia's original inhabitants that accompanied the discourse of settlement.[62]

This visual strategy of manufactured nostalgia, anchored in the art of arrangement, is reinforced through the placement of a corroboree scene at Wallaroo Bay, South Australia (1860), by the South Australian artist William Wyatt, in the middle of the sequence of Hodgkinson's imagery and poem (Plate 8).[63] With the recent discovery of large quantities of copper in 1859, the development of mining at Wallaroo became integral to the narrative of colonial progress in South Australia. Wyatt's portrayal belongs to a significant genre of colonial corroboree painting that presented a staged vision of indigenous culture consigned to a romantic prehistory incompatible with the advancement of European civilization. As Anita Callaway and Candace Bruce have argued in their discussion of this genre, through an emphasis on the regimented movements of the Aboriginal figures, colonial artists transformed this potent form of ceremony into a choreographed theatrical performance intended to suppress its threatening otherness.[64]

Such concerted regulation is evident in Wyatt's exotic moonlit scene wherein the repeated pattern of the figures' raised arms and bent legs further resembles the intersecting forms of branches and trunks of the surrounding trees of the bush backdrop, conflating the dancers with the native environment. Through this alignment of indigenous culture and nature, a conventional colonial equation, Aborigines were transformed into a scientific spectacle of the primitive other underwritten by an imperial hierarchical notion of race that legitimized

their removal from the land. Displayed in a sentimental roundel, much like Hodgkinson's sketch of Koorliatto, Wyatt's contained vision of Aboriginal culture is reinforced through its presentation in Eliza's album as an exotic variant of the native picturesque. As album compilers selecting and arranging such imagery, colonial women were instrumental in the nostalgic enshrinement of settler fantasies of a primordial native race through this process of picturesque inscription.[65]

# Conclusion

An extension of the home and garden, the album functioned as a gendered space wherein women could exercise their feminine prerogative to culturize the colonial landscape through the art of arrangement based in an aesthetic reading of the natural realm. The album not only tangibly transported imperial ideals of nature to the colonies and colonial nature to the imperial metropolis, but also presented a significant vehicle through which British women could reconcile a distancing imperial gaze trained on the colonial landscape with their personal experience of Empire.[66] Beyond representing symbolic extensions of 'Home', albums were active sites of cultural mediation that were enlisted in negotiating various landscapes of imperial culture filtered through predominant notions of gender and status.

Feminine amateur artistic traditions performed and displayed within the space of the album such as botanical illustration and flower painting inspired a particularized approach to the colonial environment, while the picturesque genre promoted a generalized aesthetic envisioning of the colonial landscape. An examination of the assembled contents of Eliza Younghusband's album reveals how the deployment of floral imagery and the language of flowers not only provided an expressive medium to articulate allegiances, advertise taste and nurture relationships in colonial society, but was also enlisted as an agent of acclimatization in South Australia in the mid-nineteenth century. Similarly, the integration of views of indigenous nature and culture into the album's topography of taste represented an extension of the picturesque's subjugation of the colonial environment through aesthetic arrangement. Armed with scissors and paste-pots, pencils and brushes, and an assortment of produced, purchased and gifted imagery encoded with ideals of the natural realm, women defined and domesticated the colonial landscape through album compilation.

# Notes

1 National Library of Australia (hereafter NLA), Album of Miss Eliza Younghusband, South Australia, 1856–65, 41.

2 Mark Laird and Alicia Weisberg-Roberts (eds), *Mrs. Delany and Her Circle* (New Haven and London: Yale University Press, 2009).

3 Shirley Hibberd, *Rustic Adornments for Homes of Taste*, intro. John Sales. 1st edn (1856; reprint, London: Century Hutchinson Ltd., 1987). For more on Ruskin's lecture, see Anne Helmreich, *The English Garden and National Identity: The Competing Styles of Garden Design, 1870–1914* (Cambridge: Cambridge University Press, 2002), 20–2.

4 For more on Victorian women's album compilation, see Melissa Meyer and Miriam Schapiro, 'Waste Not, Want Not: An Inquiry into What Women Saved and Assembled,' *Heresies* 1, no. 4 (Winter 1978): 66–9; Elizabeth Siegel (ed.), *Playing with Pictures: The Art of Victorian Photocollage* (New Haven and London: Art Institute of Chicago and Yale University Press, 2009); Patrizia Di Bello, *Women's Albums and Photography in Victorian England: Ladies, Mothers and Flirts* (Farnham, Surrey; Aldershot: Ashgate, 2007).

5 The colonial album was part of a greater flow of portable domestic objects throughout the empire that allowed, as Janet Myers has argued, British emigrants to create a home away from home. Janet C. Myers, *Antipodal England: Emigration and Portable Domesticity in the Victorian Imagination* (New York: SUNY Press, 2009).

6 Eric Richards, 'William Younghusband and the Overseas Trade of Early Colonial South Australia,' *South Australiana* 17, no. 2 (September 1978): 172, 184. The Younghusband villa, designed by George Kingston, is illustrated in *Album of Domestic Architecture in Australia with Original Photographs by H. Cazneaux, J. Paton, J. Kauffmann and J. Wilkinson* (1919).

7 Eliza Younghusband Album, 4.

8 Several maritime images in Eliza's album allude to her father's involvement in the Murray River Steam Navigation Company in the 1850s, such as a drawing of the steamboat *Corio* crossing the sandbar at the mouth of the Murray at Goolwa, South Australia, in 1857 by B. Douglas. Eliza Younghusband Album, 15.

9 See for instance, Jordan, 'Progress versus the Picturesque', 341–57; Renate Dohmen, 'Mensahibs and the "Sunny East": Representations of British India by Millicent Douglas Pilkington and Beryl White,' *Victorian Literature and Culture* 40 (2012): 153–77.

10 Bermingham, *Learning to Draw*, 225.

11 For an overview of its history, consult Beverly Seaton, *The Language of Flowers: A History* (University of Virginia: University Press of Virginia, 1995).

12  Louisa Ann Twamley, *The Romance of Nature, or, The Flower Seasons Illustrated* (London: Charles Tilt, 1836), viii.

13  Shteir, *Cultivating Women, Cultivating Science*, 50; Gil Saunders, *Picturing Plants: An Analytical History of Botanical Illustration* (Berkeley and Los Angeles: University of California Press, 1995), 55–8.

14  Jordan, *Picturesque Pursuits*, 88–9, 111.

15  Joan Kerr and James Broadbent, *Gothick Taste in the Colony of New South Wales* (Sydney: David Ell Press, 1980), 25.

16  *South Australian Advertiser*, 12 July 1858, 3.

17  Jennifer Long, "'If that Mallee Desert is Converted into a Garden …'", in *A Primrose from England: 19th-Century Narratives from the Collection of Bendigo Art Gallery* (Bendigo: Bendigo Art Gallery, 2002), 16.

18  Jennifer Isaacs, *The Gentle Arts: 200 Years of Australian Women's Domestic and Decorative Arts* (Sydney: Ure Smith Press, 1987), 35.

19  As quoted in Richard Aitken, *Seeds of Change: An Illustrated History of Adelaide Botanic Garden* (Adelaide: Board of the Botanic Gardens and State Herbarium, 2006), 40.

20  Long, *A Primrose from England*, 46. See also Ruth Brimacombe, 'Edward William John Hopley, *A Primrose from England*', in *Exiles and Immigrants: Epic Journeys to Australia in the Victorian Era*, ed. Patricia Macdonald (Melbourne: National Gallery of Victoria, 2005), 116.

21  Seaton, *The Language of Flowers*, 188.

22  C. Hill, flower arrangement, 1857, Eliza Younghusband Album, 13.

23  Jordan, *Picturesque Pursuits*, 165.

24  James Andrews, *Flora's Gems; or, The Treasures of the Parterre: Twelve Bouquets Drawn and Coloured from Nature with Poetical Illustrations by Louisa Anne Twamley* (London: Charles Tilt, 1837), preface.

25  *South Australian Advertiser*, 4 November 1859, 3; *South Australian Advertiser*, 5 November 1860, 2.

26  Eliza Younghusband Album, 18; Seaton, *The Language of Flowers*, 182. For Tyas, the white lily is epitomized in Susannah, 'the Jewish matron whose spotless chastity is … recorded in the "apocryphal books of the Old Testament"'. Tyas, 127.

27  Elizabeth Campbell, 'Don't Say It with Nightshades: Sentimental Botany and the Natural History of Atropa Belladonna,' *Victorian Literature and Culture* (2007): 608.

28  Samantha George, *Botany, Sexuality and Women's Writing: 1760–1830* (Manchester and New York: Manchester University Press, 2007), 153.

29  Kim Sloan, 'Mrs. Delany's Prints and Drawings: Adorning Aspasia's Closet,' in *Mrs. Delany and Her Circle*, eds Mark Laird and Alicia Weisberg-Roberts (New Haven

and London: Yale University Press, 2009), 115–16; Maria Zytaruk, 'Epistolary Utterances, Cabinet Spaces and Natural History,' in *Mrs. Delany and Her Circle,* 133.

30  Tyas, 35. Moreover, the inclusion of a butterfly in a number of the compositions suggests another subtle signification of desire. While a common motif in botanical illustration, this insect was associated in popular Victorian visual and literary culture with flirtateous behaviour. Flitting about a group of attractive flowers, the butterfly in Eliza's album is transformed from a scientific specimen into a hovering admirer, a coy gesture conveniently masked by botanical convention. See Di Bello, *Women's Albums,* 113.

31  Twamley, *The Romance of Nature*, 157; Eliza Younghusband Album, 9.

32  Eliza Younghusband Album, 10.

33  Ibid., 60–1. The author is identified only as 'H.F.'

34  For more on Meredith's Australian career, see Barbara Gates, 'Shifting Continents, Shifting Species: Louisa Anne Meredith at "Home" in Tasmania,' in *Intrepid Women: Victorian Artists Travel*, edited by Jordana Pomeroy (Aldershot: Ashgate, 2005), 77–88. The impact of such flower books on colonial women's album culture is suggested by a number of floral illustrations adapted from Meredith's *Some of My Bush Friends* in the Helen Lambert Album, 1868–70, National Gallery of Australia.

35  Jordan, *Picturesque Pursuits*, 166.

36  Fanny Elizabeth de Mole, preface to *Wild flowers of South Australia* (Adelaide, 1861).

37  Preface to *The Language of Australian Flowers* (Melbourne: George Robertson and Company, 1891).

38  For instance, the record of the Sydney International Exhibition of 1879 includes a submission to the Tasmanian Court from a Mrs Montagu of 'A Language of the Flowers of Australia' comprising of mounted specimens. *Sydney International Exhibition with Photo-Type Illustrations* (Sydney: Government Printing Office, 1880), 291.

39  Martha Sear, '"Common Neutral Ground": Feminising the Public Sphere at Two Nineteenth-Century Australian Exhibitions of Women's Work,' in *Seize the Day: Exhibitions, Australia and the World*, eds Kate Darian-Smith, Richard Gillespie, Caroline Jordan and Elizabeth Willis (Clayton, VIC: Monash University ePress, 2008), 455–6, 472.

40  The inscription continues, 'Respectfully dedicated to the best dancer in the place, W.W.', reiterating the social role of the languae of flowers in colonial Adelaide. Eliza Younghusband Album, 34.

41  James Allen, Jr., *Journal of an Experimental Trip by the 'Lady Augusta' on the River Murray* (Adelaide: C.G.E. Platts, 1853); Australiana facsimile editions, ed. Peter J. Reilly (Canberra: National Library of Australia, 1995), 202, accessed 15 March 2011, http://users.esc.net.au/~pereilly/ladya.htm; *South Australian Register*, 26 August 1853, 3.

42  For more on the allegorical figure of Australia, see Margaret Anderson, *When Australia was a Woman: Images of a Nation* (Perth: Western Australian Museum, 1998).

43  Pure and virginal, tall and stately, her portrayal echoes the conflicting representation of the scarlet lily in her album in which nascent buds vie with a flourishing bloom, suggesting that as a colonial fantasy, the figure of Miss Australia was charged by a sexual undercurrent that framed Australia as an object to be possessed. See Marilyn Lake and Penny Russell, 'Miss Australia,' in *Symbols of Australia*, eds Melissa Harper and Richard White (Sydney: University of New South Wales Press, 2010), 94.

44  Jordan, *Picturesque* Pursuits, 158.

45  Ian McLean, 'The Expanded Field of the Picturesque: Contested Identities and Empire in *Sydney-Cove 1794*,' in *Art and the British Empire*, eds Tim Barringer, Geoff Quilley, Douglas Fordham (Manchester and New York: Manchester University Press, 2009), 23–37.

46  Jordan, 'Progress versus the Picturesque', 346; Renate Dohmen, 'Material (Re) collections of the "Shiny East": A Late Nineteenth-Century Travel Account by a Young British Woman in India', *Travel Writing, Visual Culture and Form, 1760*-1900, eds Mary Henes and Brian Murray (New York: Palgrave Macmillan, 2015), 59.

47  Susan K. Martin, 'The Gender of Gardens: The Space of the Garden in Nineteenth-Century Australia,' in *Imagining Australian Space: Cultural Studies and Spatial Inquiry*, ed, Ruth Barcan and Ian Buchanan (Nedlands, WA: University of Western Australia Press, 1999), 115–25. See also Susan K. Martin, Katie Holmes, and Kylie Mirmohamadi, *Reading the Garden: The Settlement of Australia* (Melbourne: Melbourne University Press, 2008).

48  Eliza Younghusband Album, 51.

49  *South Australian Advertiser*, 6 April 1860, 2; *South Australian Advertiser*, 15 November 1861, 2.

50  Aitken, *Seeds of Change*, 42; *Converting the Wilderness: The Art of Gardening in Colonial Australia* (Sydney: Australian Gallery Directors Council, 1979), 19; Ann Bermingham, *Landscape and Ideology: The English Rustic Tradition, 1740–1860* (Berkeley, Los Angeles and London: 1986), 157.

51  Eliza Younghusband Album, 11. By way of comparison, see James Shaw's 1865 painting of the Adelaide Botanic Gardens in the Art Gallery of South Australia.

52  For a brief overview of this genre, see Sophie C., Ducker, *Story of Gum Leaf Painting* (Melbourne: School of Botany, University of Melbourne, 2001).

53  Patricia Dobrez, 'Constance à Beckett (1860–1944), *Untitled Bush Scene (Kookaburras), 1872*,' in *Heritage: The National Women's Art Book* (Roseville East, NSW: Craftsman House, 1995), 273.

54  Such ornamental *naturalia* was prevalent in Victorian womens albums. See Molly Duggins, "'Which Mimic Art Hath Made': Crafting Nature in the Victorian Book and Album,' in *Of Green Leaf, Bird, and Flower: Artists' Books and the Natural World,* ed. Elisabeth Fairman (New Haven and London: Yale University Press, 2014), 47–63. Other examples in the Younghusband album include a flower painting on a leaf support and an arrangement of pressed seaweeds in a paper basket. Eliza Younghusband Album, 29, 35.

55  In 1859 the South Australian government offered a reward for the first successful south-north crossing of the continent.

56  Eliza Younghusband Album, 39, 40, 41.

57  Ibid., 42.

58  Ian Clark and Fed Cahir (eds) *The Aboriginal Story of Burke and Wills: Forgotten Narratives* (Collingwood, VIC: CSIRO Publishing, 2013), 100–2.

59  Eliza Younghusband Album, 46; Clark and Cahir, 102.

60  I am indebted to David Hansen, who has highlighted the importance of such albums and scrapbooks in his research on Thomas John Domville Taylor's *The Blacks who robbed the drays on the Main Range of Mountains – attacked by a party of Darling Downs Squatters after following them for a week,* 1843, NLA.

61  Caroline Jordan, 'Emma Macpherson in the "Blacks' Camp" and Other Australian Interludes: A Scottish Lady Artist's Tour in New South Wales in 1856-57,' *Intrepid Women,* 91.

62  Jordan, 'Progress versus the Picturesque', 353.

63  Eliza Younghusband Album, 44.

64  Anita Callaway and Candace Bruce, 'Dancing in the Dark: Black Corroboree or White Spectacle?' *Australian Journal of Art* 9 (1991): 78–104.

65  Jordan, Progress versus the Picturesque', 355. Unlike the frontier conflict represented by Hodgkinson, which was far removed from the contact zone, it is possible that Eliza would have witnessed a staged corroboree. See Jordan's discussion of contemporary colonial women's accounts of corroborees in 'Emma Macpherson in the "Blacks' Camp"', 101. See also Dohmen, 'Mensahibs and the "Sunny East"', 160.

66  Jordan, 'Emma Macpherson in the "Blacks' Camp"', 97.

# Collecting the 'East': Women Travellers on the New 'Grand Tour'

Amy Miller

Reviewing John Murray's new *Handbook for India* in January 1859, *The London Times* noted that 'after conducting travellers and tourists over the whole of Europe, Mr. Murray has extended his valuable guide to the East. ... A tour in India need scarcely occupy much more time than one in Russia.'[1] A return trip to India including sightseeing, the author proposed, might be completed in just nine weeks: the East was now just as close as more exotic parts of Europe. A decade later, with the official opening of the Suez Canal in November 1869, a new route provided faster access to the East. It quickly became incorporated into the network of railways and shipping lines that would be exploited by tour operator Thomas Cook, who offered an 'Around the World Tour' from 1872.[2] The influx of new leisure tourists, dubbed 'globetrotters', at Eastern ports did not go unnoticed. Maria Hay Murray Mitchell, wife of missionary John Murray Mitchell, wrote of her encounter in Madras with 'three young-looking lords, who are 'doing' the East, they say; India, China and Japan being now quite included in the "grand tour"'.[3] Travelling around the world became available to anyone with the means to afford it.

One of the early uses of the term 'globetrotter' came from traveller Robert Fowler, who in 1876 noted its use in China 'for the tourist travelling the globe'.[4] The emergence of the globetrotting leisure tourist in the 1870s signalled the latest in successive waves of Western travellers to the 'East'. Earlier, professional, travellers included the military, merchants, diplomats, missionaries and civil servants and their families, all of whom established a lasting presence, first in India and then in China and Japan.[5] What ensured the success of the globetrotter was not Thomas Cook's offices and his 'Round the World Tour', but the confluence of key historic developments: British imperial dominance in India, the additional presence of

British enclaves in Chinese and Japanese Treaty Ports, and the technological improvements of steam power, railway networks and the engineering that produced the Suez Canal.[6] While this vaunted ease of travel opened the way to leisure tourists, one of its draws was the social prestige that could be conferred from a world tour. Globetrotters were invariably wealthy but the majority were newly rich and aspired to becoming socially, as well as financially, elite. An Eastern tour gave them access to the colonial elite in India, as well as to maharajahs, mandarins and the Meiji emperor's court.[7] By the late 1870s, globetrotters were no longer primarily wealthy young men but included increasing numbers of women and family groups.[8] India, in particular, was promoted as a suitable winter tourist destination for this diversifying group of travellers.[9]

Changes to the nature of travel can be discerned in the accounts and collections of three female travellers examined in this chapter: Lady Brassey (travelled 1876–7), Annie Russell Cotes (travelled 1884–6) and Nora Beatrice Gardner (travelled 1894). Their journeys coincided with the height of the British Empire in India. All three belonged to the class of the newly rich. First, Annie Brassey (née Allnut) was the daughter of a jockey, while her husband, Thomas, was the son of a railway contractor whose large fortune derived from building the railways that connected the British Empire.[10] While the Brasseys were extremely wealthy at the time of their voyage, and Thomas was the Liberal MP for Hastings, he did not receive his knighthood until 1881.[11] Second, Annie Russell Cotes and her husband Merton owned the Royal Bath Hotel in Bournemouth, where Merton was awarded the mayoralty of the town from 1894–5. He received a knighthood for his philanthropic works in 1909. Their world tour not only allowed them to forge new social connections that would enhance their business, but the collections they amassed and displayed in the hotel created an additional draw for guests. Third, Nora Gardner was the daughter of wine merchant James Blyth, who was created 1st Baron Blyth in 1907. Her husband, Alan Coulstoun Gardner was, arguably, the most socially elite of those considered in this chapter. The son of Alan Legge Gardner, 3rd Baron Uttoxeter, he was, however, born before his parent's marriage and ineligible to succeed to the title. He served in the army and had contacts in India through his former regiment.

The value of the objects these travellers collected and the publications they produced lay in part in their use as signifiers of their participation in an expensive and lengthy world tour that generated social capital. Both the Brassey and Russell Cotes collections contained various art objects, such as Chinese porcelains or decorative lacquered pieces, that were desirable in the marketplace

of late nineteenth-century Britain.[12] However, they also acquired less-expensive souvenirs, specifically manufactured for Western tourists, including Indian clay figures, small enamelled Chinese brooches and lacquered chopstick sets from Japan. Even in the late nineteenth century the presence of tourist souvenirs within collections was viewed as detrimental to the value of the collection as a whole and the value judgements of the collector.[13] If these objects did not represent social distinction, then we must consider what function they did fulfil for the collector. Here, it is useful to interrogate these collections within the context of what anthropologist Igor Kopytoff terms 'spheres of exchange', which offers a means of conceptualizing these seemingly disparate groups of objects.[14] In this model, objects that held a monetary value – for example, status objects and subsistence items – could be exchanged across these seemingly separate spheres.[15] Objects within their collections occupied distinct spheres: high art or status objects, commercially produced souvenirs, and material representative of daily life, such as smaller tokens of cultural engagement. These collections and narratives materially constituted a cultural construction of the East, which instructed those unable to travel and inspired the next generation of travellers. Annie Brassey's *Voyage in the Sunbeam* (1878) was one of the earliest, and most ambitious, examples of what the world tour could achieve for the traveller. It secured her social standing, gave her a degree of celebrity and generated the aspiration to create her own museum. In addition, her account shows how she used her mobile, domestic interior to engage actively in the global politics of her husband. The outcomes from Annie Russell Cotes's world tour were no less ambitious than Brassey's. The wife of a self-made man, she jointly founded a museum and gallery and personally endowed the museum. By contrast, Nora Gardner presented her experiences in a deluxe publication that reinforced global travel as the preserve of the social elite, acting in part as an alternative 'form of ennoblement' expressed through the objects she collected.[16]

These kinds of sociocultural processes interacted in complex ways with gendered and racial identities as the three women travelled in the East. Angela Woollacott has noted how local populations viewed elite British women travelling in the 'East' as masculine, since whiteness was equated with the colonizer.[17] In a similar vein, Mary Louise Pratt has written of how descriptive, panoramic texts of travel, like those produced by Brassey, Russell Cotes and Gardner, were a means of mastering the landscape, whereby the writer took on the role of masculine colonizer.[18] Nora Gardner, for example, locates much of her narrative in camps in Kashmir, that were a base for hunting excursions, an

elite activity popular among the officials of the Raj. The textual accounts by the women discussed in this chapter must be considered in conjunction with the collections relating to their travels which further reinforce the idea that Eastern travel allowed them to adopt the status of an 'honorary man', moving beyond the traditionally feminine practices of collecting and displaying decorative and applied arts within the home towards the more masculine domains of fine art and natural history collecting, and the creation of the museum.[19]

## Annie Brassey: *Voyage in the Sunbeam*

Annie Brassey's globetrotting was groundbreaking in many ways. Her travels differed from those of ordinary tourists, in that they were undertaken on her private yacht *Sunbeam*, named for her daughter Constance Alberta who had died of scarlet fever, aged four. As historian Lorrain Sterry has noted, Brassey 'chose to take her house with her' – the yacht was a travelling home to the Brasseys and their children, a small group of friends, domestic staff and a professional crew.[20] When *Sunbeam* left Chatham on 1 July 1876, the Brasseys were attempting to circumnavigate the globe, making this the first voyage of that type undertaken on a private yacht. The progress of the yacht was reported regularly in the newspapers, which also published excerpts of Annie Brassey's letters to friends and family. The public interest generated was such that, when the Brasseys arrived in Yokohama in late January 1877, they were overwhelmed by visitors, who included 'the reporters of newspapers, full of curiosity, questions, and astonishment'.[21] When Brassey's account *A Voyage in the 'Sunbeam'* was published in 1878, it proved similarly popular. Written in what one reviewer described as a 'frank, cordial spirit of intelligent enjoyment', the book went through nineteen editions and numerous translations.[22] It was published in both a lavish, 508-page hardcover edition – which, at the price of 21 shillings included 109 woodcut illustrations and 7 maps and charts – and a cheaper abridged 64-page paper version with 59 woodcuts, that sold for sixpence and was reviewed in the press as 'the most instructive and interesting six pen'orth out'.[23] Brassey's voyage, her collections and her publications were used as both a means of educating those who could not travel, at the same time securing her own social position through philanthropic endeavour and celebrity.

Although Thomas Brassey was the registered owner of *Sunbeam*, the yacht quickly became primarily associated with Annie after she published her voyage.

In 1882, *The Hampshire Telegraph* reported the arrival of 'the *Sunbeam*, Lady Brassey's yacht' at Gibraltar.[24] Her identification with the yacht was publicly reinforced further through her 1882 article, 'The Decoration of a Yacht' for the *Magazine of Art*, in which she credited herself as the principle designer of *Sunbeam's* interiors.[25] The first lines of the article make clear that she espoused the ideals of Aesthetic design in her treatment of *Sunbeam's* interior which was, she wrote, 'capable of artistic improvement, and that without the aid of arts would be almost comfortless and desolate looking'.[26] The illustrations accompanying the article were engravings that were copied from Brassey's own photographs of *Sunbeam's* interior. They revealed a debt to Charles Locke Eastlake, an influential architect, designer and author of 'taste' manuals on decoration, who coined the term 'Art Furniture' for objects designed by artists and made by artisans.[27] Eastlake's publication *Hints on Household Taste* (1868), was one of the key texts of the Aesthetic Movement, indicating the way that eclectic collections encompassing the craftsmanship of both East and West should be displayed in the interior:

> The smallest example of rare old porcelain, of ivory carving, of ancient metalwork, of enamels, of Venetian glass, of anything which illustrated good design and skilful workmanship, should be acquired whenever possible, and treasured with the greatest care. It is impossible to overrate the influence which such objects may have in educating the eye to appreciate what really constitutes good art. An Indian ginger-jar, a Flemish beer-jug, a Japanese fan, may each become in turn a valuable lesson in decorative form and colour.[28]

Photographs of *Sunbeam*'s interior show natural history specimens hung from ceiling beams alongside examples of artisan crafts that were both gifted and purchased as Brassey travelled the world (Plate 9). Although her collections of the family's world travels were not of the typically decorative wares that Eastlake recommended, she wrote that she deliberately chose to hang objects in this way for the practical consideration of securing them in rough seas, but also because they served to divert and educate the eye.[29]

In fine art the Aesthetic Movement and its followers focused on creating a cult of beauty.[30] However, in regard to the domestic interior, the Aesthetic Movement mobilized public discourse on design reform and art education.[31] Politics also informed the Aesthetic debate.[32] One area where art and politics notably overlapped was in the relationship between the growing Radical Liberal debate on women's suffrage and the identity of the Aesthetic Movement as a 'women's movement', with women taking the lead in both the designing and

producing of aesthetic goods.[33] The Aesthetic interior was one that expressed individuality, but was transformative for its inhabitants.[34] Another area where design reform and liberal ideals coincided was the advocacy of free access to museums whose collections would have an improving and instructive effect on the working classes.[35] A travelling domestic interior like *Sunbeam* which displayed Brassey's collections would not only better the lives of those living in it, but had the potential to reach visitors as well when docked near the Brassey's home at Hastings and elsewhere too. In 1881, when *Sunbeam* had been temporarily stranded in the Orkney Islands, it was reported in the papers that 'a large number of Orcadians have availed themselves of the privilege of inspecting the vessel and the wonderful collection of curiosities on board from all parts of the world'.[36] A month later, the yacht was moored in Middlesborough during the town's Jubilee celebrations and the public could buy tickets through the mayor's office to tour it.[37] Described in the local newspaper, *The Northern Echo*, as 'at once a floating palace and a museum', Brassey's collections did not disappoint.[38] Ticket holders were given access to the ship's saloon, a well-appointed room in which paintings, prints and drawings lined the walls, while nautilus shells, jugs and amphorae were hung from the ceiling beams. This domestic display of fine and decorative art in conjunction with natural history specimens emulated the encyclopaedic collections in public museums that opened across Britain from the late 1860s as a result of the Museums Act of 1845.[39]

Annie Brassey also employed her travelling home as a means of informally disseminating British domestic and intellectual ideals.[40] At home in Britain, her collections were used to educate the local populace about their place within the British Empire and the wider world. In 1884, she lent a large portion of her natural history collections – largely specimens of marine life and models of a Chinese junk, Japanese and Fijian craft – to the West Cornwall Fisheries Exhibition.[41] The aim of the exhibition was to raise money for a fisherman's pier and harbour at Newlyn. The Brassey collection, which the public would pay to view in this cause, was given special notice in all published accounts of the exhibition, one noting that this portion of the collection was 'quite an exhibition in itself, and comprises more of the unique collection her Ladyship made during the famous voyage of the *Sunbeam*'.[42]

Almost from the beginning of her 1876 trip, Brassey's aim was that her collection might form a museum in Britain in a more permanent setting, an ambition she shared with her contemporary, Marianne North, who acquired a permanent exhibition space at Kew for the paintings of botanical specimens

she had produced during the global tour she undertook after her father's death in 1869 (North's father, like Brassey's husband, was Liberal MP for Hastings).[43] Despite Brassey's efforts, the museum, which was initially to be in her London home on Park Lane, never came to fruition in her lifetime. She died of malaria in 1887 and her husband opened the museum in her memory, noting her intentions 'to afford instruction and recreation of the members of the Working Men's Clubs, to who she proposed to give constant facilities of an access to the collection'.[44] However, the museum levied an entry charge and required those who wanted to see the collections to apply in advance.[45] This conflict between Brassey's wishes to make her collections more widely accessible and the reality that the museum she wanted was not open to all, reflects some of the deeper divisions of both Liberal and Aesthetic discourse in this period. Those who sought reform, both politically and in terms of design, often held contradictory views on how it was to be achieved and whom ultimately it would benefit. In her work on the Aesthetic Movement and Liberal politics, Judith Neiswander notes that John Stuart Mill, for example, felt participation in political reform was 'strictly for the cultured class', often making derogatory references to the 'uncultivated herd'.[46] William Morris, meanwhile, whose artisan products were beyond the economic reach of those whose lives they were meant to improve, saw radical socialism as the answer.[47]

Annie Brassey's own voice, as it emerged in *A Voyage in the Sunbeam* revealed someone who was politically aware and took an interest in the trading connections of Britain and of the countries she encountered on her global voyage.[48] On her travels through the Straits Settlements, she gave an astute assessment of the geopolitical importance of Johor to the opium trade, illuminating how the British maintained allies in the Straits Settlements. The objects she acquired in there at first glance appear to comprise an inchoate assemblage encompassing the 'little objects of everyday life' (including a wooden headrest and joss candles that she purchased in the local market) mixed with status objects personally presented to her by the maharajah (including 'Malay silk sarongs, made and woven in his kingdom').[49] However, a deeper analysis of the objects collected, the contexts of their acquisitions and the social and political aspirations of Annie Brassey, reveals a more complex set of linkages. In Johor, Brassey used *Sunbeam* to carve out a more distinctive political and social position for herself. The yacht was recurrently used for 'soft' diplomacy both domestically and internationally. Thomas Brassey undertook one of *Sunbeam*'s early voyages to the Mediterranean in 1874. His reports of his visit to Italy, Greece and Turkey were published in

the newspapers and addressed British political and mercantile interests.[50] In September 1885, the *Sunbeam* sailed to Norway with Gladstone who wrote his election manifesto during the trip.[51] During the Brasseys' world tour, Abu Bakar, the maharajah of Johor visited *Sunbeam*. Lady Brassey noted that he showed the 'utmost interest', though his 'Mohammedan ideas about women were considerably troubled when he was told that I had had a great deal to do with the designing and arrangement of the interior'.[52] She omitted from her account that the maharajah of Johor was an Anglophile who was politically pro-British, had visited Britain in 1862 and maintained a friendship with Queen Victoria. In the mid-1870s, at the time of his visit to *Sunbeam*, the Straits governor, William Jervois was considering him for a greater political role on the peninsula. By making him the overlord of local leaders in Negri Sembilan, an area prone to rebellions which the British struggled to control, Abu Bakar would exert a pro-British influence and in turn would be supported in his desire for expansion of his own state.[53] Prevalent British Liberal views of Eastern rulers, as voiced by Thomas Brassey's political contemporary John Stuart Mill, deemed that there was no true equality between subjects of a 'civilized' nation and those who were 'barbarous'.[54] Annie Brassey echoes this view in her narrative. Exposure to the interior and collections displayed in accordance with Aesthetic principles was 'improving', while the scope of the collections demonstrated Britain's global reach, elucidating the power of the Empire. As the chief designer of this interior, Annie Brassey places herself in a diplomatic role, mobilizing her collection as a means through which she could dispense the Liberal ideals of the benefits of Empire to British subjects both at home and in empire.

## Annie Russell Cotes: *Westward from the Golden Gate*

According to his 1921 memoir, *Home and Abroad: An Autobiography of an Octogenarian*, Merton Russell Cotes built up the Royal Bath Hotel through his tireless promotion of Bournemouth as a tourist destination, and his campaign for a direct train line. All of this took its toll on his health leading to what he described as a 'nervous breakdown' in 1884, for which his doctor recommended a 'restorative' voyage.[55] He duly embarked on a world tour with his family, including his son and daughter. The Russell Cotes travelled through Australia and New Zealand, the children returning to Britain and – since Merton's health had not improved – the couple continuing to Hawaii, where Annie sustained

an injury exploring a volcanic crater. Following medical advice that travel on the United States continental railway would aggravate Annie's injury, the couple took a sea-route back to Bournemouth via Japan and additionally took in China and India.[56]

Annie Russell Cotes's account of their journey, *Westward from the Golden Gate* (c. 1900) was well received and she was elected as a fellow of the Royal Society of Literature in 1903.[57] Although not as lavish a production as *Voyage in the Sunbeam*, and published in only one version, *Westward from the Golden Gate* featured forty-five photographs (collected by Russell Cotes from commercial studios in the East) and specially commissioned illustrated chapter heads. Like Annie Brassey, the account of her world tour conferred a degree of social distinction and celebrity on Annie Russell Cotes, who took care to distinguish herself from common tourists such as the Cook's 'All the World Round' party that shared the Russell Cotes's voyage from San Francisco to Japan ('we did not care for them', she noted).[58] Unlike Annie Brassey's narrative, which showed social interaction across class boundaries, Annie Russell Cotes exclusively described her encounters with the social elite, including the Italian ambassador to Japan who sailed with them to Yokohama.[59]

Through her husband, Annie Brassey had enjoyed political connections with the British Empire. The Russell Cotes, meanwhile, through their business interests, underscored the commercial benefits of empire. Merton Russell Cotes sought to cultivate acquaintances with individuals who could enhance both his social status and his commercial ventures. He courted Inoue Kaoru, an influential senior statesman in the Meiji government who became Japan's first minister of foreign affairs in 1885, and pressed him to visit the Royal Bath Hotel. After Inoue's death in 1915, his widow visited Bournemouth and Merton reproduced her letter of thanks for the hospitality of the hotel in his memoir, thus underlining how his travels enhanced both his business and his social standing.

The Russell Cotes particularly appreciated Japan, a country relatively recently 'opened' to the West. They collected extensively and eclectically, Merton sending home over 'a hundred cases filled with curios … some very rare and antique specimens of Japanese art'.[60] The most significant object that he acquired was a large cabinet shrine that had belonged to a *daimio*, a member of the Japanese nobility under the Shogunate – it required diplomatic assistance to export it to Bournemouth.[61] By collecting the fine and the rare, Russell Cotes sought to distinguish himself not only as a collector but a connoisseur of the foreign cultures he visited. Although by his own admission, he did not know the full

provenance of the shrine, which his guide had secured for him from a local curio shop in Kyoto. Russell Cotes activities seem to conform to Rudyard Kipling's blistering assessment that globetrotters' cultural immersion in Japan was largely confined to the curio shops of Yokohama.[62] It was Annie's collecting practices that gave greater depth and nuance to their collections. On this same trip to Kyoto, she collected a set of simple wooden chopsticks held in a paper wrapper on which she inscribed: 'Chopsticks used by M and A Russell Cotes, 28 November 1885, Kyoto'.[63] The meal, in which the chopsticks were used, was described in her book: 'we stayed at a native hotel in order to get a thorough insight into the ways and customs of the people. We had our dinner squatting on the floor, there being neither chairs not table in the apartment'.[64] The chopsticks, of little artistic merit or monetary value, function in the context of Annie Russell Cotes's narrative as an important material representation of cultural engagement.

While Japan had its Treaty Ports and enclaves of British residents both political and mercantile, its political relationship with Britain was different from that of India in that it was only ever part of an informal empire. After the Meiji restoration of 1868, the Japanese government and members of the aristocracy began a programme of cultural activities of alignment with Western powers designed to bolster Japan's position in renegotiating the unequal treaties.[65] Part of the political strategy included demonstrating to Western powers that Japan was a modern country, industrializing and embracing Western ideals and technologies.[66] The historian E. W. Griffis, who taught physics at Tokyo Imperial University (chartered under the Meiji government under its modernization program) further popularized an already prevalent theory in his publication, *The Mikado's Empire* (1886), that Japan, with its rapid industrialization, ready embrace of Western technologies, and seemingly endless capacity for technological innovation, would in turn offer a type of regeneration of the West.[67] The translation of these political ideas to material culture can be seen in the craft of ivory carving, which underwent a shift from the production of netsuke to okimono (toggles and small carved statuettes). Netsuke were in high demand by both travellers and Western collectors, prized as art objects that confirmed their views of Japan as an 'artistic' society and also fulfilled the vogue for Japanese aesthetics in late-nineteenth-century Britain.[68] In order to meet demand, ivory carvers turned out netsuke in greater numbers but lesser quality. Okimono replaced netsuke as examples of artistic objects that displayed virtuoso carving; they were eminently collectable both domestically and by Western travellers.[69] The value of these objects was not restricted to their aesthetic quality – for the

Japanese they were indicators of modernity, their export and display abroad a means of demonstrating cultural imperialism.[70] For Western travellers these objects fed into the ideals of the Aesthetic Movement at home, with its emphasis on the handmade.[71]

Annie Russell Cotes collected a large number of netsuke and okimono, which became one of the focuses of the displays in the Russell Cotes Gallery.[72] In the decade following the couple's return, their Japanese collection was displayed in the Royal Bath Hotel in the Japanese drawing room. A photograph from the 1890s shows a densely-packed display, not unlike the Saloon of *Sunbeam,* with swords and textile panels mounted on the wall, tables of lacquer ware and okimono, and numerous lanterns hanging from the ceiling (Figure 6.1).[73] It was during this period, in 1898, that the Russell Cotes began to build their new home East Cliff Hall, located directly next door to the Royal Bath Hotel.[74] Given to Annie Russell Cotes as a birthday present, East Cliff Hall was a private, palatial residence that afforded them the opportunity to display their collections in an eclectic style: marble sculptures and Victorian paintings intermixed with maori axes, Japanese armour and an 'old English weighing machine'.[75] In 1907, the

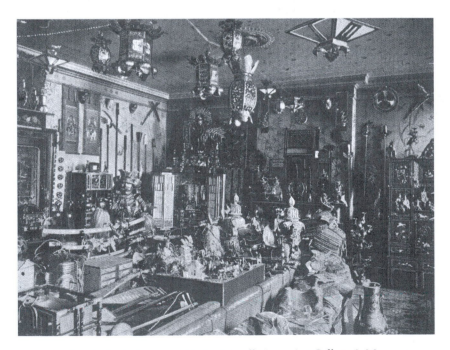

**Figure 6.1** The Mikado Room, 1886–91. Russell-Cotes Art Gallery & Museum, Bournemouth, Dorset.

Russell Cotes formally presented the building and its contents to the residents and town of Bournemouth, with the agreement that although the building would be a publicly accessible art gallery, it would also continue as their residence for the remainder of their lives.[76] Although presented as a joint endeavour, it would appear that Annie Russell Cotes played a key role in the creation of the museum, presenting in 1917 an additional endowment to the town to ensure the future running costs of the gallery, which did not charge an admission fee.[77] Between 1916 and 1926 the scope of the house was extended with the addition of formal art galleries.[78]

While the creation of the gallery and, more importantly, the formation of the collections themselves were clearly a joint endeavour, the press often attributed them to Merton, who was described as an 'art collector and connoisseur'.[79] Annie clearly played an influential role, and although her collecting activities have often been obscured in press reports crediting her husband as the collector, the photographic illustrations of natural history specimens acquired during the course of their travels in Australia and New Zealand credit her with their acquisition.[80] Examples of her photography collections illustrating Japanese life are included in the chapters describing time spent in Kyoto and Yokohama.[81] Though by no means as politically astute as Lady Brassey's earlier work, Annie Russell Cotes's publication engaged with both formal and informal empire in ways which highlighted the author's social distinction. In both India and Japan she engaged with diplomats and British residents: the colonial society of the Raj and the mercantile elite in Japan. Due to the perceived novelty of Japan in Western markets and their demand for Japanese art objects, it was this country and her experiences in the Treaty Ports that gave both her narrative and subsequent displays, such as the Mikado Room in the Hotel, greater distinction. These confirmed her social status as a wealthy traveller and cultural connoisseur but also to secured her legacy through the joint creation of a public museum. Both women staged their collections in an iteration of home – *Sunbeam* and East Cliff Hall – turning private interiors into publicly accessible spaces and displaying their social capital while securing their own legacies.

## Nora Beatrice Gardner: *Rifle and Spear with the Rajpoots*

Annie Brassey and Annie Russell Cotes were unusual in using domestic interiors to create public museum spaces. Nora Beatrice Gardner employed a similar

strategy through print to make her collections and travels accessible. Although her narrative lacks the overarching philanthropic aims of Brassey and Russell Cotes, it nonetheless functioned as a means of realizing her own legacy through the reiteration of social position. The frontispiece of *Rifle and Spear with the Rajpoots* (1895) shows Gardner in formal dress, wearing a velvet evening cloak trimmed with fur over a tightly corseted dress (Figure 6.2). Her hair is fashionably styled with an elaborately curled fringe topped with a small headpiece. The image captures a form of fashionable femininity and wealth appropriate to Gardner's luxuriously-bound, illustrated publication, which described her winter tour in northern India.

Gardner was quick to assert at the outset of the publication that she and her husband were select travellers: 'we have not very many fellow-passengers, as it is early for globe-trotters and return Indians'.[82] They actively exploited social

**Figure 6.2** Portrait of Nora Beatrice Gardner, photograph reproduced by Hentschel. Frontispiece to *Rifle and Spear with the Rajpoots: Being the Narrative of a Winter's Travel and Sport in Northern India* (London: Chatto &Windus, 1895). British Library Board: 10056.h.10.

and familial connections to access military, mercantile and political networks inhabited by the colonial elite. By participating in Raj society, they accessed what they believed to be an 'authentic' experience of life in India, beyond the reach of the Cook's tourist. Officers from Alan Coulson Gardner's former regiment facilitated the couple's access to private hunting grounds and to social interactions with local British officials and maharajahs. The Gardners' itinerary was principally concerned with game hunting, an activity which allowed them to align themselves with the colonial elite.[83] Emphasizing the authenticity of her text, Nora stated that it was a 'simple, plain and unvarnished account of our rough but very pleasant experience of Indian Camp Life', highlighting experiences that took her beyond the touristic 'happy hunting grounds' of urban centres such as Jaipur frequented by the Cook's traveller.[84]

For British travellers, game hunting was a means of demonstrating a connectedness with empire, and figured as such in their narratives.[85] Game hunting was an important leisure activity of the colonial elite of the Raj. To display a degree of proficiency in the sport was to participate in a social practice that forged relationships of both a professional and romantic nature: promotions were secured and marriages were made. [86] High-ranking British officials appropriated the Indian term for game hunting shikar, to demonstrate their command of the environment (it was also adopted by the colonial class, appearing in the dictionary of Anglo-Indian colloquialisms, *Hobson-Jobson* in 1886).[87] Ralph Crane and Lisa Fletcher note that shikari and shikar began to develop into a 'philosophy of hunting which emphasized the superiority of shikar over the pomp and ceremony of the elephant hunt … shikar expeditions openly and repeatedly align hunting with British imperial might'.[88] The trophies the Gardeners collected were representative of their participation in the elite activities of the Raj made possible through their exploitation of social networks.

Mary Procida writes of how female participation in game hunting in India was a means of demonstrating women's alliance on both a personal and political level. However, for a female traveller like Gardner, who was not fully part of the world of the Raj, active participation in the hunt was more complicated. She framed her own participation in a leopard hunt, using the insistent invitation of the maharaja of Chamba, a strong supporter of the Raj, to justify her seemingly reluctant taking up of the gun: 'The Maharaja handed me a rifle and begged that I would take the first shot. It was a nervous moment for an inexperienced markswoman before so many spectators, but he would not hear of a refusal.'[89] While the maharajah, his brother and her husband all shot at and eventually

killed the leopard, Gardner, who fired the first shot, noted with pride that when the body was recovered, 'part of my bullet, a little 450, was found in his body, so I had the satisfaction of knowing that I really had not missed'.[90] Her account balances her engagement in masculine spheres with her activities in traditionally feminine areas, specifically painting watercolours, earning the approbation of one male reviewer that she was a 'modern woman, but not a new woman'.[91]

Nora Gardner's decision to stay in camp and paint while her husband tracked game enabled a balancing of feminine and masculine behaviours, but it also was a means of pursuing the authentic through the picturesque. The Gardners were able to travel to India due to accelerated technologies, specifically steam and Britain's global networks of trade and Empire that created an infrastructure exploited by leisure travellers. Their globetrotting was the epitome of nineteenth-century globalization.[92] However, the ease with which they circled the globe also meant that their travels could be limited to a tour of culturally diverse port cities that, many travellers felt, did not represent the culture of the country they were purporting to experience.[93] Susan Stewart writes that as lived experience became 'increasingly mediated and abstracted' the search for the 'authentic' and its representation materially became increasingly important.[94] Caroline Jordan highlights what she terms the 'conservation' aspect of the picturesque that heightened an awareness of the impact of technological change and economic development on the landscape.[95] She writes that while a critique of encroaching modernity was at the heart of the picturesque, it was also tempered with a degree of ambivalence engendered by the realization that these technological changes underpinned the expansion of the British Empire and personal economic and social gains. That ambivalence that Jordan notes was also apparent in Gardner's account, with its claims to authenticity. This was in part a reaction to the increasing change brought about by technology, which allowed the Gardners to conduct their tours of the East, but at the same time threatened to alter the landscapes they viewed.

The images that illustrated Nora Gardner's book – her watercolours, photographs of Indian subjects from commercial studios, photographs of hunting trophies displayed in the domestic interiors of her home – can be read in terms of the spheres of objects they represent. Like Annie Brassey's collections of status objects that were presented to her, or the fine art and rare artefacts of the Russell Cotes collection, the status objects that the Gardners collected in India were twofold: the hunting trophies and the acquaintance of maharajahs. The first were represented through commissioned photographs

showing the trophies in situ in her Hertfordshire home. One photograph of a bear her husband shot in Kota shows the taxidermied animal on his hind legs, at the foot of a staircase, holding a tray in its paws, much as a butler would have done. The trophies were a means not only of conveying the Gardners' social status, as participants in shikar, but by modelling this Indian trophy as a servant they reinforced constructs of class and power. Nora's collection of studio photographs of the maharajahs she met in the course of her travels in India also serve to convey her social capital. These photographs were commissioned by the rulers themselves and were used to convey ideas of strength, power and enlightenment as princely rulers exploited new technologies to convey their modern leadership.[96] It was a common practice for Indian rulers to give these images as souvenirs to British and other foreign visitors as a gesture of political loyalty and means of conferring favour.[97]

Gardner's presentation of her collections for public consumption was also an exercise in her construction of an elite identity. Like Brassey and Russell Cotes she conveyed this through the presentation of objects in a domestic interior. However, Gardener did not allow physical access to her home, but rather controlled and directed what was seen by presenting her collections as illustrations in her lavishly produced publication described by a reviewer in *The Morning Post* as 'almost an *édition de luxe*. Print and paper alike are excellent, the binding sumptuous, and the margins ample.'[98] Her collections were carefully curated in her text to make clear that a winter's excursion among the colonial elite, and the 'authentic' experience of India, hunting in Kashmir, might only be enjoyed by the privileged.

## Conclusion

Examining the acquisition of collections demonstrates how social networks were accessed and exploited to fulfil aspirations, whether political (the Brasseys), mercantile (the Russell Cotes) or social (the Gardners). However, the material representations of Eastern travel and experiences represent more than the acquisition of social capital. The significance of souvenirs, Susan Stewart suggests, lies in the context of their acquisitions – the object becomes a material representation of, and monument to, what was ultimately the ephemeral experience of travel. Without the context of their narratives, the collections of Annie Brassey and Annie Russell Cotes would risk losing their distinction,

becoming no different from the many domestic arrangements of the Asian porcelain or lacquer available through exporters, dealers or auction houses that were acquired by collectors in Britain who never experienced the East.

Further, in addition to representing their travels, the women considered in this chapter used smaller, personal souvenirs in conjunction with status objects, the later often collected by their husbands, creating collections that served to differentiate each of these travellers from the Cook's tourist. These smaller, more modest pieces illustrate, if not an experience off the beaten track, certainly one that was representative of a degree of cultural engagement with local populations beyond the curio shops, underpinning the social significance of the status objects. When interrogating these objects, both the status and the personal, within the context of the travel narrative, it becomes apparent that they do not simply represent travel but are used as a means to authenticate it.

The ways in which Brassey, Russell Cotes and Gardener used their collections demonstrate how each woman engaged with prevailing political and social debates. The impact of modernity, and the social and political concerns that it engendered, underpinned the display of these collections. For example Brassey dispensed her collection in a way that engaged with Liberal discourse on social issues, the impact of modernity through design reform, and the wider aspirations of empire. Annie Russell Cotes's collection followed the fashionable vogue for all things Japanese, part of which was the desire in the West for the artisan to offset the encroachment of technological modernity, even though that same modernity enabled the Russell Cotes to travel to the East. Nora Gardner used her collections to capture the picturesque Kashmiri landscape, through watercolours rather than photographs thus imbuing them with a degree of handmade authenticity. The objects that Brassey, Russell Cotes and Gardener collected and the way that they used them in their narratives culturally produced an East that reflected the desires, concerns and preoccupations of those at home.

## Notes

1    *The London Times*, 31 January 1859.

2    Lynne Withey, *Grand Tours and Cook's Tours: A History of Leisure Travel, 1750 to 1915* (London: Aurum Press, 1998), 36; James Buzard, *The Beaten Track: European Tourism, Literature, and the ways to 'Culture', 1800-1918* (Oxford: Oxford University Press, 1993), 66.

3  Maria Hay Murray Mitchell, *In India: Sketches of Indian Life and Travel from Letters and Journals* (London: T. Nelson & Sons, 1876), 57.

4  Robert Nicholas Fowler, *A Visit to Japan, China and India* (London: Sampson, Low, Marston, Searle & Rivington, 1877), 26.

5  J. E. Hore, *Embassies in the East: The Story of the British and Their Embassies in China, Japan and Korea from 1859 to the Present* (London: Routledge, 1999), 3–5.

6  Cara Murray, *Victorian Narrative Technologies in the Middle East* (London: Routledge, 2008), 120.

7  Egerton K. Laird, *The Rambles of a Globe Trotter in Australia, Japan, China, Java, India, and Cashmere*, 2 vols. (Birkenhead: Printed for private circulation, 1875); Annie Russell Cotes, *Westward from the Golden Gate* (London: W.H. & L. Collingridge, circa 1900); Frederick Diodati Thompson, *In the Track of the Sun: Readings from the Diary of a Globe Trotter* (London: William Heinemann, 1893).

8  Christine Guth, *Longfellow's Tattoos: Tourism, Collecting, and Japan* (Seattle: University of Washington Press, 2004), 15–16.

9  W. E. Baxter, *A Winter in India* (London: Cassell & Company, 1882), 196. Baxter travelled through India with his wife and five daughters, recommending it as a suitable tour for family groups.

10  Charles Walker, *Thomas Brassey: Railway Builder* (London: Frederick Muller, 1969), 160.

11  Nancy Micklewright, *A Victorian Traveller in the Middle East: The Photography and Travel Writing of Annie Lady Brassey* (Aldershot: Ashgate, 2003), 30.

12  Anne Eatwell, 'Lever as a Collector of Wedgwood: And the Fashion for Collecting Wedgwood in the Nineteenth Century', *Journal of the History of Collections* 4 (1994): 240; Monika Bincsik, 'European Collectors and Japanese Merchants of Lacquer in "Old Japan": Collecting Japanese Lacquer Art in the Meiji Period', *Journal of the History of Collections* 20 (2008): 223.

13  Anca I. Lasc, 'A Museum of Souvenirs', *Journal of the History of Collections* 28 (2016): 57.

14  Igor Kopytoff, 'The Cultural Biography of Things: Commoditization as Process', in *The Social Life of Things: Commodities in Cultural Perspective*, ed. Arjun Appadurai (Cambridge: Cambridge University Press, 1986), 71.

15  Kopytoff, 'The Cultural Biography of Things'.

16  Giles Waterfield, 'A Home of Luxury and a Temple of Art', in *A Victorian Salon: Paintings from the Russell-Cotes Art Gallery and Museum*, eds Simon Olding, Giles Waterfield and Mark Bills (London and Bournemouth: Lund Humphries in association with Russell-Cotes Art Gallery and Museum, 1999), 18.

17  Angela Woollacott, *To Try her Fortune in London* (Oxford: Oxford University Press, 2001), 39.

18  Mary Louise Pratt, *Imperial Eyes: Travel Writing and Transculturation*, 2nd edn (London: Routledge, 2008), 125.

19  Leora Auslander, 'The Gendering of Consumer Practices in Nineteenth-Century France', in *Consumption: The History and Regional Development of Consumption*, ed. Daniel Miller (London: Routledge, 2001), 158. Auslander cites the creation of the museum as the ultimate expression of masculine collecting that was also state sponsored and not only constructed ideas of national identity through art and objects, but those of Empire as well.

20  Lorrain Sterry, *Victorian Women Travellers in Meiji Japan: Discovering a New Land* (Folkestone: Global Oriental, 2009), 6.

21  Annie Brassey, *A Voyage in the 'Sunbeam', Our Home on the Ocean for 11 Months* (London: Longmans & Co., 1878), 314.

22  *Hastings and St. Leonard's Observer*, 25 May 1878; James R. Ryan, '"Our Home on the Ocean": Lady Brassey and the Voyages of the Sunbeam, 1874-1887', *Journal of Historical Geography* 32 (2006): 580.

23  *Western Times*, 24 September 1881.

24  'Yachting Notes and News', *The Hampshire Telegraph*, 11 March 1882.

25  Annie Brassey, 'The Decoration of a Yacht', *The Magazine of Art* 5, no. 3 (January 1882): 103.

26  Brassey, 'The Decoration of a Yacht'.

27  Charlotte Gere, *Artistic Circles: Design & Decoration in the Aesthetic Movement* (London: V&A Publishing, 2010), 64.

28  Charles Locke Eastlake, *Hints on Household Taste in Furniture, Upholstery and other Details* (London: Longmans & Co., 1872), 121.

29  Brassey, 'The Decoration of a Yacht', 106.

30  Gere, *Artistic Circles*, 16.

31  Ibid.

32  Ibid.; Judith A. Neiswander, *The Cosmopolitan Interior: Liberalism and the British Home 1870-1914* (New Haven: Yale University Press, 2008), 8.

33  Louise Campbell, 'Questions of Identity: Women, Architecture and the Aesthetic Movement', in *Women's Places: Architecture and Design 1860-1960*, eds Brenda Martin and Penny Sparke (London: Routledge, 2003), 1.

34  Ibid, 34.

35  Gere, *Artistic Circles*, 16; Waterfield, 'A Home of Luxury and a Temple of Art', 18.

36  *The London Times*, 26 September 1881.

37  *The Northern Echo*, 6 October 1881.

38  Gere, *Artistic Circles*, 158.

39  Waterfield, 'A Home of Luxury and a Temple of Art', 14.

40  Ryan, 'Our Home on the Ocean', 582.

41  'West Cornwall Fisheries Exhibition', *The Cornish Telegraph*, 28 August 1884.

42  Ibid.

43  Micklewright, *A Victorian Traveller in the Middle East*, 45. On North, see Michelle Payne, *Marianne North: A Very Intrepid Painter* (Kew: Kew Publishing, 2011), 8–10.

44  Mickelwright, *A Victorian Traveller in the Middle East*, 44–5.

45  Ibid.

46  Neiswander, *The Cosmopolitan Interior*, 145.

47  Gere, *Artistic Circles*, 20.

48  Brassey, *A Voyage in the 'Sunbeam'*, 217, 228, 245, 248, 340, 415.

49  Ibid., 416.

50  'Mr. Brassey's Cruise in the Mediterranean', *Hastings and St Leonards Observer*, 21 November 1874.

51  Ryan, 'Our Home on the Ocean', 584.

52  Ibid.

53  Barbara Watson Andaya and Leonard Y. Andaya, *A History of Malaysia* (London: Macmillan, 1982), 164.

54  John Stuart Mill, *Dissertations and Discussions: Political, Philosophical and Historical* (London: Longmans, 1875), 166–7.

55  Merton Russell Cotes, *Home and Abroad: An Autobiography of an Octogenarian* (Bournemouth: Printed for private circulation, 1921), 375.

56  Russell Cotes, *Westward from the Golden Gate*, 67.

57  *Essays by Diverse Hands, Being the Transactions of the Royal Society of Literature of the United Kingdom*, vol. 24, reprint, original work published pre-1945, year unknown (London: Forgotten Books, 2013), 333.

58  Russell Cotes, *Home and Abroad*, 454.

59  Ibid., 446, 449.

60  Ibid., 446.

61  Ibid.

62  Martha Chaiklin, *Ivory and the Aesthetics of Modernity in Meiji Japan* (Basingstoke: Palgrave Macmillan, 2014), 21.

63  The chopsticks are in the Russell Cotes Art Gallery and Museum, Bournemouth.

64  Russell Cotes, *Westward from the Golden Gate*, 33.

65  This series of treaties allowed for trade, extraterritoriality and access, albeit with restrictions to the cities of Nagasaki, Yokohama, Yedo (Tokyo), Hakodadi (Hakodati), Osaka, Kobe and Kyoto. Travel to the interior was allowed with a passport, for which travellers had to apply to the British Consul-General.

66  Andrew Elliott, 'British Writing and the Japanese Interior, 1854-1899', in *The British Abroad since the Eighteenth Century*, vol. 1, *Travellers and Tourists*, eds Martin Farr and Xavier Guegan (Basingstoke: Palgrave Macmillan, 2013), 197.

67   William Elliot Griffis, *The Mikado's Empire*, fifth edition with supplementary chapters: *Japan in 1883*, and *Japan in 1886* (New York: Harper & Bros., 1887), 602.

68   Martha Chaiklin, 'Politicking Art: Ishikawa Komei and the Development of Meiji Sculpture', *East Asian History* 39 (2014): 56.

69   Chaiklin, 'Politicking Art'.

70   Chaiklin, *Ivory and the Aesthetics of Modernity in Meiji Japan*, 3.

71   Ibid., 4.

72   Russell-Cotes Art Gallery and Museum, *Souvenir of the Japanese Collection* (Bournemouth: Russell-Cotes Art Gallery and Museum, 1931), 4.

73   Olding, Waterfield and Bills, *A Victorian Salon*, 9, figure 3.

74   Simon Olding, 'A Victorian Salon: An Introduction', in Olding, Waterfield and Bills, *A Victorian Salon*, 7.

75   Olding, 'A Victorian Salon', 10.

76   *Western Gazette*, 8 November 1907.

77   *Western Gazette*, 4 February 1921. The Gallery introduced an entry fee in 2011.

78   Olding, 'A Victorian Salon', 7.

79   'Bournemouth Undercliff Drive Official Opening. Magnificent Gift to the Town', *Hampshire Advertiser*, 9 November 1907.

80   Russell Cotes, *Home and Abroad*, 448–9.

81   Ibid.

82   Nora Beatrice Gardner, *Rifle and Spear with the Rajpoots: Being the Narrative of a Winter's Travel and Sport in Northern India* (London: Chatto & Windus, 1895), 1.

83   Procida, *Married to the Empire*, 145.

84   Gardner, *Rifle and Spear with the Rajpoots*, iv, 267.

85   Ralph Crane and Lisa Fletcher, 'Picturing the Indian Tiger: Imperial Iconography in the Nineteenth Century', *Victorian Literature and Culture* 42, no. 3 (2014): 370.

86   Procida, *Married to the Empire,* 145.

87   Crane and Fletcher, 'Picturing the Indian Tiger', 373; Kate Teltscher, Henry Yule and A. C. Burnell (eds), *Hobson-Jobson: The Definitive Glossary of British India* (Oxford: Oxford University Press, 2013), 468–9.

88   Ralph Crane and Lisa Fletcher, 'Picturing the Indian Tiger', 373.

89   Gardner, *Rifle and Spear with the Rajpoots*, 128.

90   Ibid., 129.

91   *The Graphic*, August 1895. The term 'New Woman' emerged in 1870s to describe – and criticize – the rising phenomenon of the independent and affluent woman. See Ruth Borden, *Alice Freeman Palmer: The Evolution of a New Woman*. (Ann Arbor: University of Michigan Press, 1993), 2.

92   Jonathan H. Grossman, 'The Character of a Global Transport Infrastructure: Jules Verne's *Around the World in Eighty Days*', *History and Technology* 29 (2013): 261.

93  Traveller Isabella Bird voiced this in regard to Shanghai which she saw as not representative of China. See Isabella Bird, *The Yangtze Valley and Beyond: An Account of Journeys in China, Chiefly in the Provinces of Sze Chuan and among the Man-Tze of the Somo Territory* (London: John Murray, 1899), 15; Martha Chaiklin, *Ivory and the Aesthetics of Modernity in Meiji Japan*, 20.

94  Susan Stewart, *On Longing: Narratives of the Miniature, the Gigantic, the Souvenir, the Collection* (Durham: Duke University Press, 1992), 133.

95  Jordan, *Picturesque Pursuits*, 170–6.

96  Deborah Hutton, 'The Portrait Photography of Raja Deen Dayal', in *Indian Paintings and Photographs, 1590-1900*, ed. Prahlad Bubbar (Exhibition Catalogue, London: Prahlad Bubbar Mayfair, 2012), 6; Barbara N. Ramusack, *The New Cambridge History of India: The Indian Princes and Their States* (Cambridge: Cambridge University Press, 2004), 156.

97  Anil Relia, *The Indian Portrait VI: A Photographic Evolution from Documentation to Posterity* (Ahmedabad: Archer Art Gallery, 2015), 12.

98  *The Morning Post*, 6 August 1895.

Part Three

# Administering

# Agents of Affect: Queen Victoria's Indian Gifts

Rosie Dias

On 3 December 1875, Queen Victoria recorded in her journal a portrait sitting at Windsor to William Downey, a photographer from Newcastle whose services she had used on several occasions over the previous decade. Although Victoria's journal does not elaborate on the nature of the portrait commission, the result was most likely a small number of photographic plates produced in anticipation of her accession to the title of Empress of India, formalized through the Royal Titles Act in May 1876.[1] The portrait illustrated in Figure 7.1 shows a typically sombre Victoria, attired in mourning dress and seated upon an exotic marker of her new imperial role: an intricately carved ivory throne chair and footstool, gifted to her in 1851 by the maharaja of Travancore, rich with ornamental motifs – including elephants, lions and peacocks – and embellished with gold, rubies, diamonds and emeralds. The moment of Victoria's ascension to the status of empress clearly called for commemoration, and the celebratory events which took place over the following year did not disappoint, culminating most notably with the spectacular Delhi Coronation Durbar held on 1 January 1877, during which the viceroy of India, Lord Lytton, received homage from sixty-three Indian princes on her behalf.[2] Victoria's commission of the Downey portrait took place several months in advance of the formal announcement of her new title, and perhaps sought to capture an image of herself as empress that asserted her own control over her imperial status and royal body at a moment of anticipated contention within Parliament over the implications of the new title.[3] As Miles Taylor has pointed out, Victoria had long acted under an assumed de facto Empress status in relation to India, using the term explicitly over the previous two decades.[4] Both Albert and she had pressed for her to be able to style herself empress, and both had also taken a strong interest in Indian affairs,

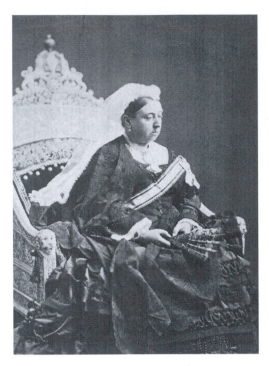

**Figure 7.1**  William Downey, *Queen Victoria as Empress of India*, 1876, albumen print. Royal Collection Trust ©Her Majesty Queen Elizabeth II 2017.

insisting on key provisions in the 1858 India Bill, most notably the conciliation and recognition of the native princes after the so-called Mutiny. The portrait, then, can be read alongside such proactive engagements with imperial domains, as a taking of control in the midst of Parliament's reservations over the desired title, particularly when it is considered in light of the queen's reassertion, through portraiture, of her claim to monarchical status in the 1870s, following her period of seclusion after Albert's death.[5] Implicating a nexus of identities – queen, empress and widow – the photograph encapsulated the political, imperial, domestic, and even sentimental, modes through which Victoria experienced her Indian empire.

As queen-empress, Victoria clearly enjoyed an exceptional status when compared with the women discussed elsewhere in this volume, many of whom travelled in empire due to the political roles or business activities undertaken by their male relatives. Victoria – an imperial figure in her own right – never travelled across her expanding empire; instead it came to her, its political business, social transactions and material manifestations pervading

her daily life, while her own image circulated across the empire as part of a complex symbiotic process described by David Cannadine as one in which 'an imperialized monarchy merged with and moulded an monarchicalized empire'.[6] Since Cannadine pointed out the lack of understanding within imperial studies of the ways in which the relationship between monarch and empire operated, a number of scholars have begun to explore its various manifestations, analysing, for example, the Delhi Coronation Durbars, royal tours, public sculpture, the creation of orders and decorations, and other forms of institutionalization and commemoration.[7] These 'monarchicalizing' processes typically involved and invoked large-scale spectacles and a heightened visibility of monarchy, designed in part to cultivate loyalty to, and even affection for, the sovereign at a time when the imperial regime itself was hardening and being challenged. Looked at from another perspective, however, the 'imperialized monarchy' (a phenomenon which has, at this stage, been subject to rather less sustained scholarship than the 'monarchicalized empire'), at least during the reign of Victoria, was one in which the affairs and objects of empire were situated domestically as well as publicly. Indian objects flowed into Victoria's possession during the long course of her reign – as spoils of war acquired in her name, as gifts from Indian princes, and as works purchased and commissioned by the queen herself. Jewels, ceramics, metalware, furniture, paintings, drawings, photographs and even a horse from the subcontinent were absorbed into her various households, significant for their quality, craftsmanship, rarity or value, as well as for the symbolic freight they carried. Her engagements with the subcontinent were also physically enacted: she ate curries, wore fabled jewels, kept a Hindustani journal and sketched Maharaja Ranjit Singh's son, Duleep Singh, when he arrived in Britain. Victoria commissioned John Lockwood Kipling and Bhai Ram Singh to design and execute a Durbar Room for Osborne House, and despatched the Austrian artist Rudolf Swoboda to India to complete a series of portraits of her Indian subjects to hang in Osborne's new wing.[8] That empire was a domestic affair was reinforced in Victoria's household retinue, which included Indian servants and troops, and in her broad conception of family (she counted among her goddaughters the princesses Gouramma of Coorg and Sophia Duleep Singh, and also had her young sons Arthur and Alfred photographed wearing the costume of Sikh princes).[9] In 1887 and 1897, Victoria's Jubilee celebrations incorporated into its various spectacles representatives from across the empire, the most prominent and colourful of which were a number of Indian princes, encouraged to wear their native finery for the occasion. The scale, scope and nature of these

imperial engagements are such that it is difficult to disentangle the personal from the political, the domestic from the public, or the often-ossifying practices of collecting from those of everyday life.

This chapter aims to unpick some of the processes and cultural practices through which Victoria engaged with, and was shaped by, her Indian empire. Considering a small number of works gifted to her by Indian rulers, I explore how they allowed her to situate herself in relation to Indian princes and territories, and to begin the work of creating a new 'imperialized monarchy'. Undertaking this task at home, in the years after her consort's death, the rhetoric and logic which underpinned these practices are revealing in terms of both imperialism and gender, differing sharply from the parallel processes undertaken out in the field by successive Viceroys who sought to establish the monarch's authority within the subcontinent.[10] As we shall see, Victoria's material engagements with India represented a process of domestic integration (both in terms of her own household and, more broadly and symbolically, the British nation) as much as political endeavour. Victoria was not, of course, the first British monarch to collect and display objects from the subcontinent within her households. Perhaps most notably, George IV, as Prince of Wales, displayed items of Indian arms and armour within his picturesquely arranged museum of armoury at Carlton House – these included Mughal daggers and a horse-mounted figure wearing the war dress of Tipu Sultan, the latter acquired after British troops looted Tipu's palace at Seringapatam in 1799.[11] Victoria's relationship to India was fundamentally different to George IV's, however. As a result of the 1858 Government of India Act, it was both more direct and more complex, the directness accruing from the transfer of the administration of India from the East India Company (EIC) to the British Crown, and the consequent complexity borne out of the fact that this vast territory comprised regions previously ruled by dynasties deposed by the EIC as well as some 600 states which continued to be governed by hereditary princes under the British policy of Indirect Rule (and which still remained to be comprehensively listed by the colonial administration in the early decades of the Raj period).[12] Facilitated by new communication and transport networks (Victoria noted enthusiastically in her journal, a week before the portrait sitting to Downey, the government's successful purchase of £4 million of shares in the Suez Canal, guaranteeing security and speed to the imperial project), the monarch was now able to correspond with, and receive visits from, her Indian subjects and administrators with relative frequency and ease.[13] Both the directness and the complexity of this relationship produced and

necessitated new forms of political and cultural engagement with empire on the part of the monarch which – as we shall see – came to be inflected not only by imperial politics but by Victoria's gendered role and domestic practices.

## Imperial regalia?

On one of her many visits to the Indian section of the Great Exhibition in 1851, Queen Victoria spent a morning moving between viewing the country's raw products (she received an explanation of the 'excessively curious' process of opium production from the botanist and superintendent of the Exhibition's Indian department, John Forbes Royle) and its refined products of craftsmanship: jewels, shawls, embroideries, silver bedsteads and ivory chairs. She noted that these exhibits were items 'of immense interest & quite something new for the generality of people, these latter articles having hitherto, only come over as presents to the Sovereign'.[14] The queen's brief comments implicate the ocular regimes of what Carol Breckenridge has called the 'Victorian ecumene', an imagined community bought together by cultural technologies such as the international exhibition that 'situated metropole and colony within a single analytic field'.[15] Victoria's awareness and approval of the ways in which objects traditionally located within the domain of elite gifting had become visible to a wide public does not, of course, imply that royal gifts were now synonymous with public goods. Rather, colonial objects retained an exclusive status and potent force within her households, perhaps more so than ever in the decades following the Great Exhibition, when they became situated all the more emphatically within the physical and conceptual realms of royal collecting. Among the most visually prominent of the objects in the Indian court in 1851 was the Travancore Throne – one of several items that the maharaja of Travancore, Uthram Thirunal Marthanda Varma, had provided at the request of the government of Madras for display at the Great Exhibition to showcase the raw products and refined manufactures of his kingdom. The throne – which was already being made for his use – was earmarked by the maharaja, and reconceptualized in design, as a specific gift to Victoria (Figure 7.2). In the accompanying letter to the queen, he drew her attention to its materials and carving – 'the production wholly of the native artists of my country [the Kingdom of Travancore]' – adding his 'profound respect' for the queen, and noting his family's longstanding allegiance to the British.[16] The throne, therefore, traversed not only a vast geographical

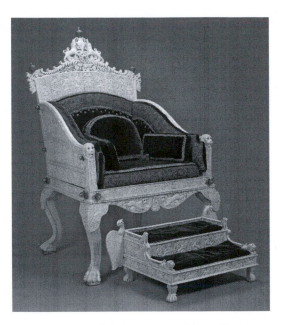

**Figure 7.2** Throne and Footstool ('The Travancore Throne'), 1850, carved ivory, gold, diamonds, emeralds, rubies, gilt bronze, hardwood and embroidered silk velvet. Royal Collection Trust ©Her Majesty Queen Elizabeth II 2017.

distance between empire and metropole, but also a conceptual one, between the world of craft, manufacture and goods, and that of elite relationships cultivated, in this case, across the space of empire.

Additionally, like Victoria's perambulations through the exhibition, the Travancore Throne could be understood in terms of its imbrication of raw and refined products of empire. The display of raw materials in the Indian section at the Crystal Palace included local and imported ivory from Madras, the Tenasserim Provinces, Nepal and the Somali coast.[17] As visitors, much like Victoria, moved between the displays they could encounter the transformation of this material into highly refined finished products, their understanding aided by textual and visual elaborations such as the *Illustrated London News's* account, on 26 April, of Bengali ivory workers, carving objects specifically for the Exhibition.[18] That Victoria herself understood the throne as both a generous gift and as exemplary of South Indian craftsmanship is indicated in a letter she wrote to the maharaja of Travancore, assuring him of her gratitude for 'so beautiful a specimen of the ability acquired by the natives of Your Highness' country in the carving of ivory'. She noted her intention to repay the maharaja's 'liberality' with

'some token of our esteem' in due course.[19] Her letter (reportedly the first to be written by Victoria to an Indian ruler) was received in a celebratory Durbar, described in the *Illustrated London News* as follows:

> A correspondent on the spot describes to us the sumptuous display of 'cloth of gold' and jewels; of state elephants and gilded howdahs, of cameleopards [giraffes] and of tamed tigers and rhinoceri, as well as troops of the line and cavalry, which escorted the valued document the entire distance (two miles) from the British Residency to the Palace; and peals of artillery shook the old fort to its foundations, as General Cullen placed the same in his Highness' eager hands.
>
> A grand banquet at the Residency, a nautch and fireworks at the Palace, in which loyal and appropriate mottoes, complementary to her Majesty and the Prince Consort, were conspicuous, terminated this (to the capital of Travancore) most auspicious day; while the event, we are informed, is to be still more permanently perpetuated by a costly work of art from the pencil of an artist (Mr Lewis), already well known by his Eastern productions, to appear in due time in England for exhibition and engraving.[20]

The publication of Frederick Christian Lewis's engraving in 1854 represented the culmination of a four-year-long exchange which brought colonial objects to the metropole and into the possession of the queen, while the prized acknowledgement of the British monarch's gratitude was incorporated into the ceremonial ritual of the Durbar, in turn recorded and disseminated back in Britain. This exchange was not only productive of things, but of sentiments too, the maharaja reportedly reading Victoria's letter of thanks as 'his eyes filled with tears of joy'.[21] This to-and-fro of objects, letters, images and even affect, across imperial space – and the heightened visibility they were afforded through public spectacles and printed reproductions – is perhaps emblematic of the symbiotic, two-way processes that Cannadine recognizes as productive of an 'imperialized monarchy' and an 'monarchicalized empire'. Looking at Downey's 1876 photograph of the queen-empress, taken a quarter of a century after the Travancore Throne's production and at the outset of Britain's era of high imperialism, it is easy to infer from it a crystallizing of the monarch's 'imperialization' as she appropriates the Indian throne to denote the impending formalization of her role as *Kaiser-I-Hind*. To understand more fully the image projected by Victoria, however, it is important to consider what happened to the throne after its exhibition in 1851, and to

explore the portrayal of the queen's royal body and its juxtaposition with this object of empire.

Following the Great Exhibition, the Travancore Throne was moved to the Garter Throne Room at Windsor Castle, where it was placed under a canopy hung with red velvet embroidered with the royal coat of arms.[22] Windsor was already the repository of a diverse and evocative collection of items from the subcontinent acquired by successive monarchs since the reign of George III, albeit in somewhat different circumstances. Close to the Garter Throne Room, Windsor's North Corridor displayed Mughal daggers as well as items of dress and regalia owned by Tipu Sultan from the collections of George III, George IV and William IV, including parts of the Mysore ruler's throne, his war dress and helmet, and the jewelled saddle of his horse.[23] The North Corridor collection continued to expand; in 1861, the crown of the last of the Mughal emperors, Bahadur Shah II, was added to it (Figure 7.3).[24] Taken after the British capture of Delhi in September 1857 as part of the victors' vengeful and extensive looting of the 'mutinous' Mughal city, it had been purchased at auction by Captain Robert Tytler, who offered it to Victoria, along with two throne chairs that had belonged to the emperor – she purchased the items for the sum of £500.[25] Displayed in glass wall cases along the North Corridor, the collection of objects associated with legendary figures of Indian history – the Mughals and the 'Tiger of Mysore', Tipu Sultan – whose dynasties had come to an end under

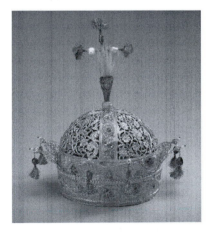

**Figure 7.3**  Crown of the Emperor Bahadur Shah II, second quarter of nineteenth century, gold, turquoises, rubies, diamonds, pearls, emeralds, feathers and velvet. Royal Collection Trust ©Her Majesty Queen Elizabeth II 2017.

British expansion and control of South Asia were freighted with symbolic value. Mrinalini Rajagopalan has noted of the rapacious looting that followed the capture of Delhi that

> in addition to their value as tradeable commodities; looted objects also became fetish objects, taking on the affective power of trauma or loss from the Mutiny. Even as looting plucked objects from their original contexts, truncating their links to Mughal imperial power and sovereignty, it also recast them as relics of the Mutiny – objects that were charged with the affect of rebellious Indians or the exuberance of British victory.[26]

Rajagopalan rightly calls attention to the emotional value that inhered in looted objects, a phenomenon that was particularly pronounced during and immediately after 1857, when outrage, revenge, trauma and a desire for memorialization structured British military and cultural responses to the Mutiny.[27] Victoria herself followed the events in India closely and with great concern, but she was attentive to measured voices like that of Governor-General Lord Canning, who warned of the dangers posed by the 'violent rancour of a very large proportion of the English community', whose clamours for indiscriminate revenge presented 'a great impediment in the way of restoring tranquillity and good order'.[28] Victoria's 1858 Proclamation assured the 'Princes, Chiefs, and People of India' of their new sovereign's sense of duty and clemency towards them, her respect of India's ancient laws and rights, and her tolerance of India's religious plurality.[29] The nature of her and Albert's involvement in the drafting of the Government of India Bill, particularly in relation to the conciliation of the Indian princes, is suggestive of a desire to close down the amplified emotional responses and registers that had structured the British response to the Mutiny. Seen in this light, objects such as Bahadur Shah's crown and other 'relics', closed off in glass cases, became not so much fetish objects charged with the emotional values of their contexts, but objects interred firmly within the terrain of history, and neutralized within the picturesque arrangement of the armoury. Representative of the expansionary regime of the East India Company (Victoria assured her Indian subjects in 1858 that Britain would attempt no further territorial conquest in the subcontinent) they remained highly symbolic, but belonged to a past era, shut away where their affect could no longer be recharged. This is not to say that objects originating in empire were now to take on a dry, exclusively museological visibility within the royal households. As we shall see, affect animated the monarch's engagement with empire and produced meanings around individual objects, but the kinds

of objects concerned differed sharply from the captured regalia and arms that dominated existing conceptions of empire in the royal collection.

Unlike the Indian items in the North Corridor displays, the Travancore Throne had come directly to the monarch from a ruler. It was fundamentally, therefore, a different category of object, and carried different kinds of meanings, to the regalia that came to Britain through conquest and capture which, more recently, had included items such as Maharaja Ranjit Singh's throne (also displayed at the Great Exhibition, and subsequently at the India Museum) and the now-repatriated Kandyan throne, seized after the East India Company's annexation of Sri Lanka and exiling of the king of Kandy in 1815 (presented to the Prince Regent around 1820, it replaced the Travancore Throne in the Garter Throne Room during Edward VII's reign). In the cases of these latter objects, capture of the regalia itself symbolized the establishing of triumphant 'overlordship … the taking away of the sovereignty of indigenous rulers'.[30] The Travancore Throne connoted none of these things. While it was used by Victoria for state events, the strong narrative that was already established around it, thanks to its public exhibition and its dissemination through various printed media, meant that it was understood both as a gift and a fine example of South Indian craftsmanship and traditional design. As Kate Smith has noted, ivory furniture was not a traded commodity in the East India Company period, but entered Britain through specific commissions by a colonial elite, consequently retaining narrative links to its place of origin and to specific empire families.[31] The Great Exhibition, however, seems to have moved ivory carving more fully into the global marketplace and re-indigenized its forms and designs, with successive maharajas of Travancore generating international interest for such goods through display in exhibitions in India and Europe, eventually necessitating the establishment of a government department of ivory carving in Travancore in 1872 to deal with the volume of orders.[32] Victoria's appropriation of the ivory throne in her portrait thus re-presented the object publicly at a moment when the skills of South Indian ivory carvers were in increasing demand, and when a revival of traditional Indian design, replacing prevalent European forms and decoration, was underway.[33] The photograph is composed in a way which allows the detail and varied techniques of the ivory work to be presented as fully as possible to the viewer. Rather than an assertion of the queen's augmented imperial role, therefore, the ivory throne represented, in Downey's photographic portrait, both an elite relationship between empress and maharajas of Travancore, and Victoria's ongoing encouragement of the

Indian manufactures that the Great Exhibition had brought so successfully to the attention of a wide public.[34]

In Downey's photograph, the figure of Victoria herself invokes other kinds of 'imperial' relationships. Fifteen years into her widowhood, the queen-empress is dressed in an elaborate mourning gown. In itself, this is ostensibly unremarkable, but Victoria's attire is suggestive on this occasion because of the specific ways in which the memory of the prince consort is evoked and conducted through the stimulus of mourning dress. Albert's interest in India had been strong, arguably more so than his wife's. Writing to the viceroy, Sir John Lawrence, in July 1864, Victoria urged him to make clear to her subjects

> the deep interest the Queen takes in the welfare of her Indian subjects, and how doubly she feels this interest, as her beloved great husband took so very deep an interest in India, and was constantly occupied with everything which could lead to the development of the resources of that great Empire, and to the prosperity and kind and just treatment of the natives; the Queen feels this is a sacred legacy, and wishes that her dear husband's great name should ever be looked upon with love by her Indian subjects.[35]

Victoria's augmented role in relation to India, and the opportunity she took to reissue, at the Coronation Durbar in Delhi in January 1877, the 1858 Proclamation guaranteeing Indians equal status with British subjects, may thus be seen as a consequence of the vow she made after Albert's death that '*his* wishes – *his* plans – about everything, *his* views about *every* thing are to be *my law!*', and as an accomplishment of his 'sacred legacy'.[36] The memory of Albert was also evoked through the throne itself, which the prince had notably sat upon for the closing ceremony of the Great Exhibition, taking the position of honour in recognition of his efforts in co-organizing the spectacle. Using the throne herself in her new role as Empress of India, Victoria structured her relationship with the subcontinent through the memory of her husband, his widely applauded achievements in 1851, and his ongoing legacy in her. In the days surrounding her sitting to Downey for the portrait, Victoria visited Albert's mausoleum at Frogmore frequently.

In addition to the maharaja's gift, and Albert's 'sacred legacy', one further relationship is invoked in Victoria's portrait as empress. Over her left shoulder, she wears the Order of Aftab, bestowed upon her by the shah of Persia, Naser al-Din, during his visit to Britain in 1873. Newly created for ladies prior to his departure for Europe, the honour that the shah bestowed upon Victoria at Windsor was

reciprocated by his investiture into the Order of the Garter during the same audience.[37] The shah's visit came at the behest of the British government, keen to improve relations with Persia, which occupied an important strategic position as a buffer zone between India and a Russian empire that was extending into Central Asia.[38] The encounter between Victoria and Naser al-Din was successful on both a diplomatic and a personal level, the queen describing it after the event as a 'pleasant and interesting recollection'.[39] The inclusion of his order in the portrait can thus be seen to reinforce and extend some of the image's other meanings, connecting Victoria to wider geographies of empire and to an international elite that now extended significantly beyond the European royal families to which she was already well-connected by blood, marriage and royal status. Downey's image was thus a complex one that positioned the figure of the empress conceptually within imperial spaces and networks, but that also – and importantly – mediated these associations through memory and affect, through personal relationships, and through a careful presentation of indigenous craft and manufacture.

A few weeks after her portrait was taken by Downey, Victoria opened Parliament for the first time in fifteen years, announcing – to the surprise of the Opposition – the introduction of the Royal Titles Bill that would grant her the coveted title of Empress of India:

> I am deeply thankful for the uninterrupted health which my dear Son, the Prince of Wales, has enjoyed during his journey through India. The hearty affection with which he has been received by my Indian subjects of all classes and races assures me that they are happy under my rule, and loyal to my throne. At the time that the direct Government of my Indian Empire was transferred to the Crown, no formal addition was made to the style and titles of the Sovereign. I have deemed the present a fitting opportunity for supplying this omission.[40]

What is worth noting here is the structural logic of Victoria's announcement which, in a few brief sentences, builds up from positioning herself as a concerned mother, to articulating her status as beloved sovereign of the Indian people, before culminating in a seemingly natural claim to the title of empress. It roots the political in the personal, and connects far off peoples within her own intimate sense of family. In this sense, it replicated the processes at work in Downey's portrait, offering reassurance that Victoria's assertion in relation to India was not, as those opposed to the creation of her new title feared, one of unconstitutional imperial aggrandizement, but was temperate, even feminine, structured through the enactment and memory of family and social relationships.

# Exhibiting imperial bonds

Victoria's official coronation, in absentia, as Empress of India at the 1877 Delhi Durbar organized by the viceroy of India, Lord Lytton, had come a long forty years after her coronation as queen. Ten years later, she celebrated her Golden Jubilee, and her Indian empire featured strongly in the year-long events. The queen-empress requested that Indian cavalry soldiers be sent to Britain, where they participated prominently in the processional celebrations.[41] A number of Indian princes (and one maharani) visited the court, while others sent delegations. Famously, the queen also acquired her two Indian servants, Abdul Karim and Mohammed Buksh, at this time, having requested from Dr John Tyler – the superintendent of Agra's Central Jail and organizer of the display of Indian craftsmen at the previous year's Colonial and Indian Exhibition – assistance in dealing with the visit of the Indian princes.[42] The princes began arriving in May, and on 30 June, Victoria held a grand reception in the Green Drawing Room at Windsor where she received the princes and deputations, and their gifts and addresses. A watercolour by Robert Taylor Prichett shows the Rao of Kutch, Khengarji III, kneeling before Victoria, perhaps receiving the miniature portrait of herself that she presented to him before investing him with the Grand Cross of the British Empire (Plate 10). To the right of the composition are tables laden with the gifts and, standing behind them, the Indian soldiers requested by Victoria (they 'looked splendid', she noted). Victoria was greatly struck by the appearances of her Indian guests – the Rao of Kutch was 'like a dream', while the maharaja and maharani of Cooch Behar were 'beautifully dressed' (the latter had previously been urged to ignore the advice of her milliner and to eschew European dress in favour of Indian finery).[43] The gifts presented to Victoria that day included silver ornaments, a ruby and diamond pendant, an ivory workbox, a pearl ornament, and addresses in gold and silver cases (many more would follow, or had already arrived). After the reception, Maharaja Thakur Wagjii II Rawaji of Morvi appeared at the entrance to Windsor Castle on a 'splendidly caparisoned' horse from his own stables 'begging [Victoria] to accept it as a present for him'.[44] The local photographer, George Piner Cartland, was sent for to capture the unconventional offering (Figure 7.4).

The exchange of gifts, portraits and honours served to reinforce and commemorate the personal encounters between Victoria and her Indian subjects. The maharani of Cooch Behar, Suniti Devi, recorded how 'very touched' she was when the queen wore the ruby pendant she had presented to her on her

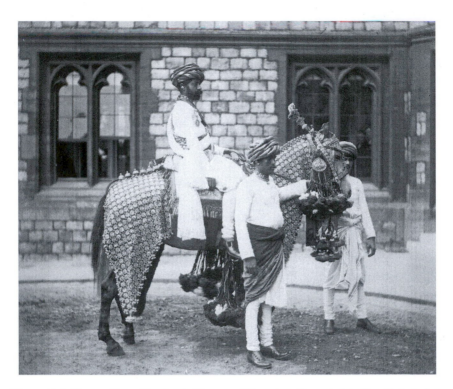

**Figure 7.4** George Piner Cartland, *Horse and Trappings Presented to Her Majesty by HH The Thakore of Morvi, KCIE*, 1887, albumen print. Royal Collection Trust ©Her Majesty Queen Elizabeth II 2017.

husband's behalf.[45] She regarded the monarch as 'an ideal ruler, and an ideal woman, linked to our hearts "across the black water" by silken chains of love and loyalty'.[46] The Jubilee year personalized and made tangible these far-reaching imperial links, but the immediate afterlife of the Jubilee gifts themselves served to make those bonds of empire visible as they were displayed to the public in a variety of locations and media. From September to December 1887, some 300 gifts were displayed at St James's Palace, which opened to the public for the first time to satisfy visitors' 'desire to see the rich offerings which have poured in from all parts of the world in token of homage, affection, and respect'.[47] The exhibition addressed its public carefully, adopting a rather different premise to that which had underpinned the exhibitions and tour in 1876–8 of the Prince of Wales's collection of gifts from his Indian tour, when the displays were conceptualized largely in terms of the narratives they could produce around national practices of design and manufacture.[48] In 1887, not only did the display of Jubilee gifts

demonstrate the strong ties that existed between the monarch and those British and imperial subjects who had showered her with gifts but, the press pointed out, the 'gracious act of her Majesty in acceding to this wish [of the public to view the gifts] is but a further proof of the strong bonds of sympathy which unite the Sovereign to her people'. [49] All visitors entered St James's through the Colour Court, undifferentiated by status, somewhat to the dismay of the 'gilt-edged ladies and gentlemen who have latch-keys for Buckingham Palace and other exclusive establishments'.[50] After collecting their entry permits, visitors were drawn through a circuit of the palace's interior 'exactly as those do who are presented at a Levée or Drawingroom'.[51] The Jubilee presents they viewed came from far and wide 'varying from the rare and costly gifts of Eastern potentates ... to the humble but not less acceptable proofs of affection ... and homely offerings from ragged school teachers and scholars'.[52] In positioning the public within the historical footsteps of Court visitors, and in juxtaposing elite and homespun gifts, the exhibition exercised a levelling effect that served to conceptualize the queen's subjects as equals in her affection. Notwithstanding the democratizing impulses of the exhibition, the Indian gifts, conspicuous for the wealth of their materials and the quality of their craftsmanship, commanded particular attention, often isolated for textual and visual description by the press. Engravings in *The Graphic* and *The Illustrated London News* focused on three gifts made by the maharaja of Travancore, on the trappings gifted with the horse of Maharaja Thakur of Morvi, and on elaborate address caskets presented by the Kathiawari chiefs, the maharaja of Kolhapur and the citizens of Allahabad (Figure 7.5).[53] Juxtaposed in the illustrations with gifts from the queen's family, the Indian offerings reinforced the sense of an imperial family and drew attention to the individuals who had bestowed them.

The circulation of the Jubilee gifts continued. Returned to Windsor briefly in December 1887, they were quickly moved again, this time to the Bethnal Green Museum, while display cases were built in Windsor's Grand Vestibule to accommodate them permanently.[54] The Bethnal Green exhibition offered a stark contrast with the levée-like experience of visiting the St James's display. An outpost of the South Kensington Museum, the Bethnal Green Museum had opened in 1872 with the aim of extending South Kensington's educational mission to the poor of London's East End; an engraving published on the front cover of *The Graphic* on 25 February 1888 suggests that the Bethnal Green exhibition may have been a more crowded experience than the St James's Palace displays, where organizers had exercised strict controls on numbers of visitors

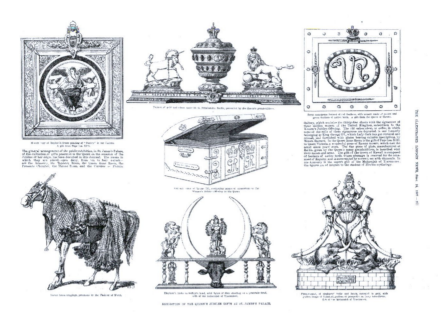

**Figure 7.5** 'Exhibition of the Queen's Jubilee Gifts at St James's Palace', *Illustrated London News*, 24 September 1887. Private Collection.

entering the rooms.[55] In a vignette at the bottom of the page, a group of visitors throngs around one of the maharaja of Travancore's gifts, a pair of gold-mounted elephant tusks purposed as a flower stand and surmounted by a gold figure of Lakshmi, the Hindu goddess of wealth (Figure 7.6). As the visitors crane their necks and distort their bodies to view the exhibit, one cannot help but detect a hint of humour in their juxtaposition with the ethereal figure of Lakshmi, rising serenely above an East End crowd which could only dream of the prosperity she symbolized. Whatever the illustrator's intention, though, *The Graphic* was clear that the exhibition, like its predecessor at St James's, 'amply testifies to the respect with which Her Majesty is regarded abroad, and the feelings of loyalty which are universally entertained throughout the British Empire'.[56] By the end of the year, the Jubilee gifts were installed in Windsor's newly fitted Gothic glass-fronted display cabinets. But it was not long before some of them moved again. By the end of October 1892, Bhai Ram Singh had completed work on the Durbar Room in Osborne House's new wing (Figure 7.7) and the gifts from the Indian princes were to be found there by the end of the decade.[57] Separated from the remainder of the Jubilee offerings, and presented on side tables in the 'splendid apartment ... in ancient Hindu and Sikh pattern', the Indian gifts seemed now

**Figure 7.6** 'Exhibition of her Majesty's Jubilee Presents at the Bethnal Green Museum', *The Graphic*, 25 February 1888 (detail). Private Collection.

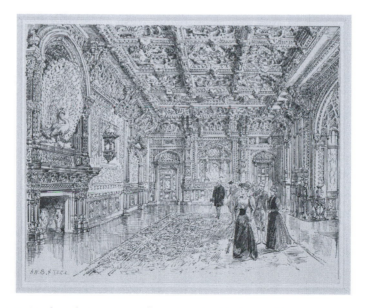

**Figure 7.7** Attributed to Henry William Brewer, *The Indian Room at Osborne House*, c.1891, ink on paper. Royal Collection Trust ©Her Majesty Queen Elizabeth II 2017.

to have returned 'home', presented in a display whose logic re-engaged their geographical origins and – in some cases – presented portraits of the gifts' donors in the adjacent corridor.[58]

Victoria's Indian gifts had traversed the distance of empire and were now to be encountered in a context which brought the empire home, situating Indian aesthetics and craft within the space of a royal household. The Durbar Hall was conceived as both a formal reception hall for 'occasions particularly concerning the Asiatic guests of her Majesty' and as a space which supplemented the domestic arrangements of Victoria's favourite residence; like their setting, the gifts cut across both political and personal territory, forging links of empire and individual friendship.[59] Their circulation across the West and East Ends of London – and, more widely, through the medium of printed reproduction – represented something more than a brief interlude before they arrived in their logical setting, however. Just as Victoria had, in 1851, indicated her approval of the opportunity that the Great Exhibition provided for the public to view works traditionally situated and hidden within the elite realm of gift exchange, so too she expressed satisfaction at the knowledge that, within a fortnight of the Jubilee gifts going on display, '100,000 people have been through the rooms, & some of the very poorest'.[60] As the publicity and reporting on the exhibitions demonstrated, the presentation of the gifts to the public ensured the proliferation of the bonds of allegiance and affection that the gifts themselves had initially reflected and engendered, extending them across space and social class. The Jubilee presents became bound up not only with the good wishes of their individual donors, but with the loyalty and respect of the British public. One periodical's assessment that 'a visit to the Jubilee gifts will be a lasting memory worthy to be handed down for ages, as a people's tribute of love and respect for a virtuous, noble Queen' suggested a belief that these bonds would prevail across time, as well as space.[61] As they settled, until Victoria's death, in the Durbar Room at Osborne, the objects thus not only complemented the craftsmanship and aesthetics of their exotic surroundings, but acted as repositories of love and loyalty to the queen-empress. Laid out on tables and susceptible – unlike the objects entombed in Windsor's North Corridor cases – to touch and engagement, their meanings and memories could be animated within the practices of state business or everyday life.

The suppressed affect of those trophies of war collected by Victoria's predecessors had thus found a positive alternative in the objects she received from, and circulated among, her Indian and British subjects. In addition, the

Jubilee gifts and their reception and circulation remedied the problematic dynamics of Durbar gift-exchange that had emerged in India between British officials and native rulers during the first half of the nineteenth century. As Bernard Cohn has noted, the British had failed to comprehend the symbolic import of the Durbar – a ritual which hinged upon the incorporation of the recipient of wearable gifts, such as clothes, jewels and arms, into the body of the donor – seeing it instead as a process of straightforward economic exchange and, consequently, of bribery and corruption that needed to be eradicated via careful restriction and management of such occasions and offerings.[62] The staging of a hybridized Indo-European form of the Durbar within the queen's household, her presentation of the princes with honours and her portrait, and her considered wearing and circulation of the gifts re-established the ritual as a symbolic and personal one that strengthened allegiances and that individualized abstract political relationships, even incorporating them bodily. In contrast to the large-scale, imperialistic spectacle of the 1877 Delhi Coronation Durbar, the reception of the Indian princes at Windsor ten years later – and the acceptance and display of their ceremonial offerings – domesticated and personalized the queen's relationship to her Indian subjects, and rooted the symbolic within the tangible.

The loyalty of Britain's imperial subjects was not, of course, as easily won and widely maintained as this narrative might appear to suggest. The years in which the Jubilee gifts were on the move saw the inception of an Indian nationalist movement, the seeds for which were sown by the founding of the Indian National Congress in 1885. The period between the Travancore Throne's arrival in London and its photographing in Victoria's official portrait as Empress of India witnessed not only the Indian Rebellion, but the consequent development of an imperial policy which was predicated on deep suspicion of India's indigenous population – Victoria's commission and display of Rudolf Swoboda's empathetic portraits of her Indian subjects can be contrasted with colonial ethnographic photography projects such as John Forbes Watson and John William Kaye's *People of India* (1868–75) to witness just how wide the gulf was between her imperial interests and her government's.[63] The cultural, social and political practices touched upon in this chapter do not tell us about the success or otherwise of imperial policy during Victoria's period as Empress of India, so much as reveal something about the means through which Victoria engaged with her Indian empire from a distance. These processes were not only geographically, but conceptually removed from the labours and violence

of imperial rule that took place in the field; they remained rooted within the royal households and – as we have seen – were structured through friendships and familial relationships, relying on the production and demonstration of bonds of affection, loyalty and sentiment. But it is important to recognize that this was an endeavour, and even a form of imperial labour, in itself, one that in our contemporary framework might be reasonably understood in terms of the (often unrecognized) emotional labour that women habitually undertake. While the newly- 'imperialised monarchy', in the figure of Victoria, embodied empire through affect rather than through feats of imperial derring-do, it was nonetheless constitutive of empire, as well as strengthening and replicating it at home. Whether Victoria's affective Indian empire mapped onto, complemented, or even subverted her successive governments' imperial policies, requires a much fuller and more extended consideration of the kinds of cultural and political processes that this chapter has begun to explore.

One late addition to Victoria's collection of Jubilee gifts arrived in November 1887, presented to her by General William Fielding on behalf of the sultan of Johor.[64] Made in London by the firm of J. W. Benson, Victoria's latest gift was a gold, silver and enamel model of the memorial to Prince Albert in Hyde Park (Plate 11). The commission (given to the queen's official watchmaker) reversed the conventional logic of imperial gift giving, electing to employ British craftsmanship over local manufacture. But in other ways, the sultan's gift encapsulated the kinds of personal relationships, embedded within objects that structured Victoria's engagement with empire. Implicating her deceased husband as well as an indigenous ruler with whom Victoria enjoyed a strong personal acquaintance, the model not only drew together figures through whose friendships and 'sacred legacy' she experienced empire, but rooted and revived them in memory and affect. Perhaps as the queen-empress looked at the sultan's present when she stayed at Osborne, she could see her own image captured in the model's wide, reflective silver base, drawing her visibly into the affective empire the gift implicated.

# Notes

1   RA VIC/MAIN/QVJ (W) 3 December 1875 (Princess Beatrice's copies). Retrieved 31 March 2017. All references to Queen Victoria's journals are to the digitized version of Princess Beatrice's transcriptions in the Royal Archive: http://www.

queenvictoriasjournals.org. Downey's photographic prints are dated in the Royal Collection records to 1 January 1876.

2 Julie Codell (ed.), *Power and Resistance: The Delhi Coronation Durbars* (Ahmedabad: Mapin Publishing, 2012).

3 Discussions about the formal conferral of the title appear to have been initiated by the queen in 1873, when her secretary, Colonel Henry Ponsonby, wrote to the foreign secretary, Lord Glanville. See Colonel Ponsonby to Earl Granville, 26 January 1873 in *The Letters of Queen Victoria: Second Series. A Selection of Her Majesty's Correspondence and Journal between the Years 1862 and 1878*, 3 vols, ed. George Earle Buckle (London: John Murray, 1926–8), II, 238. In early January 1876, Disraeli apprised Victoria of some of the reservations and legal difficulties raised in relation to the formulation of the title (*The Letters of Queen Victoria: Second Series*, II, 438–49).

4 Miles Taylor, 'Queen Victoria and India, 1837-61', *Victorian Studies* 46, no. 2 (2004): 264–74.

5 Ira B. Nadel, 'Portraits of the Queen', *Victorian Poetry* 25, no. 3/4 (1987): 169–91.

6 David Cannadine, *Orientalism: How the British Saw Their Empire* (London: Allen Lane, 2001), 101.

7 See, for example, Codell, *Power and Resistance* (2012); Kajal Meghani, *Splendours of the Subcontinent: A Prince's Tour of India* (London: Royal Collection Trust, 2017); Martina Droth, 'Empire Day Unveilings and Ceremonies', in *Sculpture Victorious: Art in an Age of Invention, 1837-1902*, eds Martina Droth, Jason Edwards and Michael Hatt (New Haven and London: Yale University Press, 2014), 127–31; Jennifer Powell, 'The Dissemination of Commemorative Statues of Queen Victoria', in *Modern British Sculpture*, eds Penelope Curtis and Keith Wilson (London: Royal Academy of Arts, 2011), 282–8; Chandrika Kaul, 'Monarchical Display & the Politics of Empire: Princes of Wales and India, 1870s-1920s', *Twentieth Century British History* 17, no. 4 (2006): 464–88; Charles V. Reed, *Royal Tourists, Colonial Subjects and the Making of a British World, 1860-1911* (Manchester: Manchester University Press, 2016); and the introductions and essays in Robert Aldrich and Cindy McCreery (eds), *Crowns and Colonies: European Monarchies and Overseas Empires* (Manchester: Manchester University Press, 2016) and Sarah Carter and Maria Nugent (eds), *Mistress of Everything: Queen Victoria in an Indigenous World* (Manchester: Manchester University Press, 2016).

8 On the new Osborne House wing and its decoration, see Julius Bryant, 'Kipling's Royal Commissions: Bagshot Park and Osborne', in *John Lockwood Kipling: Arts & Crafts in the Punjab and London*, eds Julius Bryant and Susan Weber (New Haven and London: Yale University Press, 2017), 435–67; Julius Bryant, 'Royal Gifts from Victorian India: the New Display in the Durbar Room at Osborne

House', *Collections Review* 4 (2003): 116–24; Michael Hunter, 'Faces of India at Osborne House', *Collections Review* 4 (2003): 111–15; and Saloni Mathur, *An Indian Encounter: Portraits for Queen Victoria* (London: National Gallery, 2002).

9   See Shrabani Basu, *Victoria & Abdul: The True Story of the Queen's Closest Confidant* (Stroud: The History Press, 2010) and Michael Alexander and Sushila Anand, *Queen Victoria's Maharaja: Duleep Singh, 1838-93* (London: Weidenfeld and Nicholson, 1980). The Queen's 'maternal care' of Princess Victoria Gouramma is discussed in Chapter XI of E[dith] Dalhousie Login, *Lady Login's Recollections: Court Life and Camp Life, 1820-1906* (London: Smith, Elder & Co., 1916).

10  See Bernard S. Cohn, 'Representing Authority in Victorian India', in *The Invention of Tradition*, eds Eric Hobsbawm and Terrence Ranger (Cambridge: Cambridge University Press, 1983), 165–208.

11  *Carlton House: The Past Glories of George IV's Palace* (London: Queen's Gallery, 1991). The only surviving view of the Armoury is an 1814 watercolour by Augustus Charles Pugin (Royal Collection) in which the equestrian figure in Tipu's clothes and horse furniture is prominent.

12  Caroline Keen, *Princely India and the British: Political Development and the Operation of Empire* (London and New York: I B Tauris, 2014).

13  RA VIC/MAIN/QVJ (W) 24 November 1875 (Princess Beatrice's copies). Retrieved 31 March 2017.

14  RA VIC/MAIN/QVJ (W) 16 July 1851 (Princess Beatrice's copies). Retrieved 31 March 2017.

15  Carol A. Breckenridge, 'The Aesthetics and Politics of Colonial Collecting: India at World Fairs', *Comparative Studies in Society and History* 31, no. 2 (1989): 195–216. On India at the Great Exhibition, see Lara Kriegel, 'Narrating the Subcontinent in 1851: India at the Crystal Palace', in *The Great Exhibition of 1851: New Interdisciplinary Essays*, ed. Louise Purbrick (Manchester: Manchester University Press, 2001), 146–78.

16  Uthram Thirunal Marthanda Varma, Maharaja of Travancore to Queen Victoria, 11 October 1850, quoted in P. Shungoonny Menon, *Travancore from the Earliest Times* (Madras: Higginbotham & Co., 1878), 469.

17  Great Exhibition of the Works of Industry of All Nations, *Official Descriptive and Illustrated Catalogue*, 3 vols (London: Spicer Brothers, 1851), II, 892.

18  'Indian Ivory Carving for the Great Exhibition', in *The Illustrated London News*, 26 April 1851, 335.

19  Queen Victoria to Uthram Thirunal Marthanda Varma, Maharaja of Travancore, dated 21 August 1851, quoted in Menon, *Travancore from the Earliest Times*, 474.

20  'State Reception at Trivandrum, the Capital of Travancore', in *The Illustrated London News*, 31 January 1852, 90.

21  Menon, *Travancore from the Earliest Times*, 473. Although it is not within the scope of this essay to discuss these, there are interesting parallels between Lewis's visual recording of the maharaja's receipt of Victoria's letter and the lithographic reproduction, three years later, of a watercolour by the Marchioness of Waterford depicting the reception of a letter of concern from the queen to sick and wounded Crimean soldiers. On the latter, see Rachel Bates, "'All Touched my Hand": Queenly Sentiment and Royal Prerogative', *19: Interdisciplinary Studies in the Long Nineteenth Century* 20 (2015), DOI: http://doi.org/10.16995/ntn.708

22  The canopy and throne can be seen in paintings of Napoleon III's 1855 investiture into the Order of the Garter by George Houseman Thomas and Edward Matthew Ward (both in the Royal Collection). Photographs from the 1860s also show the throne in this location.

23  Nasir al-Din Shah, *The Diary of His Majesty, the Shah of Persia, during his Tour though Europe in 1873*, trans. James W. Redhouse (London: James Murray, 1874), 202. Prince Albert had superintended the arrangement of the glass cases in 1848, displaying Tipu's former possessions 'in one case, other Indian things in another, and so on' (RA VIC/MAIN/QVJ (W) 2 November 1848 (Princess Beatrice's copies). Retrieved 31 March 2017.

24  I am grateful to Kajal Meghani of the Royal Collection for providing me with information about the North Corridor display.

25  The crown's purchase by Victoria is recounted in Harriet Tytler, *An Englishwoman in India: The Memoirs of Harriet Tytler, 1828-1858*, ed. Anthony Sattin, with an introduction by Philip Mason (Oxford: Oxford University Press, 1986), 176–7.

26  Mrinalini Rajagopalan, *Building Histories: The Archival and Affective Lives of Five Monuments in Modern Delhi* (Chicago, IL: University of Chicago Press, 2017), 42.

27  On cultural responses to the Indian Rebellion, see Sophie Gordon, 'A Sacred Interest: The Role of Photography in the City of Mourning', in *India's Fabled City: The Art of Courtly Lucknow*, ed. Stephen Markel (Los Angeles: LACMA, 2010), 145–63; Stephen J. Heathorn, 'Angel of Empire: The Cawnpore Memorial Well as a British Site of Imperial Remembrance', *Journal of Colonialism and Colonial History* 8, no. 3 (2007), available online: https://muse.jhu.edu/article/230163 (accessed 27 May 2017) and Nayarani Gupta, 'Pictorializing the "Mutiny" of 1875', in *Traces of India: Photography, Architecture, and the Politics of Representation*, ed. Maria Antonella Pelizzari (New Haven and London: Yale University Press, 2003), 216–39.

28  Viscount Canning to Queen Victoria, 25 September 1857 in *The Letters of Queen Victoria: A Selection from Her Majesty's Correspondence between the Years 1837 and 1861*, eds A. C. Benson and Viscount Esher, 3 vols (London: John Murray, 1908), III, 251–2.

29  *Proclamation by the Queen in Council to the Princes, Chiefs and People of India, Published by the Governor-General at Allahabad, November 1st, 1858* (London: HMSO, 1858).

30  See Robert Aldrich, 'The Return of the Throne: The Repatriation of the Kandyan Regalia to Sri Lanka', in *Crowns and Colonies: European Monarchies and Overseas Empires*, eds Robert Aldrich and Cindy McCreery (Manchester: Manchester University Press, 2016), 139–61.

31  Kate Smith, 'The Afterlife of Objects: Anglo-Indian Ivory Furniture in Britain', *East India Company at Home* (July 2014), available online: http://blogs.ucl.ac.uk/ eicah/files/2014/07/Ivory-Furniture-PDF-altered-20.10.16-copy-1.pdf (accessed 5 May 2017).

32  Edgar Thurston, *Monograph on the Ivory Carving Industry of Southern India* (Madras: Government Press, 1901), 5.

33  Thurston, *Monograph on the Ivory Carving Industry*, 6.

34  Marthanda Varma had died in 1860. The maharaja of Travancore in 1875 was Ayilyam Thirunal Rama Varma III, a reforming ruler who won the approval of the Madras Government, and was admitted into the Order of the Star of India in 1866.

35  Queen Victoria to Sir John Lawrence, 26 July 1864 in *Letters of Queen Victoria*, ed. Buckle, I, 242.

36  Queen Victoria to the King of the Belgians, 24 December 1861, in *Letters of Queen Victoria*, eds Benson and Esher, III, 476.

37  RA VIC/MAIN/QVJ (W) 20 June 1873 (Princess Beatrice's copies). Retrieved 31 March 2017. See also Nasir al-Din Shah, *Diary of His Majesty, the Shah of Persia*, 149.

38  See Rose Greaves, 'Iranian Relations with Great Britain and British India, 1797-1921', in *The Cambridge History of Iran*, vol. 7, eds Peter Avery, Gavin Hambly, and Charles Melville (Cambridge: Cambridge University Press, 1991), 374–425 and Jennifer Scarce, 'Entertainments East and West: Three Encounters between Iranians and Europeans during the Qajar Period (1786-1925)', *Iranian Studies* 40, no. 4 (2007): 455–66.

39  RA VIC/MAIN/QVJ (W) 11 July 1873 (Princess Beatrice's copies). Retrieved 31 March 2017.

40  United Kingdom. *Hansard Parliamentary Debates*, 3rd ser., vol. 227, c.4, 8 February 1876 (The Queen's Speech). http://hansard.millbanksystems.com/lords/1876/ feb/08/the-queens-speech (accessed 1 June 2017).

41  Earl of Dufferin to Queen Victoria, 31 March 1887 in *The Letters of Queen Victoria*, third series, 3 vols, ed. George Earle Buckle (London: John Murray, 1930-2), I, 295–6.

42  Basu, *Victoria & Abdul* (2011), 7. On the Colonial and India exhibition, see Saloni Mathur, 'Living Ethnological Exhibits: The Case of 1886', in *Cultural Anthropology* 36, no. 2 (2000): 492–524.

43  Earl of Dufferin to Queen Victoria, 31 March 1887, *op.cit.* and Sunity Devee [Suniti Devi], Maharani of Cooch Behar, *The Autobiography of an Indian Princess* (London: John Murray, 1921), 105.

44  RA VIC/MAIN/QVJ (W) 30 June 1887 (Princess Beatrice's copies). Retrieved 31 March 2017.

45  Devi, *Autobiography*, 117.

46  Ibid., 108.

47  Ibid., 5.

48  On the exhibitions of the Prince of Wales's collection, see Meghani, *Splendours of the Subcontinent*, 27–31.

49  'The Queen's Jubilee Gifts', in *The Illustrated London News*, 17 September 1887: 336.

50  'The Man About Town', in *The Country Gentleman: A Sporting Gazette and Agricultural Journal*, 1 October 1887: 1311.

51  'The Queen's Jubilee Gifts', in *The Illustrated London News*, 17 September 1887: 336.

52  'Exhibition of the Queen's Jubilee Gifts', in *The Morning Post*, 12 September 1887: 5.

53  The caption to the *Illustrated London News* engraving attributes the address case shaped in the form of a lighthouse to the non-existent 'Maharaja of Nothpur'; the catalogue to the subsequent exhibition at Bethnal Green reveals this object to be the gift of the maharaja of Kolhapur (see Bethnal Green Branch Museum, *Exhibition of the Jubilee Presents, Lent by Her Majesty the Queen* (London: Harrison & Sons, 1888), 30).

54  RA VIC/MAIN/QVJ (W) 13 December 1887 (Princess Beatrice's copies). Retrieved 31 March 2017. The gifts were laid out in the Waterloo Chamber at this point, and Victoria noted that the 'empty looking' Grand Vestibule would best accommodate the necessary cases. On the Bethnal Green exhibition, see *The Graphic*, 25 February 1888: 186.

55  On Bethnal Green, see Kriegel, *Grand Designs*.

56  'The Jubilee Presents at Bethnal Green', in *The Graphic*, 25 February 1888: 186.

57  Bryant, 'Royal Gifts from Victorian India', 118.

58  'The Indian Room at Osborne House', in *The Graphic*, 29 October 1892: 532. Rudolf Swoboda's portraits in the Durbar Corridor included representations of Sir Pratap Singh and the Rao of Kutch, who had both attended the 1887 Jubilee celebrations. On Swoboda, see Saloni Mathur, *India by Design: Colonial History and Cultural Display* (Berkeley and Los Angeles: University of California Press, 2007), 80–108 and *An Indian Encounter* (2002).

59  'The Indian Durbar Hall at Osborne', in *The Illustrated London News*, 12 August 1893: 198.

60  RA VIC/MAIN/QVJ (W) 30 December 1887 (Princess Beatrice's copies). Retrieved 31 March 2017.

61  'Mingling the Past with Present Art', in *The Ladies' Treasury: A Household Magazine*, 1 October 1887: 630.

62  Cohn, 'Representing Authority in Colonial India', 167–72.

63  See John Falconer, '"A Pure Labour of Love": A Publishing History of *The People of India*', in *Colonialist Photography: Imag(in)ing Place and Race*, eds Eleanor M. Hight and Gary Sampson (London and New York: Routledge, 2002), 51–83.

64  RA VIC/MAIN/QVJ (W) 29 November 1887 (Princess Beatrice's copies). Retrieved 31 March 2017. Victoria's journal incorrectly ascribes the gift to the maharaja of Travancore.

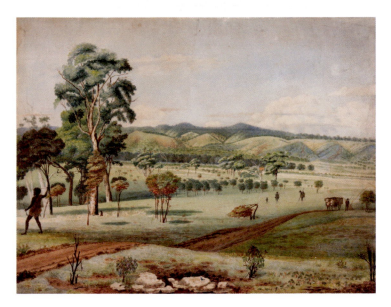

**Plate 1** Martha Berkeley, Australia, 1813–99, *Mount Lofty from The Terrace, Adelaide*, c. 1840, Adelaide. Watercolour on paper, 34.5 × 45.0 cm. South Australian Government Grant 1935. Art Gallery of South Australia, Adelaide.

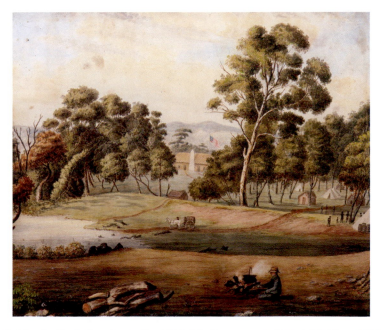

**Plate 2** Martha Berkeley, Australia, 1813–99, *Government Hut, Adelaide*, c. 1839, Adelaide. Watercolour on paper. 29.0 × 34.0 cm. South Australian Government Grant 1935. Art Gallery of South Australia, Adelaide.

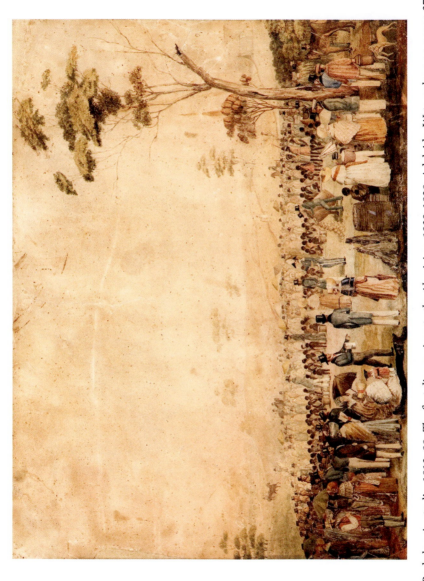

**Plate 3** Martha Berkeley, Australia, 1813–99. *The first dinner given to the Aborigines 1838*, 1838, Adelaide. Watercolour on paper, 37.5 × 49.5 cm. Gift of J. P. Tonkin 1922. Art Gallery of South Australia, Adelaide.

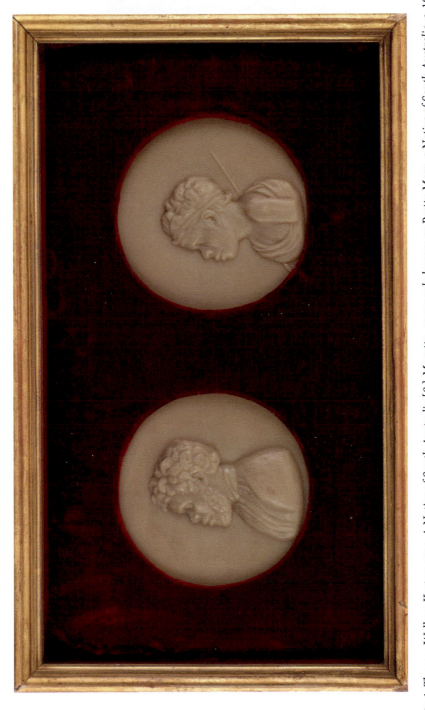

**Plate 4** Theresa Walker, *Kertamaroo, A Native of South Australia* [&] *Mocatta, commonly known as Pretty Mary, a Native of South Australia,* c. 1840, two wax medallions in velvet-covered mount. State Library of New South Wales.

**Plate 5** Front cover, lacquered board with mother-of-pearl inlay, *Album of Miss Eliza Younghusband, South Australia*, 1856–65. National Library of Australia.

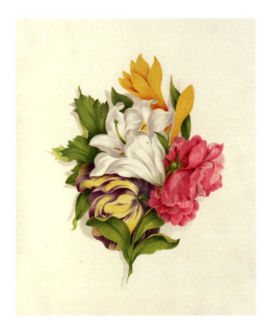

**Plate 6** 'Bouquet of flowers', c. 1860, gouache, *Album of Miss Eliza Younghusband, South Australia*, 1856–65. National Library of Australia.

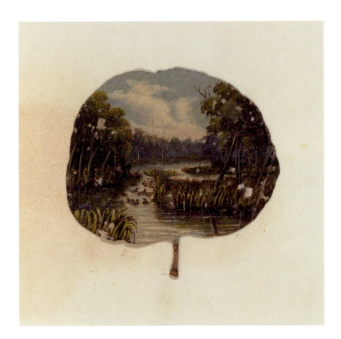

**Plate 7** 'Lake scene on a gum leaf', c. 1860, oil on gum leaf, *Album of Miss Eliza Younghusband, South Australia*, 1856–65. National Library of Australia.

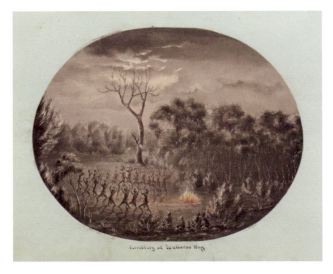

**Plate 8** William Wyatt, 'Cooroboree at Wallaroo Bay, South Australia', 1860, watercolour, *Album of Miss Eliza Younghusband, South Australia*, 1856–65. National Library of Australia.

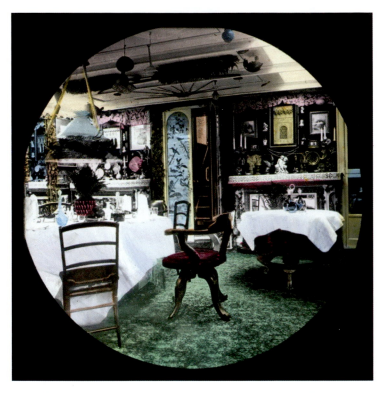

**Plate 9** Hand-coloured lantern slide showing the interior of the saloon of the Brasseys' yacht *Sunbeam*, c. 1878. Bexhill Museum, Bexhill-on-Sea, East Sussex.

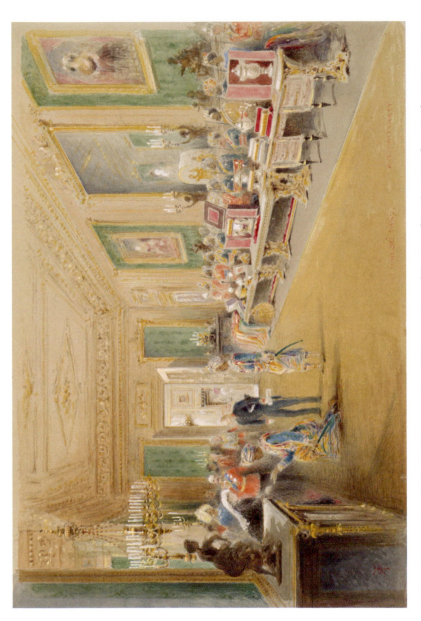

**Plate 10** Robert Taylor Pritchett, *The Golden Jubilee, June–July 1887: Reception of the Rao of Kutch at Windsor Castle*, 30 June 1887, watercolour and bodycolour. Royal Collection Trust ©Her Majesty Queen Elizabeth II 2017.

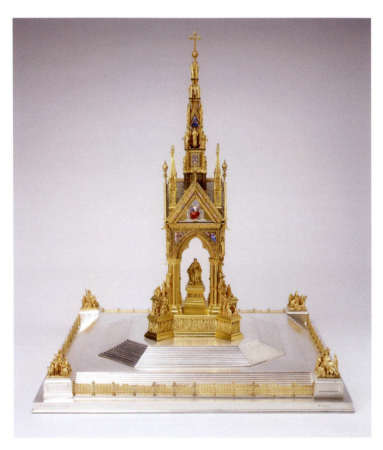

**Plate 11** J. W. Benson, *Model of the Albert Memorial*, 1887, gold, silver and enamel. Royal Collection Trust ©Her Majesty Queen Elizabeth II 2017.

# 'Prime Minister in the Home Department': Female Gendered Identity in Colonial Upper Canada[1]

Rosie Spooner

About that time the idea of emigration to Canada had taken hold of young men in England and Scotland. Land ownership was the lure. … It did not take long to convince immigrants of this type that an estate in Upper Canada was not the same sort of thing as an estate in England. Even those who realized that the value of the Canadian estate lay in the future felt little ground for satisfaction, for there was not much promise of prosperity in sight in Upper Canada.[2]

We went first to Blythe house which is, as you know, in a sad state of disrepair but we admired the butternut panelling of which Anne wrote so eloquently and which is still in excellent condition, and made our way with some trepidation up the shaky stairs to the second floor where we identified Anne's bedroom and those of her mother and aunt. The wooden mantel-piece in Anne's room still remains, so too do portions of the hand rail. … The site of Blythe house was expertly chosen and the vista was indescribably beautiful.[3]

With limited infrastructure and transportation routes, pre-industrial working and living conditions and a climate that fluctuated between intense heat over the summer and severe cold during the winter, early-nineteenth-century rural Upper Canada was a challenging place in which to eke out a comfortable existence. An article published in the *Dublin Penny Journal* in 1834, for example, stressed that migrating from Britain to North America would not necessarily result in accruing wealth and stability: 'It cannot be too strongly impressed on the minds of intending emigrants, that this is not a *Canaan* – that it is not a

land flowing with milk and honey – that, emphatically, it is on the sweat of his brow [that] man must depend for livelihood.'[4] In spite of such warnings, many Britons willingly immigrated to the region, which formed the southern portions of what is now the province of Ontario in eastern-central Canada.[5] Early arrivals to the area included those who moved after the conclusion of the American Revolution, taking up the free land grants being offered north of the border to those who had fought on the British side during the conflict. Prior to this influx of mainly English-speaking Protestant settlers, the land along the St Lawrence River that Britain had acquired through the Treaty of Paris (1763) had remained a single province that functioned largely according to cultural, religious and legal practices established when the area had been under French colonial control. The arrival of United Empire Loyalists, however, fundamentally altered the region's social and cultural composition and created a demand for a separate anglophone colony. Thus, in 1791 the former Province of Québec was divided into Upper Canada in the west and Lower Canada in the east, with the Ottawa River serving as a dividing line between the two new provinces.

Upper Canada continued to attract those who favoured the province's anglophone character, however, a high proportion of people who arrived in the decades immediately preceding the Confederation of Canada in 1867 were not once removed from Britain. Rather, this later wave of settlers came directly from England, Ireland, Scotland and Wales. A confluence of dynamics including industrialization, significant population growth, decreasing access to farmland and the economic decline caused by the Napoleonic Wars pushed many to leave Britain in this period. Factors that pulled emigrants specifically to Upper Canada included relative geographic proximity to Britain, the affordability and availability of land, and a shared sense of culture. Eager to resettle segments of the metropolitan populace, the British government promoted these benefits. Migration across the Atlantic presented a means of alleviating perceived social strains caused by a growing population, while simultaneously bolstering the fledgling colony of Upper Canada, which was seen as especially susceptible to American invasion and yet was estimated to have the capacity to develop into a major supplier of wheat, and potentially other valuable natural resources, that could be exported back to Britain.

During the 1830s, over 600,000 people left Britain for North America, with more than half choosing British colonies as their final destination over the United States.[6] While the majority were farmers, labourers, decommissioned soldiers or the very destitute, a notable segment of these newcomers came from

wealthier backgrounds and belonged to the gentry class. Popularly conceived as an expansive and sparsely populated landscape with a rugged natural beauty, perhaps Upper Canada appeared especially attractive to those with a Romantic disposition? Alternatively, more pragmatic concerns may have been the driving force, with resettlement seen as an opportunity to recoup land, income and savings lost during the economic depression of the early 1800s. Likely some combination of these factors propelled these gentlemen and gentlewomen settlers. Describing what had led his grandfather Thomas Langton to make the move from the northwest of England in 1837, W. A. Langton wrote, 'he seems to have been of an inventive, if not spectacular, disposition … [and] burned to have a hand in the contrivance of life in the backwoods'.[7] However, in his introduction to *Early Days in Upper Canada*, the published collection of letters written by his father John Langton (Thomas's youngest son who had moved to Upper Canada in 1833), W. A. Langton makes clear that the circumstances in which these comparatively affluent settlers found themselves often fell short of their expectations. As is alluded to in the opening excerpts, migrating to rural Upper Canada in the first half of the nineteenth century was a difficult process that did not always result in permanent settlement. Indeed, the Langtons left the large home they had built and furnished, Blythe Farm, after ten years of living and making a go of things on Sturgeon Lake, a period bookended by the deaths of three family members. Thomas Langton passed away in May 1838, just nine months after arriving in North America with his wife (Ellen Langton), sister-in-law (Alice Currer) and daughter (Anne Langton). With the deaths of Ellen and Alice nine years later, both due to ague, 'the tie that held [the family] to the farm was broken'.[8] This prompted John and Anne, along with John's wife Lydia (née Dunsford), to leave Blythe, initially recuperating in Peterborough and then travelling to Britain. Anne, who is this chapter's primary focus (see Figure 8.1), remained in England for three years before ultimately returning to Canada, living first in Peterborough, and latterly in Ottawa and Toronto with John, Lydia and their children.

Focusing on a particular group of British migrants, this chapter explores what it meant to settle in rural Upper Canada in the first half of the nineteenth century. Specifically, it examines the interplay between gender ideologies that were becoming increasingly dominant in Euro-North American society and the everyday realities of women's lives in this colonial outpost. Those British gentlewomen who took up the pioneering life did so amid shifting social conventions that increasingly emphasized gender segregation, with men and

women attributed a different, but ostensibly complementary, set of skills, abilities and 'natural' characteristics. As Barbara Laslett and Johanna Brenner explain, 'The turn of the nineteenth century saw the emergence of separate spheres as an ideology, and throughout the century separate spheres were institutionalized as the culturally and socially hegemonic form of gender relations.'[9] Outlining the clear incongruity between this discourse and the practicalities of women's lives in this colonial milieu, it is suggested here that negotiating this conflict was a principal facet of the settlement process for British women who left the relative comforts that befitted their elevated social positions in Britain for the so-called backwoods of Upper Canada.[10] Consequently, it builds on Dianne Lawrence's work on the intersections between migration, gender and material culture that took shape in the experiences of women whose lives traversed spheres of empire. In *Genteel Women* Lawrence posits a helpful definition, describing gentility as a 'system of values' and a 'highly nuanced form of knowledge' that directed not only how women conducted themselves in public, but the understandings of self they held within them.[11] Writing specifically about women in colonial Upper Canada, Elizabeth Jane Errington explains that understandings of femininity embodied in the ideology of separate spheres were at odds with the economic and social realities of most women's lives in the province, a dichotomy many would have found 'striking and disconcerting'.[12] Although both men's and women's day-to-day routines largely followed pre-industrial patterns, 'the cult of true womanhood was nonetheless considered by colonial leaders to be an important part of the "blue print" of what the young colony of Upper Canada should eventually become'.[13]

Building on the work of Errington and others, this chapter analyses the divergence between lived realities and dominant gender discourses through a close consideration of the circumstances of a specific colonial settler.[14] Its main argument emerges from looking at Anne Langton's letters and diaries through the lens of material culture. Indeed, it is anchored by Thomas Schlereth's evaluation that objects either made or modified by humans 'reflect the belief patterns of [the] individuals who made, commissioned, purchased, or used them, and by extension, the belief patterns of the larger society of which they are a part'.[15] Specifically, the present analysis draws on existing examinations of the relationship between women and the things they made, altered, collected, distributed, received and used.[16] The reading of Langton's diaries and letters offered here pays particular attention to her 'gendered material practices' and efforts at 'manipulating materiality', concepts that foreground the processes through which women constructed bodies of knowledge and invested both

themselves and the world around them with meaning.[17] This genre of scholarship allows us to uncover the complexities of social reproduction, a tenet of recent feminist theory that seeks to understand the 'activities and attitudes, behaviors and emotions, responsibilities and relationships' that women have routinely undertaken, but which have nevertheless been overlooked despite the crucial role they have played 'in the maintenance of life on a daily basis'.[18]

Beginning in May 1837, while en route across the Atlantic, and running until September 1846, Anne regularly wrote letters and kept a diary, the stated purpose of which was to give an impression of what was 'characteristic of the country'.[19] The recipients of these journals, which relayed the experiences and activities, sights and sounds that Anne felt typified her new lifestyle, were her older brother William and his wife Margaret, the only members of Anne's immediate family who chose to remain in Britain. Just two months after arriving on Sturgeon Lake, Anne began a letter to William by saying, 'I suspect I have not much original matter for you but shall most probably write on the two engrossing subjects of my thoughts, the progress of the house, and of the season, with my hopes concerning the one and my fears respecting the other.'[20] These subjects are indicative of Anne's writings, the majority of which comprise descriptions of her material surroundings and accounts of her interactions with the new social and physical setting in which she found herself.

In Langton's account we see overlapping layers of material practices at work. In what follows, the primary focus is Langton's lengthy and frequent descriptions of the activities that gave rhythm to her daily routine. Reading her journals gives us access to the objects she made, manipulated and arranged. We can sense their textures, smells and colours in spite of the fact that the real things – the candles made of tallow, the curtains made of muslin, the bonnets made of cotton and calico, the loaves of baked bread, and the cuts of preserved meat, to name only a few – are no longer within physical reach. Here, these varied activities are interpreted as reflections of an ambition and desire to bring together a range of objects that served both practical and decorative functions. This way of framing Langton's material practices bears the influence of scholarship on the nature of collecting and its impact on the home. Of particular relevance is the notion that the 'common denominator' among objects in personal collections is the 'collecting *subject*, whose identity then binds these objects together in a sort of visual and material biography'.[21]

In Langton's case, the act of putting pen to paper in order to purposefully narrate her domestic undertakings constitutes an additional material practice,

one that reveals added meaning since it signifies attributing value to the activities she chose to describe. As Fowkes Tobin and Daly Goggin remind us, 'Women's engagement with the material world, most obvious when a woman is making something – a doll, a sculpture, a cake – may be far less apparent, but no less productive, in cases such as writing a letter or bequeathing an heirloom.'[22] Consequently, it is suggested that for Anne the act of writing about her material practices, describing her role as a creator whose productions aligned with notions of gentility, helped manage the disruption to her identity that marked her early years in Upper Canada. This echoes Williams' assessment that an unstated reason for Anne keeping a journal was to create a written record that traces her 'personal development as she adjusts to life in a new land'.[23] As such, this chapter comprises a microhistory of one British woman's experience of moving between spheres of empire and negotiating the attendant impact on her concept of self, as glimpsed through descriptions of the things she made, the spaces she created and her personal reflections on such activities.

# Beginnings

Anne Langton (b. 1804) was born into an aristocratic mercantile family in the northwest of England and was the second child and only daughter of Ellen and Thomas Langton. Although her father's fortunes would eventually plunge in the 1820s, Anne grew up in privileged circumstances, spending much of her childhood at the family's estate Blythe Hall in Lancashire and moving within social circles made up of cultured, wealthy and aristocratic friends. As was common for women of this heightened financial and social position, Langton was well-educated and received private tutelage from an early age in a range of subjects. The intended outcome of this education was to secure a husband of an equal, or preferably higher, social rank, and to prepare women for the role they were expected to fulfil once married. These ideals are indicative of broad societal changes that were gaining traction in Britain in the early nineteenth century, namely a move towards rigid gender segregation and the emergence of stricter definitions of female experience, discourses that stemmed from a belief that men and women possessed divergent emotional, spiritual, intellectual and moral capacities. Nevertheless, as an adolescent Anne received a somewhat unconventional education compared to her peers. At her father's instigation, between 1815 and 1820 the Langton family decamped from Blythe Hall to travel

**Figure 8.1** Anne Langton, [*Self Portrait*], watercolour miniature on ivory, 1833. Archives of Ontario.

continental Europe. During this period she studied in Switzerland, learning from instructors affiliated with the radical educational reformer Johann Pestalozzi, and received extensive training in painting and drawing while in Italy and France. As a result, she became an accomplished draughtswoman and painter, as can be seen in the self-portrait reproduced here, which she completed four years before her departure to Upper Canada (Figure 8.1).

The family's European tour ended abruptly, however, as a result of some of Thomas Langton's large investments failing in the economic downturn that followed the Napoleonic Wars. Upon returning to Britain the family was forced to sell their estate and move to a small town just outside of Liverpool. As W. A. Langton explains, 'There was no bankruptcy, but there was henceforth poverty.'[24] Consequently, although Anne was at an age when marriage would normally have been pursued, such plans were stalled due to financial constraints that resulted in her living in relative social isolation with her parents.[25] Whereas Anne's older brother William had married and gained employment as a bank manager in Manchester, her younger brother John decided to seek financial stability in Upper Canada, and left Britain in 1833 determined to establish himself as an independent farmer and landowner. A mixture of financial reasons and a belief that the family would simply be of more use in Upper Canada than in Britain likely motivated

the rest of the family to join him in 1837. Discussing their forthcoming move, John wrote to his father that he is 'well aware how much better the farm would go on were there somebody about the place to act as viceroy', and continues by saying 'I do not know how I can promise you greater happiness here than you might have at home, only that it seems to be your wish to try the change.'[26]

For the first eight years she was in Upper Canada Anne acted as a surrogate wife to her younger brother, undertaking the management of Blythe Farm. From her journals it is clear that Anne took this role seriously, committing significant amounts of time and energy to every aspect of the household's operations. Anne's position within the family unit shifted following John's marriage in 1845. Nevertheless, she adapted to this change by becoming an additional carer to her brother's seven children, and chose to remain with the family as John developed a career as a politician and civil servant.[27] That Anne never married makes her an interesting example of a European settler. Her journals not only express the concerns of a woman, a voice often muted by the historical record, but also capture the experiences and personal reflections of an individual whose life did not follow the anticipated path for women of her social and cultural background.

Although the Langtons' fortunes had declined in Britain they were still considered 'settlers of means' and belonged to the 'desirable' class of immigrants.[28] They arrived in Upper Canada with a certain amount of wealth, educational attainment and material possessions, and joined a number of other British settlers who similarly were members of the gentry class. Their relative affluence was immediately recognized by those in the community, a perception that soon became apparent to the Langtons themselves. This interplay is revealed in one of Anne's earliest letters in which she admits that the family's new home, still under construction when they arrived, was 'elegantly denominated' by surrounding residents as 'the big house'.[29] This spacious log dwelling would be the family's home for the whole time they lived on Sturgeon Lake, barring the first few months after their arrival, during which time all five members of the family camped out in a small temporary cabin. Designed by John, the Langtons' new home was situated in a clearing of land and displayed 'comfortable and elegant proportions'.[30] What is more, it was named after the estate in rural Lancashire they had previously owned, Blythe Hall, where Anne had spent much of her childhood and which had been the setting for the family's 'almost paradisal life together', thereby constituting their 'ideal image of "home"'.[31] Letters sent before the family's departure from Britain reveal John and Thomas Langton exchanging ideas on how best to plan the house and grapple with its surroundings. In one

**Figure 8.2** Anne Langton, *Blythe [Farm], Ontario*, watercolour, c.1851. Archives of Ontario.

from February 1837 for example, John included a small sketch of Blythe's exterior elevation and a hand-drawn floor plan, alongside written descriptions detailing the layout of rooms and the placement of key elements like staircases, landings, fireplaces and stoves. Built with hired labour, Blythe became the first two-storey house in the area. The Langtons' home was further distinguished by the inclusion of a large open verandah, Gothic-style windows and plastered interior walls, features that are just visible in a loose watercolour painting by Anne (Figure 8.2).

## Labours

Despite the Langtons' relative wealth and social status, the nature of the Upper Canadian settler lifestyle made it necessary that every member of the family contribute to the work that was required to make the rural settlement a success. Devising a system for the efficient division of labour was integral to this, a fact John highlighted in a letter written to his father prior to the family's departure from Britain:

> I should assign you each a separate office. My father of course would be my adviser and in my absence the *alter ego*; to [mother] should be exclusively left the duties of beautifying the house and garden, no sinecure on a new farm;

Anne must be Prime Minister in the Home department; and Aunt Alice ... shall reign paramount in the pigstye, poultry yard, etc., and shall be my Master of the Wardrobe.[32]

Evidently, at the Langtons' new home tasks and responsibilities were allocated in a gendered fashion with the family's three women being responsible for all domestic matters, an arrangement not dissimilar to how the family would have operated in Britain. Although somewhat vague compared to the specific tasks allocated to her mother and aunt, Anne's designation as 'Prime Minister in the Home Department' likely meant overseeing everything related to the home's day-to-day operations. She would have thus assumed the role of 'trusted household manager', which Amanda Vickery asserts was 'indispensable to genteel and middling men for their dignity, their comfort and their convenience'.[33] Reinforcing this idea, Anne identified herself as 'housekeeper-in-chief' in a journal entry written about eighteen months after arriving in Upper Canada.[34]

In Upper Canada the household was arguably a larger and more varied entity, encompassing not just the house and its related affairs such as cleaning, cooking and decorating, but also a number of exterior spaces including the garden and animal yards. Furthermore, engaging staff on a consistent, long-term basis was unusual because the labour pool was comparatively small and servants were generally felt to be less experienced relative to those that could be employed in Britain. Writing in the autumn of 1838 for example, Anne recounts her surprise at learning that a housemaid had recently announced she would be returning home for the winter, and had never intended on boarding with the Langtons for more than three months. Although evidently annoyed by the development, which she sees as 'one of the troubles of the backwoods', Anne admits that 'it is not such a calamity to be left without [help] as it would be at home', largely because it was recognized that Upper Canadian households were more fluid. She goes on to explain that the family had willingly given leave to a previous housemaid because of needing to free up a bedroom for company who had come to stay during the sugar-making season. After noting that Mr Savage had 'come into the kitchen and helped me to set a pan upon the fire', Anne exclaims, 'How strangely one's ideas accommodate themselves to the ways and necessities of the country one is in!'[35]

Receiving assistance from someone like Mr Savage would have been a transgression in Britain, contravening both the expectation that gentlewomen

should not be required to work in the kitchen, and the belief that visitors should not enter so private a space, particularly male ones. In the settler society of Upper Canada, however, such an interaction was accepted as commonplace. Anne's account of this episode is indicative of the fact that the majority of British gentlewomen who moved to rural Upper Canada at once managed and actively undertook a diverse list of chores, duties and responsibilities, which left them with minimal spare time, especially compared to their counterparts in Britain. They were responsible for childcare; planting, tending to and harvesting the garden; looking after and butchering the family's animals; preserving meat, fruit and vegetables; cleaning, cooking and baking; and managing stores of candles, fuel, soap and other essentials. After almost ten years of living in rural Upper Canada, by which point she was an experienced settler, Anne wrote of how 'it is much more difficult to let women's work stand still than men's work. John has made up his mind that nothing could be done on the farm, but no bread! no butter! no clean clothes! – this is another matter.'[36] Indeed, for men and women settlers of all classes in Upper Canada 'theirs was clearly a world of work', and one that bore few resemblances to contemporary British society, which was becoming increasingly urban, industrial and mechanized.[37]

In her journals Langton reveals a mixture of feelings about these additional domestic responsibilities. After spending a day cleaning John's cottage she displays a sense of confidence in her specifically feminine skills and is happy when they can be applied to easing the settlement process. 'I came back', she writes 'with a strengthened conviction of the importance of woman and congratulating myself, that though I might be an old maid I never could be an old bachelor.'[38] Yet, the social beliefs Langton and other gentlewomen left Britain with, which were informed by contemporary notions of womanhood that emphasized women's gentle, thoughtful and civilizing natures, were not always so easily applicable to the settler lifestyle. In the above statement Anne seems to have successfully reconciled this conflict, but at times her demonstrations of composure are permeated by insecurities regarding her female identity and the place this affords her within Upper Canada's settler society. In one journal entry she calls on her brother to not 'be alarmed' when reading her accounts of steering boats and handling the ropes while sailing. She assures him that despite undertaking masculine tasks such as these and being surrounded by male companionship her 'feminine manners' and 'woman's avocations will always … more than counterbalance them'. Just a few sentences later, however, she

contradicts this, admitting 'I have caught myself wishing an old long-forgotten wish that I had been born of the rougher sex'.[39] This is because she believes she has become more selfish, a change in character which she sees as a particularly female affliction and one brought on by the nature of the existence in Upper Canada:

> Women are very dependent here, and give a great deal of trouble; we feel our weakness more than anywhere else. ... The greatest danger, I think, we all run from our peculiar mode of life is that of becoming selfish and narrow-minded. We live so much to ourselves and mix so exclusively with one community.[40]

Anne returns to this topic of selfishness when noting the arrival of more women on Sturgeon Lake. She credits her dislike of the prospect of having to pay morning visits to the fact that she is 'growing savage, *alias* selfish, and unaccustomed to make sacrifice to society'.[41]

## Arranging the genteel self

In rural Upper Canada women's roles as heads of households came with far more essential, hands-on duties than it did for genteel women in Britain. Daily life revolved around addressing explicitly practical needs, a rigorous routine that left the majority of women with little time to foster and maintain this crucial part of their identity. That said, Anne utilized a number of activities, particularly those connected to furnishing and arranging individual rooms, to express her desired social and gendered identity. While it was laborious sewing heavy curtains by hand, unpacking boxes, moving furniture, overseeing carpenters and even doing the odd bit of plastering, such undertakings also presented opportunities for Anne to exercise her skills in making and decorating.

For the first few months after their arrival, when Blythe Farm was still under construction, all the family lived in John's two-room cabin or shanty. Anne made sketches of the interior of the family's rudimentary home (see Figures 8.3 and 8.4), and described these conditions as 'very snug'.[42] Illustrating the cabin's front room, her drawings show a space adorned with simple wooden furniture, essential items like snowshoes, axes and muskets, and a few ornamental objects like framed pictures and bookcases. The single table is an important piece because it would have served a variety of functions, such as preparing and eating

**Figure 8.3** Anne Langton, *Interior of John's House* [*looking north*], drawing, 1837. Archives of Ontario.

**Figure 8.4** Anne Langton, *Interior of John's House* [*looking south*], drawing, 1837. Archives of Ontario.

meals, convening and conversing, and reading and writing, as revealed by the open books, leaves of paper, inkwell and quill. From the family's letters, we know that the second room contained little more than a bed, some carpets and a hammock that was set up every night for Thomas Langton to sleep in. Although Anne was aware of how different her new lifestyle was, she seemed confident

that the initial shock would subside as the family's living conditions improved and they became more acclimatized:

> When I mention any of these primitive ways of doing things it is with the desire of making you more exactly conceive the precise style of civilization to which we have attained, not at all in the spirit of grumbling, indeed it would be absurd to make grievances of such things; and after fastening your window with a string or round a nail, or shading it with a boat flag for a month, you are very apt to forget that there is any other sort of hasp or blind.[43]

This extract reveals how familiarity with material surroundings played a large part in Langton's overall sense of comfort. In the same letter, she describes a recent contribution to endowing the house with a greater degree of order, an action that both required and reinforced her gendered sense of self. 'I have been well occupied … diving into the depths of the storeroom, where the traces of womankind may now be seen amongst the possessions of the bachelor.'[44] Writing three months later, she enthusiastically promises to send William 'a plan of our dwelling when we are settled, with the situation of all our pieces of furniture'. Although this was to allow her brother to 'form something of a picture of our interior', Langton may also have wanted to demonstrate the fruits of her leisurely and gentle labour, in order to stress to her brother that her feminine gentility was not being compromised by the roughness of her new surroundings.[45]

As Di Bello explains, in Victorian society it fell to women to be the 'arrangers of the domestic interior, purchasing decorative objects and materials to recontextualize them in their own homes'.[46] A woman of the household was expected to fashion the family home in such a way that visitors would be able to read the interiors as signs of her family's social status and her own gentility. This convention was transplanted to Upper Canadian settler society and resulted in dwellings that reflected a distinctly British sense of taste. Gentlewomen settlers in particular sought to project their family's British heritage through material possessions, and it seems to have been desirable to mask as much as possible the external setting that lay beyond a home's conscientiously decorated interior. However, there were few stores where one could buy home furnishings in rural Upper Canada and these were only located in larger towns. If one lived outside of more developed areas buying furniture was expensive and transportation of these goods was tedious. As a result, most homes would have been sparsely furnished compared to those in Britain. While less wealthy than they had been, the Langtons however could nonetheless afford to transport most of their

possessions from Britain to Canada. Their shipment consisted of large pieces of furniture such as beds, chairs, chests of drawers and a sofa, as well as smaller items like books, textiles, glassware and even eggcups.

In her journals Langton eagerly conveys instances when she employed her expertise in arrangement and is keen to detail her successes. In one letter she exclaims to her brother, 'I fancy we have more English elegancies about us than most of our neighbours.' In the same entry she asserts that once their 'striped green print' is mounted, the family will 'feel as grand as Queen Victoria amidst the damask hangings at Buckingham Palace.'[47] Anne reiterates the presentation of this English fashion just ten days later when recounting the occasion of having five nearby residents for dinner, remarking 'our room looked exceedingly snug and English, with its Turkey carpet, its crimson curtains, and its ceiling, even notwithstanding its log walls.'[48] She makes a similar comment a few months later following a dinner held at Blythe over the Christmas holiday season, a gathering that afforded her the opportunity to detail her efforts at creating an attractive space in which to entertain guests. Describing the furnishings in the drawing room, Anne reveals a sense of satisfaction with the results:

> The carpet looks uncommonly well, and it happens that the new hearth-rug we brought out suits it as if it had been made to correspond. We have had book-shelves put up on each side of the window, which come down to the ground, and without taking much from the size of the room they give us a very snug appearance. John's books as well as our own now adorn the room. The other bookcases we had a little lowered to admit of the busts being placed upon them. The *tout ensemble* gives great satisfaction.[49]

Anne enthusiastically notes how happy the family is with the room, which was completed just in time for Christmas Day, and does not hesitate to add 'no doubt [the guests] did admire.'[50] The following reflection makes expressly clear the connection between Anne Langton's attempts at furnishing and decorating the house and the expectation of how it will be received or read by others:

> The two elder ladies [Ellen Langton and Alice Currer] were still very busy upholstering. I do not think any ladies on the lake have better fitting garments than our two arm-chairs. As the fine season approaches we begin to think of the entertainments we must give to the newcomers.[51]

Here we see Anne, her mother and her aunt consumed with getting the house in order by the early summer, which is when regular visits between residents

on Sturgeon Lake would resume, meaning their house had to be ready to accept visitors. Anne's comparison between the furnishings in her home and those in the houses of other women cannot but be interpreted as a pronouncement on her own expertise and, by association, her feminine gentility since, in order to make such a comparison, Anne must have carefully noted others' interiors. Just as Langton displays a sensitivity to the visitor's gaze and assessments of her own decorative efforts, she participates in the same process when in the opposite position.

Indeed, writing in the spring of 1839, Anne details a recent visit to a neighbour's home and remarks to William how 'in Mrs. Dobbs' little drawing room which was very neatly set out with books, handsome workboxes, and alabaster ornaments, there hung also a saddle'.[52] Such possessions suggest Mrs Dobbs's cultivated social status is on par with Anne's, with the presence of multiple workboxes being particularly noteworthy since this type of object signified the owner's relative affluence and, crucially, her gentility. As Young explains, the workbox 'indicated a degree of elegance above mere mundane work, and thus reflected the owner's femininity and class'.[53] This was because workboxes contained the materials and tools used in fancy sewing, such as embroidery and appliqué, as opposed to regular sewing boxes, which were used for more utilitarian projects like clothes-making and upholstery. Embroidery carried particularly potent associations. Parker, for instance, argues that this genre of needlework represented the bourgeois family's ideal identity and embodied femininity. For British women 'the family's [social] position was ensured and protected through the constant exercise and reinforcement of femininity embodied in embroidery'.[54] Anne prefaces her description of Mrs Dobbs's home by stating that it exemplifies how in time 'the inconsistencies and incompletenesses' of residents' collections of material possessions, not to mention the manner in which these are displayed, 'become too familiar to be observed'.[55] Having lived in Upper Canada for about two years Langton does not regard herself as a newcomer and maintains that as a result she no longer notices certain elements of domestic presentation in the way she once did. However, by identifying and listing objects inside Mrs Dobbs's home that embody a particular type of female identity, Anne exhibits that she still has the capacity for seeing and recognizing signs of a woman's feminine refinement and, by extension, her family's social status. She has perhaps grown more accustomed to the appearance of certain items that would be regarded as inappropriate in British society, but her ability to read the language of consumption and visual culture has not diminished or faded.

# Conclusion

To a large extent Anne Langton was a 'quintessential gentlewoman' whose gendered identity was informed by the 'societal code of genteel conduct'.[56] The concept of gentility stressed women's domestic and feminine natures, and as such conflicted with the patterns and requirements of her new life in early-nineteenth-century rural Upper Canada. According to Lawrence, many gentlewomen who settled in emergent colonial societies found that performing as genteel women 'was essential for their psychological well-being'.[57] She suggests that any erosion of their gentility rendered them adrift in landscapes that were socially and geographically alien. Upon moving to Upper Canada in 1837, Anne Langton's daily life became tiring, laborious and physically demanding. It also ceased to be based around rigid separations between public and private spheres, and between men's and women's spaces. Butchering animals, laundering in full view of neighbours and exploring the surrounding woods on one's own – all activities Langton details in her letters and diaries – can hardly be said to conform to the notions of restraint that underpinned feminine gentility. Indeed, this discourse stressed a woman's capacity to control her body and personal space, behaviours that were indicative of an ability to regulate her inner passions and desires.[58] As such, resettlement compelled Anne Langton to develop new understandings of her gendered identity.

In the above discussion it has been illustrated how the values, forms of conduct and understandings of social relations Anne Langton brought with her from Britain, what can be conceived as the 'gentle immigrants' cultural baggage', were seldom compatible with the nature of rural life in Upper Canada.[59] This analysis reiterates Loren's assessment that individuals' personal beliefs, daily practices and larger sociopolitical discourses intersected in complex and troubling ways in colonial societies. As the 'Prime Minister' of a rather different type of household than the one she had been accustomed to, Langton negotiated new duties and responsibilities that at times conflicted with her existing sense of self, one rooted in the dominant societal code of genteel conduct. This was a complicated process of adaptation given the contemporary recognition that for a woman to be a 'capital help-mate' in Upper Canada, it was necessary for her to be able to 'do the work of a man, as well as her own domestic duties'.[60] Anne Langton's journals and letters reveal that addressing the fissures between the dominant gender ideologies that informed her self-identity and the activities and responsibilities that structured her daily life was a challenging task.

A topic that surfaces throughout Anne's writings is furnishing and decorating the family's new home. Letters sent to her brother and sister-in-law contain detailed descriptions of the improvements being made by her and the other female members of the family in the area of interior decoration. Evidently, Anne saw it as a priority to endow the family's new home with a sense of familiarity, which involved trying to replicate what would have been found in homes maintained by peers in Britain. She repeatedly highlights her attempts at effecting décor that adhered to contemporary middle-class and aristocratic notions of taste, style and arrangement. Just one element of the array of chores both inside and outside the home that fell to Langton, such activities took on especial significance because they enabled the domestic interior to act as a clear marker of her own feminine gentility. Her efforts yielded practical results and helped create a domestic space that was welcoming and liveable, which allowed the family to feel more settled. Moreover, on a personal level, this task offered Anne the opportunity to exercise what was conceived as a distinctly female skill-set, one that reflected the refined taste and civilized values of the woman who executed it along with the financial and social status of her family. It can therefore be argued that decorating and arranging the family's new home according to notions of civility and comfort was a means of negotiating the disparity between the daily routine of Anne's new life and dominant understandings of domesticity and genteel womanhood, a conflict that challenged her existing sense of self. This hastens the conclusion that for women gentry settlers in Upper Canada gentility and decency were often confined to being ideological values, and no longer existed as a uniform material standard.

Anne Langton sought to resolve the conflict between her existing gendered identity and the realities of colonial life by immersing herself in the task of creating a suitable domestic interior. As has been argued, however, detailing her efforts in letters that were destined to be read was also fundamental to this process. Anne's descriptions of her material practices, not to mention her reflections on what she perceived as the successes and failures of these endeavours, reinforce the argument that 'for genteel women their response to the shock of the new and the resultant refashioning of their identities were to find expression through their material culture and its associated practices'.[61] The structure and content of her journals demonstrate that ensuring others knew of her commitment to these endeavours was just as important as carrying them out in the first place. When it came to projecting her desired identity, for Langton the act of writing was as crucial as physically undertaking the activities that were central to dominant

notions of female identity. Whether through making and arranging material goods or documenting her progress at these tasks, Langton's account reveals that she sought to resolve her shifting sense of self, an instability that was brought on by leaving Britain and resettling in rural Upper Canada, by engaging in a series of overlapping material practices.

# Notes

1 John Langton to Thomas Langton, 28 July 1834, as cited in Anne Langton, *A Gentlewoman in Upper Canada*, ed. Hugh Hornby Langton (Toronto: Clarke, Irwin & Company Ltd., 1964), 5.

2 John Langton, *Early Days in Upper Canada: Letters of John Langton from the Backwoods of Upper Canada and the Audit Office of the Province of Canada*, ed. William Alexander Langton (Toronto: The Macmillan Company of Canada Ltd., 1926), xxi. All citations refer to unbound copy held at the Archives of Ontario (hereafter AO) as part of the Langton Family Collection, F-1077-5, MU 1694.

3 AO, Langton Family Collection, R. W. W. Robertson to H. H. Langton, 26 May 1949, F-1077-1, MU 1690.

4 'Interesting and Important to Persons Intending to Emigrate to British America,' *Dublin Penny Journal* 3, no. 116 (20 September 1834): 95–6.

5 For a general history see Gerald Craig, *Upper Canada: The Formative Years, 1784-1841* (Toronto: McClelland & Stewart, 1963).

6 Elizabeth Jane Errington, 'British Migration and British America, 1783-1867,' in *Canada and the British Empire*, ed. Phillip Buckner (Oxford: Oxford University Press, 2008), 141.

7 W. A. Langton, 'Biographical Sketch,' in *Early Days in Upper Canada*, xiii.

8 Ibid., xv.

9 Barbara Laslett and Johanna Brenner, 'Gender and Social Reproduction: Historical Perspectives,' *Annual Review of Sociology* 15 (1989): 386.

10 There is a developed literature written by British women who either travelled through or settled in Upper Canada. Wives of colonial officials, 'company men' (high-ranking fur trade employees) and military officers who produced accounts include Elizabeth Simcoe, Anna Jameson, Frances Anne Hopkins and Lady Dufferin. Perhaps the most well-known texts are those written by Susanna Moodie and her sister Catharine Parr Traill (both née Strickland), gentlewomen who emigrated with their Scottish husbands to Upper Canada in 1832. Published during their lifetimes, the sisters' works tapped into a popular fascination in Britain with frontier life in the Canadas, and brought these women a degree of fame and

notoriety. See, for example, Susanna Moodie's immigration trilogy *Roughing it in the Bush; or, Forest Life in Canada* (first published 1852), *Life in the Clearings* (first published 1853) and *Flora Lyndsay; or, Passages of an Eventful Life* (first published 1854). Unlike these works, Anne Langton's diaries and letters were not published until after her death, and it is unlikely she desired or envisaged her writing would be distributed beyond its original, intended audience of her older brother William and his wife Margaret.

11  Lawrence, *Genteel Women*, 3.

12  Elizabeth Jane Errington, *Wives and Mothers, School Mistresses and Scullery Maids: Working Women in Upper Canada, 1790-1840* (Montréal and Kingston: McGill-Queen's University Press, 1995), 22.

13  Errington, *Wives and Mothers,* 22.

14  See also Jane Mattison, 'The Journey through Selfhood in *The Journals of Mary O'Brien 1828-1838* and *A Gentlewoman in Upper Canada: The Journals of Anne Langton*,' *Prose Studies* 25, no. 2 (2002): 51–78; Cecilia Morgan, 'Gender, Loyalty and Virtue in a Colonial Context: The War of 1812 and Its Aftermath in Upper Canada,' in *Gender, War and Politics: Transatlantic Perspectives, 1775-1839*, eds Karen Hagemann, Gisela Mettele and Jane Rendall (New York, NY: Palgrave Macmillan, 2010). For a discussion of the relationship between women's work, imperialism and Canadian national identity in the later nineteenth century see Katie Pickles, *Female Imperialism and National Identity: Imperial Order Daughters of the Empire* (Manchester: Manchester University Press, 2002).

15  Thomas J. Schlereth, *Material Culture Studies in America* (Nashville, TN: Rowman Altamira, 1982), 3.

16  See, for example, the series of four volumes on women and material culture edited by Maureen Daly Goggin and Beth Fowkes Tobin and published by Ashgate between 2009 and 2013.

17  Daly Goggin and Fowkes Tobin, 'Introduction', 2–3.

18  Laslett and Brenner, 'Gender and Social Reproduction,' 382.

19  Langton, *A Gentlewoman in Upper Canada*, 115. (Anne Langton Journal, March 1840).

20  Ibid., 42. (Anne Langton Journal, 8 November 1837).

21  John Potvin and Alla Myzelev, 'Introduction: The Material of Visual Cultures,' in *Material Cultures, 1740-1920: The Meanings of Pleasures of Collecting*, eds John Potvin and Alla Myzelev (Farnham, Surrey: Ashgate, 2009), 2. Italics in original.

22  Potvin and Myzelev, 'Introduction', 2.

23  Barbara Williams, 'Introduction,' in Barbara Williams (ed.), *A Gentlewoman in Upper Canada: The Journals, Letters, and Art of Anne Langton* (Toronto: University of Toronto Press, 2008), 45.

24  W. A. Langton, 'Biographical Sketch,' in *Early Days in Upper Canada*, xiv.

25  'Anne Langton,' *Maryboro Lodge – The Fenelon Museum* http://www.maryboro.ca/LangHis.html (accessed 19 April 2016).

26  Langton, *A Gentlewoman in Upper Canada*, 4. (John Langton to Thomas Langton, 28 July 1834)

27  John Langton first became involved in politics and the civil service in 1841 when he was elected to the newly created district council for the Fenelon Township. In the 1850s he gained a seat in the provincial legislature as the Conservative party representative for the Peterborough area. In 1855, John A. Macdonald appointed Langton chairman of the new Board of Audit, which prompted a move to Toronto. Soon afterwards, he was appointed to the senate of the University of Toronto and served as vice chancellor from 1856–60. He moved to Ottawa in 1866 during the lead-up to Confederation, apportioning debt and laying the groundwork for the new Dominion's accounts. Increased responsibilities followed Confederation, after which Langton became a member of the Civil Service Commission, secretary to the Treasury Board and deputy minister of finance in 1870. He retired from politics in 1878, but remained involved in public life, serving as president of the Canadian Institute from 1880–2.

28  Williams, 'Introduction', 31.

29  Langton, *A Gentlewoman in Upper Canada*, 31. (Anne Langton to Margaret Langton, 22 August 1837).

30  Ibid.

31  Williams, 'Introduction', 5.

32  Langton, *A Gentlewoman in Upper Canada*, 5. (John Langton to Thomas Langton, 28 July 1837) Italics in original text.

33  Amanda Vickery, *Behind Closed Doors: At Home in Georgian England* (New Haven, CT: Yale University Press, 2009), 10.

34  Langton, *A Gentlewoman in Upper Canada*, 92. (Anne Langton Journal, 30 April 1839).

35  Ibid.

36  Ibid., 194. (Anne Langton to William Langton, 19 September 1846).

37  David Gagan, '"The Prose of Life": Literary Reflections of the Family, Individual Experience and Social Structure in Nineteenth-Century Canada,' *Journal of Social History* 9, no. 3 (1976): 367–70.

38  Langton, *A Gentlewoman in Upper Canada*, 82. (Anne Langton Journal, 25 January 1839).

39  Ibid., 60. (Anne Langton Journal, 13 October 1838).

40  Ibid.

41  Ibid., 107. (Anne Langton Journal, 3 December 1839). Italics in original text.

42  Ibid., 31. (Anne Langton to Margaret Langton, 22 August 1837).

43  Ibid., 35. (Anne Langton to William and Margaret Langton, September 1837).

44  Ibid., 32. (Anne Langton to Margaret Langton, 22 August 1837).

45  Ibid., 42. (Anne Langton to William Langton, 8 November 1837).

46  Di Bello, *Women's Albums*, 3.

47  Ibid., 59. (Anne Langton Journal, 11 October 1838).

48  Ibid., 66. (Anne Langton Journal, 21 October 1838).

49  Ibid., 70–71. (Anne Langton to William Langton, 1 January 1839). Italics in original.

50  Ibid.

51  Ibid., 88. (Anne Langton Journal, 13 April 1839).

52  Ibid., 90. (Anne Langton Journal, 18 April 1839).

53  Young, 'Material Life in South Australia', 81.

54  Rozsika Parker, *The Subversive Stitch: Embroidery and the Making of the Feminine* (London: Women's Press, 1984), 159.

55  Langton, *A Gentlewoman in Upper Canada*, 90. (Anne Langton Journal, 18 April 1839).

56  Williams, 'Introduction', xiii–xv.

57  Lawrence, *Genteel Women*, 234.

58  Ibid, 3.

59  Errington, *Wives and Mothers*, 22.

60  Thomas Langton, 'Account of the settlers in the townships of Fenelon and Verulam, 1838,' in Langton, *A Gentlewoman in Upper Canada*, 49.

61  Lawrence, *Genteel Women*, 1.

# Reconstructing the Lives of Professional Women in 1930s Zanzibar through Image, Object and Text[1]

Sarah Longair

On 31 December 1936, Helen Wilson, assistant to the chief secretary of Zanzibar, enjoyed 'a gay end of the year' with the lavish annual fancy dress ball attended as always by the sultan. The morning after was not a holiday, but involved an annual chore, as Wilson recalled: 'Unfortunately the 1st January by Colonial Office order was devoted to checking the inventories of all government departments, and I with the woman Curator of the Museum, crawled up and downstairs checking mugs, blankets, etc., in the hostel attached to the Arab Girls' School.'[2] Wilson's companion in this task was Ailsa Nicol Smith, who had arrived in 1936 – the year after Wilson – to take charge of the Zanzibar Museum. Wilson and Nicol Smith were two of only ten women serving in the Zanzibar government in the late 1930s and early 1940s.[3] Both played critical professional roles: Wilson as a trusted assistant responsible for recording the most confidential government matters while Nicol Smith led the principal cultural and educational institution in the protectorate. They even shared accommodation at one point in the same building. As Wilson recorded: 'By 1938 the block of 4 flats, known as Paradise Mansions (or amongst the bachelors as "Virgins Retreat") was occupied by the Lady Doctor, the Schoolmistress, the Lady Curator of the museum and myself.'[4] This sentence illuminates several realities of professional women's lives in interwar Zanzibar, drawing attention not only to the range of professions women undertook but also the facetious and derogatory perceptions of their male counterparts. It is also the only other occasion when Wilson mentions Nicol Smith in her diary – evidently they interacted professionally and shared living quarters but the curator does not feature elsewhere in Wilson's descriptions of Zanzibar's lively social scene. This chapter will examine the careers of these two

women in Zanzibar through their material and visual legacies. Their diverse temperaments, interests and skills offer insights into the multiplicity of female responses to working within the colonial world and the negotiations necessary to establish themselves as independent actors within the colonial sphere.

Women in colonial settings had to forge a pathway through the complex and overlapping spheres of class, gender and race. In the words of Ann Laura Stoler, European women 'experienced the cleavages of racial dominance, and internal social distinctions very differently than men precisely because of their ambiguous positions, as both subordinates in colonial hierarchies and as agents of empire in their own right'.[5] Interrogating thoroughly the ways in which women dealt with this ambiguity is a rich and burgeoning field of imperial history. Pioneering work on professional women examined the traditionally feminine fields of nursing and teaching, as undertaken by the other inhabitants of Paradise Mansions in Zanzibar.[6] Elsewhere, colonial wives, earlier ignored in the literature or derided as racist 'memsahibs', are being considered as political figures in their own right, highlighting the ways in which they were able to exert influence, as well as offering more nuanced interpretations of their attitudes to race and class.[7] Jane Haggis reminds us, however, to be wary of 'recuperating' the stories of white women in a simplistic fashion by ensuring white women's stories are considered carefully alongside those of colonized men and women.[8] The exposure of the competing forces acting upon women in the empire has also contributed to the development of a significant seam of literature on masculinity and empire and the ways in which men negotiated their own situation with respect to gender, class and race.[9]

Throughout these studies, which recognize the complexities of women's experiences of empire, the availability of sources is a central concern. Diaries and letters by female writers have been mined successfully to offer alternative perspectives upon imperial society, while official documents shed light on particular instances relating to women's participation. They can also be read against the grain to reveal the way in which the creation of documentation itself contributed to the gendered politics of empire. Taking a material approach to texts, objects and images with careful attention to the production of sources is a valuable strategy as can be seen in this volume.[10] While the close analysis of domestic space has been an important avenue in gender history and also in imperial settings, my focus here is upon the material worlds of professional women.[11] I compare the ways in which two women with differing professions and temperaments negotiated colonial

service by reconstructing their experiences through a combination of visual, material and textual sources. Each woman left different types of records of their colonial life: Wilson, for example, deposited a personally edited selection of papers at Rhodes House Library in Oxford comprising a daily diary of her first few months of service, photographs and cuttings, as well as a retrospective account written some decades later. In contrast, Nicol Smith's service in Zanzibar is mainly documented in government correspondence and official papers, through which her professional struggles become clear. Only a handful of letters so far located hint at her private reactions to the pressures she faced. She also commissioned photographs of her work in the museum and the material legacy of her curation of the museum remains today. These extant sources make it possible to construct two alternative visions of empire as produced by professional women in the 1930s.

Photographic records in both these cases are vital. The groundbreaking work of Elizabeth Edwards and James Ryan, among others, has transformed the study of colonial photography into a vibrant field in which questions of objectivity and subjectivity are particularly relevant to this discussion.[12] Wilson's retention of particular official photographs alongside her diary accounts allows us to flesh out scenes captured in the images. The photographs documenting Nicol Smith's work were the result of a specific commission for a journal article, taken at a time when her work in the museum was being questioned. In this case the shaping of the image of her work was critical and informed, and her subjectivity and agency is clear within their production. It is worth noting too, that in Zanzibar, the principal photographic companies documenting the colonial period were established families of Goan origin, who had emigrated to Zanzibar during the nineteenth century.[13] They fulfilled an essential role in recording and capturing the colonial society in both informal and formal settings. It is likely that Gomes & Son took the photographs for Nicol Smith as they were the regular museum photographers and highly regarded for their technical and aesthetic skills. When analysing official photographs, therefore we must recall that several members of Zanzibar's mixed community shaped the production of the visual record.

Wilson and Nicol Smith were both pioneering in their own fields in the Zanzibar government, but their histories must be reconstructed in quite different ways. While Wilson's papers are the more conventional source to interrogate, they are further enriched through a careful analysis of their material production, meaning and retention. I will first situate these female professionals within the context of women in colonial Zanzibar and the status of women professionals in

their respective fields, then examine the events surrounding their appointments before analysing episodes in their respective careers, paying close attention to the ways in which visual and material productions add further texture to our understanding of female colonial experience.

## Women at work in Zanzibar in the 1930s: Professionalism, gender and the colonial world

The experience of white women in Zanzibar must be examined in the context of the protectorate's diverse population and society. Zanzibar is an archipelago comprising the principal island Unguja, known in the colonial era as Zanzibar Island, Pemba and other smaller islands. Zanzibar Town on Unguja contains the area known as Stone Town, where in the colonial era the majority of the elite populations lived in large nineteenth-century palaces.[14] Political and economic power lay with the three elite communities: firstly the plantation-owning Arabs, originally from Oman. The Omani al-Busaidi dynasty governed Zanzibar and the East African coast from the late eighteenth century and moved their capital to Unguja in the 1830s. After the territory became a British protectorate in 1890, the sultan nominally led the British administered-government. The second-largest elite group was the South Asian community that had dominated the island's financial services since its arrival in the nineteenth century. The European community formed the smallest elite group, numbering 278 in Zanzibar in the 1931 census, and was by that time predominantly British.[15] Of their number, ninety-five were women. The island's majority population was termed 'African' by the British but included groups of varied origins, including the indigenous Swahili community, former slaves and their descendants, and recent economic migrants from the African mainland. The society was predominantly Muslim, with many elite women living according to the purdah system. As in Malaya, Hong Kong and India, female spouses from all communities were integral in the careful management of the regular elite racially mixed social events, creating an arena in which women enabled the smooth running of the government.[16] In the social sphere, therefore, as Bush reminds us: 'Their presence was essential in securing race discipline, uniformity, normalcy and order in colonial societies.'[17]

The nature of professionalism for women in the 1930s and its transfer to the colonial world are worth considering in more detail to ascertain the significance of Nicol Smith's and Wilson's experiences. Numbering only ten in 1935, European

professional women were a tiny minority in Zanzibar in the 1930s, with many more arriving after the Second World War.[18] Other than Wilson and Nicol Smith, women were employed in education and nursing departments. Although a novelty in Zanzibar, Wilson's role as a secretary was unremarkable in Britain at this time. By this period, the suitability of women as clerical workers in Britain was well established, and these roles offered opportunities for women with the requisite training and experience to engage in white-collar, respectable work.[19] In the colonial Zanzibar government, men of South Asian origin largely held clerical and minor administrative positions. As this chapter will demonstrate, Wilson's appointment was motivated by government concerns over racial tensions, providing an opening for her, as a woman with clerical expertise in the metropole, to become the first female secretary in the government.

The intersection of curatorship, expertise and professionalism in the colonial world represents a particularly complex case, and one which presented repeated challenges to Nicol Smith. In Britain, the development of curatorship as a paid profession was slow to develop in the late nineteenth and early twentieth centuries. Professions that provided a specialized service relied upon education and certification to define the market value of their expertise.[20] Yet curators struggled with the common notion that their work was seen as an interesting and pleasurable activity. Gladstone reportedly stated that he would not support increasing curators' salaries as he could imagine 'no more delightful an existence'.[21] This perception of dilettantism persisted in spite of little actual knowledge of curatorial practice and the question of remuneration remained a troublesome issue for museum workers.[22] The creation of the Museums Association in 1889, a professional society which should have asserted the service of this profession to society, did not begin seriously to address how to establish standards in practice, training and salaries until the 1910s.[23]

A significant constituency of curators with a shared set of skills and values emerged by the 1920s, though they varied widely, from university academics and retired enthusiasts to local council administrators.[24] In the absence of qualifications or recognized training, they often struggled to receive the recognition, salaries or status they believed they merited. Sir Henry Miers, who would visit the Zanzibar Museum in 1930, reiterated the need for improved status and salaries in his 1928 report on the state of museums in Britain, sponsored by the Carnegie United Kingdom Trust. The report exposed stark realities. In some cases the caretaker was paid more than the curator and Miers railed against the lack of recognition of curatorial skill and expertise.[25] Few women held curatorial

positions: the majority of women undertook administrative or education roles.[26] In the following decade, Marjorie Quennell became curator of the Geffrye Museum in 1935, taking over the role from her husband, and succeeded by another woman, Molly Harrison, in 1940, although it was certainly a rarity for a woman to lead a museum.[27] Both were charged with enhancing the educational aspect of the museum's work, thus focusing on the traditionally female skills of pedagogy rather than academic scholarship.

The challenge to assert curatorial professionalism was exacerbated still further when transposed to the colonial context. The leisure time that colonial officers enjoyed provided rich opportunities for amateur anthropologists, linguists and historians, many of whom created societies, gave lectures and published the results of their research.[28] The progenitors of colonial museums were often such enthusiastic amateurs, as in Zanzibar.[29] While they possessed wide-ranging local knowledge, they lacked 'behind-the-scenes' museum experience. Nicol Smith's predecessor, Dr. Alfred Spurrier, had been a long-serving medical officer with extensive local historical knowledge and experience – comparable with retired amateur curators present in British museums. His status as a doctor gave credibility to his work as a curator, particularly with his focus upon public health education. Nicol Smith was theoretically well-placed to develop his legacy. However, careers in the Colonial Office were becoming increasingly specialized during the 1920s and 1930s, including the fields of agriculture and public health, the very areas in which the Zanzibar Museum had made significant inroads. Nicol Smith, as a museum specialist but academic generalist, struggled to persuade the government to recognize curatorship as a professional skill.[30]

Africa in the mid-twentieth century provided opportunities for women in unchartered territory, as can be seen by the contributions of prominent women in the academic sphere including Audrey Richards, Gertrude Caton-Thompson and Margery Perham.[31] The arts of the colonial world similarly opened up new avenues for women in India such as Stella Kramrisch and Mildred Archer, who both became world-renowned experts in Indian art.[32] Nicol Smith's appointment was itself determined by gender and racial issues, as we shall see, which created an opportunity for a woman to take a role previously held by a man in the Zanzibar Museum. Yet her tenure was plagued by the government's doubts over the validity and value of the curatorship. The obstacles Nicol Smith faced in asserting the professional status of the curatorship to the colonial Government, who failed to understand the skills associated with museum work, ultimately prevented her from realizing both her own and the museum's full potential.

Not only was she a woman struggling to assert herself in the male-dominated colonial administrative world, she also had to defend a profession of which many questioned the value.

## Appointment to Zanzibar

The appointments of both Wilson and Nicol Smith are indicative of new avenues opening for women in the empire in the 1930s. Nicol Smith benefitted from the empire-wide interwar drive towards colonial welfare and women's education but, unique to Zanzibar, this was led by the museum. This institution was established in 1925 by Spurrier, its first curator, as a centre for public health education to 'improve the lot of the labouring classes of the island' as well as a repository for artefacts.[33] This focus upon public health ensured the institution was not only ahead of its time in the mid-1920s, but also became a factor in the struggles to define the museum's role in the late 1930s. After Spurrier's death in 1935 the position of curator was advertised seeking a candidate with experience in museums and teaching.[34] Nicol Smith, a Newnham graduate with a particular interest in women's education in Africa and at that time in her fourth year of employment at the Cambridge Museum of Archaeology and Ethnology, was well-suited for the role. Following interviews in London, the Colonial Office passed the decision between two candidates – Nicol Smith and a less-experienced male candidate – to the British resident in Zanzibar.[35] The Colonial Office interviewer believed Nicol Smith to be the more qualified candidate but he appreciated that 'local conditions may render it preferable that this appointment should not be held by a lady'.[36] The British resident replied on 29 November 1935 that, on the contrary, due to the purdah system, 'a suitable woman' was in fact an advantage.[37] The government at that time was keen to expand women's education in the museum, currently impossible with the all-male staff, and recommended that Nicol Smith be appointed. This situation is comparable to the commercial establishment of zenana photographic studios in India, which often, although not exclusively, employed European female photographers.[38] In both cases, female professionals sought to overcome purdah restrictions and engage the Muslim female population, allowing them to participate in previously inaccessible domains.

Wilson's appointment was similarly prompted by local socioeconomic and racial circumstances. In the early 1930s, the government had tried to introduce

measures to protect the largely Arab plantation-owning community, many of whom were indebted to South Asian financiers. According to Wilson, 'The clerical staff of the administration was almost wholly Indian and was not entirely to be trusted to keep the Government's confidence.'[39] The chief secretary, Samuel B. B. McElderry, therefore asked his daughter to assist him with confidential work during her visits to Zanzibar. McElderry decided that the role was essential and when on leave in April 1935 had lunch with Wilson, who had formerly worked in an office with his daughter. Wilson did not know if any others were interviewed but following 'considerable prodding' of the Zanzibar government by McElderry, she was appointed and sailed for Zanzibar on 5 September 1935.[40] On board ship, she started to learn kiSwahili and recalled, as many others did, how the long voyage was 'of great advantage to new appointees to the Colonial Service, for one met old hands and learnt much of what to expect in a completely new environment'.[41]

## Wilson: Navigating Zanzibar's professional and social world

Wilson's appointment to Zanzibar commenced in unusual and challenging circumstances, in part prompted by the novelty of a young woman embarking on a colonial career. A faded photocopy in Wilson's papers reproduces a newspaper article, entitled 'Girl Sails to Romance: In An "Arabian Nights" Island', which was the cause of a controversy that threatened to curtail her fledgling career (see Figure 9.1).[42] Featuring a portrait of the young woman, the piece described the departure of Wilson, 'a twenty-two-year old brunette' who explained she had been told '"that I was the first girl ever to go out to Zanzibar as a Government servant"'. The article's text peddled stereotypical images of Zanzibar as a site of intrigue and exotic romance with Wilson as a young female adventurer, highlighting her excitement about attending the sultan's dances: '"I feel that getting this job is like having a passport from the twentieth century to the Arabian Nights' Entertainments."'[43] Her memoir provides further information about the events surrounding the publication of the article. Wilson's mother, excited by her daughter's departure to foreign climes, contacted the *Daily Express*. Wilson said only a few words in a telephone call to the reporter and instructed them to contact the Colonial Office. She hoped to hear no more of the matter – 'I wonder if I shall be hauled over the

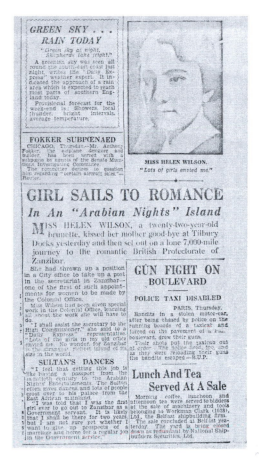

**Figure 9.1** 'Girl sails to Romance', cutting from the *Daily Express*, 6 September 1935. The Bodleian Libraries, The University of Oxford, MSS.Afr.s.1946/1, fol. 21r.

coals!' she innocently noted in her diary. 'Alas no', and the story 'almost put an end to my career in Zanzibar before it started'. [44]

At a personal level Wilson regretted that she came across as a naïve young woman 'on a social spree'. However, the article had potentially more serious professional consequences. It circulated worldwide and was republished on 22 September 1935 in the *Zanzibar Voice*, the main English language newspaper of the South Asian community which regularly republished material from metropolitan papers. It incensed the Indian community who resented a woman being sent out from England at a 'high salary' to work in the Secretariat. [45] Wilson kept a copy of the original offending article from this local Zanzibar newspaper marked up with red-pencilled crosses. Although she argued in her

memoirs that her salary was not disproportionate to those of her colleagues, the whole episode infuriated the British resident, who had not been in favour of a new appointment. She was, in her words, 'punished' by not receiving invitations to lunch at the Residency, as all new arrivals were, or to the Christmas party. McElderry told Wilson that the only response was to prove her professional value to the administration. After three months, 'I had proved myself and was invited to lunch', the symbolic end to her official exclusion. She explains in her memoir that she was attaching copies of the article 'to see how really innocuous it was by present day standards'.[46] The article had lost its potency by the time she was compiling the memoir and evidently intrigued her for the depiction of particular social values of the earlier era. However, these were at one time highly charged documents. Through global media circulation, an apparently innocent interview arranged by her mother threatened her career and had a significant impact upon her reception in Zanzibar in what would in any case have been a challenging first few months overseas.

Wilson described the nature of her duties in her memoirs. She worked in the government Secretariat, at that time located in the Beit al-Ajaib, a nineteenth-century former sultan's palace. This vast and imposing building dominated Zanzibar town's seafront and was the heart of government administrative activity. She described the airy office and detailed the different items of furniture around the large room. There was no typewriter, however, and she had to use her own portable one for the first few months of service. Notably her office was located between that of McElderry, the chief secretary, and the general office for the clerical staff.[47] Spatially, therefore she controlled access to the more senior officer. She noted in her memoirs that prior to her departure, she and her mother had discussed what office attire would be suitable in the absence of guidance from the Colonial Office, there being no precedent for a female employee in the Zanzibar's Secretariat. In her previous job at the London firm APCO, she and the other secretaries had a uniform. She decided to replicate this practice and carried in her luggage, along with golf clubs, tennis racket, books and riding kit, nine piqué dresses with an identical pattern. She wore these dresses throughout her career in Zanzibar, exporting the metropolitan norms for women in the workplace.[48] Dianne Lawrence has explored the pitfalls that women, especially newcomers, could experience with choices over clothing, which regularly exposed tensions between perceptions of appropriateness at 'home' and 'away'.[49] In this respect Wilson successfully negotiated this potentially problematic issue through

her astute choice, which asserted her professional status in the masculine environment of government.

Included in Wilson's papers is a varied selection of images and documents relating to her career. In one official mounted photograph we see her wearing one of her work dresses during a Legislative Council meeting in 1936 (see Figure 9.2). It was only after a slow start to her professional duties that she took on a critical role as the reporter for this significant government body with representatives from all communities. Prior to taking on the role regularly, she trained with the Indian clerks in the office to understand intonations of different accents.[50] Clearly these important meetings added to her professional status as testified in this image. On the reverse Wilson handwrote a key to the figures in the photograph. She is the only woman present and is seated centrally, turning to face the camera, alongside the clerk of Council. Behind them in this central section are press representatives from the *Zanzibar Voice* and *Al-Falaq*, the principal Arab-community newspaper, and other un-named individuals. The Council members are seated in a horseshoe with the British resident, Sir

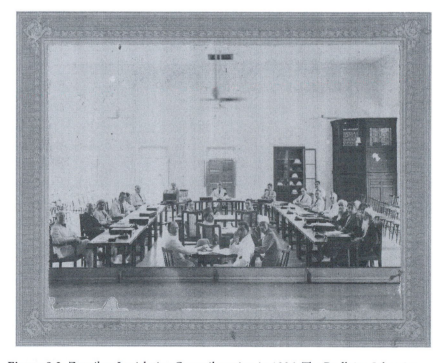

**Figure 9.2** Zanzibar Legislative Council session in 1936. The Bodleian Libraries, The University of Oxford, MSS.Afr.s.1946/7, Legislative Council photograph.

Richard Rankine, at the far end flanked by McElderry, the chief secretary and the attorney general. Directors of other Government departments were seated on either side, with two Indian representatives on the left, the manager of the National Bank of India, and three un-named Arab members on the right. The meeting took place in one of the large rooms of the Beit al-Ajaib used as a council chamber, with doors to the verandah behind the group alongside a cabinet used for storing pith helmets during the meeting. The photograph is dated 1936 and Wilson does not record it as a special meeting, presumably representing a typical image of her working environment. She is not immediately obvious in the image, her hair tied back and her clothing hidden. Countless images of all-male councils and government bodies such as this were recorded across the colonial world. Although her presence signals a revolutionary moment in the Zanzibar administration, she does not stand out. This inconspicuousness seems to have been her intention and must have made the sensation surrounding her arrival all the more galling.

Another memento in Wilson's papers is a copy of the commemorative booklet produced for the sultan of Zanzibar in December 1936 on the occasion of his jubilee by the Clove Growers Association (CGA). Wilson took up a second job doing secretarial work for this body late in 1936.[51] She records being part of preparations for the sultan's jubilee and it is likely she helped to compile this booklet, with its gold-laminated card imported from Britain. The CGA represented the interests of the Arab plantation owners and was, in the late 1930s, the centre of tensions between the South Asian and Arab communities, requiring the utmost diplomacy by Wilson in her work as it involved communication with the India Office as well as the CGA, local communities and the Zanzibar government. There was some danger at this time, with the riot over copra prices on 7 February 1936 resulting in the death of one of Wilson's friends, Ian Rolleston.[52] The glossy brochure entitled 'A Glimpse of the Clove Industry' with its twenty-four pages of images illustrating the process from plantation to export is a celebratory publication and one which veils the strained and tragic circumstances which Wilson experienced.

Wilson's diaries offer fascinating insights into the 'the very gay social life' of the elite communities. She was initially wary of this: 'The young people all appear to be rather of the "Bright Young Things" type, which I can't live up to. Still you never know and it is very early days to judge yet!'[53] Soon, she was attending parties which 'lasted to the small hours' and she regularly returned to her lodgings at 3 am after late dinners, drinks, dancing, fancy dress parties,

scavenger hunts and drives into the shamba (countryside). She and her close friend Miss Jones, the assistant mistress at the Arab Girls' School, felt fortunate in their professional status. In contrast to the 'young marrieds', 'we both worked hard at our jobs and found much to interest us. Life for a young wife was pretty boring by present day standards.'[54] While the majority of the women in this set were sisters, wives or daughters, Wilson, as a single professional woman, successfully managed to maintain her standing as a trusted assistant to the senior members of government while taking full advantage of the entertainment on offer.

## Nicol Smith: Negotiating colonial Zanzibar as a 'lady curator'

Nicol Smith's experiences in Zanzibar have to be reconstructed from a handful of letters she wrote to former colleagues in Cambridge and from professional records of her career. In these personal letters, she makes no mention of the social scene, discussing only her work. She was five years older than Wilson who does not mention her as a member of the younger social coterie. The records suggest that she was a serious yet independent character, who in a later post as a headmistress in Rhodesia was deemed too liberal in her racial attitudes by the conservative parents.[55] The official correspondence reveals the views expressed by her male colleagues. One of the more complimentary descriptions was that she was 'a live wire'.[56] More often, her actions were criticized for stereotypically female traits, such as apparently impulsive, irrational and emotional decisions.[57] Grudgingly, they recognized her curatorial experience – she, indeed, was a professional in an area none of them truly understood. But like many colonial museums, the Zanzibar Museum had previously been the domain of male amateurs. Repeatedly, she was forced to reiterate her curatorial knowledge, exemplified in an advisory memorandum to the government on her departure on how to run the museum in which she emphatically stated that 'the domestic affairs of the Museum ... are the business of the professional'.[58] A series of photographs reproduced in the *Museums Journal* in 1941 provide illuminating visual depictions of her activities and success. Copies of these images were also sent to the Colonial Office at this time (see Figures 9.3 and 9.4). The text accompanying the article reproduced standard histories of the museum and its work, and it is the photographs that I will focus upon here. While these are

carefully constructed images to present the museum as pioneering and in the most positive light, delving further into the context of their publication sheds light on the underlying tensions in Nicol Smith's work.

The museum Nicol Smith inherited had, as mentioned earlier, been founded by Spurrier and his colleagues as an 'educational centre for all communities'.[59] The *Museums Journal* article illustrates the range of facets of the museum's work. Several images (see Figure 9.3 – 6 and 7 and Figure 9.4 – 14) show the meticulous arrangement of the displays with written interpretation clearly engaging Swahili

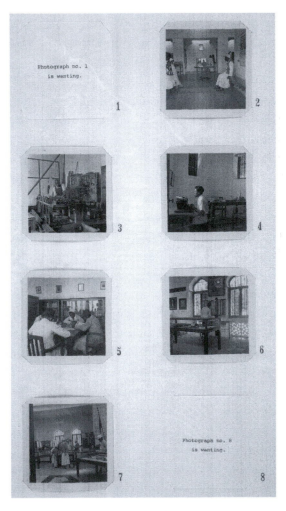

**Figure 9.3** Zanzibar Museum: members of staff, the museum library and visitors in the museum: photographs 1–8. The National Archives, ref. CN3/24.

visitors (recognizable through their dress). This was one of Nicol Smith's priorities on her arrival in 1936. She first concentrated on bringing the museum up to professional standards in the areas of cataloguing and display. She quickly deployed her knowledge and experience from Cambridge to improve the work of her predecessors, none of whom had any museum training. She proudly wrote to Dr Clarke, one of her mentors in Cambridge, in 1937: 'I have been revelling in the orgy of rearrangement and the Hygiene section is really looking better and I think means more, with its sage green backgrounds and bilingual labels.'[60] She paid special attention to the visual attractiveness and logic of the displays, believing this to be of particular importance for the many illiterate visitors.

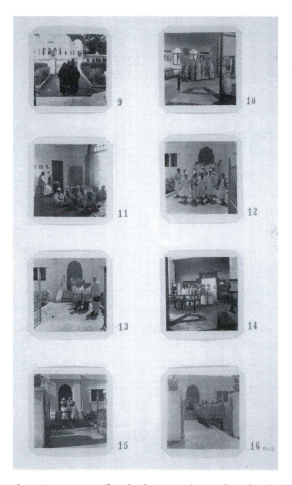

**Figure 9.4** Zanzibar Museum: staff and educational visits by school children, Arab women and Zanzibar police: photographs 9–16. The National Archives, ref. CN3/24.

Nicol Smith enthusiastically took on the mantle of teaching visitors directly in the museum and in outreach programmes. This aspect of the museum's work drew praise and recognition internationally.[61] The images (see Figure 9.4) show the diversity of visitors: adults – both male and female – and school children from all communities. It will be recalled that Nicol Smith, as a woman, was able to develop women's education, at that time seen as a critical facet of colonial development in improving conditions in the homes and diets of so-called 'native' communities. This pioneering element of her work is clearly emphasized in the photographs. In Figure 9.4 – 10 she herself is just visible teaching a group of South Asian women while others include (see Figure 9.4 – 9) a striking image of veiled Muslim school girls in black uniforms contrasting with the white-washed museum building. The often-remarked-upon similarity of the museum building to a mosque adds further resonance to this image.

Figure 9.4 – 11 illustrates another important strand of the museum's work: the film service. Spurrier and his colleagues, including the chief secretary, McElderry, had successfully been awarded a Carnegie grant from the Museums Association to expand the public health education programme through slides, models and films. The photograph shows the weekly film service for young people in the museum's annexe, while Nicol Smith took a portable film camera in to villages. Films such as 'Amazing Maize' created by the Colonial Film service, were viewed with a voiceover by her or the local assistants, who she increasingly trusted to run the outreach programme independently.[62] In 1938, she herself made two films about medical and agricultural activities, which sadly do not survive.[63] While they were likely to be amateur and limited in production expertise, we should recognize Nicol Smith's determination to bring such a proposal to fruition.

Integral to Nicol Smith's success was her relationship with local and regional communities and networks. The six members of the museum's staff provided vital conduits into the community. Two of the assistants or 'Subordinate staff' are shown in Figure 9.3 – two wearing their new uniforms described by Nicol Smith in detail in the caption. The provision of these smart uniforms was the result of a recent campaign with the government.[64] Other images of the staff at work (see Figure 9.3 – 3 and 4) show Juma Rajab, the senior assistant carpenter, at work in his well-equipped workshop and the clerk seated at a typewriter. She does not name them in this article, only notes their job title and ethnic origin. In spite of occasional frustrations with the staff, she generally worked well with them: 'I have only to think of my old museum at Cambridge to realise that they are the same breed of museum worker, devoted to the institution and gentle

with things.'[65] She took great interest in local culture and supported a local Arab schoolteacher, Muhammed Abdulrahman, in researching Swahili culture and assisting him in publishing his findings in the *Tanganyika Notes and Records* journal.[66] At the regional level, she was recognized as the museum expert in 1939 when she was asked to design the opening display for the new King George V Memorial Museum in Dar es Salaam and to train the museum assistants. This initiative was the subject of another *Museums Journal* article, co-authored with Clement Gillman, curator of the new institution in Tanganyika. Juma Rajab accompanied her to assist in the training. She also enthusiastically supported attempts to create a federation of curators of the East African museums by Dr van Someren, curator of the Coryndon Museum in Nairobi in 1937.[67] This proposal foundered but Nicol Smith herself revived the discussion in 1941 prior to her resignation in 1942. She therefore bolstered her status through local and regional networks, within which she could more clearly assert her expertise as a museum professional than in Zanzibar's government circles.

It is worth noting that in these images described above the presence of local Zanzibari people is integral to validating Nicol Smith's work. They are variously presented as a curious audience, receiving the benefit of engaging displays and programmes. Although it is highly likely that the photographer and Nicol Smith staged the images, visitor figures, newspapers and other documents corroborate this vision of a popular institution.[68] Only the museum's staff are presented as active agents in the museum's activities, although not named individually. While other records signal her good relations and appreciation of working with these individuals, Nicol Smith's priority within this article was to present herself as an effective manager of this local workforce. In the captions, she notes their technical skills, placing herself in a position to make these judgements as a museum expert. Her interactions with women, men and children from various communities make clear that a professional female curator was in a unique position to engage fully with this diverse community.

Though passionate about and experienced in museum work, Nicol Smith was a novice in the negotiations necessary to succeed in the colonial service. She struggled to convince her colleagues in government of the importance of the museum's work and consistently felt undermined by them. In spite of her clear abilities as a communicator with local people, the officers in the agricultural and medical departments did not approve of her undertaking public health education programmes. She regularly came into conflict with them over independent control of the budget of the museum, the non-permanent status

of her position and insufficient support for the Carnegie Fund film outreach project. Through a lack of government commitment, this grant was returned to the Museums Association, in spite of Nicol Smith threatening to resign on more than one occasion. Christopher Cox, education advisor of the Colonial Office and enthusiastic supporter of the museum, was disappointed by this outcome. He and colleagues on the Advisory Committee for Education in the Colonies, including Margery Perham, held Nicol Smith's work in high esteem and credited her with the success of the museum in 1940.[69] By 1941, however, with the return of the Carnegie grant, the situation had become irrevocable. Cox attempted to demonstrate his support for Nicol Smith and 'do the Zanzibar Museum really proud in the next issue of the Museums Journal, printing all Miss Nicol Smith's photos'.[70] These images of success and engagement therefore take on a new meaning when we consider that they only came to be circulated in the wake of the withdrawal of funding from the museum amid ongoing challenges for Nicol Smith. One committee member presciently noted at this time that the museum 'is, or has been, an institution of astonishing vitality, and it would be difficult to exaggerate its value as an educational influence'.[71] Certainly the photographs in the *Museums Journal* article reflected this view of an enterprising institution, but their publication also heralded a period of decline.

## Conclusion

Like countless colonial servants before them, both Wilson and Nicol Smith continued their careers in the empire. Wilson stayed in East Africa after her marriage and later received an MBE for her work with returning soldiers and village communities in Tanganyika. Nicol Smith resigned from her position in Zanzibar in 1942 after further deterioration of her relations with government. She remained committed to education, working in Uganda, Rhodesia and finally in Penang, where she was training teachers and in the process of setting up Penang's new museum at the time of her death in 1965. Their alternative visions of empire demonstrate clearly the diversity of white women's attitudes towards and experiences in colonial settings, and represent the myriad pathways women forged to participate in, produce and contest the imperial project.

The images and texts discussed in this chapter open a window onto a critical juncture in the immediate pre-1939 period when opportunities were opening up for women to participate in colonial governance. Yet once stationed to imperial

territories, both women discovered how carefully the social and professional world had to be navigated with so few women employed outside the school and hospital. Each woman was an agent in her own representation. Analysing the production of these records offers further insights into the use of images and the potential tensions surrounding them. Wilson compiled her collection of images and cuttings with the specific aim of representing her career in Zanzibar. The albums and memoirs were doubtless carefully edited before deposition in the Rhodes House archive. Nonetheless, the inclusions and emphases are revealing. Nicol Smith similarly selected the series of images for publication in the *Museums Journal* astutely to paint a highly positive picture. The photographs celebrate her individual efforts and demonstrate to a readership of museum professionals in Britain the central role museums might play in the empire. The inclusion of the local community is critical in presenting an image of a benign and effective educational institution. The images, however, take on a sour note when discovering the reason for their publication. Effectively analysing how women deployed visual culture therefore requires full attendance to the contingencies surrounding their production and the tensions they reveal in women's professional participation in colonial governance.

# Notes

1 My thanks to Rosie Dias, Kate Smith and other attendees of the 'Visualising Colonial Spaces' conference at the University of Warwick in January 2014 for their insightful comments on my presentation, as well as Leonie Hannan, Claire Davies and the anonymous readers for further advice on the chapter.

2 Rhodes House Library (hereafter RHL), Helen Haylett (née Wilson), 'An Account of my Two Tours as Office Assistant in the Secretariat, Zanzibar, 1935 – 1942', MSS. Afr.s.1946/1, 9. In this chapter I will use her maiden name as the research pertains to the period before her marriage in 1940 to Cecil Haylett, the manager of the Zanzibar branch of the African Mercantile Company.

3 Royal Commonwealth Society Library (hereafter RCSL), Zanzibar Government European Staff List, 1937, SC.47.1.1937. All were nurses except for Nicol Smith, Mrs Johnson (superintendent of female education) and Wilson. This ratio of female officers across departments was typical in British Africa. Across the continent, from 1922–43, 83 women were employed in education, 72 for medical posts, 8 for 'miscellaneous' posts and 2189 as nursing sisters: Callaway, *Gender, Culture and Empire*, 14.

4  RHL, 'An Account of my Two Tours', MSS.Afr.s.1946/1, 14.

5  Stoler, *Carnal Knowledge and Imperial Power*, 41.

6  For example, Dea Birkett, 'The "White Woman's Burden" in the "White Man's Grave": The Introduction of British Nurses in Colonial West Africa', in *Western Women and Imperialism*, eds Nupur Chaudhuri and Margaret Strobel (Bloomington and Indianapolis: Indiana University Press, 1992), 177–91.

7  For an overview of the field of gender and empire, see Midgley, 'Introduction', 1–18; Philippa Levine, 'Introduction: Why Gender and Empire?', in *Gender and Empire*, ed. Philippa Levine (Oxford: Oxford University Press, 2004), 1–13.

8  Haggis, 'White Women and Colonialism', 45–75.

9  See for example: Graham Dawson, *Soldier Heroes: British Adventure, Empire, and the Imagining of Masculinities* (London: Routledge, 1994); Mrinalini Sinha, *Colonial Masculinity: The 'Manly Englishman' and the 'Effeminate Bengali' in the Late Nineteenth Century* (Manchester: Manchester University Press, 1995).

10  See Lawrence, *Genteel Women*.

11  Deborah Cohen, *Household Gods: The British and Their Possessions* (New Haven, CT and London: Yale University Press, 2006); Robin D. Jones, *Interiors of Empire: Objects, Space and Identity within the Indian Subcontinent, c. 1800 – 1947* (Manchester: Manchester University Press, 2007); Lawrence, *Genteel Women*, 73–134.

12  James R. Ryan, *Picturing Empire: Photography and the Visualization of the British Empire* (London: Reaktion, 1997); Elizabeth Edwards, *Raw Histories: Photographs, Anthropology and Museums* (Oxford: Berg, 2001); Christopher Pinney, *Photography and Anthropology* (London: Reaktion, 2011).

13  Pamila Gupta, 'Goans in Mozambique and Zanzibar: Case Studies from Littoral East Africa', lecture at *Connections and Disconnections in the History and Cultures of East Africa* conference, BIEA, Nairobi 30–31 March 2015; Margret Frenz, *Community, Memory, and Migration in a Globalizing World: The Goan Experience, c. 1890–1980* (New Delhi: Oxford University Press, 2014), 102–4.

14  Stone Town was in fact a more varied urban space than the image of a segregated society projected by British planners in the 1920s, see Abdul Sheriff, 'The Spatial Dichotomy of Swahili Towns: The Case of Zanzibar in the Nineteenth Century', in *The Urban Experience in Eastern Africa c. 1750–2000*, ed. Andrew Burton (Nairobi: British Institute in Eastern Africa, 2002), 63–81.

15  *Annual Report of the Zanzibar Government for 1931* (London: HMSO, 1932), 5. For wider context of women's work relating to Africa in this period, see: Barbara Bush, '"Britain's Conscience on Africa": White Women, Race and Imperial Politics in Inter-War Britain', in *Gender and Imperialism*, ed. Clare Midgley (Manchester: Manchester University Press, 1998), 200–23.

16  Barbara Bush, 'Gender and Empire: The Twentieth Century', in *Gender and Empire*, ed. Philippa Levine (Oxford: Oxford University Press, 2004), 94.

17  Barbara Bush, *Imperialism and Postcolonialism*, (Harlow: Longman, 2006), 130.

18  RCSL, Zanzibar Government European Staff List, 1937, SC.47.1.1937.

19  See Gregory Anderson (ed.), *The White-Blouse Revolution: Female Office Workers since 1870* (Manchester: Manchester University Press, 1989).

20  Harold James Perkin, *The Rise of Professional Society: England Since 1880* (London: Routledge, 1989), 16.

21  Geoffrey D. Lewis, 'Collections, Collectors and Museums in Britain to 1920', in *Manual of Curatorship: A Guide to Museum Practice*, ed. John M. A. Thompson (London: Butterworths, 1984), 35.

22  Samuel J. M. M. Alberti, 'The Status of Museums: Authority, Identity, and Material Culture', in *Geographies of Nineteenth-Century Science*, eds David N. Livingstone and Charles W. J Withers (Chicago, IL: University of Chicago Press, 2011), 59.

23  Gaynor Kavanagh, 'The Museums Profession and the Articulation of Professional Self-Consciousness', in *The Museums Profession: Internal and External Relations*, ed. Gaynor Kavanagh (Leicester: Leicester University Press, 1991), 44.

24  Gaynor Kavanagh, *History Curatorship* (Leicester: Leicester University Press, 1990), 45.

25  Henry Miers, *A Report on the Public Museums of the British Isles, other than the National Museums to the Carnegie United Kingdom Trustees* (Edinburgh: T & A Constable, 1928), 21; Geoffrey Lewis, *For Instruction and Recreation: A Centenary History of the Museums Association* (London: Quiller Press, 1989), 45.

26  For an impression of the figures, using Miers, *A Report on the Public Museums of the British Isles*, of the named persons in charge (i.e. equivalent to Nicol Smith), 23 out of the 530 museums in Britain were women. Of these 11 had 'curator' in their title, and 5 were honorary. The rest were named as librarians, secretaries or assistants. Many more were employed as typists and secretaries.

27  Laura Carter, 'The Quennells and the "History of Everyday Life" in England, C. 1918–69', *History Workshop Journal* 81, no. 1 (April 2016): 126–7.

28  A. H. M. Kirk-Greene, *Symbol of Authority: The British District Officer in Africa* (London: I. B. Tauris, 2006), 174.

29  John M. MacKenzie, *Museums and Empire: Natural History, Human Cultures and Colonial Identities* (Manchester: Manchester University Press, 2009).

30  A. H. M. Kirk-Greene, *On Crown Service: A History of HM Colonial and Overseas Civil Services, 1837 – 1997* (London: I. B. Tauris, 1999), 28.

31  Lyn Schumaker, 'Women in the Field in the Twentieth Century: Revolution, Involution, Devolution', in *A New History of Anthropology*, ed. Henrika Kuklick (Oxford: Blackwell, 2008), 277–92.

32    Both published numerous scholarly texts on Indian art. Kramrisch taught at the University of Calcutta in the 1920s and 30s and later at universities in the United States and Europe: Thomas Lawton, 'Dr. Stella Kramrisch May 29, 1898-August 31, 1993', *Artibus Asiae* 53, no. 3/4 (1993): 499–500. Archer became the Curator of Prints and Drawings at the India Office Library after her return from India after 1947 and remained in post for many decades: Raymond Head, 'Obituary Dr Mildred Archer OBE, MA(OXON), D.Litt (1911–2005)', *Journal of the Royal Asiatic Society* 15, no. 3 (November 2005): 351–4.

33    Zanzibar National Archives (hereafter ZNA), Peace Memorial Buildings, Memorandum on the Peace Memorial Research and Education Museum by A. H. Spurrier 31 January 1923, AB 41/1. For a full history of this museum, see Sarah Longair, *Cracks in the Dome: Fractured Histories of Empire in the Zanzibar Museum, 1897–1964* (Farnham: Ashgate, 2015).

34    'Public Appointments', *The Times,* 16 September 1935, 2.

35    Born in 1908, Nicol Smith was a capable student, taking her degree in modern and medieval Languages and receiving an exhibition in her second year: Newnham College Archive, Cambridge: Newnham College Roll Record for Ailsa Nicol Smith.

36    The National Archives (hereafter TNA), Secretary of State for the Colonies to Resident, 15 November 1935, CO 618/63/3.

37    TNA, Telegram from Resident to Colonial Office, 29 November 1935, CO 618/63/3.

38    The earliest studio was set up by an English woman, Mrs E. Mayer in Calcutta in 1863, see Ghosh, 'Zenana Studio: Early Women Photographers of Bengal, from *Taking Pictures: The Practice of Photography by Bengalis*', trans. Debjani Sengupta, *In Translation* 4, no. 2 (2014). Online source: http://hdl.handle.net/2027/spo.7977573.0004.202.

39    RHL, 'An Account of my Two Tours', MSS.Afr.s.1946/1, 1.

40    Ibid.

41    Ibid., 2.

42    RHL, 'Girl sails to Romance', Cutting from the *Daily Express* Friday 6 September 1935, MSS.Afr.s.1946/1, 3; 21.

43    Ibid.

44    RHL, 'An Account of my Two Tours', MSS.Afr.s.1946/1, 3.

45    Ibid.

46    Ibid.

47    RHL, 'An Account of my Two Tours', MSS.Afr.s.1946/1, 4.

48    Ibid., MSS.Afr.s.1946/1, 3.

49    Lawrence, *Genteel Women*, 65.

50    RHL, 'An Account of my Two Tours', MSS.Afr.s.1946/1, 5.

51    Ibid., MSS.Afr.s.1946/1, 8.

52  RHL, Undated newspaper cutting 'Zanzibar riots', MSS.Afr.s.1946/1, 23.

53  RHL, 'Diary of a voyage to Zanzibar 1935', 4 October 1935, MSS.Afr.s.1946/2.

54  RHL, 'An Account of my Two Tours', MSS.Afr.s.1946/1, 6.

55  Dorothy Twiss and Rosemary Cochrane, *Grace and Learning from Africa: Arundel School – the First Fifty Years* (Harare: Arundel School, 2005), 36–8.

56  ZNA, Provincial Commissioner to Chief Secretary, 17 April 1938, AB 86/323.

57  For detailed discussion of her professional struggles, see Sarah Longair, 'The Experience of a "Lady Curator": Negotiating Curatorial Challenges in the Zanzibar Museum', in *Curating Empire: Museums and the British Imperial Experience*, eds John McAleer and Sarah Longair (Manchester: Manchester University Press, 2013), 122–44; Longair, *Cracks in the Dome*, 111–57.

58  ZNA, Nicol Smith, Memorandum, 27 July 1942, DF 9/1, 3.

59  ZNA, Peace Memorial Museum buildings, Dr. Aders (Economic Biologist) to Chief Secretary, 11 September 1924, AB/1.

60  Cambridge Museum of Archaeology and Anthropology, Letter from Nicol Smith to Dr Clarke, 3 March 1937.

61  The museum was described as 'one of the best educational museums' in Miers and Markham's survey of museums in British Africa in the early 1930s: Henry Alex Miers and S. F. Markham, *A Report on the Museums and Art Galleries of British Africa* (Edinburgh: Constable, 1932), 58.

62  This B.E.K.E. film 'Tropical Hookworm' created in 1936 can be viewed at: www.colonialfilm.org.uk/node/735 (accessed 16 October 2011).

63  ZNA, Nicol Smith to Museum Committee Chairman, 9 May 1938, DF 9/10.

64  Longair, *Cracks in the Dome*, 143–4.

65  National Museums Tanzania Archive, Nicol Smith, Speech to SAMA meeting July 1941, AM101.D33/R46, 17.

66  Muhammed Abdurahman, 'Anthropological Notes From the Zanzibar Protectorate', *Tanganyika Notes and Records* 8 (December 1939): 59–84.

67  ZNA, Dr. Van Someren, Memorandum, 15 July 1937, AB 41/19.

68  Longair, *Cracks in the Dome*, 224.

69  TNA, Peace Memorial Museum 1939–41, Extract from Minutes of the 105th Meeting held on 18 July 1940, CO 618/76/15.

70  TNA, Cox to Scott 4 February 1941, CO 618/76/15.

71  TNA, Scott to Cox 14 March 1941, CO 618/76/15.

# Bibliography

## Manuscript sources

British Library, London
British Museum, London
    British Museum Middle East Department Archives
Cambridge Museum of Archaeology and Anthropology, Cambridge
Claydon House Trust, Buckingham
    Sarah Hay-Williams Collection
National Library of Australia, Canberra
    Album of Miss Eliza Younghusband, South Australia, 1856–65
National Library of Scotland, Edinburgh
National Museum of Scotland, Edinburgh
National Trust Collections
Rhodes House Library, Oxford
Royal Archive
Royal Commonwealth Society Library, Cambridge
Russell Cotes Gallery, Bournemouth
State Library of Queensland
The National Archives, Kew
Yale University Library, New Haven
    Yale: Diaries (Miscellaneous) Collection (MS 181) Manuscripts and Archives
Zanzibar National Archives, Kilimani

## Periodicals and newspapers

*Athenaeum*
*Eclectic Review*
*Eskdale and Liddesdale Advertiser*
*Hastings and St. Leonard's Observer*
*South Australian Advertiser*
*South Australian Register*
*The Cornish Telegraph*
*The Country Gentleman: A Sporting Gazette and Agricultural Journal*
*The Graphic*

*The Hampshire Telegraph*
*The Illustrated London News*
*The Ladies' Treasury: A Household Magazine*
*The London Times*
*The Morning Post*
*The Northern Echo*
*The Times*
*Times of India*
*Western Gazette*
*Western Times*

# Printed sources

Abdurahman, Muhammed. 'Anthropological Notes From the Zanzibar Protectorate'. *Tanganyika Notes and Records* 8 (1939): 59–84.

Allen, James, Jr. *Journal of an Experimental Trip by the 'Lady Augusta' on the River Murray*. Adelaide: C.G.E. Platts, 1853. Australiana facsimile editions, edited by Peter J. Reilly. Canberra: National Library of Australia, 1995. Accessed 15 March 2011. http://users.esc.net.au/~pereilly/ladya.htm.

Andrews, James. *Flora's Gems; or, The Treasures of the Parterre: Twelve Bouquets Drawn and Coloured from Nature with Poetical Illustrations by Louisa Anne Twamley*. London: Charles Tilt, 1837.

*Annual Report of the Zanzibar Government for 1931*. London: HMSO, 1932.

Anonymous. '*Scenes and Characteristics of Hindostan* by Miss Emma Roberts'. *Quarterly Review* 55, no. 109 (1835): 93–105.

Archer, E. C. *Tours in Upper India and in Parts of the Himalaya Mountains*, 2 vols. London: Richard Bentley, 1833.

Baxter, W. E. *A Winter in India*. London: Cassell & Company, 1882.

Belnos, S. C. *The Sundhya, or the Daily Prayers of the Brahmins Illustrated in a Series of Original Drawings from Nature*. London: Day & Son, 1851.

Bird, Isabella. *The Yangtze Valley and Beyond: an Account of Journeys in China, Chiefly in the Provinces of Sze Chuan and Among the Man-Tze of the Somo Territory*. London: John Murray, 1899.

Bonwick, James. *The Last of the Tasmanians*. London: Sampson Low, Son and Marsden, 1870.

Branch Museum, Bethnal Green. *Exhibition of the Jubilee Presents, Lent by Her Majesty the Queen*. London: Harrison & Sons, 1888.

Brassey, Annie. *A Voyage in the 'Sunbeam'. Our Home on the Ocean for 11 Months*. London: Longmans & Co., 1878.

Brassey, Annie. 'The Decoration of a Yacht'. *The Magazine of Art* 5, no. 3 (January 1882): xx.

Briggs, John. *Letters Addressed to a Young Person in India*. London: John Murray, 1828.

Cockburn, Kathleen, ed. *Letters of Sara Hutchinson from 1800–1835*. London: Routledge & Kegan Paul, 1954.

Cotes, Annie Russell. *Westward from the Golden Gate*. London: W.H. & L. Collingridge, 1900.

Cotes, Merton Russell. *Home and Abroad: An Autobiography of an Octogenarian*. Bournemouth: Printed for private circulation, 1921.

Deane, Ann. *A Tour through the Upper Provinces of Hindostan*. London: C. & J. Rivington, 1823.

de Mole, Fanny Elizabeth. *Wild Flowers of South Australia*. Adelaide: Paul Jerrard & Son, 1861.

Devee, Sunity [Devi, Suniti], Maharani of Cooch Behar. *The Autobiography of an Indian Princess*. London: John Murray, 1921.

Eastlake, Charles Locke. *Hints on Household Taste in Furniture, Upholstery and Other Details*. London: Longmans & Co., 1872.

Eden, Emily. *'Up the Country': Letters Written to Her Sister from the Upper Provinces of India*. London: R. Bentley, 1867.

Eden, Emily. *Letters from India*, 2 vols. Edited by Eleanor Eden. London: Richard Bentley, 1872.

Eden, Emily. *Water Colour Sketches on the Princes and People of India*. Calcutta: Victoria Memorial, 1972.

Edwardes, H. B. and Herman Merivale. *Life of Sir Henry Lawrence*, 2 vols. 2nd edn. London: Smith, Elder, 1872.

Elwood, Colonel. *Narrative of a Journey Overland from England*, 2 vols. London: Henry Coulburn and Richard Bentley, 1830.

*Essays by Diverse Hands, Being the Transactions of the Royal Society of Literature of the United Kingdom*, vol. 24. Year unknown, pre-1945. Reprinted. London: Forgotten Books, 2013.

'Exhibition of Antiquities and Paintings held in the Society's Museum, March, 1866'. *Transactions of the Hawick Archaeological Society* (1866): xx.

Falkland, Lady. *Chow-Chow: Being Selections from a Journal Kept in India, Egypt, and Syria*, 2 vols. 2nd edn. London: Hurst & Blackett, 1857.

Fowler, Robert Nicholas. *A Visit to Japan, China and India*. London: Sampson, Low, Marston, Searle & Rivington, 1877.

Gardner, Nora Beatrice. *Rifle and Spear with the Rajpoots: Being the Narrative of a Winter's Travel and Sport in Northern India*. London: Chatto & Windus, 1895.

Gibbes, Phoebe. *Hartley House, Calcutta*. 1789. Edited, with an introduction, by Michael J. Franklin. Oxford: Oxford University Press, 2007.

Graham, Maria Dundas. *Journal of a Voyage to Brazil, and Residence There During Part of the Years 1821, 1822, 1823, 1824*. New York: Frederick A. Praeger, 1969.

Graham, Maria. *Journal of a Residence in India*. Edinburgh: Archibald Constable, 1812.

Gray, Robert. *Reminiscences of India and North Queensland 1857–1912*. London: Constable and Company, 1913.

Griffis, William Elliot. *The Mikado's Empire*. 5th edn. with supplementary chapters: *Japan in 1883* and *Japan in 1886*. New York: Harper & Bros., 1887.

Hibberd, Shirley. *Rustic Adornments for Homes of Taste.* 1858. Reprinted with introduction by John Sales. London: Century Hutchinson Ltd., 1987.

'Interesting and Important to Persons Intending to Emigrate to British America'. *The Dublin Penny Journal* 3, no. 116 (20 September 1834): 95–6.

Kaye, John William. *The Life and Correspondence of Major-General Sir John Malcolm.* London: Smith, Elder & Co., 1856.

Langton, Anne. *A Gentlewoman in Upper Canada.* Edited by Hugh Hornby Langton. Toronto: Clarke, Irwin & Company Ltd., 1964.

Langton, Anne. *A Gentlewoman in Upper Canada: The Journals, Letters, and Art of Anne Langton.* Edited by Barbara Williams. Toronto: University of Toronto Press, 2008.

Langton, Anne. *Langton Records: Journals and Letters from Canada, 1837–1846.* Edited by Ellen Josephine Philips. Edinburgh: R. & R. Clark, 1904.

Langton, John. *Early Days in Upper Canada: Letters of John Langton from the Backwoods of Upper Canada and the Audit Office of the Province of Canada.* Edited by W. A. Langton. Toronto: The Macmillan Company of Canada Ltd., 1926.

Lawrence, Honoria. 'English Women in Hindustan'. *Calcutta Review* 4, no. 7 (1845): 96–127.

Lawrence, John and Audrey Woodiwiss. *The Journals of Honoria Lawrence: India Observed, 1837–1854.* London: Hodder & Stoughton, 1980.

Login, E[dith] Dalhousie. *Lady Login's Recollections: Court Life and Camp Life, 1820–1906.* London: Smith, Elder & Co., 1916.

Mackenzie, Colin. *Life in the Mission, the Camp, and the Zenana; Or, Six Years in India,* 2 vols. 2nd edn. London: Richard Bentley, 1854.

Maitland, Julia. *Letters from Madras, during the Years 1836–39, by a Lady.* London: John Murray, 1846.

Malcolm, John. *Political History of India.* London: John Murray, 1826.

Malcolm, John. *The Government of India.* London: John Murray, 1833.

Marchioness of Dufferin and Ava, Harriot Georgina Blackwood. *My Canadian Journal, 1872–8: Extracts From My Letters Home Written While Lord Dufferin Was Governor-General.* Toronto: Coles Publishing Company, 1971. Originally published, New York: D. Appleton & Company, 1891.

Martineau, Harriet. *Suggestions Towards the Future Government of India.* 2nd edn. London: Smith, Elder, 1858.

Menon, P. Shungoonny. *Travancore from the Earliest Times.* Madras: Higginbotham & Co., 1878.

'Middlesex Hospital: Introductory Address by Mr. Hensman'. *Lancet* 110, no. 2823 (1877): 490–91.

Miers, Henry Alex and S. F. Markham, *A Report on the Museums and Art Galleries of British Africa.* Edinburgh: Constable, 1932.

Miers, Henry. *A Report on the Public Museums of the British Isles, other than the National Museums to the Carnegie United Kingdom Trustees.* Edinburgh: T & A Constable, 1928.

Mill, John Stuart. *Dissertations and Discussions: Political, Philosophical and Historical.* London: Longmans, 1875.

Mitchell, Maria Hay Murray. *In India: Sketches of Indian Life and Travel from Letters and Journals.* London: T. Nelson & Sons, 1876.

Montagu, Mary Wortley. *Letters.* London: Everyman's Library, 1992.

Moodie, Susanna. *Flora Lyndsay; or, Passages of an Eventful Life.* Ottawa: University of Ottawa Press, 2014. Originally published, London: 1854.

Moodie, Susanna. *Roughing it in the Bush; or, Forest Life in Canada.* Toronto: McClelland & Stewart, 1970. Originally published, London: 1852.

Moodie, Susanna. *Life in the Clearings.* Toronto: Macmillan Company of Canada, 1959. Originally published, London: 1853.

Nixon, Francis Russell. *The Cruise of the Beacon: A Narrative of a Visit to the Islands in Bass's Straits.* London: Bell and Daldy, 1857.

Nixon, N. (comp.). *The Pioneer Bishop in Van Diemen's Land 1843–1863: Letters and Memories of Francis Russell Nixon, D.D. First Bishop of Tasmania.* Hobart: J. Walch & Sons, 1953.

North, Marianne. *Recollections of a Happy Life, being the Autobiography of Marianne North, edited by her sister Mrs John Addington Symonds,* 2 vols. London: Macmillan and co., 1892.

*Official Descriptive and Illustrated Catalogue of the Great Exhibition of the Works Industry of All Nations,* 3 vols. London: Spicer Brothers, 1851.

Park, William. *The Vale of Esk, and Other Poems.* Edinburgh: William Blackwood, 1833.

Parkes, Fanny. *Wanderings of a Pilgrim in Search of the Picturesque,* 2 vols. London: Pelham Richardson, 1850.

Postans, Marianne. *Cutch: Or, Random Sketches, Taken during a Residence in One of the Northern Provinces of Western India.* London: Smith, Elder, 1839.

*Proclamation by the Queen in Council to the Princes, Chiefs and People of India, Published by the Governor-General at Allahabad, November 1st, 1858.* London: HMSO, 1858.

Roberts, Emma, ed. *The Zenana and Minor Poems of L. E. L.* London: Fisher & Son, 1839.

Roberts, Emma. *A New System of Domestic Cookery, by a Lady.* London: John Murray, 1842.

Roberts, Emma. *Scenes and Characteristics of Hindostan, with Sketches of Anglo-Indian Society,* 3 vols. London: William H. Allen, 1835.

Shah, Nasir al-Din. *The Diary of His Majesty, the Shah of Persia, during his Tour though Europe in 1873.* Translated by James W. Redhouse. London: James Murray, 1874.

Smith, James Edward. 'Memoirs and Correspondence of the Late Sir James Edward Smith'. *The Edinburgh Review* 57, no. 155 (1833): 39–69.

Swift, Jonathan, *Gulliver's Travels.* Oxford: Oxford World's Classics, 1941.

*Sydney International Exhibition with Photo-Type Illustrations.* Sydney: Sydney Government Printing Office, 1880.

Tiechelmann, C. G. *Aborigines of South Australia: Notes of the Manners, Customs, Habits and Superstitions of the Natives of South Australia*. Adelaide: Committee of the South Australian Wesleyan Methodist Auxilliary Missionary Society, 1841.

*The Language of Australian Flowers*. Melbourne: George Robertson and Company, 1891.

*The Letters of Queen Victoria: Second Series. A Selection of Her Majesty's Correspondence and Journal between the Years 1862 and 1878*, 3 vols. Edited by A. C. Benson and Reginald Brett, Viscount Esher. London: John Murray, 1908.

*The Letters of Queen Victoria: Second Series. A Selection of Her Majesty's Correspondence and Journal between the Years 1862 and 1878*, 3 vols. Edited by George Earle Buckle. London: John Murray, 1926–8.

*The Letters of Queen Victoria: Third Series. A Selection of Her Majesty's Correspondence and Journal between the Years 1886 and 1901*, 3 vols. Edited by George Earle Buckle. London: John Murray, 1930–2.

Thomas, E. K. ed. *The Diaries and Letters of Mary Thomas (1836–1866)*, 2nd edn. Adelaide: W. K. Thomas & Co., 1915.

Thompson, Frederick Diodati. *In the Track of the Sun: Readings from the Diary of a Globe Trotter*. London: William Heinemann, 1893.

Twamley, Louisa Ann. *The Romance of Nature, or, The Flower Seasons Illustrated*. London: Charles Tilt, 1836.

Tytler, Harriet. *An Englishwoman in India: The Memoirs of Harriet Tytler, 1828–1858*. Edited by Anthony Sattin, with an introduction by Philip Mason. Oxford: Oxford University Press, 1986.

## Secondary sources

Aitken, Richard. *Seeds of Change: An Illustrated History of Adelaide Botanic Garden*. Adelaide: Board of the Botanic Gardens and State Herbarium, 2006.

Akel, Regina. *Maria Graham: A Literary Biography*. Amherst, NY: Cambria Press, 2009.

Alberti, Samuel J. M. M. 'The Status of Museums: Authority, Identity, and Material Culture'. In *Geographies of Nineteenth-Century Science*. Edited by David N. Livingstone and Charles W. J. Withers, 51–72. Chicago, IL: University of Chicago Press, 2011.

*Album of Domestic Architecture in Australia with Original Photographs by H. Cazneaux, J. Paton, J. Kauffmann and J. Wilkinson* (1919).

Aldred, Cyril. 'A New Diorama in the Egyptian Hall of the Royal Scottish Museum'. *The Museums Journal* 11 (1949): 232–35.

Aldred, Cyril. *Scenes from Ancient Egypt in the Royal Scottish Museum Edinburgh*. Edinburgh: The Royal Scottish Museum, 1979.

Aldrich, Richard. 'The Return of the Throne: The Repatriation of the Kandyan Regalia to Sri Lanka'. In *Crowns and Colonies: European Monarchies and Overseas Empires*, edited by Robert Aldrich and Cindy McCreery, 139–61. Manchester: Manchester University Press, 2016.

Aldrich, Robert and Cindy McCreery, eds. *Crowns and Colonies: European Monarchies and Overseas Empires*. Manchester: Manchester University Press, 2016.

Alexander, Michael and Sushila Anand. *Queen Victoria's Maharajah: Duleep Singh, 1838–93*. London: Weidenfeld and Nicholson, 1980.

Allen, Brian, ed. *Towards a Modern Art World*. New Haven and London: Yale University Press, 1995.

Allen, Lindsay. '"Come then ye classic thieves of each degree": The Social Context of the Persepolis Diaspora in the Early Nineteenth Century'. *Iran* 51 (2013): 207–34.

Andaya, Barbara Watson and Leonard Y. Andaya. *A History of Malaysia*. London: Macmillan, 1982.

Anderson, Gregory, ed. *The White-Blouse Revolution: Female Office Workers since 1870*. Manchester: Manchester University Press, 1989.

Anderson, Margaret. *When Australia was a Woman: Images of a Nation*. Perth: Western Australian Museum, 1998.

Andrews, C. E. 'Scarred, Suffering Bodies: Eighteenth-Century Scottish Women Travellers on Slavery, Sentiment and Sensibility'. In *Women in Eighteenth-Century Scotland: Intimate, Intellectual and Public Lives*, edited by Katie Barclay and Deborah Simonton, 171–89. Farnham: Ashgate, 2013.

Appadurai, Arjun, ed. *The Social Life of Things: Commodities in Cultural Perspective*. Cambridge: Cambridge University Press, 1986.

Archer, Mildred. 'British Patrons of Indian Artists'. *Country Life* 118 (1955): 340–1.

Archer, Mildred. *Company Paintings: Indian Paintings of the British Period*. London: Grantha, 1992.

Arnold, David. *The Tropics and the Traveling Gaze: India, Landscape and Science, 1800–1856*. Seattle: Washington University Press, 2006.

Auslander, Leora. 'The Gendering of Consumer Practices in Nineteenth-Century France'. In *Consumption: The History and Regional Development of Consumption*, edited by Daniel Miller, 79–112. London: Routledge, 2001.

Avery, Peter, Gavin Hambly and Charles Melville, eds. *The Cambridge History of Iran*. Cambridge: Cambridge University Press, 1991.

Baker, Julian C. T. 'Darkness, Travel and Landscape: India by Fire- and Starlight, c. 1820–c.1860'. *Environment and Planning D* 33 (2015): 749–65.

Ballantyne, Tony, and Antoinette Burton, eds. *Moving Subjects: Gender, Mobility and Intimacy in an Age of Global Empire*. Urbana and Chicago: University of Illinois Press, 2009.

Banivanua Mar, Tracey, and Penelope Edmonds, eds. *Making Settler Colonial Space: Perspectives on Race, Place and Identity*. Basingstoke: Palgrave Macmillan, 2010.

Barcan, Ruth, and Ian Buchanan, eds. *Imagining Australian Space: Cultural Studies and Spatial Inquiry*. Nedlands, WA: University of Western Australia Press, 1999.

Barclay, Katie, and Deborah Simonton, eds. *Women in Eighteenth-Century Scotland: Intimate, Intellectual and Public Lives*. Farnham: Ashgate, 2013.

Barr, Pat. *The Dust in the Balance: British Women in India, 1905–1945*. London: Hamish Hamilton Ltd., 1989.

Barringer, Tim, *Men at Work: Art and Labour in Victorian Britain*. New Haven and London: Yale University Press, 2005.

Barringer, Tim and Tom Flynn, eds. *Colonialism and the Object: Empire, Material Culture and the Museum*. Abingdon: Routledge, 1998.

Barringer, Tim, Geoff Quilley and Douglas Fordham, eds. *Art and the British Empire*. Manchester: Manchester University Press, 2009.

Barton, D. and H. Hall, eds. *Letter Writing as Social Practice*. Amsterdam and Philadelphia: John Benjamins Publishing, 1999.

Baskerville, Peter. *A Silent Revolution? Gender and Wealth in English Canada, 1860–1930*. Montréal and Kingston: McGill-Queen's University Press, 2008.

Basu, Shrabani. *Victoria & Abdul: The True Story of the Queen's Closest Confidant*. Stroud: The History Press, 2010.

Batchelor, Jennie and Cora Kaplan. *Women and Material Culture, 1660–1830*. New York, NY: Palgrave Macmillan, 2007.

Bates, Rachel. "'All Touched my Hand': Queenly Sentiment and Royal Prerogative'. *19: Interdisciplinary Studies in the Long Nineteenth Century* 20 (2015), DOI: http://doi.org/10.16995/ntn.708

Baucom, I. *Out of Place: Englishness, Empire and the Locations of Identity*. Princeton: Princeton University Press, 1999.

Bendigo Art Gallery. *A Primrose from England: 19th-Century Narratives from the Collection of Bendigo Art Gallery*. Bendigo: Bendigo Art Gallery, 2002.

Bennett, Tony. *The Birth of the Museum: History, Theory, Politics*. Abingdon: Routledge, 1995.

Berg, T. *The Lives and Letters of an Eighteenth-Century Circle of Acquaintance*. Aldershot: Ashgate, 2006.

Berger, Carl. *The Sense of Power: Studies in the Ideas of Canadian Imperialism, 1867–1914*. Toronto: University of Toronto Press, 1970.

Bermingham, Ann. *Landscape and Ideology: The English Rustic Tradition, 1740–1860*. Berkeley, Los Angeles and London: University of California Press, 1986.

Bermingham, Ann. 'The Aesthetics of Ignorance: The Accomplished Woman in the Culture of Connoisseurship'. *Oxford Art Journal* 16 (1993): 3–20.

Bermingham, Ann. 'An Exquisite Practice: The Institution of Drawing as a Polite Art in Britain'. In *Towards a Modern Art World*, edited by Brian Allen, 50–2. New Haven and London: Yale University Press, 1995.

Bermingham, Ann. *Learning to Draw: Studies in the Cultural History of a Polite and Useful Art*. New Haven and London: Paul Mellon Centre for Studies in British Art, 2000.

Bickham, Troy. 'Eating the Empire: Intersections of Food, Cookery and Imperialism in Eighteenth-Century Britain', *Past and Present* 198 (2008): 71–109.

Bincsik, Monika. 'European Collectors and Japanese Merchants of Lacquer in "Old Japan": Collecting Japanese Lacquer Art in the Meiji Period'. *Journal of the History of Collections* 20 (2008): 217–36.

Birkett, Dea. 'The "White Woman's Burden" in the "White Man's Grave": The Introduction of British Nurses in Colonial West Africa'. In *Western Women and Imperialism*, edited by Nupur Chaudhuri and Margaret Strobel, 177–91. Bloomington and Indianapolis: Indiana University Press, 1992.

Bissell, William C. *Urban Design, Chaos, and Colonial Power in Zanzibar*. Bloomington, IN: Indiana University Press, 2010.

Bleichmar, Daniela. *Visible Empire: Botanical Expeditions and Visual Culture in the Hispanic Enlightenment*. Chicago and London: Chicago University Press, 2012.

Blow, David. 'Persia: Through Writers' Eyes'. *Asian Affairs* 39 (2008): 400–12.

Blunt, Alison. 'Embodying War: British Women and Domestic Defilement in the Indian "Mutiny", 1857–8', *Journal of Historical Geography* 26 (2000): 403–28.

Bohls, E. A. 'The Aesthetics of Colonialism: Janet Schaw in the West Indies, 1774–1775'. *Eighteenth-Century Studies* 27, no. 3 (1994): 363–90.

Borden, Ruth. *Alice Freeman Palmer: The Evolution of a New Woman*. Ann Arbor: University of Michigan Press, 1993.

Bothmer, Bernard. 'Cyril Aldred'. In *Chief of Seers: Egyptian Studies in Memory of Cyril Aldred*, edited by Elizabeth Goring, Nicholas Reeves and John Ruffle, 1–2. London: Kegan Paul International, 2009.

Bourdieu, Pierre. 'The Forms of Capital'. In *Theory: An Anthology*, edited by Imre Szeman and Timothy Kaposy, 81–93. Chichester: John Wiley & Sons, Ltd., 2011.

Bowie, Fiona, Deborah Kirkwood and Shirley Ardener, eds. *Women and Missions: Past and Present: Anthropological and Historical Perspectives*. Providence and Oxford: Berg, 1993.

Boyd, William K. 'Review: Journal of a Lady of Quality; Being the Narrative of a Journey from Scotland to the West Indies, North Carolina, and Portugal, in the Years 1774 to 1776 by Evangeline Walker Andrews; Charles McLean Andrews'. *The American Historical Review* 27, no. 4 (1922): 801–3.

Breckenridge, Carol A. 'The Aesthetics and Politics of Colonial Collecting: India at World Fairs'. *Comparative Studies in Society and History* 31, no. 2 (1989): 195–216

Briefel, Aviva. 'On the 1886 Colonial and Indian Exhibition'. *BRANCH: Britain, Representation and Nineteenth-Century History*. Accessed 10 May 2017. http://www.branchcollective.org/?ps_articles=aviva-briefel-on-the-1886-colonial-and-indian-exhibition

Brimacombe, Ruth. 'Edward William John Hopley, *A Primrose from England*'. In *Exiles and Immigrants: Epic Journeys to Australia in the Victorian Era*, edited by Patricia Macdonald, 178–92. Melbourne: National Gallery of Victoria, 2005.

Broome, Richard. *Aboriginal Victorians: A History Since 1800*. Crows Nest, NSW: Allen & Unwin, 2005.

Brown, L. 'Reading Race and Gender: Jonathan Swift'. *Eighteenth-Century Studies* 23, no. 4 (1990): 425–43.

Brown, L. *Homeless Dogs & Melancholy Apes: Humans and Other Animals in the Modern Literary Imagination*. Ithaca and London: Cornell University Press, 2010.

Bryant, Julius. 'Royal Gifts from Victorian India: the New Display in the Durbar Room at Osborne House'. *Collections Review* 4 (2003): 116–24

Bryant, Julius. 'Kipling's Royal Commissions: Bagshot Park and Osborne'. In *John Lockwood Kipling: Arts & Crafts in the Punjab and London*, edited by Julius Bryant and Susan Weber, 435–67. New Haven and London: Yale University Press, 2017.

Bryant, Julius and Susan Weber, eds. *John Lockwood Kipling: Arts & Crafts in the Punjab and London*. New Haven and London: Yale University Press, 2017.

Bubbar, Prahlad, ed. *Indian Paintings and Photographs, 1590–1900*. Exhibition Catalogue, London: Prahlad Bubbar Mayfair, 2012.

Buck, Pamela. 'Collecting An Empire: The Napoleonic Louvre and the Cabinet of Curiosities in Catherine Wilmot's *An Irish Peer on the Continent*'. *Prose Studies* 33, no. 3 (2011): 188–99.

Buckner, Phillip, ed. *Canada and the British Empire*. Oxford: Oxford University Press, 2008.

Buettner, Elizabeth. *Empire Families: Britons and Late Imperial India*. Oxford: Oxford University Press, 2004.

Burton, Andrew, ed. *The Urban Experience in Eastern Africa c.1750–2000*. Nairobi: British Institute in Eastern Africa, 2002.

Burton, Antoinette, *Burdens of History: British Feminists, Indian Women and Imperial Culture, 1865–1915*. Chapel Hill: University of North Carolina, 1994.

Bush, Barbara. '"Britain's Conscience on Africa": White Women, Race and Imperial Politics in Inter-War Britain'. In *Gender and Imperialism*, edited by Clare Midgley, 200–23. Manchester: Manchester University Press, 1998.

Bush, Barbara. 'Gender and Empire: The Twentieth Century'. In *Gender and Empire*, edited by Philippa Levine, 77–111. Oxford: Oxford University Press, 2004.

Bush, Barbara. *Imperialism and Postcolonialism*. Harlow: Longman, 2006.

Buzard, James. *The Beaten Track: European Tourism, Literature, and the Ways to 'Culture', 1800–1918*. Oxford: Oxford University Press, 1993.

Callaway, Anita and Candace Bruce. 'Dancing in the Dark: Black Corroboree or White Spectacle?' *Australian Journal of Art* 9 (1991): 78–104.

Callaway, Hellen. *Gender, Culture and Empire: European Women in Colonial Nigeria*. Basingstoke: Macmillan, 1987.

Campbell, Elizabeth. 'Don't Say It with Nightshades: Sentimental Botany and the Natural History of Atropa Belladonna'. *Victorian Literature and Culture* 25, no. 2 (2007): 607–15.

Campbell, Louise. 'Questions of Identity: Women, Architecture and the Aesthetic Movement'. In *Women's Places: Architecture and Design 1860–1960*, edited by Brenda Martin and Penny Sparke, 1–21. London: Routledge, 2003.

Campbell Orr, Clarissa, ed. *Women in the Victorian Art World*. Manchester and New York: Manchester University Press, 1995.

Cannadine, David. *Orientalism: How the British Saw Their Empire*. London: Allen Lane, 2001.

*Carlton House: The Past Glories of George IV's Palace*. London: Queen's Gallery, 1991.

Carter, Laura. 'The Quennells and the "History of Everyday Life" in England, C. 1918–69'. *History Workshop Journal* 81, no. 1 (2016): 126–7.

Carter, Sarah and Maria Nugent, eds. *Mistress of Everything: Queen Victoria in an Indigenous World*. Manchester: Manchester University Press, 2016.

Castle, T. *Masquerade and Civilization: The Carnivalesque in Eighteenth-Century English Culture and Fiction*. London: Methuen, 1986.

Chaiklin, Martha. *Ivory and the Aesthetics of Modernity in Meiji Japan*. Basingstoke: Palgrave Macmillan, 2014.

Chaiklin, Martha. 'Politicking Art: Ishikawa Komei and the development of Meiji Sculpture'. *East Asian History* 39 (2014): 53–74.

Chattopadhyay, Swati. 'Blurring Boundaries: The Limits of "White Town" in Colonial Calcutta', *Journal of the Society of Architectural Historians* 59, no. 2 (2000): 154–79.

Chattopadhyay, Swati. '"Goods, Chattels and Sundry Items": Constructing 19th-Century Anglo-Indian Domestic Life'. *Journal of Material Culture* 7, no. 3 (2002): 243–71.

Chaudhary, Zahid R. *Afterimage of Empire: Photography in Nineteenth-Century Empire*. Minneapolis: University of Minnesota Press, 2012.

Chaudhuri, Nupur, and Margaret Strobel, eds. *Western Women and Imperialism*. Bloomington and Indianapolis: Indiana University Press, 1992.

Chaudhuri, Nupur and Margaret Strobel. 'Introduction'. In *Western Women and Imperialism: Complicity and Resistance*, edited by Nupur Chaudhuri and Margaret Strobel, 1–15. Bloomington and Indianapolis: Indiana University Press, 1992.

Chauncey, Philip. *Memoirs of Mrs Poole and Mrs Chauncey*. Kilmore, Vic: Lowden, 1974.

Clarence-Smith, William Gervase, *Cocoa and Chocolate, 1765–1914*. London: Routledge, 2000.

Clark, Ian and Fed Cahir, eds. *The Aboriginal Story of Burke and Wills: Forgotten Narratives*. Collingwood, Vic: CSIRO Publishing, 2013.

Clark, John Willis. *Endowments of the University of Cambridge*. Cambridge: Cambridge University Press, 1904.

Cleall, Esme, Laura Ishiguro and Emily J. Mantelow. 'Imperial Relations: Histories of Family in the British Empire'. *Journal of Colonialism and Colonial History* 14, no. 1 (2013): n.p.

Codell, Julie, ed. *Power and Resistance: The Delhi Coronation Durbars*. Ahmedabad: Mapin Publishing, 2012.

Codell, Julie, and Dianne S. Macleod, eds. *Orientalism Transposed: The Impact of the Colonies on British Culture*. Aldershot: Ashgate, 1998.

Cohn, Bernard S. 'Representing Authority in Victorian India'. In *The Invention of Tradition*, edited by Eric Hobsbawm and Terrence Ranger, 165–208. Cambridge: Cambridge University Press, 1983.

Cohen, Deborah. *Household Gods: The British and Their Possessions*. New Haven, CT and London: Yale University Press, 2006.

Coleman, D. 'Janet Schaw and the Complexions of Empire'. *Eighteenth-Century Studies* 36, no. 2 (2003): 169–93.

Colley, Linda. *The Ordeal of Elizabeth Marsh: A Woman in World History*. London: Harper Collins, 2007.

Collingham, E. M. *Imperial Bodies: The Physical Experience of the Raj, c.1800–1947*. Malden, MA and Cambridge: Polity, 2001.

Collingham, Elizabeth, *Curry: A Tale of Cooks and Conquerors*. New York: Oxford University Press, 2006.

Coltman, Viccy. *Fabricating the Antique: Neoclassicism in Britain, 1760–1800*. London: University of Chicago Press, 2006.

Conner, Patrick. *Oriental Architecture in the West*. London: Thames and Hudson, 1979.

*Converting the Wilderness: The Art of Gardening in Colonial Australia*. Sydney: Australian Gallery Directors Council, 1979.

Coombes, Annie E. *Reinventing Africa: Museums, Material Culture and Popular Imagination in Late Victorian and Edwardian England*. New Haven, CT: Yale University Press, 1994.

Coombes, Annie E., ed. *Rethinking Settler Colonialism: History and Memory in Australia, Canada, Aotearoa New Zealand and South Africa*. Manchester: Manchester University Press, 2006.

Cooper, Frederick and Laura Ann Stoler, eds. *Tensions of Empire: Colonial Cultures in a Bourgeois World*. Berkeley: University of California Press, 1997.

Cooper, Frederick and Laura Ann Stoler. 'Between Metropole and Colony: Rethinking a Research Agenda'. In *Tensions of Empire: Colonial Cultures in a Bourgeois World*, edited by Frederick Cooper and Ann Laura Stoler, 1–56. Berkeley: University of California Press, 1997.

Craig, Gerald. *Upper Canada: The Formative Years, 1784–1841*. Toronto: McClelland & Stewart, 1963.

Crane, Ralph and Lisa Fletcher. 'Picturing the Indian Tiger: Imperial Iconography in the Nineteenth Century'. *Victorian Literature and Culture* 42, no. 3 (2014): 369–86.

Creighton, Donald. *The Empire of the St. Lawrence*. Toronto: The Macmillan Company of Canada Ltd., 1956.

Crowley, John E. *Imperial Landscapes: Britain's Global Visual Culture*. New Haven and London: Yale University Press, 2011.

Dalrymple, William. *Begums, Thugs and White Mughals: The Journals of Fanny Parkes*. London: Sickle Moon Books, 2002.

Daly Goggin, Maureen and Beth Fowkes Tobin, eds. *Material Women, 1750–1950: Consuming Desires and Collecting Practices*. Farnham, Surrey: Ashgate, 2009.

Daly Goggin, Maureen and Beth Fowkes Tobin, eds. *Women and the Material Culture of Death*. Farnham, Surrey: Ashgate, 2013.

Daly Goggin, Maureen and Beth Fowkes Tobin, eds. *Women and the Material Culture of Needlework and Textiles, 1750–1950*. Farnham, Surrey: Ashgate, 2009.

Daly, Suzanne, *The Empire Inside: Indian Commodities in Victorian Domestic Novels*. Ann Arbor: The University of Michigan Press, 2011.

Darian-Smith, Kate, Richard Gillespie, Caroline Jordan and Elizabeth Willis, eds. *Seize the Day: Exhibitions, Australia and the World*. Clayton: Monash University, 2008.

Dawson, Graham. *Soldier Heroes: British Adventure, Empire, and the Imagining of Masculinities*. London: Routledge, 1994.

Dehejia, Vidya, ed. *India through the Lens: Photography, 1840–1911*. Washington DC: Smithsonian Institution, 2000.

Dehejia, Vidya. 'Fixing a Shadow'. In *India through the Lens: Photography, 1840–1911*, edited by Vidya Dehejia, 11–33. Washington DC: Smithsonian Institution, 2000.

Devine, T. M. *Scotland's Empire, 1600–1815*. London: Penguin, 2003.

Di Bello, Patrizia. *Women's Albums and Photography in Victorian England: Ladies, Mothers and Flirts*. Farnham, Surrey: Ashgate, 2007.

Dickie, W. 'To Burnfoot, in Eskdale'. *The Transactions and Journal of Proceedings of the Dumfriesshire and Galloway Natural History and Antiquarian Society* 13 (1898): 141–47.

Dierks, K. *In My Power: Letter Writing and Communications in Early America*. Philadelphia: University of Pennsylvania Press, 2009.

DiPiero, T. 'Missing Links: Whiteness and the Color of Reason in the Eighteenth Century'. *The Eighteenth Century* 40, no. 2 (1999): 155–74.

Dobrez, Patricia. 'Constance à Beckett (1860–1944), *Untitled Bush Scene (Kookaburras)*, 1872'. In *Heritage: The National Women's Art Book*, edited by Joan Kerr, 75. Roseville East, NSW: Craftsman House, 1995.

Dohmen, Renate. 'Mensahibs and the "Sunny East": Representations of British India by Millicent Douglas Pilkington and Beryl White'. *Victorian Literature and Culture* 40 (2012): 153–77.

Dohmen, Renate. 'Material (Re)collections of the "Shiny East": A Late Nineteenth-Century Travel Account by a Young British Woman in India'. In *Travel Writing, Visual Culture and Form, 1760–1900*, edited by Mary Henes and Brian Murray, 42–64. New York: Palgrave Macmillan, 2015.

Dolan, Brian. *Ladies of the Grand Tour*. London: Flamingo, 2002.

Downes, Stephanie, Andrew Lynch and Katrina O'Loughlin, eds. *Emotions and War: Medieval to Romantic Literature*. Basingstoke: Palgrave Macmillan, 2015.

Drayton, Richard. *Nature's Government: Science, Imperial Britain and the 'Improvement' of the World*. New Haven and London: Yale University Press, 2000.

Droth, Martina, Jason Edwards and Michael Hatt, eds. *Sculpture Victorious: Art in an Age of Invention, 1837–1902*. New Haven and London: Yale University Press, 2014.

Droth, Martina. 'Empire Day Unveilings and Ceremonies'. In *Sculpture Victorious: Art in an Age of Invention, 1837–1902*, edited by Martina Droth, Jason Edwards and Michael Hatt, 127–31. New Haven and London: Yale University Press, 2014.

Ducker, Sophie C. *Story of Gum Leaf Painting*. Melbourne: School of Botany, University of Melbourne, 2001.

Duggins, Molly. '"Which Mimic Art Hath Made": Crafting Nature in the Victorian Book and Album'. In *Of Green Leaf, Bird, and Flower: Artists' Books and the Natural World*, edited by Elisabeth Fairman, 47–62. New Haven and London: Yale University Press, 2014.

Earle, Rebecca, ed. *Epistolary Selves: Letters and Letter-Writers, 1600–1945*. Aldershot, Brookfield, Singapore and Sydney: Ashgate, 1999.

Eaton, Natasha. *Mimesis across Empires: Artworks and Networks in India, 1765–1860*. Durham, NC: Duke University Press, 2013.

Eatwell, Anne. 'Lever as a Collector of Wedgwood: And the Fashion for Collecting Wedgwood in the Nineteenth Century'. *Journal of the History of Collections* 4 (1994): 239–56.

Edmonds, Penelope. 'The Intimate, Urbanising Frontier: Native Camps and Settler Colonialism's Violent Array of Spaces around Early Melbourne'. In *Making Settler Colonial Space: Perspectives on Race, Place and Identity*, edited by Tracey Banivanua Mar and Penelope Edmonds, 129–54. Basingstoke: Palgrave Macmillan, 2010.

Edwards, Elizabeth. *Raw Histories: Photographs, Anthropology and Museums*. Oxford: Berg, 2001.

Edwards, Elizabeth, Chris Gosden and Ruth B. Phillips, eds. *Sensible Objects: Colonialism, Museums and Material Culture*. Oxford: Berg, 2006.

Edwards, P. *The Story of the Voyage: Sea-Narratives in Eighteenth-Century England*. Cambridge: Cambridge University Press, 1994.

Elliott, Andrew. 'British Travel Writing and the Japanese Interior, 1854–1899'. In *The British Abroad since the Eighteenth Century*, edited by Martin Farr and Xavier Guegan, 197–216. Vol 1, *Travellers and Tourists*. Basingstoke: Palgrave Macmillan, 2013.

Endersby, Jim. *Imperial Nature: Joseph Hooker and the Practices of Victorian Science*. Chicago: University of Chicago Press, 2008.

Errington, Elizabeth Jane. *The Lion, the Eagle, and Upper Canada: A Developing Colonial Ideology*. Montréal and Kingston: McGill-Queen's University Press, 1987.

Errington, Elizabeth Jane. *Wives and Mothers, School Mistresses and Scullery Maids: Working Women in Upper Canada, 1790–1840*. Montréal and Kingston: McGill-Queen's University Press, 1995.

Fairman, Elisabeth, ed. *Of Green Leaf, Bird, and Flower: Artists' Books and the Natural World*. New Haven and London: Yale University Press, 2014.

Falconer, John. "'Pure Labour of Love": A Publishing History of *The People of India*'. In *Colonialist Photography: Imag(in)ing Place and Race*, edited by Eleanor M. Hight and Gary Sampson, 51–83. London and New York: Routledge, 2002.

Faragher, John Mack. 'History From the Inside-out: Writing the History of Women in Rural America'. *American Quarterly* 33, no. 5 (1981): 537–57.

Farr, Martin, and Xavier Guegan. *The British Abroad since the Eighteenth Century*. Vol 1, *Travellers and Tourists*. Basingstoke: Palgrave Macmillan, 2013.

Festa, Lynn. *Sentimental Figures of Empire in Eighteenth-Century Britain and France*. Baltimore: John Hopkins University Press, 2006.

Finn, Margot. 'Anglo-Indian Lives in the Later Eighteenth and Early Nineteenth Centuries', *Journal for Eighteenth-Century Studies* 31, no. 1 (2010): 49–65.

Finn, Margot. 'Slaves Out of Context: Domestic Slavery and the Anglo-Indian Family, c. 1780–1820', *Transactions of the Royal Historical Society* 19 (2009): 181–203.

Finn, Margot C. 'Colonial Gifts: Family Politics and the Exchange of Goods in British India, c. 1780–1820'. *Modern Asian Studies* 40, no. 1 (2006): 203–32.

Finn, Margot C. 'Family Formations: Anglo India and the Familial Proto-state'. In *Structures and Transformations in Modern British History*, edited by David Feldman and Jon Lawrence, 100–17. Cambridge: Cambridge University Press, 2011.

Fletcher, Marion. *Costume in Australia 1788–1901*. Melbourne: Oxford University Press, 1984.

Flint, Kate. *The Victorians and the Visual Imagination*. Cambridge: Cambridge University Press, 2000.

Florance, Arnold. *Queen Victoria at Osborne*. London: Yelf Bros, 1997.

Foster, Robert, Amanda Nettlebeck and Rick Hosking, *Fatal Collisions: The South Australian Frontier and the Violence of Memory*. Kent Town, SA: Wakefield Press, 2001.

Fowler, Marian. *Below the Peacock Fan: First Ladies of the Raj*. New York, 1987.

France, Peter. *The Rape of Egypt: How the Europeans Stripped Egypt of Its Heritage*. London: Barrie & Jenkins, 1991.

Freedgood, Elaine, *The Idea in Things: Fugitive Meaning in the Victorian Novel*. Chicago: University of Chicago Press, 2006.

Frenz, Margret. *Community, Memory, and Migration in a Globalizing World: The Goan Experience, c. 1890–1980*. New Delhi: Oxford University Press, 2014.

Fry, Michael. *The Scottish Empire*. East Linton: Tuckwell Press, 2001.

Fulford, T. and P. J. Kitson, eds. *Romanticism and Colonialism: Writing and Empire, 1780–1830*. Cambridge: Cambridge University Press, 1998.

Gagan, David. "'The Prose of Life": Literary Reflections of the Family, Individual Experience and Social Structure in Nineteenth-Century Canada'. *Journal of Social History* 9, no. 3 (1976): 367–81.

Gates, Barbara. 'Shifting Continents, Shifting Species: Louisa Anne Meredith at "Home" in Tasmania'. In *Intrepid Women: Victorian Artists Travel*, edited by Jordana Pomeroy, 77–88. Aldershot: Ashgate, 2005.

George, Samantha. *Botany, Sexuality and Women's Writing 1760–1830: From Modest Shoot to Forward Plant*. Manchester: Manchester University Press, 2007.

Gerber, David. 'Acts of Deceiving and Withholding in Immigrant Letters: Personal Identity and Self-Presentation in Personal Correspondence'. *Journal of Social History* 39, no. 2 (2005): 315–30.

Gere, Charlotte. *Artistic Circles: Design & Decoration in the Aesthetic Movement*. London: V&A Publishing, 2010.

Gerritsen, Anne and Giorgio Riello, eds. *Writing Material Culture History*. London and New York: Bloomsbury, 2015.

Ghose, Indira. *Women Travellers in Colonial India: The Power of the Female Gaze*. New Delhi: Oxford University Press, 1998.

Ghosh, Durba. *Sex and the Family in Colonial India: The Making of Empire*. Cambridge: Cambridge University Press, 2006.

Gilroy, A. and W. M. Verhoeven, eds. *Epistolary Histories: Letters, Fiction, Culture*. Charlottesville and London: University of Virginia Press, 2000.

Glover, William J. '"A Feeling of Absence from Old England": The Colonial Bungalow', *Home Cultures* 1, no. 1 (2004): 61–82.

Goldsworthy, Joanna. 'Fanny Parks. 1794–1875: Her "Grand Moving Diorama of Hindostan", Her Museum and Her Cabinet of Curiosities.' *East India Company at Home*, 1–23. Accessed June 2014. http://blogs.ucl.ac.uk/eicah/files/2014/06/Fanny-Parks-PDF-Final-19.08.14.pdf.

Gordon, Beverley. 'Intimacy and Objects: A Proxemic Analysis of Gender-Based Response to the Material World'. In *The Material Culture of Gender*, edited by Katharine Martinez and Kenneth L. Ames, 237–52. Winterthur, DL: Henry Francis du Pont Winterthur Museum, 1997.

Gordon, Sophie. '"A Sacred Interest": The Role of Photography in the City of Mourning'. In *India's Fabled City: The Art of Courtly Lucknow*, edited by Stephen Markel, 145–63. Los Angeles: LACMA, 2010.

Goring, Elizabeth, Nicholas Reeves and John Ruffle, eds. *Chief of Seers: Egyptian Studies in Memory of Cyril Aldred*. London: Kegan Paul International, 2009.

Goring, Elizabeth. 'Cyril Aldred: "A Very Cautious Young Man"'. In *Chief of Seers: Egyptian Studies in Memory of Cyril Aldred*, edited by Elizabeth Goring, Nicholas Reeves and John Ruffle, 5–6. London: Kegan Paul International, 2009.

Goswami, Manu. *Producing India: From Colonial Economy to National Space*. Chicago: University of Chicago Press, 2004.

Gray, Charlotte. *Sisters in the Wilderness: The Lives of Susanna Moodie and Catharine Parr Traill*. Toronto: Viking, 1999.

Greaves, Rose. 'Iranian Relations with Great Britain and British India, 1797–1921'. In *The Cambridge History of Iran*, vol. 7, edited by Peter Avery, Gavin Hambly and Charles Melville, 374–425. Cambridge: Cambridge University Press, 1991.

Greig, Hannah, Jane Hamlett and Leonie Hannan, eds. *Gender and Material Culture in Britain Since 1600*. London: Palgrave Macmillan, 2015.

Grewal, Inderpal. *Home and Harem: Nation, Gender, Empire and the Cultures of Travel*. London: Duke University Press, 1996.

Grimshaw, Patricia and Julie Evans. 'Colonial Women on Intercultural Frontiers: Rosa Campbell Praed, Mary Bundock and Katie Langloh Parker'. *Australian Historical Studies* 27, no. 106 (1996): 79–95.

Grossman, Jonathan H. 'The Character of a Global Transport Infrastructure: Jules Verne's *Around the World in Eighty Days*'. *History and Technology* 29 (2013): 247–61.

Grundy, Isobel. '"The Barbarous Character We Give Them": White Women Travellers Report on Other Races'. *Studies in Eighteenth-Century Culture* 22 (1993): 73–86.

Guha, Ranajit. 'Not at Home in Empire'. *Critical Inquiry* 23, no. 3 (1997): 482–93.

Gupta, Narayani. 'Pictorializing the "Mutiny" of 1857'. In *Traces of India: Photography, Architecture and the Politics of Representation*, edited by Maria Antonella, 216–39. New Haven and London: Yale University Press.

Guth, Christine. *Longfellow's Tattoos: Tourism, Collecting, and Japan*. Seattle: University of Washington Press, 2004.

Hadjiafxendi, Kyriaki and Patricia Zakreski, eds. *Crafting the Woman Professional in the Long Nineteenth Century: Artistry and Industry in Britain*. Farnham and Burlington, VT: Ashgate, 2013.

Haggerman, Karen, Gisela Mettele and Jane Rendell, *Gender, War and Politics: Transatlantic Perspectives, 1775–1830*. New York: Palgrave Macmillan, 2010.

Haggis, Jane. 'Gendering Colonialism or Colonising Gender? Recent Women's Studies Approaches to White Women and the History of British Colonialism'. *Women's Studies International Forum* 13, no. 1/2 (1990): 105–14.

Haggis, Jane. 'White Women and Colonialism: Towards a Non-Recuperative History'. In *Gender and Imperialism*, edited by Clare Midgley, 45–75. Manchester: Manchester University Press, 1998.

Hagglund, Betty. 'The Botanical Writings of Maria Graham'. *Journal of Literature and Science* 4, no. 1 (2011): 44–58.

Hall, C. and S. O. Rose, eds. *At Home with the Empire: Metropolitan Culture and the Imperial World*. Cambridge: Cambridge University Press, 2006.

Hall, Catherine, ed. *Cultures of Empire: A Reader: Colonizers in Britain and the Empire in the Nineteenth and Twentieth Centuries*. Manchester: Manchester University Press, 2000.

Hancock, David, *Oceans of Wine: Madeira and the Emergence of American Trade and Taste*. New Haven and London: Yale University Press, 2009.

Hansen, David. 'The Lady Vanishes (Or, an Adventure in Conoisseurship)'. *Art Monthly Australia* 241 (2011): 46–49.

Harper, Melissa and Richard White, eds. *Symbols of Australia*. Sydney: University of New South Wales Press, 2010.

Hawes, Christopher J., *Poor Relations: The Making of a Eurasian Community in British India, 1773–1833*. London: Routledge, 1996.

Hawker, James C. *Early Experiences in South Australia*. facsimile ed. Adelaide: Libraries Board of SA, 1975.

Head, Raymond. 'Obituary Dr Mildred Archer OBE, MA (OXON), D. Litt (1911–2005)'. *Journal of the Royal Asiatic Society* 15, no. 3 (2005): 351–4.

Heathorn, Stephen J. 'Angel of Empire: The Cawnpore Memorial Well as a British Site of Imperial Remembrance'. *Journal of Colonialism and Colonial History* 8, no. 3 (2007). Accessed 27 May 2017. https://muse.jhu.edu/article/230163

Helmreich, Anne. *The English Garden and National Identity: The Competing Styles of Garden Design, 1870–1914*. Cambridge: Cambridge University Press, 2002.

Henes, Mary, and Brian Murray, eds. *Travel Writing, Visual Culture and Form, 1760–1900*. New York: Palgrave Macmillan, 2015.

Herbert, Eugenia. 'The Gardens of Barrackpore'. *Studies in the History of Gardens & Designed Landscapes* 27, no. 1 (2007): 31–60.

Heron, Liz and Val Williams, eds. *Illuminations: Women Writing on Photography from the 1850s to the Present*. London and New York: I. B. Tauris, 1996.

Hicks, Dan and Mary C. Beaudry, eds. *The Oxford Handbook of Material Culture Studies*. Oxford: Oxford University Press, 2010.

Hight, Eleanor M. and Gary D. Sampson, eds. *Colonialist Photography: Imag(in)ing Place and Race*. London: Routledge, 2002.

Hobsbawm, Eric, and Terrence Ranger, eds. *The Invention of Tradition*. Cambridge: Cambridge University Press, 1983.

Hore, J. E. *Embassies in the East: The Story of the British and their Embassies in China, Japan and Korea from 1859 to the Present*. London: Routledge, 1999.

Howes, Jennifer. *Illustrating India: The Early Colonial Investigations of Colin Mackenzie*. New Delhi: Oxford University Press, 2010.

Huber, Mary Taylor, and Nancy C. Lutkehaus, eds. *Gendered Missions: Women and Men in Missionary Discourse and Practice*. Ann Arbor: University of Michigan Press, 1999.

Hunter, Michael. 'Faces of India at Osborne House'. *Collections Review* 4 (2003): 111–15.

Hutton, Deborah. 'The Portrait Photography of Raja Deen Dayal'. In *Indian Paintings and Photographs, 1590–1900*, edited by Prahlad Bubbar, 6–9. Exhibition Catalogue, London: Prahlad Bubbar Mayfair, 2012.

Hylton, Jane. *Colonial Sisters: Martha Berkeley and Theresa Walker*. Adelaide: Art Gallery of South Australia, 1994.

Irvin, B. H. 'Tar, Feathers and the Enemies of American Liberties, 1768–1776'. *The New England Quarterly* 76, no. 2 (2003): 197–238.

Irwin, Francesca. 'Amusement or Instruction: Watercolour Manuals and the Woman Amateur'. In *Women in the Victorian Art World*, edited by Clarissa Campbell Orr, 149–66. Manchester and New York: Manchester University Press, 1995.

Isaacs, Jennifer. *The Gentle Arts: 200 Years of Australian Women's Domestic and Decorative Arts*. Sydney: Ure Smith Press, 1987.

Jasanoff, Maya. 'Collectors of Empire: Objects, Conquests and Imperial Self-Fashioning'. *Past & Present* 184 (2004): 109–36.

Jasanoff, Maya. *Edge of Empire: Conquest and Collecting in the East, 1750–1850*. London: Fourth Estate, 2005.

Jones, Robin. "'Furnished in English Style": Anglicization of Local Elite Domestic Interiors in Ceylon (Sri Lanka) c. 1850 to 1910', *South Asian Studies* 20 (2003): 45–56.

Jones, Robin D. *Interiors of Empire: Objects, Space and Identity within the Indian Subcontinent, c. 1800–1947* Manchester: Manchester University Press, 2007.

Jordan, Caroline. 'Progress Versus the Picturesque: White Women and the Aesthetics of Environmentalism in Colonial Australia, 1820–1860'. *Art History* 25, no. 3 (2002): 341–57.

Jordan, Caroline. 'Emma Macpherson in the "Blacks' Camp" and Other Australian Interludes: A Scottish Lady Artist's Tour in New South Wales in 1856–57'. In *Intrepid Women: Victorian Artists Travel*, edited by Jordana Pomeroy, 69–108. Aldershot and Burlington, VT: Ashgate, 2005.

Jordan, Caroline. *Picturesque Pursuits: Colonial Women Artists and the Amateur Tradition*. Carlton: Melbourne University Press, 2005.

Joseph, Betty, *Reading the East India Company 1720–1840: Colonial Currencies of Gender*. Chicago: University of Chicago Press, 2003.

Kaul, Chandrika. 'Monarchical Display & the Politics of Empire: Prince of Wales and India, 1870s–1920s'. *Twentieth Century British History* 17, no. 4 (2006): 464–88.

Kavanagh, Gaynor. *History Curatorship*. Leicester: Leicester University Press, 1990.

Kavanagh, Gaynor, ed. *The Museums Profession: Internal and External Relations*. Leicester: Leicester University Press, 1991.

Kavanagh, Gaynor. 'The Museums Profession and the Articulation of Professional Self-Consciousness'. In *The Museums Profession: Internal and External Relations*, edited by Gaynor Kavanagh, 39–55. Leicester: Leicester University Press, 1991.

Keen, Caroline, *Princely India and the British: Political Development and the Operation of Empire*. London and New York: I. B. Tauris, 2014.

Kerr, Joan and James Broadbent. *Gothick Taste in the Colony of New South Wales*. Sydney: David Ell Press, 1980.

Kerr, Joan and Hugh Falkus. *From Sydney Cove to Duntroon*. Richmond, Vic: Hutchison, 1982.

Kim, E. S. 'Complicating "Complicity/Resistance" in Janet Schaw's *Journal of a Lady of Quality*'. *Auto/Biography Studies* 12, no. 2 (1997): 166–87.

Kinsey, Danielle. 'Koh-i-Noor: Empire, Diamonds and the Performance of British Material Culture'. *Journal of British Studies* 48, no. 2 (2009): 391–419.

Kirk-Greene, A. H. M. *On Crown Service: A History of HM Colonial and Overseas Civil Services, 1837–1997*. London: I. B. Tauris, 1999.

Kirk-Greene, A. H. M. *Symbol of Authority: The British District Officer in Africa*. London: I. B. Tauris, 2006.

Knapman, Claudia. *White Women in Fiji, 1835–1930: The Ruin of Empire?* Sydney: Allen and Unwin, 1986.

Kopytoff, Igor. 'The Cultural Biography of Things: Commoditization as Process'. In *The Social Life of Things: Commodities in Cultural Perspective*, edited by Arjun Appadurai, 64–91. Cambridge: Cambridge University Press, 1986.

Korte, Barbara. *English Travel Writing: From Pilgrimages to Postcolonial Explorations*. Basingstoke: Palgrave, 2000.

Kriegel, Lara. 'Narrating the Subcontinent in 1851: India at the Crystal Palace'. In *The Great Exhibition of 1851: New Interdisciplinary Essays*, edited by Louise Purbrick, 146–78. Manchester: Manchester University Press, 2001.

Kriegel, Lara. *Grand Designs: Labor, Empire and the Museum in Victorian Culture*. Durham, NC and London: Duke University Press, 2007.

Kriz, Kay Dian. *Slavery, Sugar and the Culture of Refinement*. New Haven and London: Yale University Press, 2008.

Kuklock, Henrika, ed. *A New History of Anthropology*. Oxford: Blackwell, 2008.

Laird, Egerton K. *The Rambles of a Globe Trotter in Australia, Japan, China, Java, India, and Cashmere*, 2 vols. Birkenhead: Printed for private circulation, 1875.

Laird, Mark and Alicia Weisberg-Roberts, eds. *Mrs. Delany and Her Circle*. New Haven and London: Yale University Press, 2009.

Lake, Marilyn and Penny Russell. 'Miss Australia'. In *Symbols of Australia*, edited by Melissa Harper and Richard White, 91–5. Sydney: University of New South Wales Press, 2010.

Lane, Kris E., *Color of Paradise: The Emerald in the Age of Gunpowder Empires*. New Haven and London: Yale University Press, 2010.

Lasc, Anca I. 'A Museum of Souvenirs'. *Journal of the History of Collections* 28, no. 1 (2016): 57–71.

Laslett, Barbara and Johanna Brenner. 'Gender and Social Reproduction: Historical Perspectives'. *Annual Review of Sociology* 15 (1989): 381–404.

Lawrence, Dianna. *Genteel Women: Empire and Domestic Material Culture, 1840–1910*. Manchester: Manchester University Press, 2012.

Lawton, Thomas. 'Dr. Stella Kramrisch May 29, 1898-August 31, 1993'. *Artibus Asiae* 53, no. 3/4 (1993): 499–500.

Levine, Philippa. *Gender and Empire*. Oxford: Oxford University Press, 2004.

Levine, Philippa. 'Introduction: Why Gender and Empire?' In *Gender and Empire*, edited by Philippa Levine, 1–13. Oxford: Oxford University Press, 2004.

Levine, Philippa. 'Naked Truths: Bodies, Knowledge, and the Erotics of Colonial Power', *Journal of British Studies* 52, no. 1 (2013): 5–25.

Lewis, Geoffrey D. 'Collections, Collectors and Museums in Britain to 1920'. In *Manual of Curatorship: A Guide to Museum Practice*, edited by John M. A. Thompson, 23–37. London: Butterworths, 1984.

Lewis, Geoffrey. *For Instruction and Recreation: A Centenary History of the Museums Association*. London: Quiller Press, 1989.

Lind, Mary Ann. *The Compassionate Memsahibs: Welfare Activities of British Women in India, 1900–1947*. New York: Greenwood Press, 1988.

Livingstone, David N., and Charles W. J. Withers, eds. *Geographies of Nineteenth-Century Science*. Chicago, IL: University of Chicago Press, 2011.

Long, Jennifer. 'If that mallee desert is converted into a garden…'. In *A Primrose from England: 19th-Century Narratives from the Collection of Bendigo Art Gallery*, edited by Bendigo Art Gallery, 15–20. Bendigo: Bendigo Art Gallery, 2002.

Longair, Sarah. 'The Experience of a "Lady Curator": Negotiating Curatorial Challenges in the Zanzibar Museum'. In *Curating Empire: Museums and the British Imperial Experience*, edited by John McAleer and Sarah Longair, 122–44. Manchester: Manchester University Press, 2013.

Longair, Sarah. *Cracks in the Dome: Fractured Histories of Empire in the Zanzibar Museum, 1897–1964*. Farnham: Ashgate, 2015.

Longair, Sarah and John McAleer, eds. *Curating Empire: Museums and the British Imperial Experience*. Manchester: Manchester University Press, 2012.

Loren, Diana DiPaolo. 'Social Skins: Orthodoxies and Practices of Dressing in the Early Colonial Lower Mississippi Valley'. *Journal of Social Archaeology* 1, no. 2 (2001): 172–89.

Lukisch, Joanne. '"Simply Pictures of Peasants": Artistry, Authorship and Ideology in Julia Margaret Cameron's Photography in Sri Lanka, 1875–1879'. *The Yale Journal of Criticism* 9, no. 2 (1996): 283–308.

MacKenzie, John M. *Museums and Empire: Natural History, Human Cultures and Colonial Identities*. Manchester: Manchester University Press, 2009.

MacMillan, Margaret. *Women of the Raj*. New York: Thames and Hudson, 1988.

Malcolm, John. *Malcolm – Soldier, Diplomat, Ideologue of British India*. Edinburgh: John Donald, 2014.

Mani, Lata. *Contentious Traditions: The Debate on Sati in Colonial India*. Berkeley: University of California Press, 1998.

Manktelow, Emily J.. 'The Rise and Demise of Missionary Wives', *Journal of Women's History* 26, no. 1 (2014): 135–59.

Manne, Robert, ed. *Whitewash: On Keith Windschuttle's Fabrication of Aboriginal History*. Melbourne: Black Inc. Agenda, 2003.

Markel, Stephen, ed. *India's Fabled City: The Art of Courtly Lucknow*. Los Angeles: LACMA, 2010.

Martin, Brenda and Penny Sparke, eds. *Women's Places: Architecture and Design 1860–1960*. London: Routledge, 2003.

Martin, Susan K. 'The Gender of Gardens: The Space of the Garden in Nineteenth-Century Australia'. In *Imagining Australian Space: Cultural Studies and Spatial Inquiry*, edited by Ruth Barcan and Ian Buchanan, 115–25. Nedlands, WA: University of Western Australia Press, 1999.

Martinez, Katharine, and Kenneth L. Ames, eds. *The Material Culture of Gender*. Winterthur, DL: Henry Francis du Pont Winterthur Museum, 1997.

Mathur, Saloni K. 'Living Ethnological Exhibits: the Case of 1886'. *Cultural Anthropology* 36, no. 2 (2000): 492–524.

Mathur, Saloni K. *An Indian Encounter: Portraits for Queen Victoria*. London: National Gallery, 2002.

Mathur, Saloni K. *India by Design: Colonial History and Cultural Display*. Berkeley and Los Angeles: University of California Press, 2007.

Martin, Susan K., Katie Holmes and Kylie Mirmohamadi, eds. *Reading the Garden: The Settlement of Australia*. Melbourne: Melbourne University Press, 2008.

Massey, Doreen. *Space, Place and Gender*. Oxford: Polity Press, 1994.

Mattison, Jane. 'The Journey Through Selfhood in *The Journals of Mary O'Brien 1828–1838* and *A Gentlewoman in Upper Canada: The Journals of Anne Langton'*. *Prose Studies* 25, no. 2 (2002): 51–78.

Maxwell, Anne, *Colonial Photography and Exhibitions: Representations of the Native and the Making of European Identities*. London and New York: Leicester University Press, 1999.

Maynard, Margaret. *Fashioned from Penury: Dress as Cultural Practice in Colonial Australia*. Melbourne: Cambridge University Press, 1994.

McAleer, John, and Sarah Longair eds. *Curating Empire: Museums and the British Imperial Experience*. Manchester: Manchester University Press, 2013.

McClintock, Anne, *Imperial Leather: Race, Gender and Sexuality in the Colonial Context*. London: Routledge, 1995.

McGilvary, George. *East India Patronage and the British State: The Scottish Elite and Politics in the Eighteenth Century*. London: I. B. Tauris, 2008.

McLean, Ian. 'The Expanded Field of the Picturesque: Contested Identities and Empire in *Sydney-Cove 1794*'. In *Art and the British Empire*, edited by Tim Barringer, Geoff Quilley and Douglas Fordham, 23–37. Manchester and New York: Manchester University Press, 2009.

McMillan, D. 'Some Early Travellers'. In *A History of Scottish Women's Writing*, edited by D. Gifford and D. McMillan, 119–42. Edinburgh: Edinburgh University Press 1997.

Meghani, Kajal. *Splendours of the Subcontinent: A Prince's Tour of India*. London: Royal Collection Trust, 2017.

Melman, Billie. *Women's Orients: English Women and the Middle East, 1718–1918*. Basingstoke: Macmillan, 1992.

Meyer, Melissa and Miriam Schapiro. 'Waste Not, Want Not: An Inquiry into What Women Saved and Assembled'. *Heresies* 1, no. 4 (Winter 1978): 66–9.

Micklewright, Nancy. *A Victorian Traveller in the Middle East: The Photography and Travel Writing of Annie Lady Brassey*. Aldershot: Ashgate, 2003.

Midgley, Clare, ed. *Gender and Imperialism*. Manchester: Manchester University Press, 1998.

Midgley, Clare. 'Introduction: Gender and Imperialism: Mapping Connections'. In *Gender and Imperialism*, edited by Clare Midgley, 1–18. Manchester: Manchester University Press, 1998.

Midgley, Clare. 'Can Women be Missionaries? Envisioning Female Agency in the Early Nineteenth-Century British Empire', *Journal of British Studies* 45 (2006): 335–58.

Midgley, Clare, *Feminism and Empire: Women Activists in Imperial Britain, 1790–1865*. London: Routledge, 2007.

Miller, Daniel, ed. *Consumption: The History and Regional Development of Consumption*. London: Routledge, 2001.

Mills, David. *The Idea of Loyalty in Upper Canada, 1784–1850*. Montréal and Kingston: McGill-Queen's University Press, 1988.

Mills, Sara. *Discourses of Difference: An Analysis of Women's Travel Writing and Colonialism*. London: Routledge, 1991.

Mills, Sara. *Gender and Colonial Space*. Manchester and New York: Manchester University Press, 2005.

Mills, Sara. 'Colonial Domestic Space', *Renaissance and Modern Studies* 39, no. 1 (1996): 46–60.

Mintz, Sidney. *Sweetness and Power: The Place of Sugar in Modern History*. New York and London: Sifton, 1985.

Mitchell, Timothy. *Colonizing Egypt*. Cambridge: Cambridge University Press, 1988.

Montag, W. 'The Universalisation of Whiteness: Racism and Enlightenment'. In *Whiteness: A Critical Reader*, edited by M. Hill, 281–93. New York and London: New York University Press, 1997.

Moore, Lisa L. 'Queer Gardens: Mary Delany's Flowers and Friendships'. *Eighteenth-Century Studies* 39 (2005): 49–70.

Morgan, Cecilia. *Public Men and Virtuous Women: The Gendered Languages of Religion and Politics in Upper Canada, 1791–1850*. Toronto: University of Toronto Press, 1996.

Morgan, Cecilia. 'Gender, Loyalty and Virtue in a Colonial Context: The War of 1812 and its Aftermath in Upper Canada'. In *Gender, War and Politics: Transatlantic Perspectives, 1775–1830*, edited by Karen Hagermann, Gisela Mettele and Jane Rendell, 307–24. New York: Palgrave Macmillan, 2010.

Morris, Marry. 'Introduction'. In *The Virago Book of Women Travellers*, edited by Mary Morris, xv–xxii. London: Virago, 1996.

Murray, Cara. *Victorian Narrative Technologies in the Middle East*. London: Routledge, 2008.

Myers, Janet C. *Antipodal England: Emigration and Portable Domesticity in the Victorian Imagination*. Albany: SUNY Press, 2009.

Nadel, Ira B. 'Portraits of the Queen'. *Victorian Poetry* 25, no. 3/4 (1987): 169–91

Nair, Janaki. 'Uncovering the Zenana: Visions of Indian Womanhood in Englishwomen's Writings, 1813–1940'. *Journal of Women's History* 2, no. 1 (1990): 8–34.

Nash, R. *Wild Enlightenment: The Borders of Human Identity in the Eighteenth Century*. Charlottesville and London: University of Virginia Press, 2003.

Nechtman, Tillman, *Nabobs: Empire and Identity in Eighteenth-Century Britain*. Cambridge: Cambridge University Press, 2010.

Nechtman, Tillman W. 'Nabobinas: Luxury, Gender, and the Sexual Politics of British Imperialism in India in the Late Eighteenth Century', *Journal of Women's History* 18, no. 4 (2006): 8–30.

Neiswander, Judith A. *The Cosmopolitan Interior: Liberalism and the British Home 1870–1914.* New Haven: Yale University Press, 2008.

Nussbaum, Felicity. *Torrid Zones: Maternity, Sexuality and Empire in Eighteenth-Century Narratives.* Baltimore, MD and London: John Hopkins University Press, 1995.

O'Loughlin, Katrina. '"In Brazen Bonds": The warring landscapes of North Carolina, 1775'. In *Emotions and War: Medieval to Romantic Literature*, edited by Stephanie Downes, Andrew Lynch and Katrina O'Loughlin, 217–34. Basingstoke: Palgrave Macmillan, 2015.

Olding, Simon, Giles Waterfield and Mark Bills, eds. *A Victorian Salon: Paintings from the Russell-Cotes Art Gallery and Museum.* London and Bournemouth: Lund Humphries in association with Russell-Cotes Art Gallery and Museum, 1999.

Olding, Simon. 'A Victorian Salon: An Introduction'. In *A Victorian Salon: Paintings from the Russell-Cotes Art Gallery and Museum*, edited by Simon Olding, Giles Waterfield and Mark Bills, 7–13. London and Bournemouth: Lund Humphries in association with Russell-Cotes Art Gallery and Museum, 1999.

Parker, Rozsika. *The Subversive Stitch: Embroidery and the Making of the Feminine.* London: The Women's Review, 1984.

Pascoe, Judith. *The Hummingbird Cabinet: A Rare and Curious History of Romantic Collectors.* Ithaca: Cornell University Press, 2006.

Payne, Michelle. *Marianne North: A Very Intrepid Painter.* Kew: Kew Publishing, 2011.

Pearce, Susan. 'Material History as Cultural Transition: A La Ronde, Exmouth, Devon, England'. *Material Culture Review* 50 (1999): 26–34.

Pearsall, Sarah M. S. *Atlantic Families: Lives and Letters in the Later Eighteenth Century.* Oxford: Oxford University Press, 2008.

Perkin, Harold James. *The Rise of Professional Society: England since 1880.* London: Routledge, 1989.

Petersen, Anna K. C. 'The European Use of Maori Art in New Zealand Homes, c.1890–1914'. In *At Home in New Zealand: History, Houses, People*, edited by Barbara Brookes, 58–9. Wellington: Bridget Williams Books, 2000.

Phillips, Ruth. *Trading Identities: The Souvenir in Native North American Art from the Northeast, 1700–1900.* Montréal and Kingston: McGill-Queen's University Press, 1998.

Pickles, Katie. *Female Imperialism and National Identity: Imperial Order Daughters of the Empire.* Manchester: Manchester University Press, 2002.

Pinney, Christopher. *Camera Indica: The Social Life of Indian Photographs.* London: Reaktion, 1997.

Pinney, Christopher. *Photography and Anthropology.* London: Reaktion, 2011.

Plotz, John, *Portable Property: Victorian Culture on the Move*. Princeton, NJ: Princeton University Press, 2008.

Plotz, John. 'The First Strawberries in India: Cultural Portability in Victorian Greater Britain', *Victorian Studies: An Interdisciplinary Journal of Social, Political and Cultural Studies* 49, no. 4 (2007): 659–84.

Pomeroy, Jordana, ed. *Intrepid Women: Victorian Artists Travel*. Aldershot: Ashgate, 2005.

Potvin, John and Alla Myzelev, eds. *Material Cultures, 1740–1920: The Meanings of Pleasures of Collecting*. Farnham, Surrey: Ashgate, 2009.

Powell, Jennifer. 'The Dissemination of Commemorative Statues of Queen Victoria'. In *Modern British Sculpture*, edited by Penelope Curtis and Keith Wilson, 282–88. London: Royal Academy of Arts, 2011.

Pratt, Mary Louise. *Imperial Eyes: Travel Writing and Transculturation*. 2nd edn. London: Routledge, 2008.

Procida, Mary A. *Married to the Empire: Gender, Politics and Imperialism in India, 1883–1947*. Manchester: Manchester University Press, 2002.

Quilley, Geoff and John Bonehill, eds. *William Hodges, 1744–1797: The Art of Exploration*. New Haven and London, 2004.

Quilley, Geoff and Kay Dian Kriz. *An Economy of Colour: Visual Culture and the North Atlantic World, 1660–1830*. Manchester: Manchester University Press, 2003.

Rajagopalan, Mrinalini. *Building Histories: The Archival and Affective Lives of Five Monuments in Modern Delhi*. Chicago, IL: University of Chicago Press, 2017.

Ramusack, Barbara N. *The New Cambridge History of India: The Indian Princes and their States*. Cambridge: Cambridge University Press, 2004.

Ray, Romita. 'The Memsahib's Brush: Anglo-Indian Women and the Art of the Picturesque'. In *Orientalism Transposed: The Impact of the Colonies on British Culture*, edited by Julie Codell and Dianne S. Macleod, 89–111. Aldershot: Ashgate, 1998.

Ray, Romita. *Under the Banyan Tree: Relocating the Picturesque in British India*. New Haven and London: Yale University Press, 2013.

Raza, Rosemary. *In Their Own Words: British Women Writers and India, 1740–1857*. New Delhi: Oxford University Press, 2006.

Reed, Charles V. *Royal Tourists, Colonial Subjects and the Making of a British World, 1860–1911*. Manchester: Manchester University Press, 2016.

Reid, Donald Malcolm. *Whose Pharaohs? Archaeology, Museums, and Egyptian National Identity from Napoleon to World War I*. London: University of California Press, 2002.

Reinwald, Brigitte. '"Tonight at the Empire?" Cinema and Urbanity in Zanzibar, 1920s to 1960s'. *Afrique & Histoire* 5, no. 1 (2006): 81–109.

Relia, Anil. *The Indian Portrait VI: A Photographic Evolution from Documentation to Posterity*. Ahmedabad: Archer Art Gallery, 2015.

Reynolds, Henry. *Forgotten War*. Kensington: University of New South Wales Press, 2013.

Richards, Eric. 'William Younghusband and the Overseas Trade of Early Colonial South Australia'. *South Australiana* 17, no. 2 (1978): 151–93.

Riello, Giorgio, *Cotton: The Fabric that Made the Modern World*. Cambridge and New York: Cambridge University Press, 2013.

Robert, Dana L., ed. *Gospel Bearers, Gender Barriers: Missionary Women in the Twentieth Century*. New York: Orbis, 2002.

Roberts, Daniel Sanjiv. '"Merely Birds of Passage": Lady Hariot Dufferin's Travel Writings and Medical Work in India, 1884–1888'. *Women's History Review* 15, no. 3 (2006): 443–57.

Rosen, Jeff. 'Cameron's Colonized Eden: Picturesque Politics at the Edge of the Empire'. In *Intrepid Women: Victorian Artists Travel*, edited by Jordana Pomeroy, 109–28. Aldershot and Burlington, VT: Ashgate, 2005.

Rosenthal, Angela. '*Visceral* Culture: Blushing and the Legibility of Whiteness in Eighteenth-Century British Portraiture'. *Art History* 27, no. 4 (2004): 563–92.

Rothschild, Emma. *The Inner Life of Empires: An Eighteenth-Century History*. Princeton and Oxford: Princeton University Press, 2011.

Russell-Cotes Art Gallery and Museum. *Souvenir of the Japanese Collection*. Bournemouth: Russell-Cotes Art Gallery and Museum, 1931.

Ryan, James, *Picturing Empire: Photography and the Visualisation of the British Empire*. Chicago: University of Chicago Press, 1998.

Ryan, James R. '"Our Home on the Ocean": Lady Brassey and the Voyages of the Sunbeam, 1874–1887'. *Journal of Historical Geography* 32 (2006): 579–604.

Said, Edward. *Orientalism*. London: Routledge and Kegan Paul, 1978.

Said, Edward. *Culture and Imperialism*. London: Vintage Books, 1994.

Saunders, Gil. *Picturing Plants: An Analytical History of Botanical Illustration*. Berkeley and Los Angeles: University of California Press, 1995.

Scarce, Jennifer. 'Entertainments East and West: Three Encounters between Iranians and Europeans during the Qajar Period (1786–1925)'. *Iranian Studies* 40, no. 4 (2007): 455–66

Schlereth, Thomas J. *Material Culture Studies in America*. Nashville, TN: Rowman Altamira, 1982.

Schumaker, Lyn. 'Women in the Field in the Twentieth Century: Revolution, Involution, Devolution'. In *A New History of Anthropology*, edited by Henrika Kuklick, 277–92. Oxford: Blackwell, 2008.

Schurmann, Edwin A. *I'd Rather Dig Potatoes: Clamor Schurmann and the Aborigines of South Australia 1838–1853*. Adelaide: Lutheran Publishing House, 1987.

Schwartz Cowan, Ruth. *More Work for Mother: The Ironies of Household Technology from the Open Hearth to the Microwave*. New York, NY: Basic Books, 1983.

Scott, Joan Wallach. 'Gender: A Useful Category of Historical Analysis'. *The American Historical Review* 91, no. 5 (1986): 1053–75.

Sear, Martha. '"Common Neutral Ground": Feminising the Public Sphere at Two Nineteenth-Century Australian Exhibitions of Women's Work'. In *Seize the Day: Exhibitions, Australia and the World*, edited by Kate Darian-Smith, Richard Gillespie, Caroline Jordan and Elizabeth Willis, 14.1–14.16. Clayton: Monash University Press, 2008.

Seaton, Beverly. *The Language of Flowers: A History*. Charlottesville and London: University Press of Virginia, 1995.

Semple, Rhonda A., *Missionary Women: Gender, Professionalism and the late Victorian Idea of Christian Mission*. Woodbridge: Boydell, 2003.

Sheller, M. *Consuming the Caribbean: From Arawaks to Zombies*. London and New York: Routledge, 2003.

Sheriff, Abdul. 'The Spatial Dichotomy of Swahili Towns: The Case of Zanzibar in the Nineteenth Century'. In *The Urban Experience in Eastern Africa c. 1750–2000*, edited by Andrew Burton, 62–81. Nairobi: British Institute in Eastern Africa, 2002.

Shields, Nancy K. *Birds of Passage: Henrietta Clive in South India, 1798–1801*. London: Eland Publishing, 2007.

Shteir, Ann B. *Cultivating Women, Cultivating Science: Flora's Daughters and Botany in England, 1760 to 1860*. Baltimore and London: The John Hopkins University Press, 1996.

Shtier, Anne B., and Bernard V. Lightman, eds. *Figuring It Out: Gender, Science and Visual Culture*. Lebanon, NH: Duke University Press, 1999.

Siegel, Elizabeth, ed. *Playing with Pictures: The Art of Victorian Photocollage*. New Haven and London: Art Institute of Chicago and Yale University Press, 2009.

Sinha, Mrinalini. *Colonial Masculinity: The 'Manly Englishman' and the 'Effeminate Bengali' in the Late Nineteenth Century*. Manchester: Manchester University Press, 1995.

Sloan, Kim. *'A Noble Art': Amateur Artists and Drawing Masters, c.1600–1800*. London: British Museum Press, 2000.

Sloan, Kim. 'Mrs. Delany's Prints and Drawings: Adorning Aspasia's Closet'. In *Mrs. Delany and Her Circle*, edited by Mark Laird and Alicia Weisberg-Roberts, 110–29. New Haven and London: Yale University Press, 2009.

Sloboda, Stacey. 'Material Displays: Porcelain and Natural History in the Duchess of Portland's Museum'. *Eighteenth-Century Studies* 43 (2010): 455–72.

Smith, Kate. 'Imperial Families: Women Writing Home in Georgian Britain', *Women's History Review* 24, no. 6 (2015): 843–60.

Smith, Kate. 'The Afterlife of Objects: Anglo-Indian Ivory Furniture in Britain'. *East India Company at Home* (July 2014), 1–26. Accessed 27 May 2017. http://blogs.ucl. ac.uk/eicah/files/2014/07/Ivory-Furniture-PDF-altered-20.10.16-copy-1.pdf

Solkin, David H. *Painting for Money: The Visual Arts and the Public Sphere in Eighteenth-Century England*. New Haven and London: Yale University Press, 1996.

Stanworth, Karen. *Visibly Canadian: Imaging Collective Identities in the Canadas, 1820–1910*. Montréal and Kingston: McGill-Queen's University Press, 2014.

Sterry, Lorrain. *Victorian Women Travellers in Meiji Japan: Discovering a New Land*. Folkestone: Global Oriental, 2009.

Stewart, Susan. *On Longing: Narratives of the Miniature, the Gigantic, the Souvenir, the Collection*. Durham: Duke University Press, 1992.

Stoler, Ann Laura, *Race and the Education of Desire: Foucault's 'History of Sexuality' and the Colonial Order of Things*. Durham, NC: Duke University Press, 1995.

Stoler, Ann Laura. *Carnal Knowledge and Imperial Power: Race and the Intimate in Colonial Rule*. Berkeley and London: University of California Press, 2002.

Stoler, Ann Laura, *Along the Archival Grain: Epistemic Anxieties and Colonial Common Sense*. Princeton: Princeton University Press, 2009.

Strobel, Margaret. *European Women and the Second British Empire*. Bloomington and Indianapolis: Indiana University Press, 1991.

Sumerling, Patricia. *The Adelaide Parklands: A Social History*. Kent Town, SA: The Wakefield Press, 2011.

Tague, I. H. *Animal Companions: Pets and Social Change in Eighteenth-Century Britain*. Pennsylvania: Pennsylvania State University Press, 2015.

Taylor, Miles. 'Queen Victoria and India, 1837–61'. *Victorian Studies* 46, no. 2 (2004): 264–74.

Teltscher, Kate. 'The Sentimental Ambassador: The Letters of George Bogel from Bengal, Bhutan and Tibet, 1770–1781'. In *Epistolary Selves: Letters and Letter-Writers, 1600–1945*, edited by Rebecca Earle, 79–94. Aldershot, Brookfield, Singapore and Sydney: Ashgate, 1999.

Teltscher, Kate, Henry Yule and A. C. Burnell, eds. *Hobson-Jobson: The Definitive Glossary of British India*. Oxford: Oxford University Press, 2013.

Thompson, John M.A., ed. *Manual of Curatorship: A Guide to Museum Practice*. London: Butterworths, 1984.

Thorne, Susan, *Congregational Missions and the Making of an Imperial Culture in Nineteenth-Century England*. Stanford, CA: Stanford University Press, 1999.

Thurston, Edgar. *Monograph on the Ivory Carving Industry of Southern India*. Madras: Government Press, 1901.

Tobin, Beth Fowkes. *The Duchess's Shells: Natural History Collecting in the Age of Cook's Voyages*. New Haven: Yale University Press, 2014).

Tobin, Fowkes Beth. *Picturing Imperial Power: Colonial Subjects in Eighteenth-Century British Painting*. Durham, NC: Duke University Press, 1999.

Tucker, Jennifer. 'Gender and Genre in Victorian Scientific Photography'. In *Figuring It Out: Gender, Science and Visual Culture*, edited by Anne B. Shtier and Bernard V. Lightman, 140–63. Lebanon, NH: University Press of New England, 2006.

Twells, Alison, *The Civilising Mission and the English Middle Classes, 1792–1850: The 'Heathen' at Home and Overseas*. Basingstoke: Palgrave Macmillan, 2009.

Twiss, Dorothy and Rosemary Cochrane. *Grace and Learning from Africa: Arundel School – the First Fifty Years*. Harare: Arundel School, 2005.

Uglow, Jenny. *The Pinecone: The Story of Sarah Losh*. Faber: London, 2012.

Vibert, Elizabeth. 'Writing "Home": Sibling Intimacy and Mobility in a Scottish Colonial Memoir'. In *Moving Subjects: Gender, Mobility and Intimacy in an Age of Global Empire*, edited by Tony Ballantyne and Antoinette Burton, 67–88. Urbana and Chicago: University of Illinois Press, 2009.

Vickery, Amanda and John Styles, eds. *Gender, Taste and Material Culture in Britain and North America, 1700–1830*. New Haven and London: Yale University Press, 2006.

Vickery, Amanda. *Behind Closed Doors: At Home in Georgian England*. New Haven, CT: Yale University Press, 2009.

W., T. S. 'Review: Journal of a Lady of Quality [i. e. Janet Schaw]; Being the Narrative of a Journey from Scotland to the West Indies, North Carolina, and Portugal, in the Years 1774–6 by E. W. Andrews; C. McL. Andrews; Janet Schaw'. *The Geographical Journal* 95, no. 6 (1940): 471–2.

Wahrman, D. *The Making of the Modern Self: Identity and Culture in Eighteenth-Century England*. New Haven and London: Yale University Press, 2004.

Wainwright, Charles. *The Romantic Interior: The British Collector at Home, 1750–1850*. London: Yale University Press, 1989.

Walker, Charles. *Thomas Brassey: Railway Builder*. London: Frederick Muller, 1969.

Walvin, James. *Fruits of Empire: Exotic Produce and British Taste, 1660–1800*. Basingstoke: Macmillan, 1997.

Warnapala, Kanchanakesi Channa. 'Dismantling the Gaze: Julia Margaret Cameron's Sri Lankan Photographs'. *Postcolonial Text* 4, no. 1 (2008): 1–20.

Waterfield, Giles. 'A Home of Luxury and a Temple of Art'. In *A Victorian Salon: Paintings from the Russell-Cotes Art Gallery and Museum*, edited by Simon Olding, Giles Waterfield and Mark Bills, 14–23. London and Bournemouth: Lund Humphries in association with Russell-Cotes Art Gallery and Museum, 1999.

Welch, Stuart Carey. *India: Art and Culture, 1300–1900*. New York: Metropolitan Museum of Art, 1985.

Williams, Val. *The Other Observers: Women Photographers in Britain, 1990 to the Present*. London: Virago Press, 1986.

Wilson, Kathleen. *A New Imperial History: Culture, Identity and Modernity in Britain and the Empire, 1660–1840*. Cambridge: Cambridge University Press, 2004.

Wilson, Shirley Cameron and Keith Borrow. *The Bridge Over the Ocean: Thomas Wilson (1787–1863) Art Collector and Mayor of Adelaide*. Adelaide: Wilson & Borrow, 1973.

Withey, Lynne. *Grand Tours and Cook's Tours: A History of Leisure Travel, 1750 to 1915*. London: Aurum Press, 1998.

Wolfe, Patrick. 'Settler Colonialism and the Elimination of the Native'. *Journal of Genocide Research* 8, no. 4 (2006): 387–409.

Wonders, William C. 'Log Dwellings in Canadian Folk Architecture'. *Annals of the Association of American Geographers* 69, no. 2 (1979): 187–207.

Woodward, Ian. *Understanding Material Culture*. London: Sage, 2007.

Woollacott, Angela. *To Try Her Fortune in London*. Oxford: Oxford University Press, 2001.

Wulf, Andrea. *The Brother Gardeners: Botany, Empire and the Birth of an Obsession*. London: Heinemann, 2011.

Wyrick, D. B. '"My Emigrants" and "Mere Brutes": The Rhetoric of Colonialism in Janet Schaw's *Journal of a Lady of Quality*'. *Michigan Feminist Studies* 9 (1994–5): 81–96.

Young, Linda. 'Material Life in South Australia'. *Journal of Interdisciplinary History* 25, no. 1 (1994): 65–84.

'Zenana Studio: Early Women Photographers of Bengal, from *Taking Pictures: The Practice of Photography by Bengalis* by Siddhartha Ghosh'. Translated by Debjani Sengupta. *Trans Asia Photography Review* 4, no. 2 (2014), online journal, doi: http://hdl.handle.net/2027/spo.7977573.0004.202.

Zlotnick, Susan. 'Domesticating Imperialism: Curry and Cookbooks in Victorian England', *Journal of Women Studies* 16 (1996): 51–68.

Zytaruk, Maria. 'Epistolary Utterances, Cabinet Spaces and Natural History'. In *Mrs. Delany and Her Circle*, edited by Mark Laird and Alicia Weisberg-Roberts, 130–49. New Haven and London: Yale University Press, 2009.

## Other sources

'Anne Langton'. *Maryboro Lodge – The Fenelon Museum*. Accessed 19 April 2016. http://www.maryboro.ca/LangHis.html.

Cameron, Wendy. 'Langton, John'. *Dictionary of Canadian Biography, Volume 12*. University of Toronto/Université Laval, 2003. Accessed 17 April 2016. http://www.biographi.ca/en/bio/langton_john_12E.html.

Gupta, Pamila. 'Goans in Mozambique and Zanzibar: Case Studies from Littoral East Africa'. Lecture at *Connections and Disconnections in the History and Cultures of East Africa* conference, BIEA, Nairobi 30–31 March, 2015.

Victorian Web. 'Mina Malcolm to Charlotte Stewart, 1 May 1829'. Accessed 28 December 2015. http://www.victorianweb.org/previctorian/letters/malcolm.html.

Wilson, Catherine. 'Burnfoot and the Malcolm Family'. Accessed 29 December 2015. http://www.burnfoot.net/?p=264.

# Index